CONTEMPORARY
SYNAGOGUE
ART

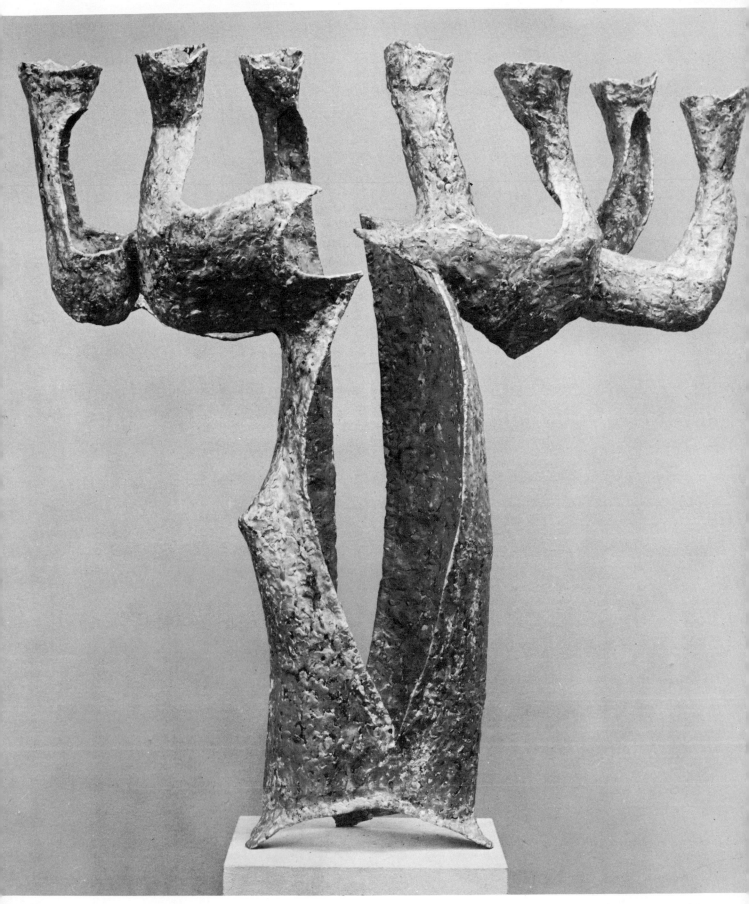

(SEE PAGE 171)

Contemporary Synagogue Art

DEVELOPMENTS IN THE
UNITED STATES, 1945-1965

by AVRAM KAMPF

Union of American Hebrew Congregations
New York, N.Y.

TO
MY
PARENTS

Preface

SINCE WORLD WAR II, more than 500 synagogues have been built in the United States. This large building program has brought into focus problems which congregations had not faced before. For reasons which we shall try to develop, the function of synagogue art suddenly became an important question to an institution which, according to general opinion, had for centuries neglected the graphic and plastic arts. The massive new building program called upon rabbis, architects, artists, and lay leaders to divest themselves of this historic inhibition. It compelled them to develop themes and forms appropriate to the contemporary synagogue.

The present study attempts to trace and analyze the various cultural and esthetic problems which have been encountered in this remarkable artistic endeavor. It seeks to clarify the nature of the synagogue past and present, and Judaism's changing attitudes toward art. The problems faced by contemporary synagogue building committees, artists and architects and the various directions which their efforts have taken are also examined. It is a healthy development that those who have been most closely associated with this trend should invite frank and critical discussion.

The approach and organization of the book evolved after numerous field trips across the United States. Its division into separate chapters dealing with the exterior and the interior of the synagogue was dictated by the nature of the relationship between art and architecture today and also by a desire to isolate these areas in order to facilitate comparative study between them.

The book might have been organized differently—perhaps according to regions, themes, materials, or individual structures. Each of these methods has advantages and shortcomings. However, since the subject of this book included not only the art of the contemporary synagogue but also its relation to the architecture, the proposed division seemed warranted. In the case of Temple B'nai Israel in Millburn, a pioneering effort, I altered my approach in order to emphasize the interrelationship of the architectural and decorative programs both of the interior and of the exterior.

I would like to thank the Union of American Hebrew Congregations' Commission on Synagogue Activities which, under the Directorship of Rabbi Eugene J. Lipman, originally

suggested and sponsored this study. I am also grateful to the UAHC's Commission on Synagogue Administration, its Chairman, Dr. Harold Faigenbaum, and its Director, Myron E. Schoen, F.T.A., for carrying forth the endeavor through its Advisory Committee on the Arts and Architects Advisory Panel. The facilities of the UAHC's Synagogue Architectural Library were invaluable on this study. I am naturally indebted to the UAHC Publications Committee and the Jewish Publication Society who are co-sponsors of this book. My deep gratitude goes to the many artists, architects and rabbis who have generously given their time to discuss with me the numerous aspects of synagogue art. This book could not have been written without the active interest of the leaders of many synagogues. They were most cooperative. I am also grateful to the Hebrew Union College-Jewish Institute of Religion and to Harvard University for permitting me the use of their library facilities. I thank Dr. Stephen Kayser, the former Director of the Jewish Museum and Tom Freudenheim, its curator, for putting at my disposal the resources of the Jewish Museum. My special thanks to my teacher, Professor Meyer Schapiro, and to Professors Sidney Morgenbesser, Horace M. Kallen and Rudolph Arnheim for encouraging the pursuit of this study. I am grateful to Rabbi Ben Zion Gold of the Hillel House at Harvard University, who shared his wide knowledge of Hebrew literature with me; to Miss Avivah Kiev for assisting me in assembling a large number of photographs; to Miss Betty Schlossman for editing the manuscript; to Ralph Davis for the actual production and design of the book, and to the Union's Proofreading Department, headed by Mrs. Josette Knight. My deepest gratitude goes to Professor Mino Badner whose careful reading of the manuscript and many critical comments were invaluable in the final preparation of this book. Finally I would like to emphasize that none of the above are in any way responsible for the shortcomings of this study.

AVRAM KAMPF
Montclair, New Jersey, 1965

Contents

synagogue activities. The quest for decorum. Demand for art coming from traditional sources and new conditions. The view of Dr. M. M. Kaplan. The idea of the Holy. The adoption of modern architecture. What should a synagogue look like? The view of Lewis Mumford. The need for reconciliation of function and expression in synagogue architecture. The failure of functional planning to satisfy psychological needs. The need for the work of art. Relationship of art and modern architecture. The solutions to the problem of art in architecture by Sullivan, Wright, the International Style and the Bauhaus. Leaders in architecture build synagogues. The function of art in today's architecture. Percival Goodman's contribution to the problem. Collaboration among the arts.

ART FOR TODAY'S SYNAGOGUE 46

The expression of the Jewish ethos. The communal art of a seventeenth-century synagogue. The breakdown of the traditional Jewish world view. Jewish theology today. The function of art in the reestablishment of Jewish communal and religious values. The artist vis-à-vis the community. The position of the architect. The role of the rabbi. The need for his education in the arts. Art as an avenue of religious experience. Modern art for the synagogue. The expansion of the repertoire of Hebrew art. A monumental scale for Jewish iconography. Adaptation of Jewish religious ideas to the world of today. Analytic, expressive, and decorative tendencies of contemporary art in the synagogue. The problem of communication in modern synagogue art. The Hebrew letter. Didactic art. Synthesis of the abstract and the concrete in synagogue art. Synagogue art and the freedom of the artist. Existence of Jewish motives in contemporary art of which the synagogue is unaware. A genuine religious art for which the synagogue is a natural home. Younger American artists and their Jewish subjects. The place of the isolated work of art in the synagogue. Relation of Jewish community to Jewish artists. The case of Ben-Zion.

CONGREGATION B'NAI ISRAEL IN MILLBURN, NEW JERSEY 75

Contemporary artists in the service of the synagogue. Artwork integrated into exterior. Sculpture aiding architecture in expressing the building's purpose. The burning bush. Use of new materials and new techniques. A mural on the theme of the temple wall. Inscriptions on the walls of the prayer hall. A congregation remembers. Stones from destroyed synagogues. Torah curtain designed by artist and executed by women of congregation. The signs of the curtain. The reaction of the congregation. The aims and achievements of the artist.

ARTWORK ON SYNAGOGUE EXTERIORS 87

The pillar of fire in hammered bronze. The creation of the world and the liberation from bondage in sgraffito, terrazzo and metal. Eight relief sculptures

on persistent ideas of Judaism. "Not by might but by my spirit . . ." The use of Hebrew mythology for representation of spirit and might. "On three things the world is founded." A bronze sculpture of Moses and the burning bush. A *menorah* designed in brick. The pillar of fire and pillar of smoke in concrete, and a *menorah* resembling a chariot. Five tile murals on Jewish ideas from the Bible. A sculptural metaphor on theme of the *menorah*. Sculpture in wrought iron. The ladder, the Torah and the crowns. A sculpture in metal and glass.

CONTEMPORARY

SYNAGOGUE

ART

The
Synagogue

I T IS customary to speak of the synagogue as fulfilling a triple function: that of a house of prayer בית תפילה, a house of study בית מדרש and a house of assembly בית כנסת. Although these terms describe the synagogue throughout its history, they do not explain it. They fail to reveal the enduring essence of the institution and its revolutionary nature.

The synagogue, unlike the ancient temple, is not a house of God where the Deity dwells, although it has been called the *Mikdash Me'at* (small sanctuary), and is often viewed as a substitute for the ancient temple. Its sanctity does not in fact derive from its location, or from its structure or from its furnishings. Sanctity rests in the worshipping congregation, in the community of believers. In the temple, God dwelled in its innermost part, inaccessible by direct means even to the priest, who approached Him by the medium of sacrifice on behalf of the people. In the synagogue, "God stands in the midst of the congregation," in the soul of man which has become the "Temple of the Lord."

The change from temple to synagogue represents an ascent to an altogether different stage of religious awareness. The temple was the house of the Lord; the synagogue is the house of its congregants. God is no longer conceived of as dwelling in a particular place. He is everywhere. He can be addressed from every corner of the world and by every man who reaches out to Him. Prayer, which had been attached to the sacrificial ceremonial in the temple, emancipated itself in the synagogue, joining with instruction and discussion. The magical elements contained in the sacrifice and the unconditional submission to God through the mediation of the priest were abandoned and gave way to symbolic rituals

and the rational elements of study and discourse. The individual member of the congregation came to the fore as an active participant in the service, standing in a direct relationship with his Creator.

The change had tremendous consequences. Those who, until then, had been at best distant observers, watching the God-appointed priest performing rites and reading from the Law which they did not understand, became actively engaged in the service. Every Jew who participated assumed a measure of responsibility for the service. He might even be called upon to lead it or to read from the Torah.

The word "synagogue" comes from the Greek *synagōgē* (assembly, synagogue) or *synagein* (to assemble, to gather). The origin of the institution is still a matter of scholarly controversy. Some scholars tend to place the origin of the synagogue in the period of the Babylonian Exile (586-538 B.C.E.) when Jews, deprived of their temple and unable to make sacrifices, gathered with their elders on the Sabbath to discuss their communal affairs, to read from their Law, and to worship together.[1] It is, however, quite plausible to assume, as Leopold Löw suggests, that the origin of the institution goes even farther back and that it was not a result of cultural needs but an outgrowth of the political life of the community.[2]

Löw assumed that the city gates referred to so often in the Bible were the center of communal life, as the town halls and courthouses were in later centuries. The city gates were market places, where country folk and artisans brought their wares, where prophets spoke their words, and where, on certain days of the week, judges sat in court. As cities grew and municipal affairs became more complex, and as important documents began to gather in the archives, a municipal structure was erected: the *Bet Am*, or People's House, of which the Bible speaks (Jer. 39:8).

An interesting passage in the Talmud points to the association between the early *Bet Am*, the People's House, and the synagogue, which Löw believed evolved from it. "Rabbi Ishmael Ben Eliezer said: On account of two sins, *Ame Ha'aretz* (the peasants, the unlearned) will die: because they call the Holy Ark a chest, and because they call the synagogue, *Bet Am*" (B. Shabbat 32a). Since the institution of the synagogue (*Bet K'nesset*) is not mentioned in the Bible, one might assume that this talmudic passage indicates a connection between the synagogue and the earlier, secular, *Bet Am*. The chest, Löw assumed, was the depository of important individual and communal documents.[3]

Salo W. Baron deepens and broadens Löw's view. He posits a cluster of forces active in ancient Israel which, in their interaction, created a set of psycho-social attitudes and institutions. These attitudes and institutions made it possible for Jews to survive in other countries outside Palestine, as an ethnic-religious group with the synagogue as its center.

The geographical heterogeneity of the land of Israel, the economic self-sufficiency of the ancient towns, the weakness of central government agencies, strong autonomous municipal administration, local self-government by representative elders—all these fostered an early sense of self-reliance and self-rule among Jews. Early pre-exilic voluntary and forced dispersion brought about an adaptation of native forms to foreign conditions. The deuteronomic revolution (621 B.C.E.) brought about a centralization of sacrificial worship at the Temple of Jerusalem by abolishing local cult areas. After the return from

the Babylonian Exile, the second religious revolution initiated by Ezra stimulated new forms of communal worship based on prayer, recitation of communal lore, liturgical song, and the sermon. These elements helped to transform the synagogue into an easily adaptable and portable institution, which ultimately any ten Jewish men could establish anywhere in the world.[4]

There was, as we have seen, a deep democratic impulse within the synagogue institution from its very inception. This impulse persisted throughout the ages and led of necessity to a wide diffusion of knowledge and of religious practice. The mode of worship itself, the reading from the Torah and its interpretation, prayer interwoven with instruction and narration of historical events, became important factors in the education of the congregants.[5]

The synagogue spread wherever a Jewish group established itself. With the destruction of the Second Temple (70 C.E.), its importance as a central institution increased enormously. It became the natural focal point of Jewish communal life. The regularity with which the prayers took place endowed daily life with sanctity and brought about a great measure of inwardness. This regularity of daily prayer also created an inner attitude that

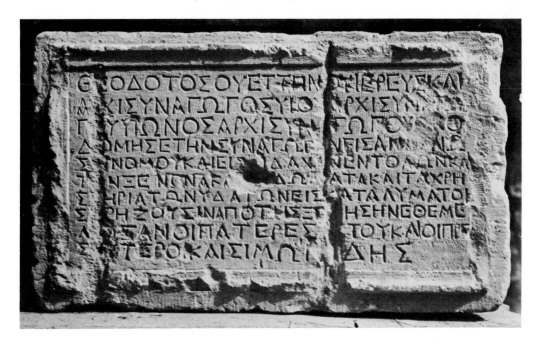

Synagogue stone, dating from before 70 C.E., found in Jerusalem, with Greek inscription:

"Theodotos, son of Vettenos, priest and archisynagogos, son of an archisynagogos, grandson of an archisynagogos, built the synagogue for the reading of the law and for the teaching of the commandments; furthermore the hospice and the chambers, and the water installation, for the lodging of needy strangers. The foundation stone thereof had been laid by his fathers, and the elders, and Simonides."

From Reifenberg, *Ancient Hebrew Arts*

persisted even when the individual departed from his community. It made him the carrier of a tradition, of a way of life, the bearer of a destiny and of an historical consciousness which he was able to transmit under the most difficult circumstances.

The synagogue continued to grow as the natural center of Jewish communal life. In the ancient world it housed a school for the education of the children and of adults; its secular activities often paralleled its religious ones. Often it possessed rooms where a passing stranger could spend the night. The community hospital was under its control. Within its premises the affairs of the community were discussed, slaves were liberated, circumcisions and marriages performed. In larger synagogues, like the one in Alexandria, guilds had specially assigned seats, so that a stranger who came to town could easily make contact with fellow-craftsmen. Court was often held in the synagogue, losses proclaimed, and in the Middle Ages there existed that remarkable institution called "Delay of Prayer." Anyone who felt that he had been wronged could delay the start of the reading from the Torah and appeal to public opinion for justice.

Today, the synagogue remains one of the most original creations of the Jewish people, the mainstay of their cohesiveness, assuring the survival of their religious group, their cultural identity and their historical consciousness. It answers their social, religious, communal and educational needs. Philo, speaking about synagogues in the first century, put it thus: "What are they but schools of wisdom and temperance, and justice and piety, and holiness and even virtue, by which human and divine things are appreciated and placed upon a proper footing."[6]

The Interpretation of the Second Commandment

Thou shalt not make unto thee a graven image, nor any manner of likeness of anything that is in the heaven above, or that is in the earth beneath (Exod. 20:4; Deut. 5:8).

THE second commandment has been interpreted strictly many times in Jewish history. Even when interpreted liberally, however, it casts a long shadow over the Jew's relationship with representational art in any form. It should be observed at the outset that, even if strictly interpreted, the commandment does not infringe upon the huge area of art which is not representational: that is, all abstract geometric or non-objective art.[1] But close examination of literary sources and archeological evidence makes obvious that, in practice, the commandment was never literally observed. The implications of talmudic Law regarding the arts of painting and sculpture were never clear cut. On the other hand, although there was no outright forbidding attitude expressed in the Talmud, the position of the sages had a continuously retarding and discouraging effect on the practice and development of art. However, the negative attitude of the rabbis was based not only on their equivocal feelings about the second commandment but was influenced also by their ascetic frame of mind which held the study of the Torah as being the only truly worthwhile intellectual pursuit.

While reading the second commandment in context, we can easily conclude that the Lawgiver, when He forbade the making of graven images, had in mind images made for the purpose of worship.[2] Otherwise, one would be hard put to explain the presence of the sixteen-foot-high carved olivewood cherubim in the biblical Tent of Testimony and in the

Temple of Solomon (I Kings 6:23-35); also the sculpture of the twelve cast oxen which carried on their backs the molten sea (II Chron. 4:3-5); or the lions which, according to the Bible, guarded Solomon's throne (II Chron. 9:17-19). Hardly compatible with a strict interpretation of the second commandment is Ezekiel's blueprint of the restored temple, the walls of which were to be decorated with "cherubim and palmtrees; and a palmtree was between cherub and cherub and every cherub had two faces; so that there was the face of a man toward the palmtree on the one side, and the face of a young lion toward the palmtree on the other side; thus was it made through all the house round about" (Ezek. 41:18-20).[3]

David Kaufmann, a well-known nineteenth-century scholar and pioneer in the study of Jewish art, declared that "the fable of the enmity of the synagogue to all art till the end of the Middle Ages and well into modern times must finally be discounted in the light of the facts of life and the testimony of literature."[4] He added that "with the disappearance of the fear of idolatry, which had been the strongest reason for the law, the fear of enjoyment of the work of art gradually disappeared among us."[5] At that time (1908) his claim seemed exaggerated and his assumption based on too limited evidence. In the main, he seemed bent on normalizing the relationship of the Jew toward art. Giving the loving care of the collector and the careful scrutiny of the scholar to any artifact or artistic document that came to his attention, he seemed too much guided by his own ardent admiration for these objects. His rejection of the widely held view that Jews had no art (because according to the second commandment they were not supposed to have any) was based on his knowledge of a number of Hebrew illuminated manuscripts that had come into his hands (among them the famous *Haggadah* of Sarajevo[6]), his awareness of wall paintings in eastern European synagogues, and his knowledge of specimens of Italian synagogue art.[7]

He had also studied the Jewish catacombs discovered at Monte Verde and the Villa Torlonia in Rome, and the richly decorated mosaic floor of a fourth-century synagogue in Hammam Lif, North Africa, which had been accidentally discovered in 1883 by a French army captain.[8]

Most scholars in Kaufmann's era did not fully realize that a revision of the traditional view of art in the synagogue had already been in the making for some time, and that Kaufmann's approach was the result of a re-evaluation of traditional Jewish attitudes toward art in the light of the nineteenth-century scientific approach of Jewish scholarship.

In 1870, Leopold Löw's book, *Graphische Requisiten und Erzeugnisse bei den Juden*,[9] had appeared. Löw, an eminent rabbi and scholar, examined post-biblical literature up to his own day, analyzing the diverse interpretations of the second commandment and the various communal disputes that had arisen from time to time as a result of the prohibition of figurative art. He found the results of his investigation both encouraging and depressing: on the one hand, Jews exhibited a need for and receptivity toward the artistic products of their time and surroundings; on the other hand, however, the attitudes of Jewish theology had a partially thwarting, discouraging effect on these endeavors.

Even earlier, Abraham Geiger, a well-known scholar, rabbi, and leader in the Reform movement, had expressed for the first time a modern post-emancipation view of art in a

Open ark, revealing Torah scrolls flanked by menorot. Marble from catacomb at Monte Verde, Italy, ca. third cent. C.E.

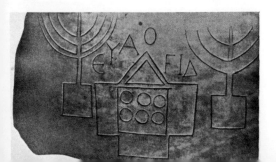

 יום אחד יהי אור ויבדל בין האור ובין החשך

Separation of Day from Night.

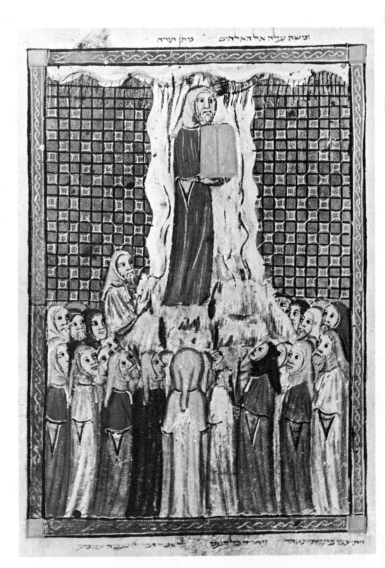

ומשה עלה אל האלהים פרק תורה

The Giving of the Law from Haggadah of Sarajevo.
Spanish manuscript mid-fourteenth century. (National
Museum, Sarajevo, Yugoslavia.)

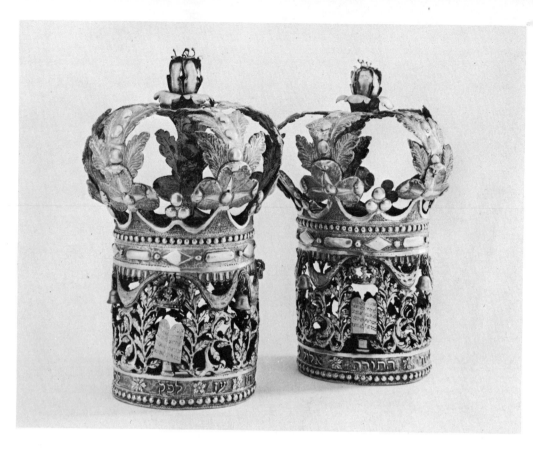

*Torah crowns, Turin, Italy, 1717.
Harry G. Friedman collection.
(Courtesy The Jewish Museum,
New York.)*

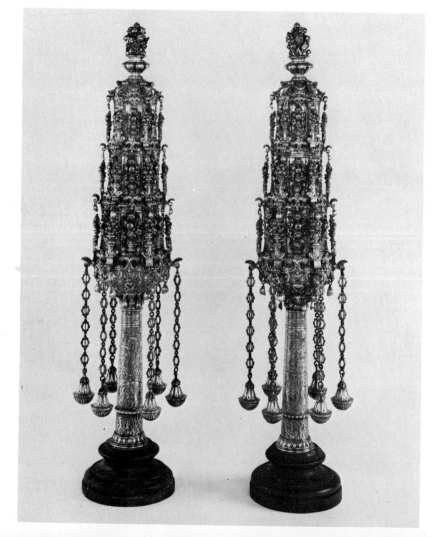

*Torah headpieces, Mantua, Italy,
ca. 1600. Samuel and Lucille Lem-
berg collection. (Courtesy The
Jewish Museum, New York.)*

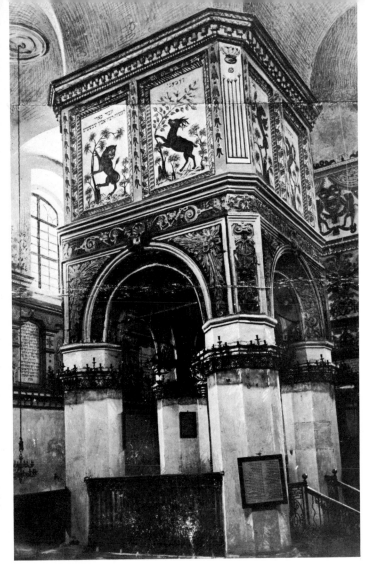

Central pillars and bimah with animal design, Luke, Poland, seventeenth cent. (Courtesy The Jewish Museum. Photo: Frank J. Darmstaedter.)

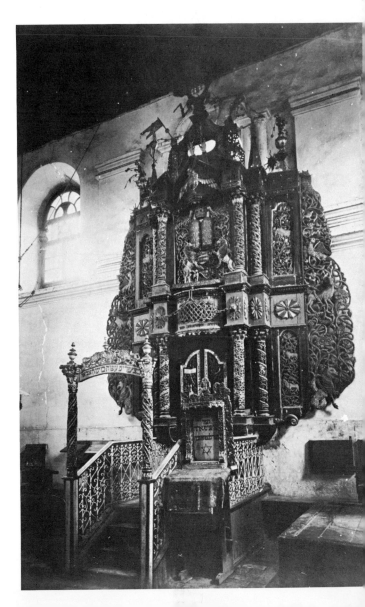

Ark of carved wood, Poland, eighteenth cent. (Courtesy The Jewish Museum. Photo: Frank J. Darmstaedter.)

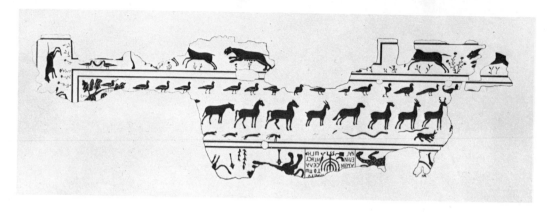

Noah's Ark, synagogue floor from Gerasa, Jordan, fifth cent. C.E. (Courtesy The Jewish Museum. Photo: Frank J. Darmstaedter.)

detailed rabbinical *Responsum*. He was asked if a picture might be installed within the synagogue without violating the Law. He answered yes, assuming, of course, that it was to be installed not for the purpose of religious worship, but for decoration. He further stressed that it made no difference whether the painting was installed in a synagogue or a private building: "That which is forbidden in the synagogue is also forbidden in any private building and vice versa; that which is allowed for the private building is also allowed for the synagogue. On the other hand, the practice of the Halakhah bases itself on the assumption that many things which are allowed in public are forbidden to the individual person, since there might be cause for suspicion of idolatry. The trust which the Halakhah has in the Jewish community is so strong that there is no room for suspicion that this trust will be abused."[10] The question, therefore, becomes a broader one: namely, whether Judaism will permit the installation of a picture in any public or private place for esthetic reasons. He continues: "Whoever has cast only a single glance into the Halakhah with regard to this subject must note that there is not the slightest reservation about this distinction. There is debate only about those works which might be used for religious worship."[11]

Contemporary scholarship, which bases its conclusions on the interpretation of literary data, on the evidence of excavations conducted in the last sixty years, and on the iconographic study and esthetic appreciation of Hebrew illuminated manuscripts, tends to accept Kaufmann's assertion, which seemed so incredible in his time.

The ever increasing accumulation of Hebrew illuminated manuscripts; the scientific study of the artwork found in the Polish synagogues with their designs of plant, animal, and legendary motifs; the amazing discovery of the ancient synagogue of Dura Europos with its murals, its repertoire of historical scenes, its procession of the events and personalities that shaped ancient Jewish history, following on the heels of the excavation of ancient synagogues in Beth Alpha, Esfiya, El Hamma, Gerasa, Nirim, and Hamat Tiberias, with richly decorated mosaic floors of original and adapted motifs; and the unearthing of sculptured friezes on the ancient synagogues of Capernaum, Chorazin, and Eshtamoa—all these discoveries have forced a further drastic revision of our notion of the Jewish historical attitude toward art.[12] They have revealed the existence of a host of original

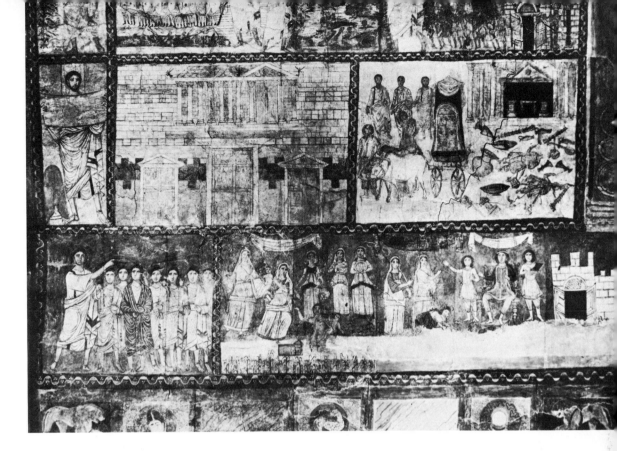

Murals with biblical themes, west wall, synagogue of Dura
Europos, third cent. C.E.

Return of the ark of the covenant from the Philistines. Detail from
west wall, synagogue of Dura Europos.

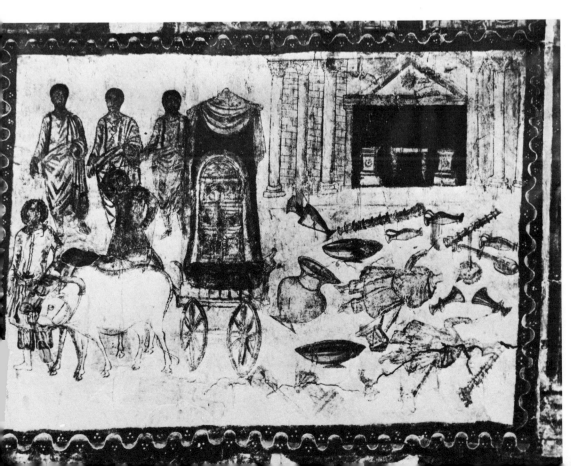

motifs, as well as motifs adapted and acculturated from the surrounding environment: the lion, the eagle, the ox, the *menorah*, the *shofar*, the censer, the ark, the sacrifice of Isaac and Daniel in the lion's den, the story of the flood, leaves, garlands, rosettas, flowers, grapes, fish, bread, vines, pomegranates, cornucopias, wreaths, sunwheels, baskets loaded with fruits, the zodiac, the figures of the seasons, pentagrams, hexagrams, birds, the scrolls, the lyre and others. These discoveries support the assumption that a body of Hebrew illustrations for the Bible existed in the ancient world, preceding and influencing early Christian art.

In the light of these new findings, it gradually became clear that no one normative interpretation of the second commandment, true for all times and all places, ever existed. The problem shifted from establishing the one exact attitude of Judaism toward the image to understanding the wide range of ways in which the prohibition against images has been observed at various times and places under various conditions.

Zodiac and figures of the seasons, central section of mosaic floor, synagogue of Beth Alpha, sixth cent. C.E.

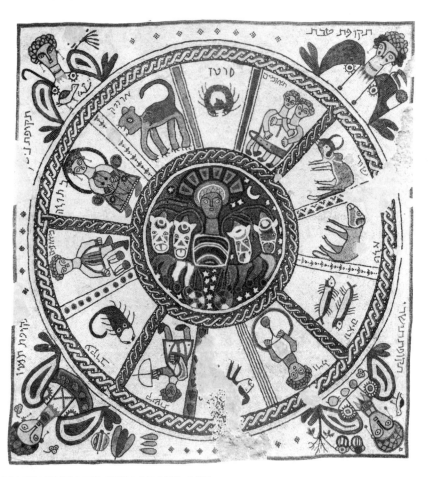

· 14 · CONTEMPORARY SYNAGOGUE ART

Scholars discern two opposing attitudes on this question, each achieving dominance under different circumstances. During periods of national crises, for example, as during the time of the Maccabees and the wars with the Romans, nationalistic feeling ran high and the extreme view of prohibition prevailed. Every image was considered a symbol of the foreign invader. National and religious elements united in their opposition against the Romans when the great eagle on top of Herod's temple was pulled down in Jerusalem, and the community was prepared to offer itself for slaughter rather than permit Roman standards bearing an image to appear in the streets of the city (Josephus: *Antiquities*, XV, 8:1-2; *Wars*, I, 33:2-3). After the destruction of the Temple, such extreme views could no longer be enforced, and as the leadership passed to the rabbis, a more discerning and analytical view on art made itself felt. Yet, basic differences remained. Rabbi Menahem ben Simai, for instance, "would not gaze even at the image on one *zuz*," since it carried the imprint of the Roman Emperor, whereas Rabban Gamaliel II had in his upper chamber a lunar diagram, and frequented a bath house where a statue of Aphrodite was set, a matter that was of some concern to his colleagues. Two rabbis of the third century, the father of Samuel the Judge and Levi, prayed in the synagogue of Shaph-weyathib in Nehardea, Babylonia, in which a statue was set up. "Yet Samuel's father and Levi entered it and prayed there without worrying about the possibility of suspicion! It is different where there are many people together" (Abodah Zarah 43b).[13]

In their debates the sages differentiated between statues which were intended for a religious or political purpose (such statues were venerated in the ancient world) and those which were made for pure ornamentation. They prohibited the use of the former ones; and restricted the latter ones to the cities. "Rabbah said: There is a difference of opinion with regard to statues in villages, but regarding those which are in cities, all agree that they are permitted. Why are they permitted? They are made for ornamentation" (Abodah Zarah 41a). The Aramaic paraphrase of the Pentateuch, known as Targum Jonathan, expressed the outlook of the third century toward figurative representation in its rendering of Leviticus 26:1, which prohibited idols and graven images: "A figured stone ye shall not put on the ground to worship, but a colonnade with pictures and likenesses ye may have in your synagogues, but not to worship thereat."[14] In the same century we also find talmudic reference to actual synagogue decoration. "At the time of Rabbi Jochanan they began to have paintings on the walls and the rabbis did not hinder them."[15] It is, in fact, from this very century that many of the artworks in ancient synagogues come to us, most of them made under Greco-Roman influence. The third-century expression of grudging permissiveness is characteristic of this period with its more lenient interpretation of the commandment.

Salo Baron sums up the talmudic attitude as follows: "The talmudic teachers certainly did not encourage the painting of nude women on synagogue walls, as was done in Dura (the Egyptian princess personally fetching Moses from the river). The text indicates, on the contrary, that the practice under the impact of Greco-Roman mores had become so deep rooted that the rabbis could not avoid legalizing it, even for Palestine."[16]

It was the considered opinion of the rabbis of the third century that all impulses toward idolatry had been eradicated by the beginning of the Second Temple period.[17] The hold

MA'ON MOSAIC PAVEMENT

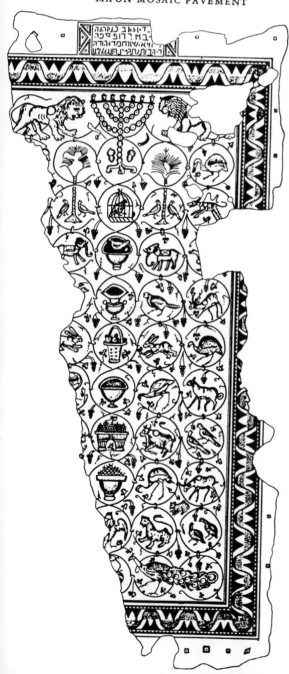

Mosaic floor and three details, synagogue of Ma'on Nirim, Israel, fourth cent. C.E. (Dept. of Antiquities, Ministry of Education and Culture, Israel.)

of idolatry had also been weakened among the pagans.[18] Recent studies have shown that, due to the great demographic changes which occurred in Israel after the war with the Romans and the revolt of Bar Kochba, Jewish craftsmen, in order to be able to compete on the open market, had adopted their neighbors' methods of ornamentation. They were makers of trinkets of gold and silver and glass vessels. Scriptural as well as archeological evidence also points to the fact that these Jewish craftsmen were engaged in the making of images and idols and participated in the construction of basilicas. They did so in order to make a living. The Sages, who trusted the craftsmen implicitly, took their economic situation into account and constantly widened the meaning of the second commandment. The first tanna to whom a ruling about idolatry is attributed is Rabbi Eliezer in the following Mishnah: "None may make ornaments for an idol, necklaces or earrings or finger rings" Rabbi Eliezer says: "If for payment, it is permitted" (Mishnah Abodah Zarah 1:8).[19] Indeed, at Beth Netopha in Judea, a workshop has been unearthed containing the remains of lamps engraved with the emblems of the *menorah* and *shofar*, and beside them images of horsemen and nude women.

The ups and downs, the dominant liberal or fundamentalist reactions to the arts, were determined by the subtle interplay of internal and external forces. External pressures and strong central control brought about a hardening of the rabbinical attitude. Relaxation of tension, free intercourse with the environment, and economic considerations brought about an adaptation to the cultural possibilities offered by the surroundings and a more lenient interpretation of the second commandment. Later on we find iconoclastic tendencies in Christianity and Islam reinforcing such tendencies in the Jewish world.

These constant reversals of attitude toward art among the Jews continued into the Middle Ages and, in fact, were still apparent as late as the nineteenth century. On the whole, the attitude of suspicion and discomfort with the image remained. This outlook became deeply ingrained, and any image evoked an almost instinctive negative reaction. However, the motivation for the prohibition had shifted by the early Middle Ages. It was not because of its associations with idolatry that the image was resented, but because it disturbed *Kavanah*, the intense devotional aspect of worship. Thus, while Maimonides (twelfth century) permitted figures in the synagogue in sunk relief, painted on a board or tablet or embroidered on tapestry, he used to close his eyes while praying near a wall where a tapestry hung so that he would not be disturbed by it.[20] Authorities continued to hold opposing viewpoints: Rabbi Ephraim ben Isak of Regensburg permitted the decoration of the *bimah* and the chair of circumcision within a synagogue with representations of horses and birds, while Rabbi Eliakim ben Joseph of Mainz is mostly remembered for removing the pictures of a lion and snakes from the stained-glass windows of the synagogue of Cologne, so that it should not appear that Jews worshipped them.[21] In the thirteenth century, Rabbi Meir of Rothenburg prohibited the illumination of festival prayer books with pictures of animals and birds, also on the grounds that they distracted the attention of the worshipper.[22] However, it is quite clear from the large number of illuminated manuscripts which have come down to us that the prohibition was not very effective. In the fifteenth century, Rabbi Judah Minz of Padua opposed the installation of a *parokhet*

Fruits and flowers, section of frieze, synagogue at Capernaum, third cent. C.E.

in his synagogue. The *parokhet* was donated by one Hirsh Wertheim: it was richly embroidered with pearls, and was ornamented with the image of a deer.

About a hundred years later a stormy controversy broke on the island of Kandia, then under Venetian rule, when a wealthy and influential member of the community, who had repaired the synagogue there, ordered a sculptured crowned stone lion to be made for the top of the ark, near an inscription carrying the name of the donor. In order to resolve the conflicting views which arose over this sculpture, it was decided to ask the advice of rabbis in various parts of the world. David Ibn-Abi Zimra in Cairo, Joseph Karo in Safed, Moses di Trani in Jerusalem, Elijah Capsali in Constantinople, and Meir Katzenellenbogen in Padua were consulted. They sided with those who opposed the installation of the lion.[23]

On the other hand, in the Jewish ghetto of Florence, many Jews had their houses painted with frescoes containing scenes from the Old Testament; wealthier ones had medallions struck, and some rabbis even had their portraits painted. In the Jewish quarter of Siena above the fountain opposite the synagogue stood a statue of Moses sculpted by the fifteenth-century artist, Antonio Federighi.[24] Visiting Jews from Posen found it offensive (1740).[25]

In the synagogues of Poland built in the seventeenth, eighteenth, and nineteenth centuries we find the burgeoning of a vital folk art. The community firmly believed that such art enhanced their synagogues, and furthermore that it had been carried out with the approval of the great scholars and founders of the community who had desired to adorn the synagogue. It was a great *mitzvah* to do so.[26] This permissive attitude was not confined to Poland alone; any visitor to the old Jewish cemetery near Amsterdam marvels at the representational figures found on many gravestones there.

We have already noted that even the strictest observance of the commandment leaves room for all art which is not representational. The splendid thirteenth- and fourteenth-century Spanish synagogues preserved in Toledo, with their geometric and arabesque designs, showing exceptionally fine proportion and taste, are good examples. It is not

design, texture, rhythm or color which are viewed with suspicion, but rather the preoccupation with them, the quest for beauty alone and the world of material appearances as such. The idea of representational art as a humanistic endeavor and discipline in itself, divorced from religious and magical concerns and distinct from other domains of life—art as a product of imagination which reflects on reality—was an approach to art either unknown at this time or susceptible to distrust because it was not controllable. Appearances were thought to hide rather than to reveal the essential nature of things. Because the idols were considered an illusion and because representational art also can be easily understood as an illusion, representational works were suspect and discouraged.

The intensely religious experience does not need to be supplemented by art. It creates its own art in that it constantly reconstructs its world and perceives the beautiful as an emanation of the divine. "The whole earth is full of His glory" (Isa. 6:3). "The Heaven is My throne and the earth My footstool" (Isa. 66:1). Religious experience as such is independent of art. Religion as an institution may use art to aid the worshipper to commune with God. But when Jewish religious tradition relied heavily for the transmission of its ideas on the oral word and on the written text, and when study and discourse were themselves a part of worship, representational art was excluded from the religious value system which was in the main preoccupied with the knowledge of Torah. It was not primarily a basic inner incompatability between the monotheistic world view and the representational image that brought art so much into disfavor with the rabbis; it was the preference for the written word as a tool for instruction and for the transmission of social and moral values that depend heavily on the spoken word.[27] For the purpose of

Stone Lion, synagogue of Chorazin, Israel, third cent. C.E.

THE INTERPRETATION OF THE SECOND COMMANDMENT · 19 ·

reinforcing the religious experience, Jews have always used the art of music. They knew the value of the musical memory and its capacity, the ability of rhythm and harmony to sink deep into the hidden recesses of the soul and to bind the individual to his group and tradition. "He who reads the Scriptures without melody and the Mishnah without song, of him it can be said as is written: Wherefore I gave them also statutes that were not good" (Ezek. 20:25).[28]

It has been suggested that Judaism's perception of the divine as outside of nature brings about a natural preference for speech and religious poetry as art forms.[29] According to this assumption, God reveals Himself not in any concrete form, "for ye saw no manner of form on the day that the Lord spoke unto you in Horeb out of the midst of the fire" (Deut. 4:15). It is through the medium of the ear that the Jew encountered the Divine, whereas other people to whom God appeared in nature perceived Him through the medium of the eye. One kind of perception necessarily leads to the development of the art of the spoken word in religious communication and the other to the use of the plastic arts.

Hermann Cohen developed this idea further, and pointed to the incompatibility between the plastic arts and the monotheistic view as it emerged. For him the conflict was basic. The second commandment is an attack on art springing from the very nature of the oneness, the invisibility, and unimaginability of God.[30] These ideas are worth serious consideration, especially since they are not offered in support of a particular point of view or to sound a note of apology, but in an attempt to penetrate the historical setting which gave birth to a certain attitude.

The God concept of a people naturally has a decisive influence on its art. A faith that proclaims one God of justice and mercy Who cannot be seen and Who uses an unseen medium like the voice inevitably deprives plastic art of one of its great incentives and opportunities. In the cultural climate of the ancient world, there existed an abundance of gods who were visible to all in some concrete form.[31] Jews became aware of art as an independent activity only after the first centuries. However, the die had been cast, and even when the battle against idolatry was won, and the belief in the efficacy of idols had become deflated, the deeply ingrained negative attitude toward art could not whole-heartedly be revised. Feelings of suspicion and instinctive deprecation of appearances remained. Monotheism is a highly abstract idea and conflicts with man's great need for concreteness. Therefore, to avoid any temptation to compromise, plastic expression continued to be shunned. It is the nature of the plastic image to assert itself, and it is more prone than any other symbol man uses in his communication with the Divine to stand between the worshipper and reality and "catch the mind in the accidents of the symbol and confuse it instead of furthering its approach to reality."[32]

Post-talmudic Judaism accepted the Talmud as normative. Attitudes existing in talmudic times were not viewed as limited in validity to their time, but were accepted generally as binding for all times. Judaism enlisted those arts which would advance its central concern: To do the will of God as commanded in the Torah.

This God is one. There is no other. He is the God Who created heaven and earth. He reigns supreme over all, is everlasting, stands outside nature and time, yet intervenes in

the affairs of man. He is the God of justice and of mercy. He is holy and demanding. He has created man in His own image. The central belief and concern of Israel flows from this God concept. Since man is made in the image of God, Who is just and merciful, man must live up to this image and not deny it. Man must practice justice and mercy. He must have respect for himself and others, whether weak or strong, a native or a stranger, a master or a slave. The foundation of the concept of the rights of man, brotherhood of man, and the dignity of man is anchored in God and receives its sanction from Him. Man, by living up to this image, becomes the co-worker of God and helps Him realize His divine plan. Israel, which entered a covenant with the Lord, accepted His Torah and His commandments and must try to become a holy people, a light to the nations. Ethical concerns thus become the central theme of Judaism, which idealizes the realm of morality and holiness rather than the realm of art and philosophy. Judaism created art values only in the realm of the psalm and prophetic speech. Common to both art forms, however, Grätz observed, is the fact that their essential characteristic is truth, not poetic fiction or playful fancy.[33] Judaism also created an historical narrative, "which had the advantage not to be silent, gloss over, or beautify the shameful and unmoral of the heroes, kings, and nations, but tells the events truthfully."[34]

Ethical values have become so all-pervasive, then, that all other values have to conform to them, may not stand in contradiction to them, or compete with them. Nor can any other value be considered apart from them. To the intensely religious person, an amoral, neutral value does not make sense. If he cannot integrate it into his scheme of thinking and feeling, it threatens him. Thus, he tends to close his eyes to works of art.

Since the knowledge of the Lord leads to the imitation of His ways, the rabbis elaborated in great detail the ways of truth and justice that man should follow. Religious vision had to be expressed in right living. The attainment of the beautiful was not to be found in the harmony of the form, but in the articulation of human needs and of right conduct in accord with the laws of the Torah, which were interpreted and reinterpreted as circumstances changed. Rabbinical interpretation of the Law is considered as binding as the Law itself. The bondage in Egypt, the wandering in the desert, the encounter with the Lord and the prophecy have created a persistent theme, a mode of living, feeling, and thinking. Confronted with works of art the rabbis weighed them against human needs. "When Rabbi Joshua b. Levi visited Rome he saw there pillars (apparently meaning statues) covered with tapestry in winter so that they should not contract and in summer that they should not split. As he was walking in the street, he spied a poor man wrapped in a mat, others say in half an ass' pack."[35] He could not but be aware of the contrast between the concern for the statue and for the man. Art was obviously seen by him as a luxury that one could do without; only actual human needs really mattered.

Rabbi Hama ben Hanina, the wealthy amora of the third century, pointed out to Rabbi Hoshaiah II a beautiful synagogue in Lydda, to which his wealthy ancestors had contributed. His colleague exclaimed: "How many lives have thy ancestors buried here? Were there no needy scholars whom that treasure would have enabled to devote themselves to the study of the law?"[36] R. Abin reproached a friend on similar grounds for

installing a beautiful gate in his large school house and applied to him the verse: "For Israel hath forgotten his Maker and builded palaces" (Hos. 8:14).[37]

Throughout these ethical concerns there is an awareness of means and ends, a scale of values in which human needs predominate. The Talmud, which has very little to say about the architecture of synagogues, points to the necessity of making the cult objects things of great beauty that will appeal to the human eye. "This is my God and I shall glorify Him" (Exod. 15:2) from the Song of Moses was interpreted by the rabbis as follows: "This is my God and I will adorn Him—adorn thyself before Him in the fulfillment of precepts. (Thus) make a beautiful *sukkah* in His honor, a beautiful *lulav*, a beautiful *shofar*, beautiful fringes and a beautiful scroll of the Law, and write it with fine ink, a fine reed (pen), at the hand of a skilled penman, and wrap it about with beautiful silks" (Shabbat 133b).[38] This seems to be a call for art and beauty based on God's word, and it has been quoted often and is known as *Hiddur Mitzvah* (adornment of the Divine Commandment). It is interesting that a dissenting view is expressed in the Talmud: Abba Saul reading the Hebrew אנוהו (I will adorn Him) as a combination אני והוא (I and He have to act alike) adjusts the passage to the primary concern of Judaism, the relationship of man to God, and he interprets "I will be like Him: just as He is gracious and compassionate, so be thou gracious and compassionate."

Judaism's real concern is not with objects, which are only means to an end. "One may even sell a Torah if one wants to continue one's studies or wishes to marry."[39] The battle against idolatry was extended from the idol, the god of wood and stone to any object which man erroneously made his ultimate concern.

The ark of the covenant on wheels, frieze from the synagogue at Capernaum.

The American Synagogue Today

WHATEVER the nature of the much-heralded religious revival, the return to the synagogue is one of the most interesting phenomena of the post-war era. It has become apparent since World War II that the survival of Judaism in the United States is possible only under the roof of religious fellowship, and that all attempts to preserve Jewish identity on a secular basis are doomed. Of all Jewish institutions, the synagogue has adapted itself most easily to a society with deep religious roots in which no one religion has a preferred status, but where organized religion enjoys a position of confidence, respect and influence.

The deep crisis in liberalism, the anxiety of a world at the brink of catastrophe, individual psychological needs for cosmic and communal orientation, and the search for identity, values, and continuity—all these have combined to bring about a return to the synagogue which truly has become a *Bet K'nesset*—a House of Assembly. The new synagogue appears to be evolving as a synagogue center, the form best suited to meet contemporary demands. It cultivates those broad educational and social activities vital to the continuation of its religious program. That which Dr. Mordecai Kaplan envisioned long ago has become real, though perhaps by a process different from the one he conceived. The synagogue is becoming a center to which "Jews resort for all their religious, cultural, social and recreational purposes."[1]

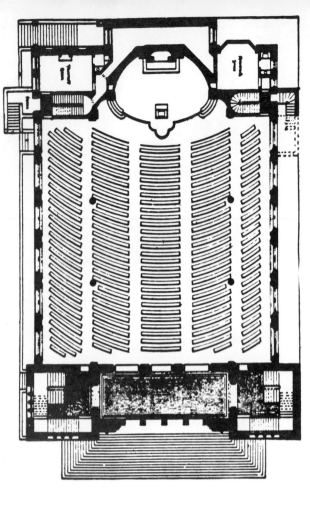

Floor plan, Temple Beth El, N.Y.C., 1891. (Rachel Wischnitzer, *Synagogue Architecture in the United States*, fig. 63. Courtesy of Professor Rachel Wischnitzer.)

Plan of main floor, Park Synagogue and Community Center, Cleveland, Ohio, 1946-52. Architect, Erich Mendelsohn.

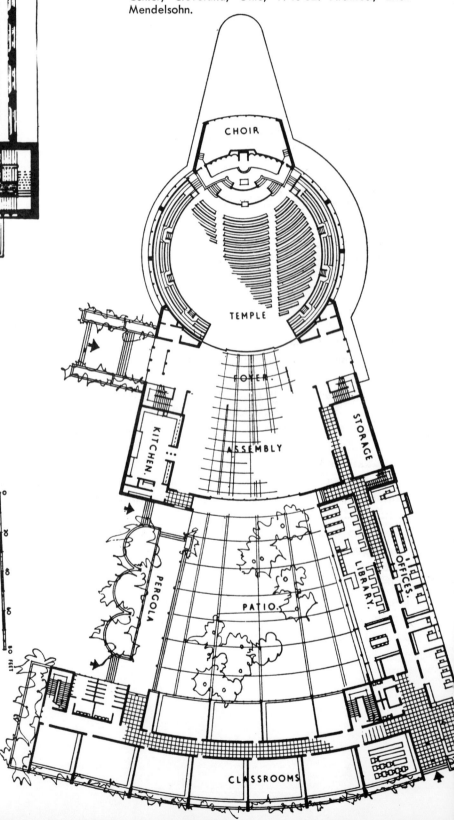

Synagogues have been built with prayer halls, social halls, stages for dramatic performances, art galleries, swimming pools, classrooms, libraries, museums, meeting rooms, and kitchens. In addition to the rabbi, they employ a staff of educational directors, administrators, teachers and even social workers. Within their walls are held services, lectures, forums, recitals, exhibitions, and social dances. Indeed, the synagogue is becoming a People's House, a *Bet Am*.

The two major factors which preserved Judaism in the past were Jews' adherence to their religious tradition and the hostility of the outside world. In the United States both these factors have declined. Under the impact of secularism traditional observances have lost much of their hold, and a friendly outside world, though not inviting outright assimilation, tends to permit the loss of positive identity. The survival of the Jewish fellowship has become, therefore, the central concern of Jewish leaders. Some organizations once cherished the hope that Jews could survive by developing a secular culture of their own within a pluralistic society. However, such hopes failed to take into account the dynamic nature of American society which, although respecting religious and ethnic identities, does not encourage the preservation of marked cultural distinctiveness.

Because of these circumstances the synagogue as an institution has taken on a new meaning. It has adapted itself to the new needs of the Jewish community. Its historic role as preserver of ethnic religious unity has become manifest. It can again shelter a full communal life. It can stem the tide of assimilation.

Today the threat to American Jewry does not lie willful desertion or hostility from the outside, but rather in ignorance on the part of its members—indifference, a drifting away, an eroding of the spirit, all of which lead to assimilation into the easy-going friendly American surroundings. The synagogue, by initiating a broad cultural program of activities and by creating new cultural resources, hopes to establish an environment which may fulfill the vital needs—both religious and other—of its members, while at the same time binding them with ties of affection and loyalty. By incorporating into its program some of the very forces which threaten it, the synagogue hopes to crystallize a Jewish way of life for its members.

It has been said that the synagogue center is the original creation of American Jewry. In point of fact, however, the synagogue has once again become what it always was before it relinquished a century ago many of its communal functions in order to conform to the dominant American-Protestant spirit of individualism.

American Jews, whatever the pattern of their observance, usually want their children to remain Jews. Indeed those who have studied the religious behavior of American Jews have been struck on the one hand by their unwillingness to throw off their Jewish heritage, and on the other by the laxity of their observances and deep ignorance of Jewish religion. In short, whatever the nature of their religious beliefs, they stubbornly want to remain Jews and to relate themselves as Jews to their neighbors and fellow men.[2]

The synagogue has become the central force that draws together various groups which have broken from the main stream of Judaism in search of adjustment to emancipation and adjustment to the secular world. Time has blunted the edge of the issues which once drove them away. Affiliation with the synagogue becomes, even for the non-observant

Jew to whom Judaism is a culture rather than a religion, a primary means by which he identifies with the Jewish community and assures its survival.

Within a society where, as a general rule, religious institutions have taken over various community functions, the synagogue can cultivate Jewish religion, customs, and folkways. It can preserve much of the ethnic element, without which Jewish religion cannot exist. It can develop and transmit the general concern Jews have for one another and for all men, and it can explain successfully to the outside world the retention of Jewish individuality.

It is in the context of these processes that the synagogue has become a complex of buildings, of which the prayer hall is but one. It is in this context, too, that the problem of synagogue art presents itself. In addition to the age-old need for *Hiddur Mitzvah* (the artistic work which is done to adorn religious objects and actions) there arises a quest for artistic expression which will stimulate worship, and be appropriate to the American environment and to the social status of the congregants. An esthetic environment has become a major concern at the services of all Jewish groups.

There arises also a need for congregations to identify themselves with the community at large through works of art designed for the exterior of the synagogue. The artist has been assigned the new function of stimulating communal pride and personal identification with the synagogue. There is, as we shall see, a demand for art which derives from the nature of the new architecture. The laity, which shapes and virtually controls the new synagogue, believes that art not only enhances the synagogue, but that it plays a role in the synagogue program and becomes one of its meaningful activities. Those who are eager to fill the existing spiritual void and who are aware of the complexity of Jewish survival under favorable conditions demand an art which is relevant, which increases consciousness of belonging, spiritual awareness, an historical understanding of the group, and a reinforcement of the sentiments the individual feels toward it.

Art becomes an activity directed at increasing communality, and an additional tool to assure the meaningful survival of the group's identity, as well as its faith. It comes into the synagogue both as a part of the traditional requirements of the service and as a need on the part of the laity for a stimulating environment and the incorporation of new cultural activities into its program.

Dr. Mordecai M. Kaplan, one of the most influential leaders and educators of rabbis, believes that the domain of religion includes all activity which helps produce creative social interaction among Jews, because it contributes to their salvation. He points to the need for the esthetic element in today's synagogue:

> Jewish life should include a multiplicity of visible activities centered upon sense objects. Such activities would enable the Jewish world of discourse to be enriched with the necessary variety of sensory images. Jewish life should be treated as an end in itself, and not as a means to outside ends. Those visible activities which delight one in themselves are the material of religio-poetic feeling, and such must be the content of self-justified Jewish life.[3]
> ... the aid of the architect, the sculptor, the painter, the worker in glass, and the tapestry weaver, would be enlisted to beautify the place of worship. The ancient

interdicts against the use of human forms are no longer valid, since the original fear of idolatrous worship has become totally meaningless. These are some of the measures necessary for releasing the dormant capacities for art in Jewish life.[4]

Dr. Kaplan read the signs of the times. But there is also implicit in his statement a recognition that something akin to a religious experience can be derived from good art. One may bemoan the passing of those days when Jews were a people who knew their prayers and parts of the Bible by heart, who were as sure of their God as of their names, and who brought their faith to the synagogue and took their laws for living from it. Art was a natural extension of their faith, manifesting itself in the ornamentation of Torah covers, of the Holy Ark, and of the walls of the synagogue. Today, when science, humanism, and industrial society, with their concomitant skepticism, have exploded the simple wholeness of that faith, and when the modern way of life, combined with an inadequate theological response, has put religion on the margin of relevancy for many—the artist is called upon as a man in whom spirit reveals itself as a creative force. His work can help awaken an intrinsically religious feeling, an elementary experience of religion, a stirring of "creature consciousness," to literally create the idea of the Holy.[5] He is called in to help create an environment conducive to devotion, and to restore a measure of awe which once surrounded the ritual objects and acts.

Some rabbis, who understand this need for a nascence of art in the synagogue and can appreciate the power of the esthetic on contemporary minds, guide the art program so as to make it a cultural asset and a force awakening the community to its central concerns. Other rabbis have withdrawn from the art program, claiming that art is not within their domain and that they do not understand it. The more sensitive among these leaders have often regretted their decision at a later time. They eventually realize that art is bound to be used in the new structure, regardless of the attitudes adopted by professional leadership.

The adoption of contemporary styles of architecture for the synagogue was not a difficult task, since the synagogue has not, traditionally, been bound to any historic style. In the nineteenth century and the first decades of the twentieth century, synagogues were built in Moorish, Byzantine, Classical and Romanesque styles. With the halt of large-scale immigration, the increasing Americanization of Jewry, the rise of the second and third generations of American Jews, the move to the suburbs, and the establishment of the synagogue center, modern architecture was adopted because it admirably suited the needs of the community. It held the promise of efficiency, rationality, economy, order, and a fresh start.

As these structures rose, with their clean lines, strict angularity, carefully balanced masses and large expanses of glass or concrete, it seemed that their austere forms were a direct expression of their function—of a down-to-earth rational approach and of an analysis of tasks to be performed. They heralded a recognition of new needs and goals, a fresh orientation toward living. A deeper feeling of group consciousness developed within American-Jewish society. This cohesiveness was accelerated by the experience of World War II, the destruction of European Jewry, and the struggle for

Israel. It was further reinforced by a new approach to education and youth activities, and a new conception of and attitude toward the synagogue which boldly anchored itself in the contemporary needs of the community and which embraced the new architecture.

It is interesting to observe that the first new buildings were almost totally devoid of decorative elements. In accordance with the theory of functionalism, the building was considered a self-contained work of art which needed no embellishment. Its exterior was the logical result of interior arrangement. The rise of abstract art had conditioned architects to design their buildings as autonomous units, compositions of surface, texture, volume, line, color, and rhythm which exhibited a strong affinity with certain abstract tendencies of modern painting, eschewing any artistic addition.[6]

This theory, which maintained that function was the one timeless and permanent feature of architecture, contained within itself a negation of relationship between architecture and other arts.[7] This austere and ascetic attitude was an understandable reaction to the meaningless over-indulgent ornamentation which preceded the advent of modern architecture. It was also an aftermath of the war years, when economy was the order of the day.

In a searching article published in 1925 Lewis Mumford advocated the general adoption of the dome for the synagogue building as particularly suited to express the religious conception of Judaism and the unity of the Jewish community.[8] Mumford felt that the dome, curving over the congregation like the sky, is the form which best expresses the concept of the oneness, the feeling that the conscience of man is as significant as the firmament, and that the stars as well as the soul of man are aspects of a unity. The dome, he argued, would declare the unity of the Jewish people and the eastern origin of the Jewish religion. Capping cubic masses, it would naturally dominate the various educational and social facilities, and thereby return to a sound geometrical foundation of art. "It promises to weld together what is best in the special cultural tradition of Judaism with what is cleanest and freshest in modern western civilization."[9] The dome is suited not only to expressing the cultural individuality of the Jewish people, but it is easily adaptable to the ferro-concrete construction which modern architecture utilizes with great effect. Once this form was adopted, the individual architect would devote himself to refining the style and designing the interior arrangement of the building.

Mumford's advice was only rarely heeded in post-war synagogue buildings. The Park Synagogue in Cleveland, Temple Emanuel in Dallas, and Har Sinai in Baltimore adopted it in various forms. However, other congregations, either for reasons of economy or because they felt no particular compulsion in this matter, have left it to the architect to decide what the dominant shape of their building should be. Because of their lack of involvement in this problem, they have proved to be neither stimulating nor demanding clients.

Having no precedent to follow, the average architect could hardly be expected to merge the practical requirements of the building with a design expressive of its symbolic purpose.[10] Architects have frequently sacrificed expression to function. They have

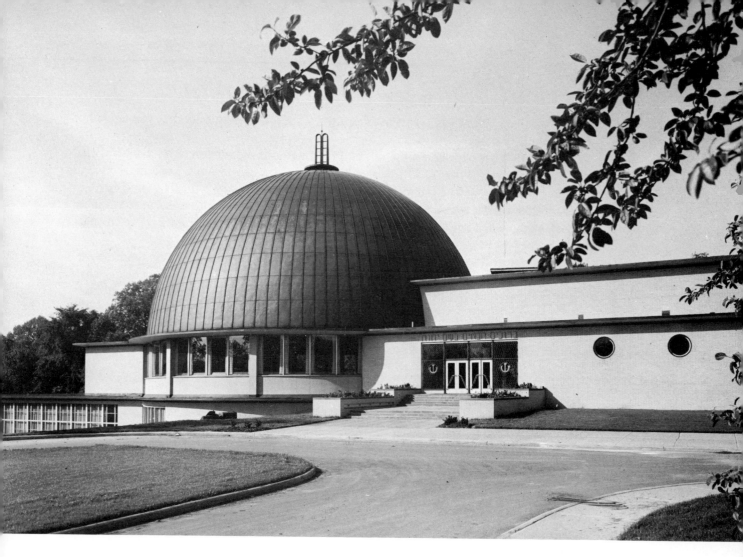

Park Synagogue, Cleveland, Ohio. (Photo: Hastings and Willinger.)

analyzed their tasks in terms of the operational demands of the service and the other functions of the synagogue. The synagogues they have erected are well built; they have convenient and soft-cushioned seating facilities, perfect acoustics, arrangements for expansion on the holy days, classrooms as good as any public school, ample ventilation, good lighting and fine plumbing. But we often hear that these buildings "do not feel like a synagogue"; nor do they convey any sense of the cultural and religious meaning of Judaism.

It is becoming increasingly clear that architects have often too literally interpreted the maxim that a building must be a consequence of its function. While all the physical needs have been calculated and incorporated carefully, many synagogue buildings are as cold and impersonal as a machine. Important psychological and spiritual elements have not been taken into account and the visual results do not seem appropriate to the purposes of the building. Too frequently the sensitive congregant cannot adjust to the artistic or spatial expression of the structure. This is particularly true because the modern architectural method has become so easily imitable and adaptable. Its basic esthetic

consists of plain large surfaces, of mass-produced standardized modular elements, and of stark, simple undecorated forms.

As new buildings with new materials and new methods of construction have blanketed the landscape, and as banks, schools, jails, police stations, libraries, supermarkets and laundromats have adopted a modern architectural vocabulary, it has become hard to distinguish one from the other. The house of worship has merged into this scene. Yet in no other building is the need for a more intimate and personalized expression more strongly felt.

We can assert that modern architecture constitutes an approach rather than a style. It is an approach based on analysis of function, standardized structural elements, a sensitive use of materials and proportions, the balancing of voids and solids, and the molding of space, rather than on outward effects and trimmings. Ideally, according to many, the building in itself is a work of art. As an art, however, architecture is the least intimate of all arts and the most difficult to appreciate. We rarely experience what the architect would like us to experience as we enter his building. We rarely see it as he does, as a whole, from the ground plan up, in all its careful organization and detail. We walk in and out, up and down; we use parts of the building and respond to the parts, but seldom to the total conception of the structure.

It has now become evident that the design of a synagogue cannot be determined solely in terms of the demands of the service or other activities it fulfills, and that its physical arrangements must be subordinate to the deeper purposes it embodies. Whatever designs are chosen to declare the building's purpose, and however eloquent they may seem, architects and laymen now feel that they need a more definitive focus. They need the intensification of the meaning of the building, the externalization of its spirit; they need some of the warmth, eloquence and passion of an individual work of art.

The reconciliation of the functional principle with the deep need to express a building's inner purpose gives the problem of the relationship between art and architecture a measure of special urgency today.

In the past, the alliance between architecture, sculpture, and painting could be taken for granted. The architect was often a painter and also a sculptor. In any case, architect and artist shared a community of ideas concerning art itself and its relationship to architecture. In the twentieth century, architecture has, as we have seen, rejected the eclectic style of the last century and stripped itself down to the bare elements of its craft in the quest for fundamental principles and the search for the means to assimilate new materials and new methods of construction. Having reemphasized the functional principle, it has, in its search for pure solutions, avoided the introduction of extraneous elements into its domain. It has tried to become self-sufficient. At the same time, painting and sculpture have emancipated themselves from previous presuppositions and have embarked on new directions. They, too, have become independent.

Attempts to preserve a relationship between architecture and art in the twentieth century have been extremely rare. One attempt to create an architectural art was undertaken in the Sullivan-Wright tradition. Ornament was conceived as an integral part of the new architecture, and sculptural units of abstract geometric patterns were designed

Mt. Zion Temple and Community Center, St. Paul, Minnesota, 1954. Architect, Erich Mendelsohn. (Photo: Hanz J. Schiller.)

Model, Temple B'nai Amoona, St. Louis, Missouri, 1950. Architect, Erich Mendelsohn.

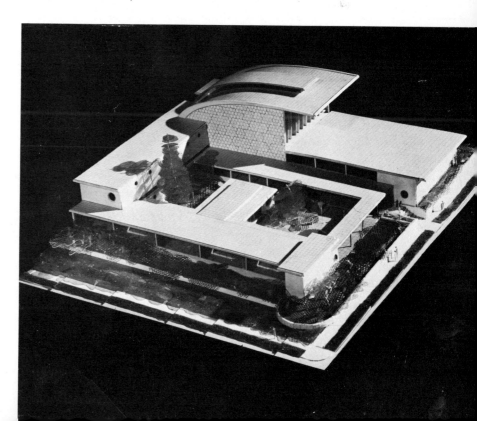

to be organically related to the building material—wood, concrete, stone or metal. The triangular theme, recurring in Wright's Beth Sholom Synagogue in Philadelphia, is carried out through the whole building, down to lamps and door handles. The ark, the *menorah*, the pulpit, the chandelier, and the memorial tablets are a reflection of this principle.

The International Style, a second great tradition, has advocated, and in a few instances attempted, another approach: the juxtaposition of works of art and architecture while preserving the autonomy of each.

A third approach which is adhered to by most architects today derives ultimately from the Bauhaus, the institution which, more than any other, was instrumental in the propagation of the enormously influential functional principle. Here the architect does not deal with the work of art at all, but is at best concerned with reconciling the functional principle with esthetic needs. This approach conceives of the building as a total functional organism, in itself a composite work of art. It does not recognize a division between art and design.[11] The individual work of art is actually distrusted and looked upon somewhat condescendingly—as a sterile activity. The Bauhaus school at first attempted to relieve the starkness of functional planning by the use of contrasting materials, variation in texture and color, rhythm of void and solid. It proceeded to surface enrichment which stemmed from the industrial process itself. Ribbed, corrugated, punched, spotted, and mottled building elements were skillfully used.

The first two solutions to the problem of art in architecture—that of Sullivan-Wright and that of the International Style—have been largely ignored. The third solution, rather popular with architects, actually bypasses the problem. It makes a fetish out of material. Can products of machine technique and industry show that man imagined while he labored? Can even intelligent design in material be a substitute for the humanizing quality of the work of art?

There have been some notable and widely publicized attempts by leading architects to extend the limitations of a strictly functional approach in their design of a contemporary synagogue, the structure of which would be symbolic of the Jewish faith. Very often, almost inevitably, the structure reflects the individual architect's conception of Judaism. In the absence of any generally accepted notion of what a synagogue should look like, the field of experimentation has been wide, and architects of great reputation have with relative ease been able to realize their own different and individual solutions.

Thus, Erich Mendelsohn, after he had built the domed Park Synagogue in Cleveland (apparently as much motivated by the contours of the terrain which he followed as by the conviction that this was the most suitable form for a synagogue) began to follow his deep romantic and expressionistic bent. Always in search of monumental and dramatic solutions, he topped B'nai Amoona in St. Louis with a huge parabolic roof which springs from the ground and rises westward to be cantilevered far beyond the steel mullions of the clerestory windows which support it. In St. Paul, at Mount Zion, he raised two large flat rectangular roofs to great height. With their coats of black color they are reminiscent of a pair of monumental phylacteries (pp. 29, 31).

Pietro Belluschi has topped a synagogue in Swampscott, Massachusetts, with a hexagonal tinted-glass cupola. The hexagon is the inside of a Star of David. In Temple B'rith

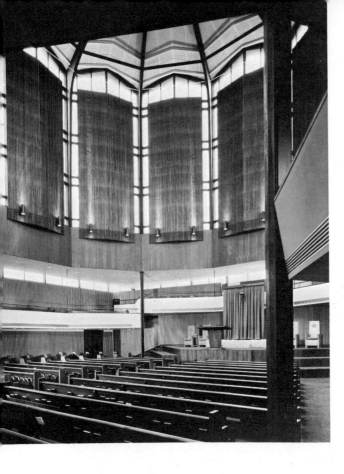

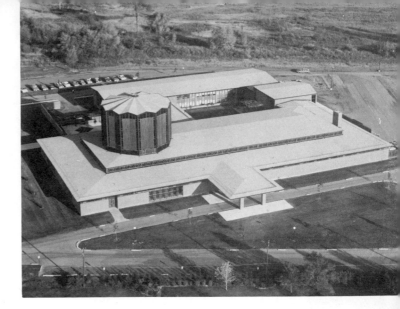

Temple B'rith Kodesh, Rochester, New York, 1964. Architect, Pietro Belluschi. *Interior*, Temple B'rith Kodesh.

View into the dome, Temple B'rith Kodesh. (Photos: Joseph W. Molitor.)

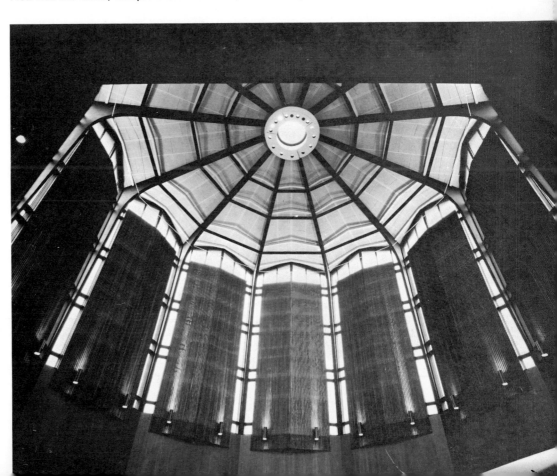

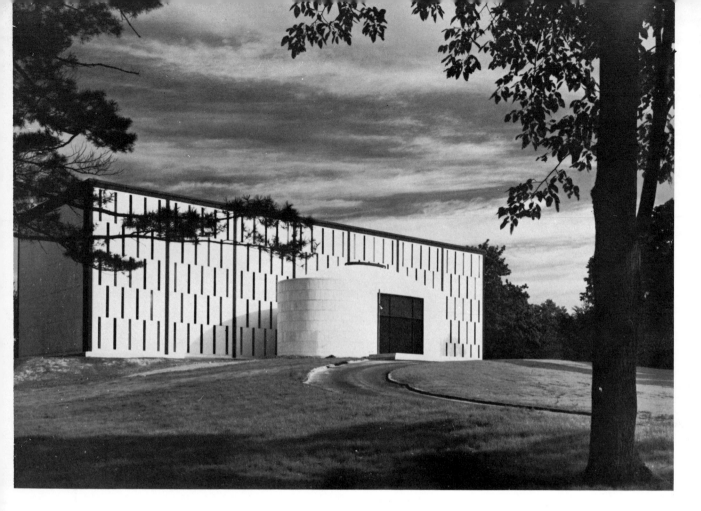

Kneses Tifereth Israel Synagogue, exterior and interior, Port Chester, New York, 1956. Architect, Philip C. Johnson.

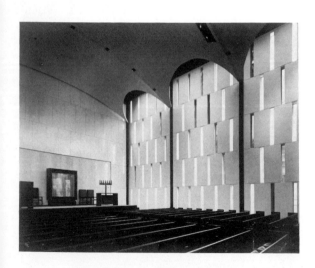

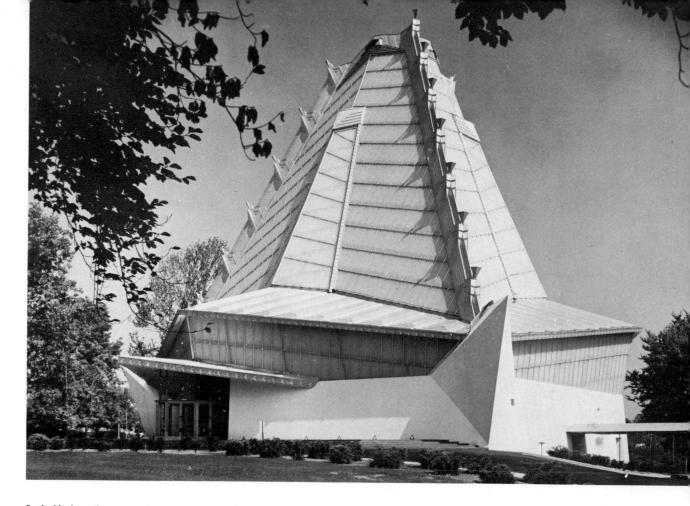

Beth Shalom Congregation, exterior and interior, Elkins Park, Pennsylvania, 1959. Architect, Frank Lloyd Wright. (Photos: Jacob Stelman.)

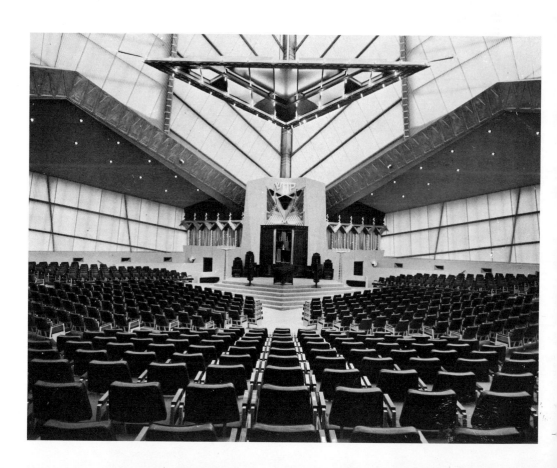

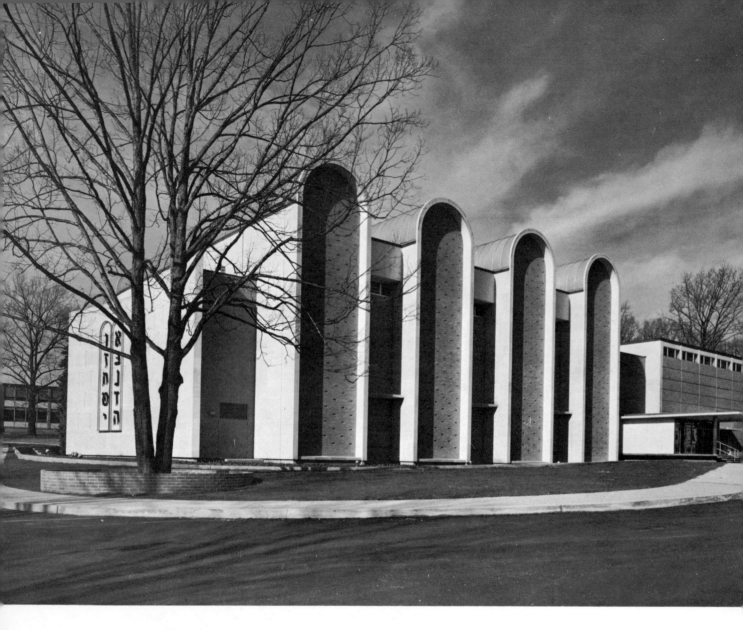

Temple Oheb Shalom, exterior and interior, Baltimore, Maryland, 1960. Architect, Walter Gropius. (Photos: Sussman-Ochs.)

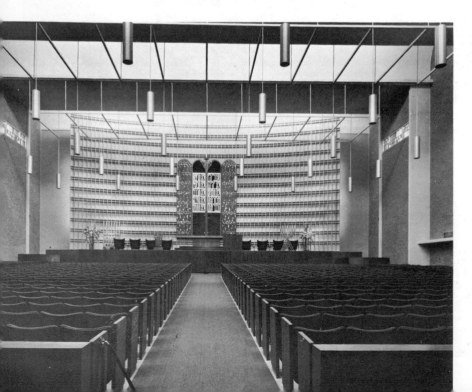

Kodesh, Rochester, New York, he designed a 12-sided wooden and glass dome, alluding to the twelve tribes. In both temples the interior is warm and intimate (p. 33).

Philip Johnson erected a white rectangular building of monumental scale, Kneses Tifereth Israel in Port Chester, New York, with its steel skeleton exposed and a fill-in of door-size slabs arranged in five tiers and separated by narrow slits of stained-glass windows. To this austere geometric form he attached an elliptically-shaped entrance pavilion with oval dome; the total effect is that of a monumental jewel box (p. 34).

Frank Lloyd Wright, in his inimitable way, built a translucent sculpture of corrugated plastic and glass on a hexagonally shaped concrete base. The construction seems to allude to Mount Sinai (a mountain of light), and remotely resembles the silhouette of Polish wooden synagogues (p. 35).

In his search for a genuinely twentieth-century synagogue, Gropius merged the shape of the turbine with the shape of the Decalogue, and thus satisfied his own belief in the machine and that of Baltimore's Oheb Shalom Congregation in the Torah (p. 36).

Fritz Nathan, Bertram Bassuk, and Sigmund Braverman sought a proper expression of the synagogue exterior and interior in the harmony of a parabolic shape (p. 38).

Architects Davis, Brody and Wisniewski in Lakewood, N.J., top their octagonal building with a double roof, over a centrally located *bimah*, and allude to the tradition of wooden synagogues in eastern Europe (p. 39).

For Congregation Mikveh Israel in Philadelphia, Penna., Louis Kahn projects a fortress-like structure bold in its massive sculptural shapes. Light breaks through arched openings and plays over the rounded walls of the centrally oriented space (p. 40).

Thin shelled concrete construction came into increased use in the late fifties and its plastic possibilities have been utilized by some architects in the construction of synagogues. In El Paso, Texas, Eisenshtat drove a wedge shaped parabolic arch into the sky opening the prayer hall to the desert and the hills beyond (p. 42). Yamasaki created an ethereal and graceful structure out of concrete and glass on the shore of Lake Michigan (p. 43).

In his best work Percival Goodman, who has had more opportunity than any other architect to design synagogues, searches for an expression of the worshipping congregation in the intimate scale of the human, rather than the monumental and overpowering. He designs modest, rustic and tentlike structures, their lightness evoking the sensation of a hurriedly erected shelter, the memory of the meeting place of a wandering people, and the easy portability of the historic synagogue (p. 76).

In all these instances the architects have attempted, with various degrees of success, to make their structures symbolic and expressive of ideas, to weld function and expression into a unity or to subordinate pure function to the deeper purpose the building embodies. The designs are often more indicative of the personal religious conception of the architect than they are of the collective experience of the congregation—the latter is obviously more complex, fragmented and harder to grasp. None of these designs has been convincing enough in its expressiveness to be generally adopted and further developed by others.

With the exception of Goodman's buildings, the art in these synagogues is dominated by the architecture. They may employ the time-honored symbols of the Jewish faith like

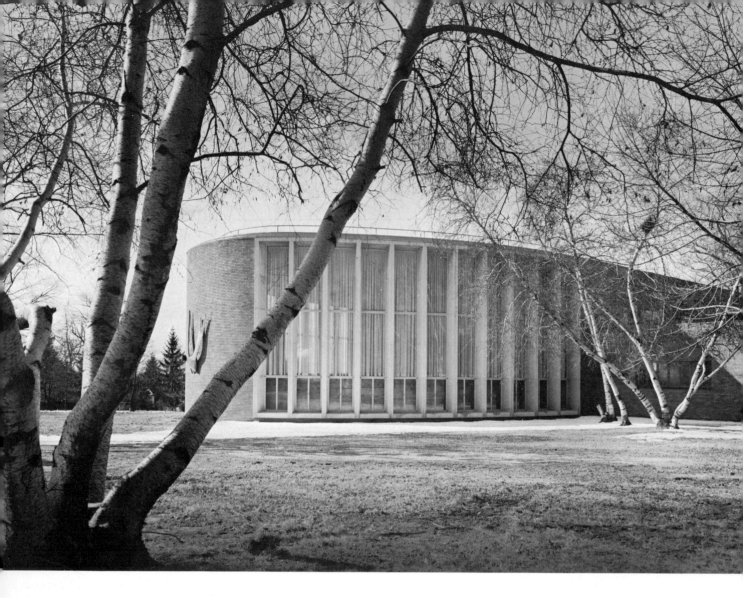

White Plains Jewish Community Center, exterior and interior, Westchester, New York, 1957. Architect, Fritz Nathan. (Photos: Lionel Freedman.)

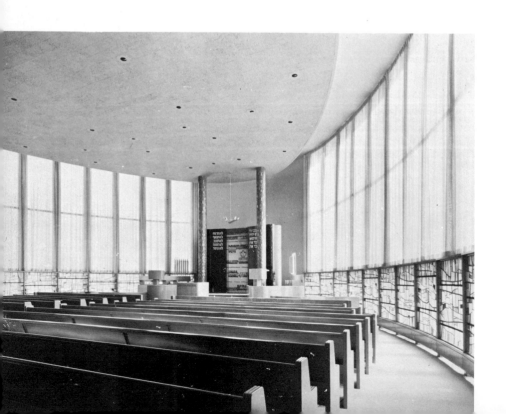

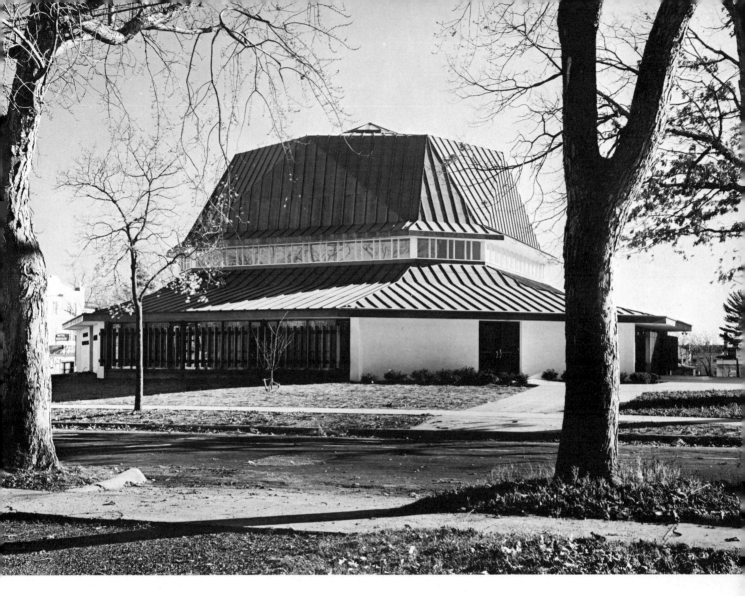

Congregation Sons of Israel, exterior and interior, Lakewood, New Jersey, 1963. Architects, Davis, Brody, and Wisniewski. (Photos: Louis Reens.)

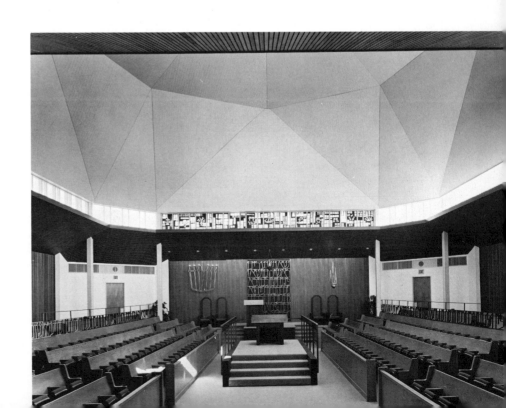

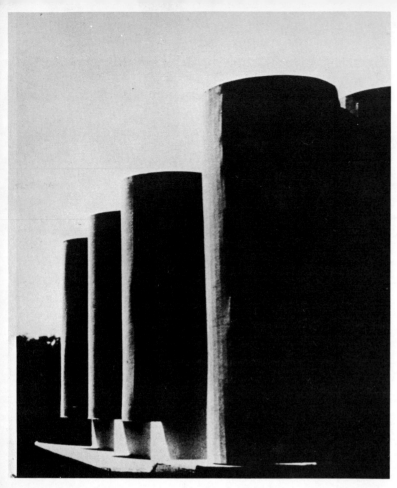

Model of project for Mikveh Israel Synagogue, Philadelphia, Pennsylvania, 1962. Architect, Louis I. Kahn. (Photo: Frank J. Darmstaedter.)

Sketch for the interior, project for Mikveh Israel Synagogue. (Collection, Museum of Modern Art, New York. Gift of the architect.)

the *menorah*, the *Magen David* or the Tablets of the Law as identification for the building. These are often organically woven into the structure, like the seven-branched *menorot* growing out of the ridges of Frank Lloyd Wright's rugged glass mountain, or the rounded Tablets of the Law which are a basic design motif of Gropius' Baltimore synagogue. Belluschi and Johnson identified the building at appropriate spots with a Star of David or a *menorah*.

For Wright and Gropius, art is an organic part of the structure, with the architect either designing the details himself or closely supervising them. These details reinforce the single-minded, massive, yet necessarily diffuse expression of the architect's basic theme. The work of art is never permitted an independent existence. It is not allowed to assert itself, and to speak more directly in its own terms. The ability of the work of art to convey specific themes, to speak with an intimate voice, and to render a more accurate and detailed message than the architecture, is ignored. Mendelsohn, Belluschi, and Johnson, in the buildings mentioned above, essentially adopt this approach toward art too, though not to the same degree of severity.

Goodman's approach to this problem is unique. He thinks that structural symbolism alone is inadequate; and that art and the artist have a significant function in the architectural endeavor. Perhaps because his conception of a synagogue is based more on the idea of the gathered congregation rather than on an abstract theological concept, he provides spaces in his architectural plans for artworks; here they can articulate their own themes, without being dominated by the architecture. The work of art is given a place to breathe and unfold; it is a part of the total design, yet it speaks with a voice of its own. Goodman thus recognizes the autonomy of the work of art, its unique "life" as an independent creation of the artist, capable of conveying aspects of the tradition or the life of the congregation which the symbolic structure alone cannot convey. In the field of contemporary synagogue architecture he has imaginatively drawn upon the resources of contemporary art more than anyone else. Through discriminating use of the works of the sculptor, the painter, the weaver, the mosaicist and the worker in stained glass, he has pioneered in the use of art to create a warm and stimulating environment in the synagogue.

However strong the expressiveness of the synagogues created by leading modern architects, most congregations cannot afford to engage a Gropius or a Wright. The average architect is generally a follower rather than a leader. He is rarely able to lift the practical demands of the building into the realm of art. In modern functional architecture the price of a pedestrian design is sterile frigidity. As a result, the synagogue building today almost inevitably depends for the intense expression of its meaning and for its spiritual atmosphere on the works of the artist. The large empty surfaces inside and outside the contemporary synagogue may act as a foil for the work of art. At the same time, the work may endow these surfaces with scale, texture, focus and color.

It would be naive to assume that the architect, once he has decided to utilize the work of art in his structure, has merely to call in the artists. Once the need to collaborate has been established, architect and artist—people who have different ideas about the world,

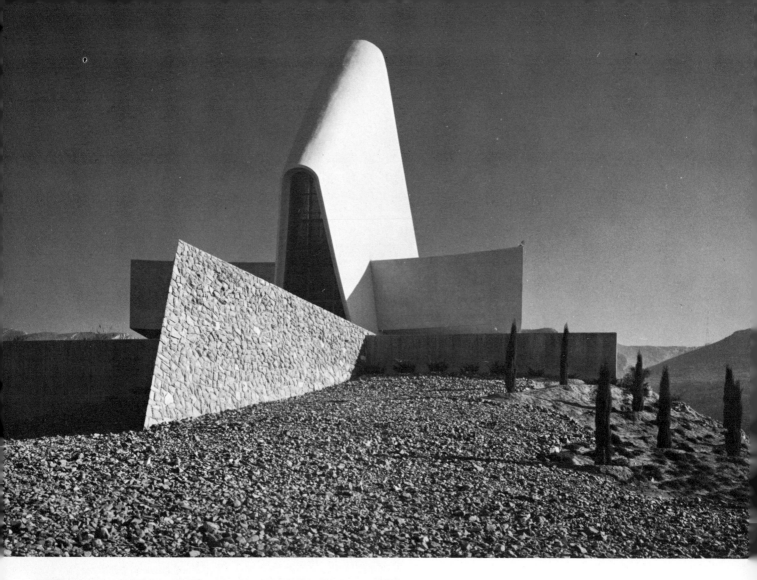

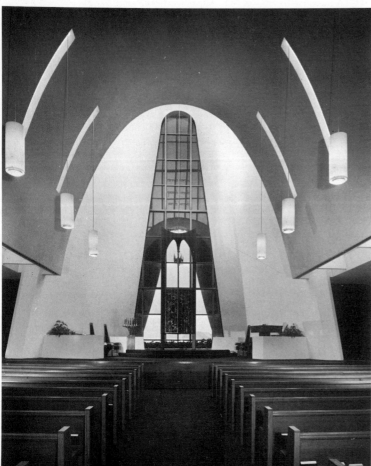

Temple Mount Sinai, exterior and interior, El Paso, Texas, 1962. Architect, Sidney Eisenshtat. (Photo: Julius Schulman.)

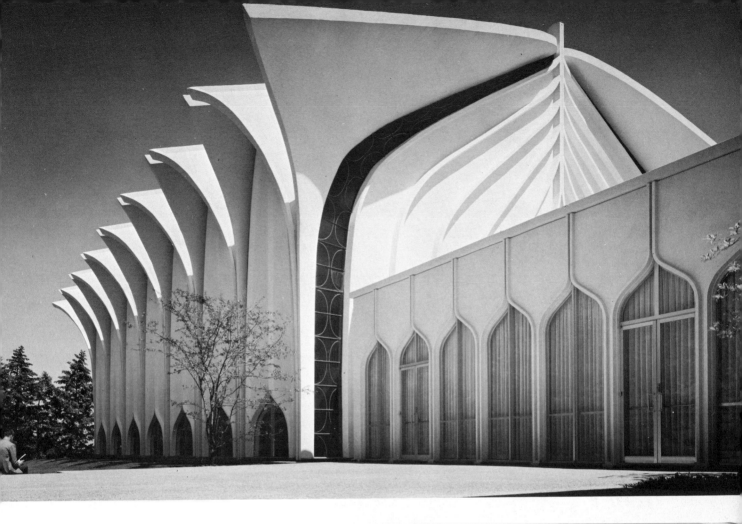

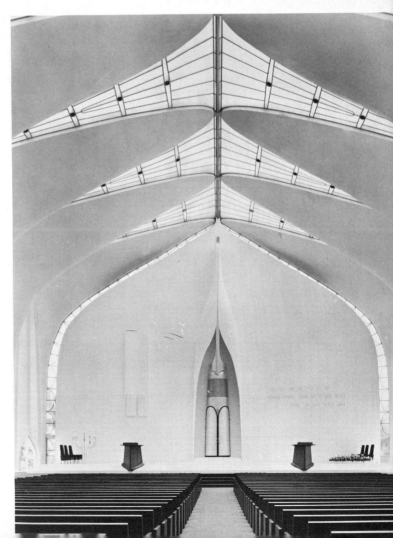

North Shore, Congregation Israel, exterior and interior, Glencoe, Illinois, 1964. Architect, Minoru Yamasaki.

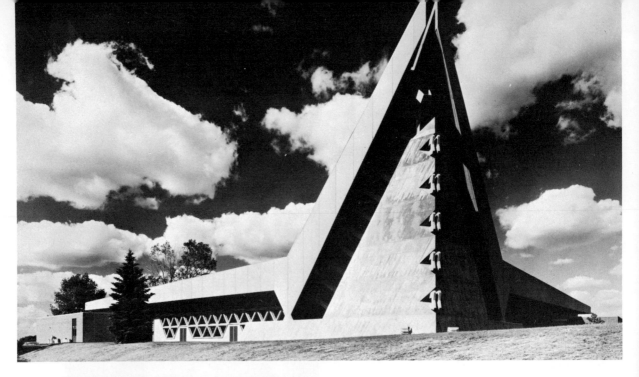

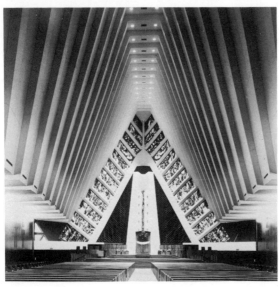

Congregation Shaarey Zedek, exterior and interior, Southfield, Michigan, 1963. Architect, Percival Goodman.

about life, about their own place within society and above all about the function of art— must confront each other.

The architect views the building, not without justification, as his. All the other arts are supportive to it. Their purpose is to furnish his building with color and texture, to articulate various aspects of its structure, embellish it, and reinforce its architectural expression.

The creative painter and sculptor view their work as of equal if not greater importance than the architect's. Theirs is the work of intimate experience and conviction, and they do not view it as subsidiary ornament. They tend to view the building as a foil or back-drop which sets off and enhances their creation.[12]

The architect, the sculptor and the painter, theoretically agree on the need for rapprochement and collaboration. However, one need only read the journals of their different professions,[13] or the minutes of their conferences and deliberations to see that while they may say the same thing they do not necessarily mean the same thing. The terms of collaboration differ.[14] The problem is much more complex than it seemed at first sight. The bringing together of first rate artists does not insure integration. Sources of true collaboration dwell in the deep wells of social feelings.[15] As we shall point out later in the field of synagogue architecture and art, this factor is further complicated by the lack of familiarity with Jewish culture on the part of the artist and architect, to say nothing of the building committee.

Collaboration means knowing the scope and nature of each of the arts involved; it means early consultation while the plans are still in formation.[16] For the architect it means familiarity with contemporary art, and particularly with the work of the artist to be commissioned; a conviction as to the projected nature of the work; and a capacity to resist pressures for engaging certain artists favored by board members for various reasons. For the artist, it means the capacity to work within an organization in which there are definite requirements; he must meet deadlines and respect the scale and unity of the structure he has been commissioned to work on. Above all he must understand the congregation and create the work with the congregation in mind. Collaboration needs, and on this all who gave this problem serious thought agree, a friendly spirit and cooperation from the very inception of the work. It needs intricate teamwork, checking and double checking, full coordination and a presiding intelligence.

The autonomy of each ought to be recognized even while accepting their interdependent relationship within each specific situation. What architecture can do art cannot, and vice versa.

As a guide to collaboration between the arts, Talbot Hamlin offers the following principles:

1. All sculpture and architecture should be designed with direct reference to the place it will occupy and to the architecture of the building as a whole.
2. Every work of painting, mosaic, or sculpture should have a definite reason for being—both functional and esthetic—and should be so placed as to emphasize its function.
3. A small number of salient works of painting and sculpture is more effective emotionally than a great number of insignificant works.
4. Every work of painting or sculpture must be well-lighted in a manner appropriate to its nature.
5. Every work of painting or sculpture must be so placed—with regard to its distance from the eye and so on—that it is visually effective.[17]

There is room for many kinds of interaction between art and architecture. Works of art may be integrated into the structure or placed in a specifically planned space in close collaboration with the architect. Other works of art, and this is of particular importance for the synagogue as we shall see, can be independently designed without a particular building in mind, but must be capable of being effectively integrated with an already completed structure.

Art
for Today's
Synagogue

THE space requirements and ritual objects necessary for the synagogue service are not difficult to establish; they are determined largely by tradition. It is much harder to find architectural and artistic forms expressive of the faith of the Jewish people and of the persistent themes which have shaped Jewish identity. A knowledge of the various historic and literary sources such as the Bible, the Talmud, the Commentaries, and the monumental histories is not sufficient to establish a total image of the historical Jewish personality or its ethos. To find such an expression is the function of the poet, the novelist, and the artist, who with their imaginative vision, weave these themes into the concerns and idioms of the day. They must take into account the particular Jewish concept of God, the sanctification of His name, the covenant, the Torah, Israel's ethical quest, its bent for justice, and its Messianic hope. They must deal with the stubbornness, the idealism, the social imagination, the devotion to learning, the capacity to adjust for survival and pioneering, the communal responsibility, the historic resistance to oppression—the traits that characterize the Jewish people—their unique contemporary American experiences and the rebirth of Israel.

No statement of faith, creed, theorem, or formal theology can present all this. Nor

can it be grasped by the intellect alone. The fact that these elements are not easily perceived in everyday existence does not mean they are not present. They exist, but they must be sought out in their various manifestations and felt thoroughly before they can be given concrete expression.

Clearly, the woodcarvers and the painters who adorned the synagogues of Poland in the seventeenth, eighteenth, and nineteenth centuries shared a common world outlook with the members of their congregations. The folk character of their art is in itself sufficient testimony to this identity. Their art was a natural extension of religious piety made to blossom on the wooden walls of their synagogues. It was not an art brought in from the outside; it was born from the way people thought, felt, and dreamed. It was an art built upon the base of the people's communality, not imposed by an intellectual or artistic elite. But it was not an art of ignorant or illiterate men. The artists looked upon their work as holy service; they sought their themes in the prayers, Scriptures, and contemporary poetry and legend.

The painter Chayim ben Isaac Segal, who painted the synagogue of Mohilev, Poland,

The City of Worms, painting in the dome of synagogue of Mohilev, 1740. Artist, Chayim ben Isaac Segal. After Rimon, 3, Berlin, 1923. Courtesy Professor Rachel Wischnitzer. (The Jewish Museum, New York, Frank J. Darmstaedter.)

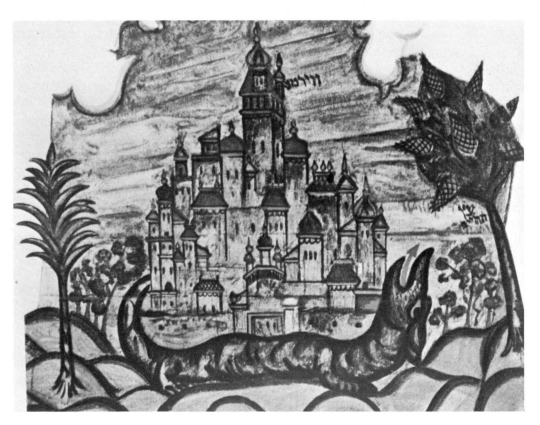

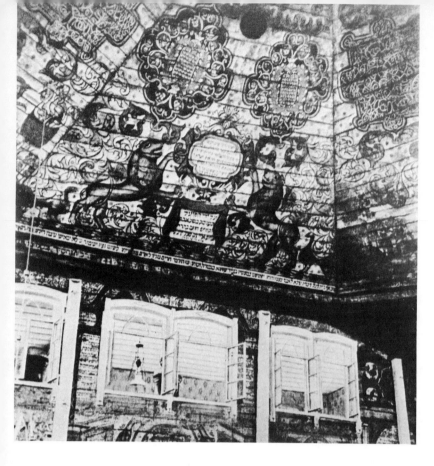

Painting in the dome of synagogue of Mohilev with inscriptions by artist:

(Upper sign) "It is for this purpose that I walked in the land of the living these many years. To fulfill my destiny to execute the paintings of this dome which were donated by pure hearts, men and women of the cemetery and charitable organization to honor our rabbi and God who brought forth mountains, may He preserve us from enemies for all times."

(Lower sign) "By the artisan who is engaged in sacred craft," Chayim the son of Isaac Segal from Sluzk.

(The Jewish Museum, New York, Frank J. Darmstaedter.)

in 1740, chose as the subject for his mural the city of Worms, as he had seen it represented in the contemporary book, *Ma'ase Nissim*, by Juspa Shammes of Worms, published in Amsterdam in 1697.[1] Segal tells us in an inscription that his work was done "by the artisan, who is engaged in sacred craft." We know there was communal response, pride, and recognition of his work because of the many legends spun around the life of this master and because various cities claimed the honor of being his burial place.[2]

The common outlook which this painter shared with his community is gone. Just as the rise of secularism and the Renaissance gradually destroyed the monolithic Christian view, so did the breakdown of ghetto walls and the advent of modernity and science shatter the relative wholeness of the Jewish world view. Judaism, which was once the truest religion to its adherents, became to many a part of the natural evolution of the human race, the history of one family among the families of men. Therefore, to say that the artist does not share the Jewish world view is not enough; rather, we must say that such a view does not exist any more, even among the very Orthodox Jews, for whom the miracles of the Bible are still proof of the existence of God. Jews have been forced, by the course of events and their rapport with the modern world, to adjust their beliefs and their relation to tradition. Contemporary Jewish theology runs the whole gamut from the belief in the full potency of the biblical God, His commandments, and the binding force of all the divinely inspired later traditions, to a position which would divorce Jewish religion totally from supernaturalism and base it only on the sense of a common past and destiny, on the peoplehood of a transnational group. This version beholds God in the fulfillment of human nature and in the highest aspirations of man. It sees survival and enhancement of Jewish life as having utmost religious significance.

Between these two extremes are many positions which are essentially pragmatic in their attempts to salvage from tradition that which still can be accepted. The Conservative movement, for example, has never taken a clear stand on theological matters, and its opinions include a great range of diversity. In practice, however, it appears to adjust its position to the pressures exerted by the laity, the rabbis, and the scholars.

The Reform group, while related to the tradition, has tried to select and stress the elements that it conceives to be of eternal value and yet fully capable of revision and adaptation. It speaks of continuous and progressive revelation. But it contains no fewer divergencies of opinion than exist in other groups. In addition, many rabbis possess their own theologies.

Whatever the degree of theological differences (and they tend to become blurred by rapid internal developments in each group), the laity has little notion of them and is neither concerned nor alarmed. The historical tie between Judaism and Jews is so strong that Judaism has become an all-embracing idea expressing on one hand, the most spiritual and purely religious concerns of the group and on the other, the actual life adjustments and experiences of fellow Jews everywhere. These more concrete concerns, due to immigration, war, destruction, the struggle for Israel, and other overwhelming realities have been so urgent that they have actually concealed the needs for religious adjustments necessitated by the intellectual, social, and cultural changes which have occurred in the world at large and within Jewry itself.

The lack of clarity of a religious conception may not affect the relationship of the individual member to his congregation, but it is bound to affect the type of art and the kind of subject matter chosen in the adornment of the synagogue, indeed, the very approach to the whole problem of synagogue art. The specific ritual objects are determined largely by tradition, but the exterior, the walls, the vestibule and the social hall require creative planning and thought, as does the form to be given the ritual objects.

Whenever a bold reconstruction of a religious view is attempted, and re-evaluation of an institution is sought through an honest confrontation with the changes that have taken place in the world, the artist too is asked to contribute. The artist's task is not then confined to mere decoration of a wall, or construction of an ark; he is also asked to explore the artistic potentialities that are contained within the new texture of reality. His imagination must project the new confrontation into the work of art.

A concrete vision embodying what a community would like itself and its synagogue to become in the future is a precondition for the attainment of such a goal. One can become only what one can imagine. It would be naive, however, to assume that the creation of works of art will bring about the actualization of religious, communal, or social goals—that life will imitate art. It would be just as naive to assume that art alone can fill the void which must instead be filled by fresh thinking and new adjustments. However, the work of the artist may bring about some change in the climate of imagination among the members of the community and thereby influence impulse, thought, and purpose. The artist at his best can, together with the rabbi and the leaders of the community, reconstruct the ideals, values, and goals of the community and make them relevant for today. This requires much thought, over and above technical competence.

What traditions of the past still retain vitality and meaning, and can be affirmed by present generations? What does the congregation believe in? What are the sentiments alive in the experience of the members, and deemed worthy to be perpetuated? What are the newly felt needs and purposes that are as yet without definable or objective existence, but that may emerge in the future?

These are questions each congregation and each planning committee must answer if the art is to mirror their thoughts and feelings. To raise and try to resolve these questions does not guarantee that the commissioned work will be satisfying. An attempt to come to grips with these questions is, however, essential for a serious approach to the problem.

The fact that the painter of the synagogue in Mohilev was a member of the community, sharing its familiar communal lore, made things relatively simple. The artist considered his work holy (קדש). Thus, time factors, planning, sketches, execution, and other complex considerations that figure heavily in the contemporary endeavor played only a secondary role for him. His attitude was not cold and professional but one of genuine dedication to the work, a concern for its relation to its site and its total integration into the physical structure as well as into the world of ideas familiar to the members of the congregation. The artist lived with and for his work, and he gave it all the time it needed.

Today the relationship of the artist to the community is in most cases a strictly contractual one. The artist often does not see the building in which his work is to be placed, he sees only the plans, or the blueprints. He often does not even meet or talk with the people of the community for which he works. He is not acquainted with their personal histories, nor does he know the history of the congregation, which may be filled with interesting and dramatic events capable of stimulating his creative process. More often than not, he lacks an elementary knowledge of Judaism and its history and literature, not to mention knowledge of the particular religious and congregational problems faced by the synagogue. Nor can it be said that his clients have a clear idea of what they want, what they believe in, what the work of the artist should represent. In some cases the necessity for the acquisition of art has been imposed upon them simply by the fact that they are about to move into a new building. In short, a situation exists where both parties are unsure of what they really want from each other. Some of the problems of this situation are well described by Paul and Percival Goodman:

> Now the architects and the artists are in a peculiar position. On the one hand, they try to carry out the purposes and express the feeling of their employers— to make the program function beautifully. On the other hand, the very fact of analyzing function and expressing meaning makes the artists soon turn on their employers—with persistent embarrassing questions and paradoxes; they point out inconsistencies in the program. To say it strongly, the building committees are not willing to have the functions really function, and the artists reach toward feelings that the committees are afraid to feel.[3]

Volumes could be written about the illusions and disillusionments that communities, artists, and architects have experienced in their attempts to enhance buildings and bring

works of art into the community. The building committee expects a sketch of the work from the artist. Once it is in their hands, however, they fail to understand that the sketch itself represents a major portion of the creative effort of the artist; that it is his property and must be treated accordingly. It must be approved or rejected within a reasonable amount of time and the artist must be paid for it whether it is accepted or rejected. On the other hand, the artist with the "give them what they want" attitude fails to consider the ignorance of the community in matters of art, is unable to establish a searching relationship to his task, sees his work only in functional terms (a pattern which fills a void), and presents the community with its own conventional conceptions, or fails to recognize the nature of public art and imposes upon the community his own personal idiosyncracies.

For the congregations, planning the synagogue often means planning only the shell. The cost of ritual and other artwork is generally not included in the budget; it is felt that once the shell has been built, individual members of the congregation will donate an ark, a *menorah*, a Torah crown, a mural, or some other "accessory" at some time in the future. The result of this piecemeal approach is that objects are acquired individually and have no relationship to their surroundings or to one another. A unified conception of design becomes nearly impossible. On the other hand, some congregations have included three to five per cent of their general building budget for the essential artwork, and have also established an art fund to which members can contribute, without influencing the choice of artist or design.

It is usually assumed that the architect will undertake leadership in this area and attempt to coordinate the desires of the community and the efforts of the artists. However, the architect's own working relationship with the community is not always a smooth one. Too often the community regards the artwork as a welcome addition rather than an integral part of the total structure. Only those architects whose position in the field or relationship with the community is very strong can enforce a view which provides for the planning of artwork at the very inception of the building. Moreover, the average architect today is, as we have seen, seldom at home in fields of art other than his own, which is itself a complex and competitive business. Most architects' attitude toward art is, at best, one of sympathy and appreciation rather than of understanding and knowledge. There is little in their training that equips them to follow the various developments in the allied arts. They depend heavily on the artist to provide a spiritual atmosphere and accent for the building, but often the architects think of art as something to be added after the building has been completed. Rarely do they call on the artists for their judgment and suggestions on the placement and integration of works of art while the plans are still being conceived.

The role of the rabbi of the congregation planning an art project should be that of leader and coordinator, enlisting every resource and person available, and working with the art and building committees. Rabbis who are able to promote the use of art as a projection of the ethos of the community are rare, however, since there is little emphasis on art in the education of the rabbi. But the art project affords him an ideal opportunity to do the work for which his training fits him best—namely, education, clarification of values, lucid summation of goals, means and ends, inspiration and leadership. Indeed,

whenever the rabbi and the lay leaders have worked intelligently with the architect and the artist, the result has been an important spiritual, cultural, and artistic contribution to the community. The planners have clarified what they believe in and stand for, what they want their art to accomplish, and what can be done within practical limitations. Having arrived at an understanding of ideas through consultation, the congregation and its leaders agree to put their trust in the intelligence, interpretive abilities and sense of social responsibility of the architect and artist.

In a large number of cases, instead of giving decisive direction to the artwork in the building, the rabbi is merely an innocent and helpless bystander. There is little hope of remedying this situation unless in the future, the education of the rabbi and other community leaders includes significant experience in the field of art. In order to lead more effectively, the rabbi will have to be open to the world of art, just as he has added to his traditional role of scholar and interpreter the new functions of minister, social worker and personal counsellor. The institutions that train him must provide opportunity for searching confrontation with the art of the past and present.

The impact of art extends deeply into the sphere of the synagogue and therefore into the domain of the rabbi's responsibility. For an increasing number of individuals today, art has become an avenue for rewarding religious experience. It appears that the deepest issues of man and his search for meaning are laid bare far more in the field of art than in any other discipline. The artist has indeed become the mirror of our existence, and his work, the upholder of that which rings true in the passing stream of the trivial and fashionable. His is still a mind sensitive, searching, and incorruptible. The quest for art is the quest for value, for life, for its humanization and enhancement.

Working together, then, does not mean that the collaborators should assume tasks beyond their range. The architect is not equipped to act as a theologian, the rabbi is not an architect, and neither of them is an artist. But each person can achieve enough of an understanding of the other fields involved in order to make possible a synagogue art that is the product of a stimulating meeting of minds, of critical judgment, and of mutual influence.

When confronted with the problem of the type of art to be used in the synagogue, art and building committees have often turned to pure abstract art. This decision enabled the art committee, rabbi, and artist to circumvent the necessity of searching for relevant themes and developing appropriate pictorial cycles. It saved the advisors from theological difficulties and the artist from a task that he may not be capable of fulfilling because his mode of thinking and feeling is alien to the assignment. Today one may commission a religious subject, but one cannot always expect to receive religious art in return. Religious art is a personal mode of expression and can be created only by an artist who is religiously inspired. Yet there are more reasons influencing the choice of abstract art for the synagogue. Some find in its independence from nature and from any concrete object an inner affinity with the Jewish faith. Abstraction ranges from a strict purism to the simplification of objective forms, from their partial elimination to their total dissolution. This range makes abstract art acceptable to congregations who interpret the stricture of the

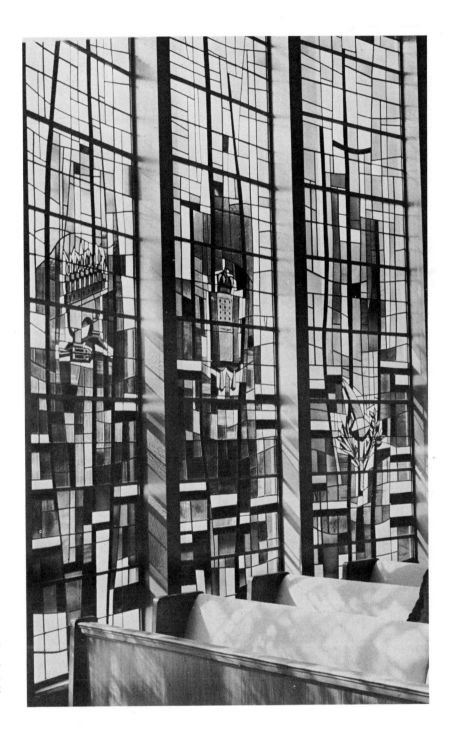

Stained-glass windows with symbols of holidays, each 20' x 4', 1961. Artist, Jacques Duval, Congregation B'nai Jacob, Woodbridge, Connecticut. Architects, Fritz Nathan and Bertram Bassuk.

second commandment with varying degrees of severity. The rhythms and designs of abstract art can be used to interpret prayers, psalms, or the sayings of the Fathers; artists may weave into their designs the letters of the Hebrew alphabet, emblems of ritual objects, or the signs of the Hebrew festivals. The abstract forms emphasize general ideas rather than specific events or religious doctrines. Since it is the dominant art of our time, abstract art places the synagogue within the main stream of modern life.

Modern art proclaimed, in its various manifestations and movements, the superiority of the imagination, originality, inventiveness, and inward states of mind—all of which it communicated with great effectiveness. It struck a sympathetic chord within the Jews, a people who were never really at ease with the classical tradition of representation. This response was strengthened by the fact that modern art gained recognition at roughly the same time many Jews were able to revise their traditional inhibitions against art in general. Modern art's long struggle for acceptance, its spirituality, its mystery, and its democratic impulse could appeal to a people whose culture and historical experience contained similar elements.

In today's synagogue, traditional themes have been woven into our lives in the rich and diversified forms of contemporary art. They are impregnated with all the trends that modern art exhibits. Artists have explored their constructive, decorative, and expressive potentialities as well as the great variety of sensations the themes evoke. The artistic possibilities of the material in which they were created have been probed as well. Moreover, in keeping with the analytical tendencies of modern art, these themes have been explored for their stark contemporary relevance. An attractive esthetic environment has

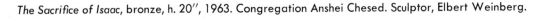

The Sacrifice of Isaac, bronze, h. 20″, 1963. Congregation Anshei Chesed. Sculptor, Elbert Weinberg.

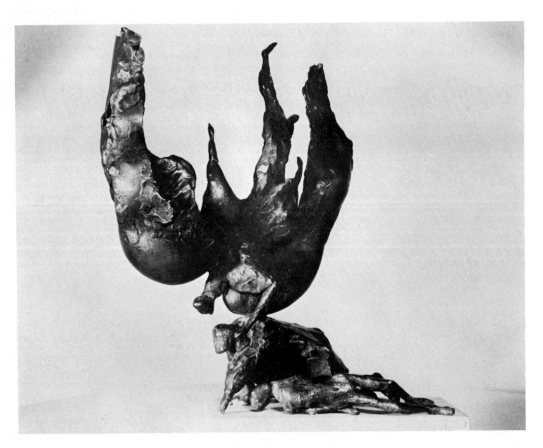

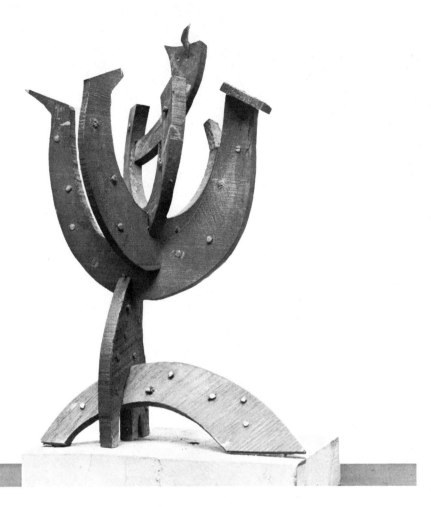

Project for menorah sculpture, wood, 1956. Artist, Sidney Simon. (Courtesy the artist.)

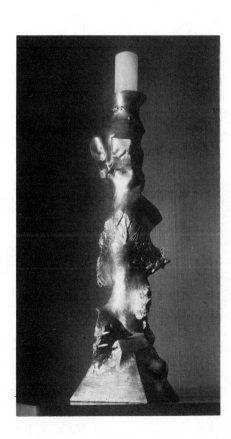

Eternal Light, project, pewter alloy, 33″, 1959. Artist, Calvin Albert. (Courtesy the artist.)

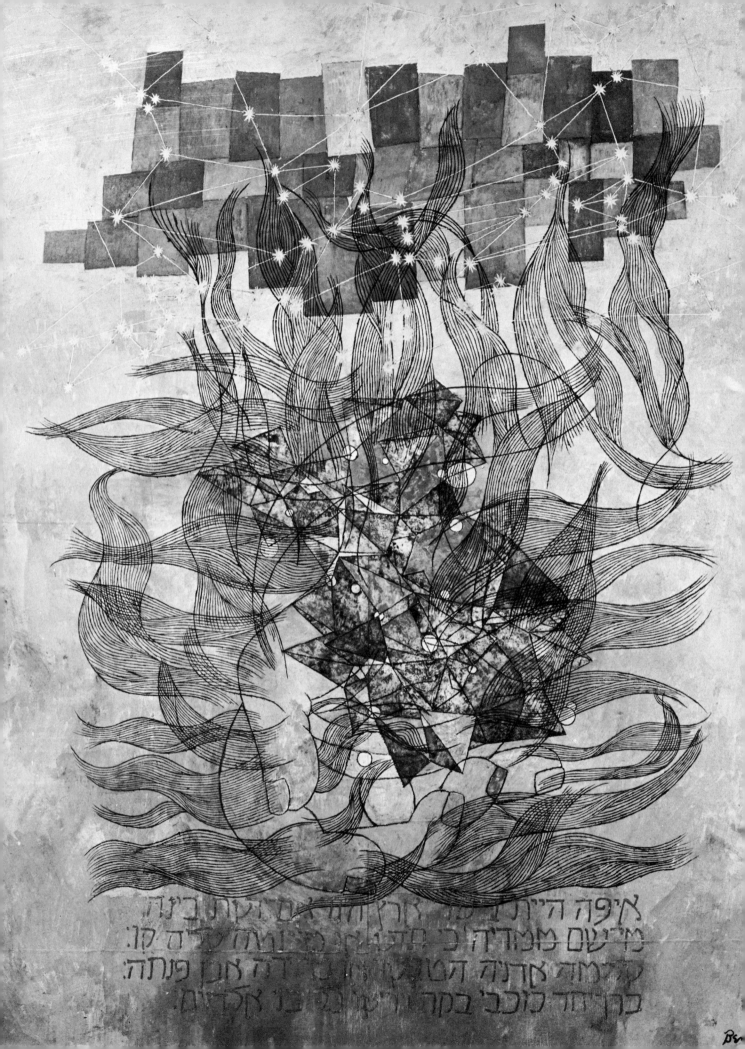

איפה היינו אם אר חטא וטרביות
מישם ממדה וכ מדלקי מצוה שלה קו:
קלמה ארנה חטטאו ושרה אמן פנתה:
כן זהר סוכבי בקרי ינש בני אלסים.

been established in many communities permitting the old and the new to merge. Art has created a stage whereon the congregation can develop its services and communal activities—a vital and meaningful background against which the young can grow toward a sense of identity and self acceptance.

The once meager repertoire of Hebrew art has been considerably expanded by the growth of modern historical awareness and by the new historic developments. For the most part, the older motifs of Hebrew art have been retained. While some few iconographic motifs may have disappeared, others have been added. New iconographic elements have been created and transformed by modern art into the idiom of our age on a monumental scale. Elements of the Jewish faith have been given forceful and concrete expression and presented to the community at large.

Such traditional themes as the creation of the world, the Exodus, the revelation on Mount Sinai, the giving of the Torah, the burning bush, the pillar of fire and the pillar of cloud, the cherub, the lion, the sacrifice of Isaac, behemot, the Torah, the three crowns, Jewish festivals, the tree of life, the *menorah*, the shield of David, the idea of Messianic hope and resurrection, Boaz and Jachin, Jacob's ladder—all these motifs of Hebrew art appear in concrete, metal, stone, mosaic, lead, alloys, glass, wood, and fabric, outside and within the contemporary synagogue.[4] In addition, some of the central concepts of Judaism—the Messianic idea of peace, the ideals of social justice, the encounter of man with God, the fearlessness of the prophet's voice, loyalty to neighbor and friend, the concept of the synagogue as a house of prayer, study, and assembly—have also been dealt with.

These themes are imbued with modern art's awareness of the natural and social sciences and with the artist's own individual reaction to the world about him. Thus we might see a representation of a *menorah* that harks back to the plant motif from which it stems, expressing traces of the persistent throbbing of nature's pulse, her cosmic force, her arbitrariness, her changes, her simultaneous workings within and without. Or the *menorah* might reflect acceptance of the world of the machine and its products and of the values of precision, discipline, clarity, and objectivity that the artist finds in the machine process. It may embody expressive and subjective elements that dominate the artist's creative process, and he may impress upon its structural members his sensitive reactions to the hopes and anguish of our time. It can convey imaginative intimations of the galaxy of stars, the fellowship of man, a towering mast at sea, or the magic forms derived from primitive cultures.

An ark door may contain an imprint of lunar landscapes; a sculpture, the power of the mythopoetic image; a stained-glass window, the rich associations of an ideogram based on an archeological discovery or a trace of our preoccupation with the relationship of the individual to his group. Sacred traditional symbols, in their imaginative arrangement and effective choice of material, create striking works of art.

The tragedy of World War II, the concentration camps and the death trains—all of

Design for stained-glass window based on Job, 40' x 26', 1965. Temple Beth Zion, Buffalo, New York. The inscription is from Job 38:4-7. Architects, Harrison and Abramowitz. Artist, Ben Shahn.

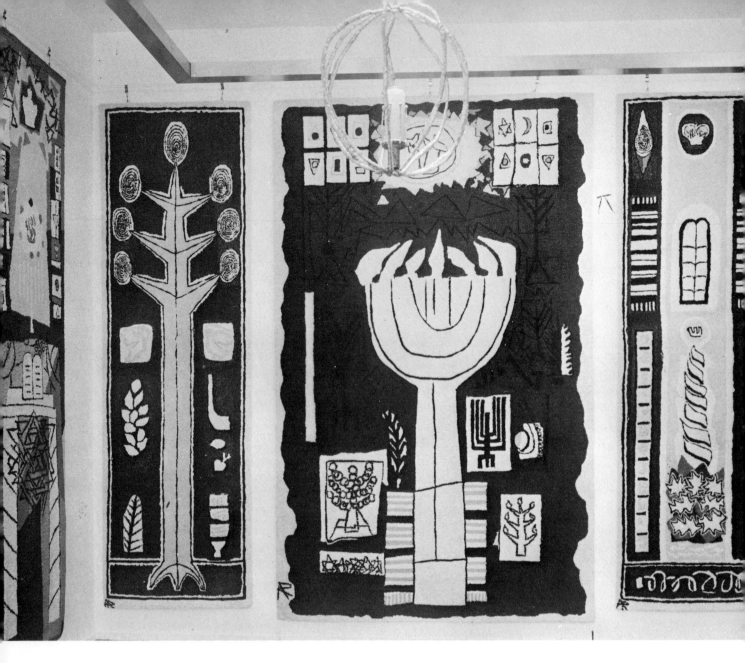

Tapestries for vestibule and ark doors, 10' x 6', 8' x 3', 1956. Congregation Anshei Chesed, Cleveland, Ohio. Artist, Abraham Rattner.

The Jewish holidays, tapestry for prayer hall, 8' x 4', 1953. Temple Beth El, Springfield, Massachusetts. Artist, Adolph Gottlieb.

Tapestry, 7' x 4', 1958. Vestibule, Temple Beth El, South Orange, New Jersey. Artist, Samuel Wiener, Jr.

Woven ark panels, cotton and lurex, gold, black and white, 7′ x 5′4″, 1962. Temple B'nai Israel, Woonsocket, Rhode Island. Architect, Samuel Glaser. Artist, Anni Albers. (Photo: John Hill.)

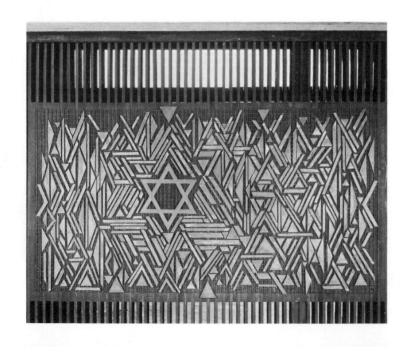

The Firmament, copper relief, 6′ x 4′, 1954. Temple Israel, Swampscott, Massachusetts. Artist, Richard Filipowsky.

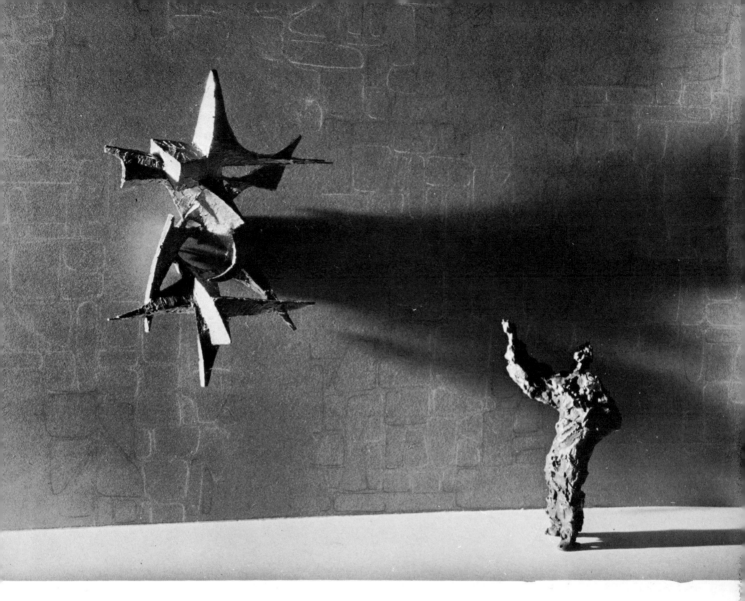

Project for sculpture on synagogue façade, 1959. Artist, Calvin Albert. (Courtesy the artist.)

Eternal Light, bronze, h. 9″, 1956. Congregation Anshei Chesed, Cleveland, Ohio. Artist, Ibram Lassaw.

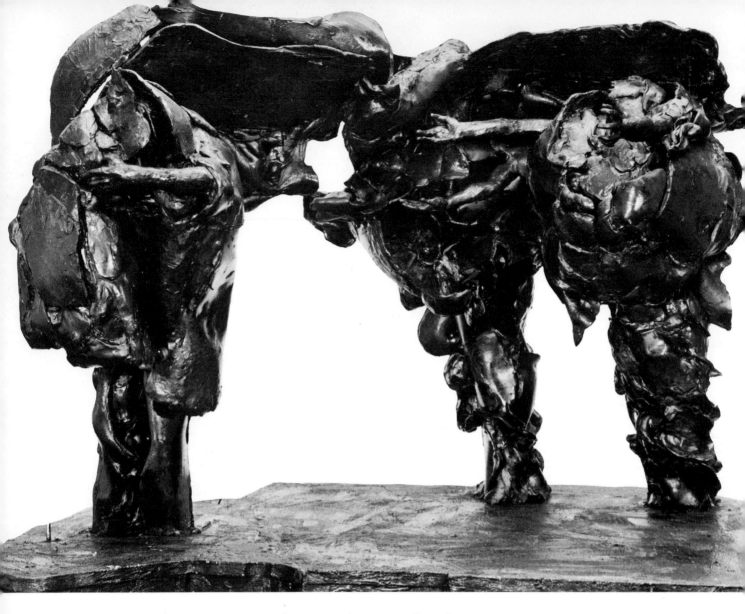

"*Whither thou goest*" (Ruth 1:15-18), bronze, 33″ x 46″, 1965. Temple Israel, Westport, Connecticut. Artist, Luise Kaish. (Photo: Nathan Rubin.)

(Opposite page) *Spice container for synagogue with figures of Adam and Eve on the cover*, bronze, 16¼″ x 7″, 1965. Artist, Luise Kaish. (Collection The Jewish Museum. Photo: Soichi Sunami.)

"Seeing that God had resolved unalterably, Adam began to weep again and implore the angels to grant him at least permission to take sweet-scented spices with him out of Paradise, that outside, too, he might be able to bring offerings unto God, and his prayers might be accepted before the Lord. Thereupon the angels came before God and spake: 'King unto everlasting, command Thou us to give Adam sweet-scented spices of Paradise,' and God heard their prayer. Thus Adam gathered saffron, nard, calamus, and cinnamon, and all sorts of seeds beside for his sustenance. Laden with these, Adam and Eve left Paradise, and came upon earth."

Ginzberg, *The Legends of the Jews*

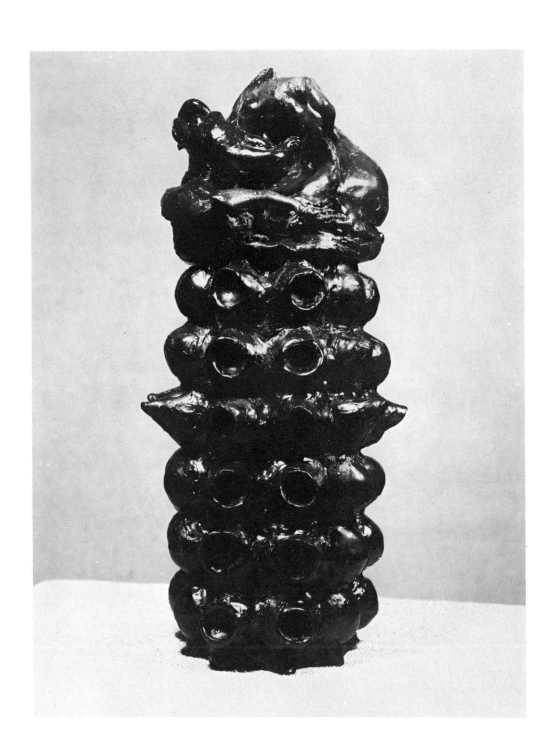

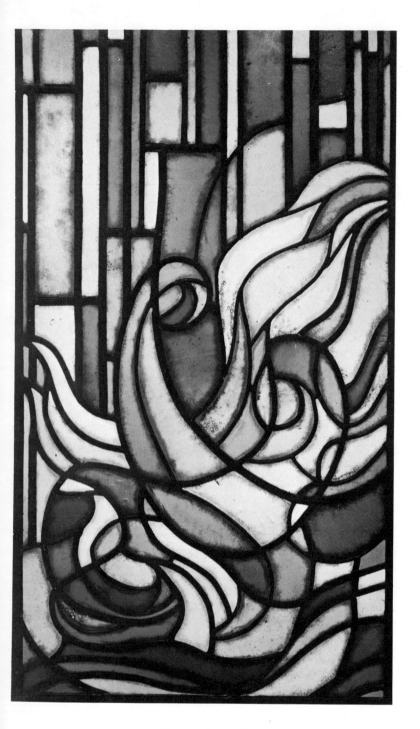

"Let justice well up as waters, and righteousness like a mighty stream" (Amos 5:24). Stained-glass window. 6' x 2½', 1955. Temple Israel, Columbus, Georgia. Artist, L. Gordon Miller. (Photo: Martin Linsey.)

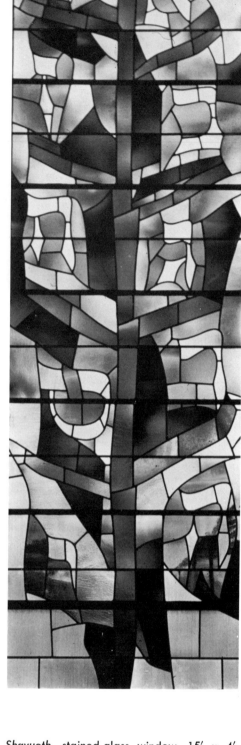

Shavuoth, stained-glass window, 15' x 4', 1962. Temple Shalom, Greenwich, Connecticut. Artist, Robert Sowers.

which had a profound effect on American Jewry—have had, with notable exceptions, a surprisingly small influence on the artworks placed on or designed for synagogues up to now. It is difficult to tell whether the congregants do not wish to be reminded of the horrors of those days or whether the artist finds it difficult to grapple with themes of such magnitude.

One of the most persistent problems in modern art has been its lack of intelligibility to the public. Pure abstract forms are especially frustrating for the layman who wants to know what things mean. The problem is most acute in public art, where communication and relevance are usually primary concerns. Many feel that in the synagogue the requirement of preserving the identity of the institution for the members, demands a familiar frame of reference, which art can provide.

For the sensitive observer of modern forms, this problem does not exist. Meyer Schapiro sees a strong affinity between abstract art and general religious sentiment:

> But if painting and sculpture do not communicate, they induce an attitude of communion and contemplation. They offer to many an equivalent of what is regarded as part of religious life: a sincere and humble submission to a spiritual object, an experience which is not given automatically, but requires preparations and purity of spirit. It is primarily in modern painting and sculpture that such contemplativeness and communion with the work of another human being, the sensing of another's perfected feeling and imagination, becomes possible.[5]

No doubt such effects have often been achieved. In some synagogues, pure abstract art has been used effectively to create an atmosphere of spirituality and solemnity. For instance, in Temple Oheb Shalom, Baltimore, we find an abstract design of rectangular shapes dominating the stained-glass windows, the ritual objects, and a large screen. These elements are themselves strictly subordinated to the architecture. The entire building is based on a constructive purism, a simplified scheme of elemental forms and proportions, a man-made harmony of rectangular shapes believed to be in accord with a basic harmony and lawfulness of the universe. The two mosaic murals in the foyer are based on purely abstract forms as well. In a world as confused, arbitrary, and unpredictable as ours, Gropius and the artists whom he employed have enveloped the congregation in an impressive and spacious scheme of regularity and predictability. How effectively this attitude is communicated to the worshippers, how effectively it meets the specific needs of the congregation, cannot be estimated. Those committed to a constructive purism may feel that color and shape alone, if handled properly, provide the right setting and the right atmosphere, and that the best results will be achieved if the work is not marred by any literal or specific symbolic elements. This is debatable.

The question naturally arises: Can this type of purism satisfy the natural longing of the worshipper for a familiar frame of reference? Can this austere art, with its vague metaphysical overtones, satisfy psychological needs? Does this art achieve all that synagogue art might when it offers us only mathematical "perfection"?

Since the work of art functions within an institutional context here, it simultaneously represents a cultural and artistic object. A certain ambiguity results regarding the criteria relevant to the assessment of the role and value of these objects. Art objects must be

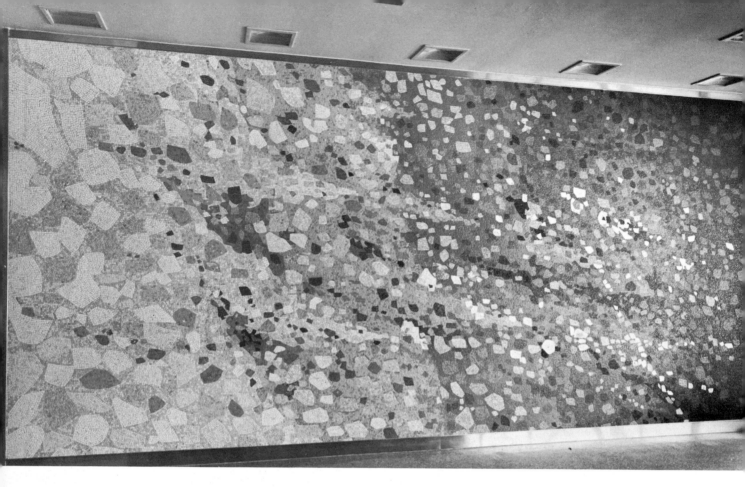

(Top) "*From Dark to Light,*" mural, glass mosaic, 9½' x 18'. Temple Oheb Shalom, Baltimore, Maryland. Artist, Gyorgy Kepes. (Photo: Sussman-Ochs.)

(*Below*) *View toward bimah.* Temple Oheb Shalom. Architect, Walter Gropius. (Photo: Sussman-Ochs.)

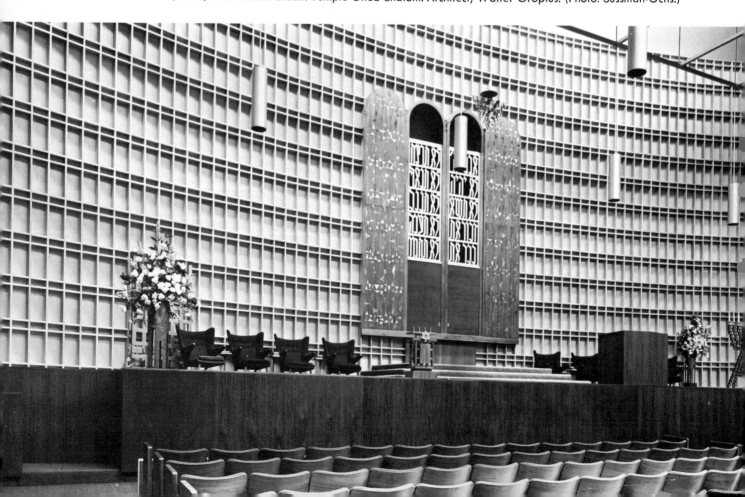

judged by esthetic criteria; appearing in a cultural context, they cannot be evaluated by these criteria alone.

Solutions that take into account traditional elements of the Jewish faith and refer to them in a fresh modern spirit or employ material and design that are intrinsically symbolic are often very satisfactory.

Thus, Herb Goldberg brings a wall to life in Temple Albert, Albuquerque, with his abstract rendering of the creation, the enslavement in Egypt, and the Exodus (pp. 91, 92). He imparts to us something of the rhythms of enslavement, of the meandering in the wilderness, and the breath of liberation. He tells us intelligently about creation without losing himself in detail. He does not say that the world was created in six days, but that God created the world and that man is the creature of God. His approach is original and inventive and shows an unexpected use of materials and color and a capacity to speak through them.

We do not tire of Ben Shahn's bold conception and interpretation of one of Judaism's maxims—the equality of man—in his mosaic mural in the foyer of Temple Oheb Shalom in Nashville, Tennessee (pp. 135-7). We are intrigued by the intricacy of the design and challenged by the unexpected juxtaposition of the races of man, the *shofar*, the haunting face of the Jew. We are drawn by the diverse rhythms of the *menorah*, of the fire of the *Shekhinah*, and of the rich calligraphy. The congregation expresses in this work its stand on a burning social issue of the day from the point of view of its religious heritage.

For different and similar reasons the *bimah* at Temple Emanuel in Dallas, Texas, is equally meaningful (p. 183). The huge expanse of Mexican brick, into which the curtain is set like a jewel, evokes both a numinous quality and a distant memory of the desert. The choice and use of the material make it intrinsically symbolic. Boris Aronson's design for the *bimah* of Temple Sinai in Washington, based on a combination of abstract and concrete elements also seems singularly effective (pp. 215-23). He transforms the biblical columns of Boaz and Jachin into a moving contemporary design, yet evokes vestiges of the way they were represented in title page designs of early Hebrew printed books and woodcarvings in Polish synagogues. All these works are capable of arousing an emotion, of representing in sensuous form a spur to direct contemplation. Here the problem of communication has not been avoided.

In sum, one type of art is not preferable to the other. We do not face an irrevocable choice between the representational and the abstract. All these works are the product of the artist's immersion in his problem, of the seriousness of his approach, of his awareness of the historic community, and of his capacity to translate his conception into material. Good art does not depend on its being either abstract or representational. The quality depends on the originality and imaginativeness of its conception, its expressiveness, its formal relations of its inner organization, and the aliveness and contemporaneity of its approach.

As long as the motives and sources of Hebrew art were largely unknown and as long as the notion of a basic hostility of Judaism toward all art prevailed, it was understandable that artists who were looking for a unique Jewish expression and for an expansion of motifs for their work in synagogues would turn to the Hebrew alphabet as a potential

Eternal Light, bronze, h. 3'. Temple Oheb Shalom, Baltimore, Maryland, 1960. Artists, Gyorgy Kepes and Robert Preusser. (Photo: Sussman-Ochs.)

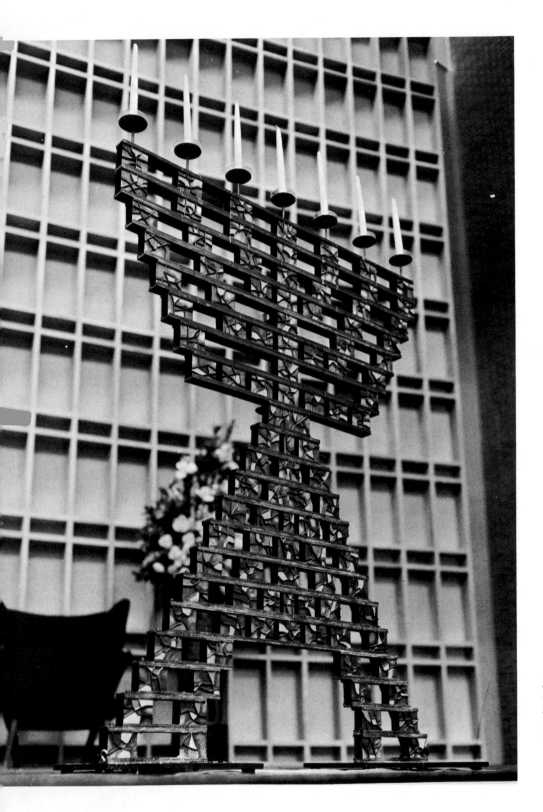

Menorah, copper and enamel, h. 8'. Temple Oheb Shalom. Artists, Gyorgy Kepes and Robert Preusser. (Photo: Sussman-Ochs.)

Menorot,(Left) bronze, h. 8'; (Right) aluminum, h. 7'. Temple Oheb Shalom. Artists, Gyorgy Kepes and Robert Preusser. Architect, Walter Gropius. (Photo: Sussman-Ochs.)

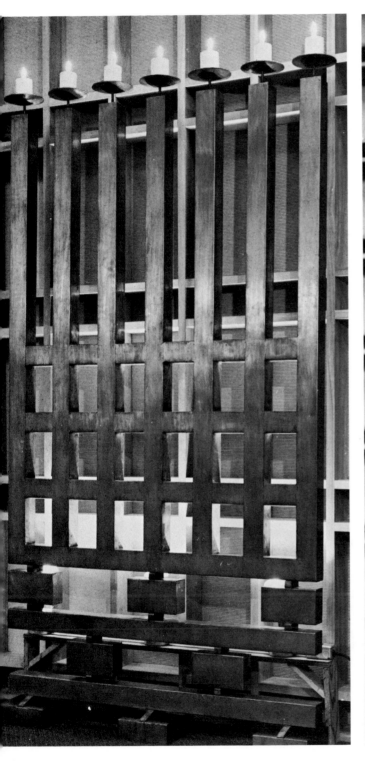
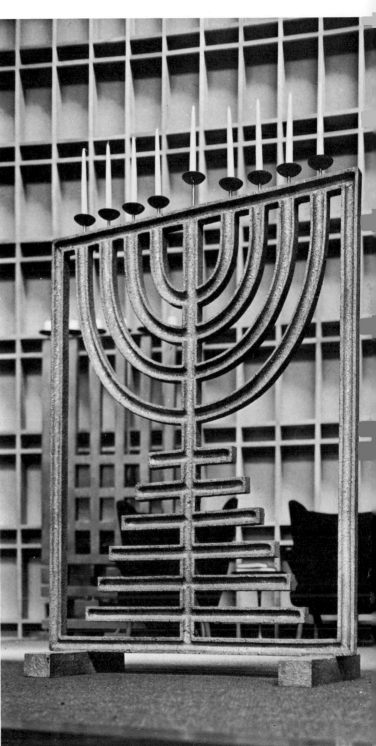

source. In this context, the work of A. Raymond Katz can be seen as a persistent attempt to give the Jewish house of worship a Jewish character. He has designed artwork for a large number of synagogues and was almost alone in the field for more than twenty years. During that time, naturally, he dominated the field and his influence was widely felt.

Katz' method consisted of changing the design of a Hebrew letter by altering its proportions in order to suggest a familiar religious object. Some of them were recognizable at first glance, others only after considerable study. He played with a letter as if it were an abstract form, always leaving a vestige of its appearance. He filled it with human and animal figures, objects and incidents related to Jewish holidays, events in Jewish history. He juxtaposed the letters with trees and oxen, hands and clouds, books and candles. Thus a *lamed* was made to look like a chicken, or a *shin* went up in smoke like Mt. Sinai. They seemed clever and amusing; they appealed to a strong folkloristic element in the customs and traditions of the Jewish community.

The success and acceptance of his art derived from a certain satisfaction that the European Jew, newly transplanted to America and on the road to emancipation, felt when he recognized the two essentially different elements in the design, both charged with homely sentiment. With the help of intelligent laymen and enlightened rabbis, other artists were able to move into the field and began to offer more profound solutions to the problems of synagogue art.

The notion that a Hebrew letter automatically creates Jewish art is naive. It cannot fulfill its decorative purpose unless it is well constructed, unless it functions in an overall design, unless its basic structure is understood. Otherwise, its distortions become meaningless and offensive. One general malady among synagogue architects and artists has been the insensitive choice of Hebrew letters suitable only as printer's type for decoration of the walls, arks, and façades of their buildings.

Because of the pioneer work of Reuben Leaf, followed by Ismar David, Francesca Baruch, Ludwig Wolpert and others, there are now different type faces of the Hebrew alphabet available to the artist engaged in synagogue work.[6] Even more important, the freedom to create new representations of the alphabet has been established.[7]

Some of the immense resources that Hebrew calligraphy offers and that are still too rarely and ineffectively used are realized in the ark designs of Victor Ries, who worked on the West Coast, and of Ludwig Wolpert and Ismar David in the East. Their works convincingly show the place of the Hebrew letter in synagogue design.

There have been notable if not always successful attempts at a pronounced didactic art in the synagogue. The most ambitious one stems from the late twenties and can be seen in the Wilshire Boulevard Temple in Los Angeles. Episodes from four thousand years of Jewish history are represented on the walls around the prayer hall. They were created by Ballin in an academic, overdramatized style.

The stained-glass windows at Har Zion, Philadelphia, designed by Louise Kayser, attempt to recognize the most important events which have shaped Jewish history and to take cognizance of the vast cultural creations of the Jewish people in the past and present (p. 250).

The windows of Tree of Life Synagogue in Pittsburgh also attempt to portray Jewish

The use of Hebrew calligraphy. (*Left*) *Ark doors, bronze 10' x 6', 1957. Temple Beth Abraham, Oakland, California. Artist, Victor Ries.* (*Right*) *Detail of Ark doors, bronze, 1963. Congregation Sons of Israel, Lakewood, New Jersey. Artist, Ludwig Wolpert.*

history, concentrated in the main on the history of the Jewish settlement in the United States (p. 252).

In a sense, every work of art is didactic in that it teaches us perfection in its own realm. In the accepted meaning of the word *didactic*, every work which bears some reference to the Hebraic tradition is bound to teach something, even if only the term, concept and shape of a ritual object such as the *shofar*. Such works as Ilya Shor's ark doors at Temple Beth El, Great Neck (pp. 204-7), with their profusion of biblical themes; the stained-glass windows, representing the various holy days of the Jewish year, by Adolph Gottlieb at the Milton Steinberg House in New York City (pp. 242-7); or George Aarons' sculpture dealing with the ideas of the Jewish faith at the Baltimore Hebrew Congregation (pp. 93-5), might surely be termed didactic. They express themes carefully planned and interrelated. The images chosen for representation have not only been carefully selected from a multitude of possibilities, but are created in artistically pleasing form. The designs arrived at do not violate the materials used, they do not subordinate the composition, the form or the color to the subject matter. They have achieved a synthesis of object and absolute form; they have again evoked the magic of "the thing in itself."

These examples are the result of collaboration between artists, architects and rabbis, and demonstrate their willingness to learn from one another, to understand one another and to explore the possibilities of art and consider the psychological and cultural needs of the congregation.

Art and esthetic values have not been sacrificed in any of these instances. Indeed, they have been nourished by contact with ideas springing from a great tradition. The ideas, the peculiarities, the ethos of an historic community were not sacrificed; nor was the personal element, the individuality which the artist brings to his work. On a deeper level, the problems of identity have been met squarely, and the "collective intimacy" of an historic group, to use the apt phrase of Ben Halperin, has been presented to the community at large in an artistically valid form.

The achievements of some synagogues point toward possibilities which can be realized, though much effort is needed. The alternative is an appalling bareness, a lack of stimulating and thoughtful communal environment. This alternative can be seen only too often in an uninviting exterior, in huge empty corridors, in a makeshift or stultified arrangement for the *bimah*, in a random choice of subjects for stained-glass windows, in a poor selection of display objects, and poor installations of artwork lifted from commercial catalogues. They point to a lack of careful planning and the absence of an underlying philosophy.

Because a close association between the ancient temple in Jerusalem and the synagogue is for the most part uncritically assumed, the true nature of the synagogue is often marred by a disturbing and embarrassing expression of opulent sanctity. In the effort to adorn the synagogue, both art and religion are misinterpreted. The objects in the prayer hall sometimes echo not a quiet harmony calling for an examination of the life one leads, but the market-place tastes of congregational leaders, who create a "sanctuary" which reflects, affirms, and sanctifies the commercial values by which they live.

The synagogue of today often has a museum and art gallery of its own. Though it is

receptive to all that is of spiritual value and pertains to Jewish existence, congregations have not taken sufficient cognizance of the fact that an art has been created which is deeply concerned with the anguish of our times, an art no less religious for its usual lack of Jewish symbols (those are by no means lacking). Because it deals with the fate of man and the fate of the Jew directly or symbolically, it is an art which has a natural place in today's synagogue. These works are religious because the artist expresses through them his ultimate concern for the state of man, and his personal faith, and thereby the corporate experience of the Jewish people. Most of these works are highly personal expressions, stemming from experiences of the artist deeply colored by his upbringing within families or communities where Jewish tradition has been pervasive. Many of these artists came to the West from the small, tightly-knit Jewish communities of eastern Europe and, looking back nostalgically on their own childhood, they communicated to us their love for a way of life which has been destroyed. I speak, of course, of artists like Adler, Band, Chagall, Segal, Menkes, Soutine, Lipchitz and others, who deal with Jewish themes, or who bring into their work elements derived from Jewish experience. There is in their work a preoccupation with the Torah, the fate of the individual and of the community, and their salvation in the world of brute force. There is a preoccupation with justice and ritual, the home and the world, the hunted and the tired, the strong and the helpless, and with all those elements of the Jewish drama witnessed in this century.

American artists too, and not only of the older generation, like Max Weber, Michelsohn, and Ben Shahn, have often dealt sensitively with Jewish themes. A whole crop of younger artists have found in the Hebraic heritage a rich ground for their creative work. Levine, Bloom, Baskin, Jacobson, Werner, Weinberg, Vodicka, and many others have consistently revealed to us convincing images of the Hebraic tradition and the Jewish experience.

Their works are not commissioned; but are done because the artist chooses to do them. They are taken from the artist's encounter with the world as it appears to him. These works spring from a great tradition and from the artist's need to be related to it. They are born out of a mature insight, an acute awareness, and a reverence for life itself. One must be impressed with the force of the Bible as a constant source of identification in these works, as a source for themes eagerly turned to for illumination of living and relevant personal sentiment. Through it the artist represents his responses to the life experience of the present; he illuminates the biblical past and invests it with new meaning. His own experience of love will be echoed in an interpretation of the Song of Songs, the "Exodus" of our day in the Exodus of long ago, political persecution of our times in a parable on Daniel in the lion's den. The events of the present illuminate the past.

It is surprising that whereas secular institutions throughout the country have acquired such works of art, the synagogue remains almost completely untouched and unaware of them. In some cases this lack of awareness seems incredible.[8] The neglect by Jewish institutions of an artist like Ben-Zion shows a profound lack of understanding, both of art itself and its function within the Jewish community. Because this artist lives the Bible, he refuses to "beautify" his biblical figures and thereby corrupt our feeling. Because his

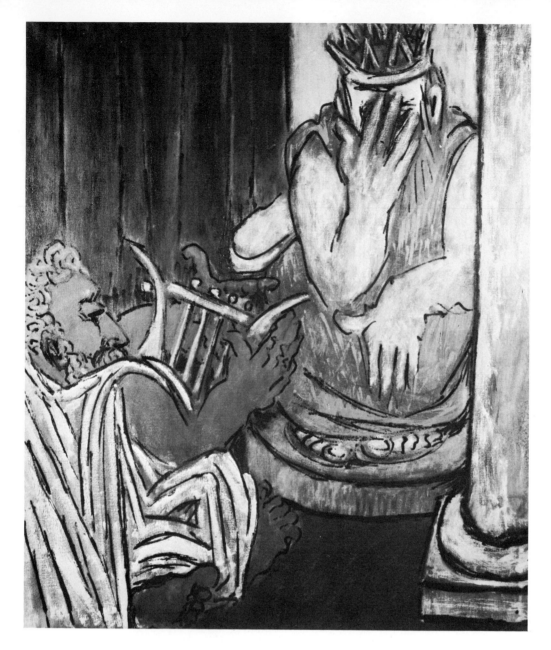

David playing before Saul. Oil on canvas, 42" x 32", 1951. Artist, Ben-Zion. Courtesy of the artist. (Photo: Erich Hartman.)

figures breathe an authentic, archaic, yet poetic quality, they are disturbing with their monumental bulkiness. The response to these unconventional images and conceptions is like the response we might expect from the congregation if Amos, in some miraculous way, walked into a synagogue service. He would be an outsider and an intruder. On speaking, he would tear off the veils of pretentiousness. In the same way the artist is often disturbing, for he destroys complacent notions.

Art is not intended to validate accepted notions or to sanctify the values of the environment. The function of art is not to please, although some artists actually try to. Art lifts the veil from aspects of reality shut out from our awareness, riveted as it is to the habits and needs of our daily existence.

Congregation
B'nai Israel
in Millburn, N. J.

THE synagogue of Congregation B'nai Israel in Millburn, New Jersey, represents a signifi-
cant milestone in synagogue art and architecture in the United States. Here, for the first
time, an architect who had for years worked in the planning of synagogues called upon
modern artists to cooperate in the creation of a house of worship in which esthetic con-
siderations would play a major role. The architect enlisted the services of three well-known
men who were struggling for recognition in the abstract movement. Their task was to
help enhance a simple, low, square building constructed out of warm tan brick, cedar
wood, blue-green glass, and surrounded by a handsome garden. There were many advan-
tageous circumstances in this assignment: a close-knit community of 250 families, an
understanding and enlightened rabbi with an interest in the beautiful, the challenge of
the endeavor, and finally the suburban and semi-rural setting. The small size of the struc-
ture brought the artistic problems down to a relatively easy and manageable scale. The
proximity of the suburb to New York City, with its forward looking, rapidly-moving art
life and art criticism and its cosmopolitan tastes, contributed to the community's willing-
ness to experiment.

The focal point of the façade is an 8′ x 12′ lead-coated copper sculptural representation
of the burning bush executed by Herbert Ferber. It is mounted on a wedge-shaped panel
built of natural cypress which projects from the center of the building and rises above its

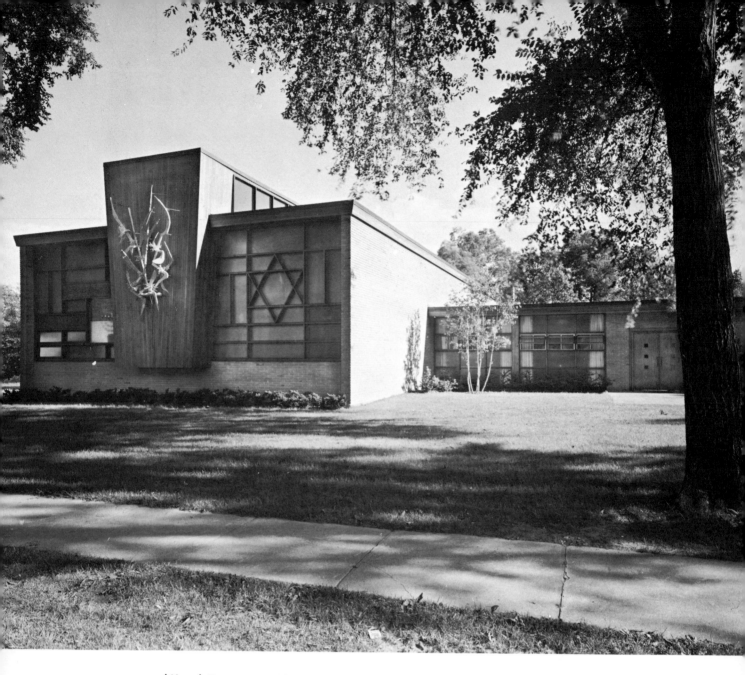

(*Above*) *Congregation B'nai Israel*, Millburn, New Jersey, 1951. Architect, Percival Goodman. (Photo: Alexandre Georges.)

(*Right*) *The Burning Bush*, copper, brass, lead, h. 12', 1951. Congregation B'nai Israel. Artist, Herbert Ferber.

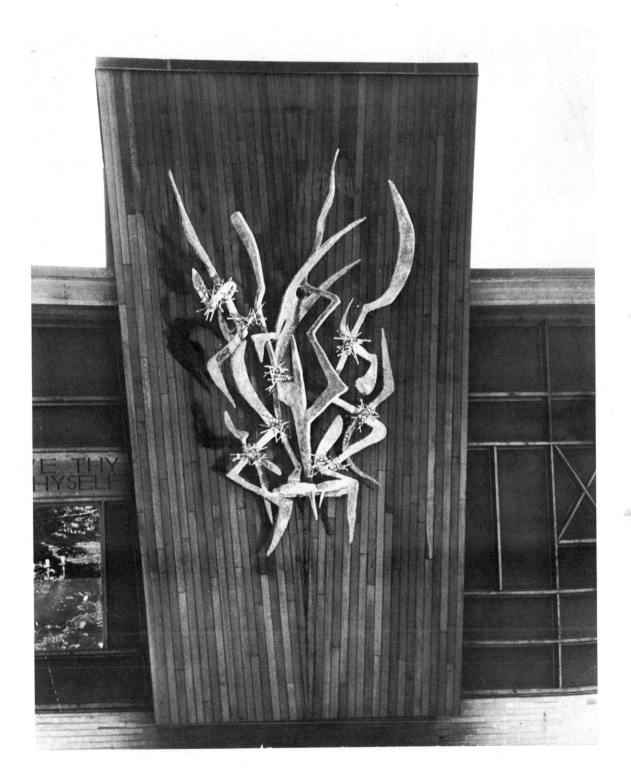

roof line. This provides a vertical accent to an otherwise horizontal structure. By means of the panel, the architect carried the idea of the ark to the outside of the building and made it the central part of the façade.

The two huge windows that flank the projecting center are treated as translucent walls, rather than as voids. Their mullions are arranged in Mondrian-like fashion, forming an asymmetrical linear pattern based on the intersection of horizontal and vertical bars. Into this design a Star of David formed by the bars of the grill is effectively integrated by enclosing the six points firmly within the horizontal bars that base themselves at the very edge of the grill. This is a method the architect has used successfully in the building of the Baltimore Hebrew Congregation and at Temple Israel in Lima, Ohio, as well. Two horizontal boards carry the inscription, "Love thy neighbor as thyself," both in Hebrew and in English, on the opposite grill on the left. The windows are glazed with frosted glass and their blue-green color blends pleasantly with the other materials. Only one panel in the glass wall is transparent, revealing the tips of a seven-branched *menorah*, which stands within the prayer hall and balances the Star of David on the opposite window.

The burning bush identifies the building. Moreover, as sculpture, it enriches and vitalizes the façade, and especially the projected ark, creating a compelling, yet natural, focal point.

Façade of prayer hall, Congregation B'nai Israel.

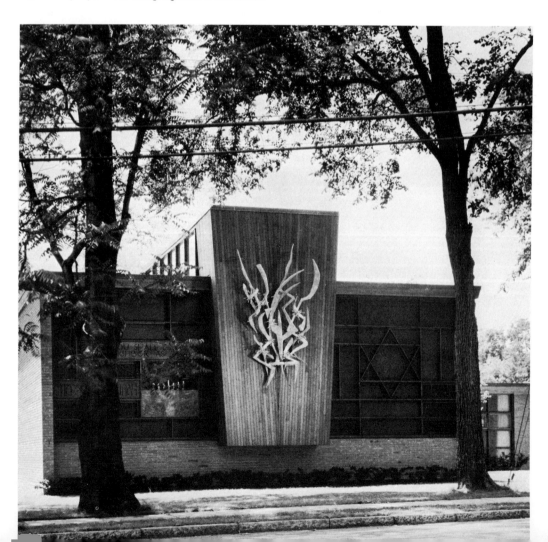

The work is an abstract representation of the burning bush, which the rabbi felt was symbolic of the fate of the Jewish people—a bush that burns but is not consumed. The associations evoked are many and deep-rooted. The biblical story of Moses confronting the bush is familiar and well-known. But its identification with a people who suffered and survived, and the wider association with an ever-burning passion or idea that cannot be consumed, make the burning bush a timely and appropriate metaphor both for self-knowledge and group identity. It is also an image of a vital force capable of undergoing great pain yet remaining immune to destruction. Certainly, the burning bush, as subject matter, encourages more artistic involvement than such a highly codified symbol as the Star of David.

In the Millburn synagogue the bush is made out of copper sheets reinforced by brass pipes and covered with lead and solder. It projects up to three feet above the façade. Its elements were made as separate units to be fastened to each other and to the wall. The sculpture moves upward and fans out, reinforcing the basic movement of the wedgelike panel as well as echoing the direction of its wooden planks. The copper sheets have been shaped and twisted into sharp-pointed spikes and give an appearance of roughness and heaviness—a feeling due mainly to the lead coating and the solder. They present an unpolished, scorched surface that has been produced by fire. This is not "finished" sculpture, but a work whose texture bears the mark of the blow torch, with its molten lead and solder that congealed suddenly when the sculpture was removed from the fire. Thus its surface is composed of furrows and bulging silverlike streaks, tortured and sculpted knots. The twisting, interlocking, copper spikes are further tangled by small thickets of thin webs of bristling copper rods placed at several intersections. These thickets evoke the sight, the sound, and even the smell of a crackling fire of kindling wood. It is a burning bush; it bends and expands but is not destroyed by the flame that struggles to consume it.

The use of new material, techniques, tools, and the emergence of new sculptural goals are sufficient in themselves to arouse new associations, and to expand the range of our sensibilities and perception. The artist's preoccupation with process, rather than polished product, can be sensed in the sharp edge cut by the torch, the variation of color produced by different degrees of heat, in the controlled randomness of dripping solder or melting and flowing lead, and in the roughened surfaces which elicit a strong kinesthetic response.

We have here a contemporary work of art. It is a sculpture constructed and welded together rather than carved from a solid block or modeled into a coherent mass. It is a sculpture of discontinuous forms, piercing and enclosing space rather than displacing it. Within it core and surface do not exist as separate parts. The eye is compelled to move in, through, and about both space and mass.

Robert Motherwell's mural effectively enhances the vestibule, although it seems too big for the small space and the observer has difficulty in grasping its excellent organization at a short distance. The artist obviously respects the wall and is mindful of the two-dimensionality of the canvas. The painting is not strictly abstract since we can identify symbols within it rather clearly. The artist renounces only the illusion of a third dimension and

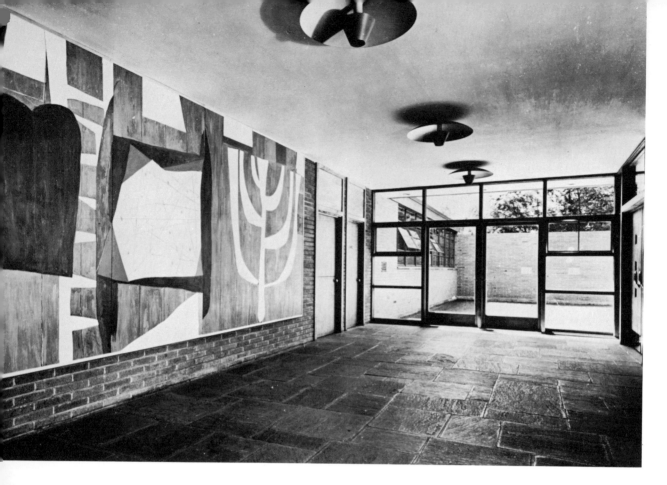

Vestibule with mural. Congregation B'nai
Israel. Artist, Robert Motherwell.

The walls of the temple, mural, oil on masonite,
8' x 16', 1952. Artist, Robert Motherwell.

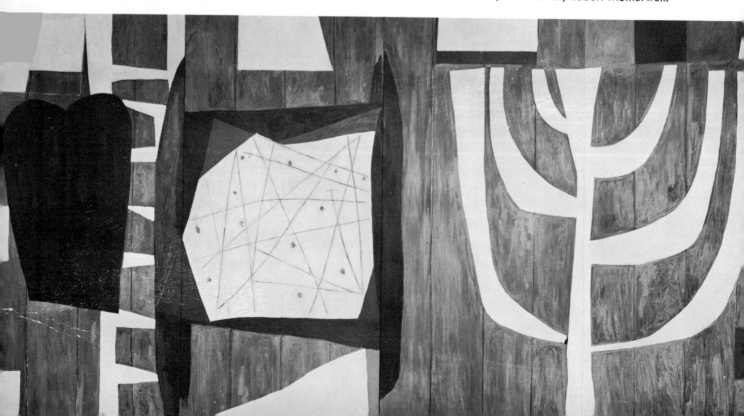

offers us instead a decorative and symbolic representation appropriate to the specific character of the place. The semi-abstract decorative design, painted on masonite board lined with even-spaced horizontals, suggests a background of wooden planks.

The artist explains his mural:

> The mural is arbitrary in not representing a particular place in the natural world; the mural is not arbitrary, in that there is a reason for everything in it. The mural is symbolic, rather than literal, in order to incorporate several levels of meaning, historical, iconographic, and artistic; the mural is abstract, in order to give a concrete feeling, a decorative feeling of freshness, to the wall against which the mural hangs. More properly, the mural itself becomes the wall (hence the mural's flatness), the wall animated with appropriate symbols, and glowing with harmony (the amount of white is exactly the amount the orange asks for harmony with itself). Indeed, the primary subject, the setting of the mural, is "The Wall of the Temple." The wall of the temple is composed of orange wooden planks; the rectangular keystones (extreme left, top, and right borders) are white, grey, or yellow ochre; beneath the ark is a triangular white shadow. The brightness of the mural is the brightness of the sunlit ancient Mediterranean, and also the brightness of the optimism of modern painting and architecture. At the left, before the orange wall of the temple, is the brown "Decalogue," the tablets of Moses, heart-shaped and yet not, clayish and yet with the sharp edge of cut stone, the sign of the presence of God's word without being written; behind, and next to the Decalogue, "Jacob's Ladder" to heaven, in white; next, "The Ark," wood-colored, with posts, top and bottom: the white surface of the ark holds twelve dots, "The Twelve Tribes of Israel," separated by lines, "The Diaspora," the dispersal of the tribes, to "The Four Corners of the World," the four bordering grey triangles. And last, to the right, the white "*menorah*," the seven-branched candlestick, which here is also "The Tree of Life."[1]

"Painting," says Motherwell, "is the painter's word," and he quotes Martin Buber:

> . . . We put aside, so to speak, all the diversity, and before us remains something simple and undivided, not a great and continuous discourse, and not enough to reconstruct such, if it should ever have existed, but at all events the word of a man, a word having its own accent and sense of life. We listen and listen, and then an amazing freshness can be heard . . .[2]

Has the painter succeeded in communicating his "word" to the congregation? It seems that of all the works of art the mural by Motherwell is the least understood and appreciated by the members of the temple. In a way, the mural strains their knowledge and imagination since they are relatively uninformed about art. To many, this is unfortunately not a work of art at which one pauses to observe or study, but rather a wall decorated with distorted yet familiar symbols that can hardly be made coherent. As has been shown, the mural presents an esthetically interesting and profoundly honest solution from the point of view of the artist. Can we ask more from him than the creation of an environment and atmosphere suitable for the purpose of the building? Can we ask him to evoke a specific religious sentiment that he does not feel? No serious artist will undertake such a task.[3]

One ought, however, to seriously consider the fact that although the mural might be

enigmatic, or even unintelligible to the average person, its compelling forms do create a specific environment for those who frequent the synagogue. The forms exercise some influence in shaping the psychic structure of the individual congregant. Nevertheless as successful as the artist was in achieving an esthetic solution, he did not create a work of **rel**igious art. The mural lacks the elements of lyricism and poetry. The mind and sympathetic understanding alone do not suffice. Even the fine modeling of the *menorah*, with its tree-like appearance and asymmetrical branches, the shyly hidden ladder whose rungs widen and narrow unexpectedly, and the ingenious criss-crossing lines representing the dispersal of the tribes are born in the mind rather than in the heart. The imaginative process, a vigorous intellect, honesty and seriousness of purpose, together with the resourcefulness of modern art, have created an orderly and well-designed "temple wall." The artist has not created a new image, but has used traditional ones in a carefully thought-out composition. The austerity of the forms and the lack of playfulness indicate the direction of the artist's energy. The quality of physical flatness in the mural is not limited to its composition and forms; the whole seems unwilling and unable to arouse emotion. On the other hand, perhaps we should not ask the work to reflect that which the artist did not intend it to reveal.

The overall simplicity of the entire building extends into the prayer hall. Here the fine and intimate proportions are impressive and the juxtaposition of natural material lends a semi-rustic quality. The adornment of the wall is consistent with the total design. Restraint and good taste have been exercised. Alongside the brick walls are Hebrew inscriptions cut out of wood that provide a gentle contrast to their background. The inscriptions are

Stones of destroyed synagogues. Prayer hall, Congregation B'nai Israel.

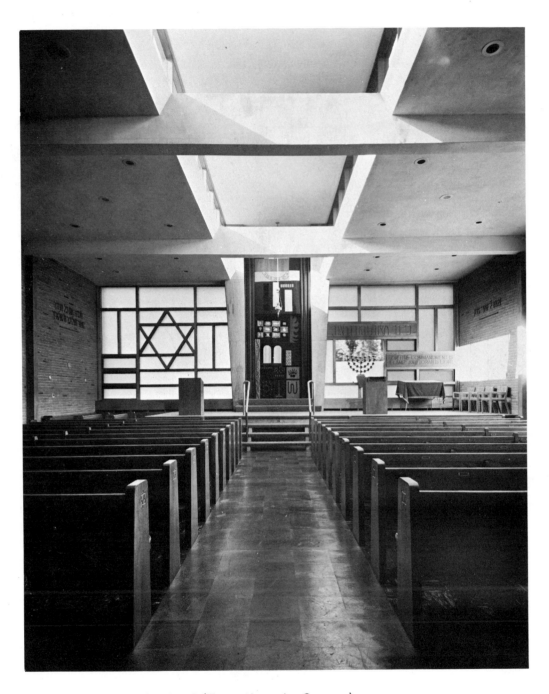

Interior, Congregation B'nai Israel. (Photo: Alexandre Georges.)

taken from various books of the Bible and express significant aspects of faith. On the right wall from rear to front we read in Hebrew:

"*I know that my redeemer liveth*" (Job 19:25).

"*Teach us to number our days that we may get us a heart of wisdom*" (Ps. 90:12).

"*Open to me the gates of righteousness*" (Ps. 118:19).

And on the left wall:

"*Remember the whole road which the Lord thy God has led thee*" (Deut. 8:2).

"*The Lord is nigh unto all them that call upon Him
To all that call upon Him in truth*" (Ps. 145:18).

"*The righteous are called living even in their death*" (B. Berachot 18a).

The window facing the congregation also bears an inscription: "For the commandment is a lamp and Torah is light" (Proverbs 6:23).

Most impressive is the memorial niche within the brick wall. It contains two small white marble cornerstones from two synagogues destroyed by the Nazis in Mannheim. The inscription reads: "To the heroes and martyrs, the known and the unknown who died for the sanctification of the Divine Name." The eye-level cornerstones and inscription in their reference to recent history add a dramatic accent as well as a degree of concreteness. Here historical continuity includes also the cultivation of memory and reverence for a holy place. The Torah curtain, which creates a natural focal point for the congregation, is a splendid quilt of colored velvet strips and rectangles, designed by Adolph Gottlieb. It stretches from the ceiling to the floor of the *bimah* and is framed by two supports which rise from the floor to the clerestory and provide support for the roof. First conceived as a painting, it was then reconceived in terms of the material and the technique of appliqué. The dominant horizontal and vertical design blends into the basic pattern of the neighboring translucent walls and re-echoes faintly the design of the bare brick on the sides. The artist chose resplendent hand-woven Italian velvets in sumptuous colors— blood reds, salmon pinks, silver gray, yellow, bright and olive greens. On these fields of color, velvet is appliquéd so as to represent various symbols in linear terms. The women of the congregation sewed the designs, guided by the cartoons which the artist supplied along with the velvet and thread. We confront a glowing collage: gray velvet tubing on rose, jet black on incandescent red, strips of white velvet on deeper softer red, areas of golden ochre, brown and green.

The artist has arranged fragmented shapes of traditional symbols like the column, the crown or the lion and rendered them in diagrammatic yet evocative forms seen from different points of view. He has drawn these forms on rectangular or circular shapes.

The upper part of the curtain contains a temple column and the marks of the column's

(*Right*) *Torah curtain*, velvet appliqué, 19' x 8', 1951. Congregation B'nai Israel. Artist, Adolph Gottlieb.

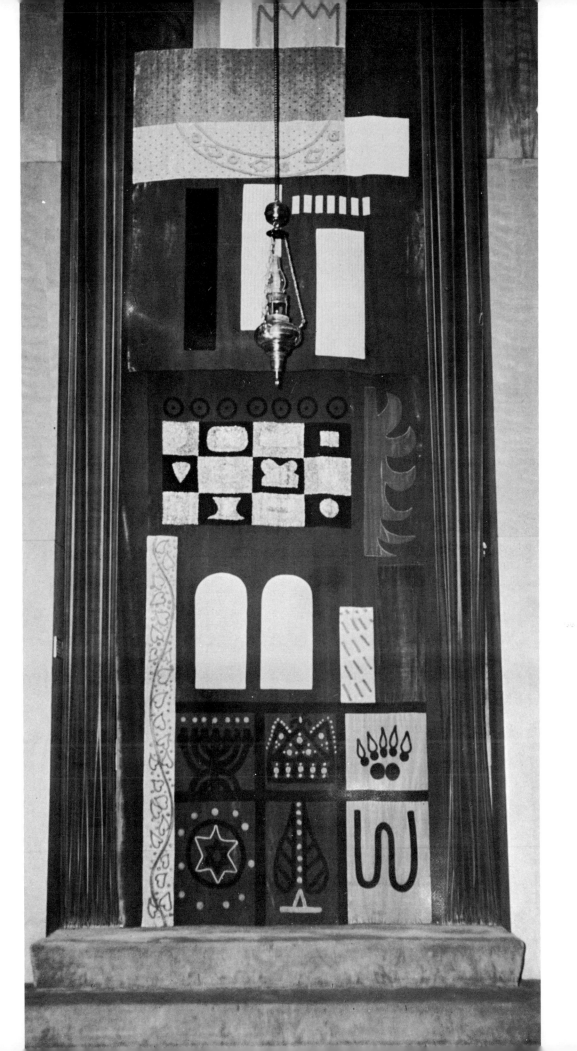

fluting. It also contains the crown viewed from the side and from above, while a segment of a curved band filled with circular and lozenge-shaped forms represents its jewel-studded rim. The center part contains seven candles and three vertically placed rectangular shapes representing Torah mantles. Under a row of small circles, pomegranates, twelve brick-like shapes in gold cloth symbolize the tribes of Israel and are flanked by a stylized view of the mane of a lion, the sign of Judah.

In the lower part of the curtain most of the symbols assume a familiar shape. On the left a narrow strip of serpentine vine stands for Israel. Directly next to it are the Tablets of the Law on whose right a diagonally streaked rectangular shape represents the coat of the lion whose mane we just saw above. The lower third of the curtain consists of two rows of symbols: the *menorah*, the crown and the lion's paw all outlined on square ground. Beneath them the shield of David, the wings of the cherubim and the design of a breast-plate are placed in rectangular areas.

Many of the symbols used in the design are familiar to the congregant. Some may have been puzzling at first because of their fragmented shape or because of the mode of their arrangement. Yet in time the familiar traditional symbols and the warm, serene and sensuous feeling which the curtain evokes, help the congregant to assimilate and enjoy elements which at first appeared strange.

The artist has succeeded in pouring the traditional symbols into a contemporary artistic mold of great beauty and exquisite taste.

We have dealt at length with the Millburn Synagogue and its art. Despite the diversity of the media and subject matter of the three artists, there is a common element in their work. All have pioneered in the abstract school of American art; and all, while preserving the essential stylistic quality of their art, have been able to give expression to old themes and symbols in a new and contemporary form. The response of the congregation and the art community testifies to the fact that the artists have been able to contribute significantly to the work of the architect. Together, they have created an harmonious religious structure.

Artwork
on Synagogue
Exteriors

THE TALMUD states that the synagogue should be the tallest building in the town; that its doors should be at the eastern end, and that it should have windows.[1] Throughout most of history it was impossible to comply with the first of these suggestions. Often an iron bar was hoisted on top of synagogues instead. Doors in the eastern wall were commonly installed only in countries west of Jerusalem, and the Talmud's third suggestion relating to windows became obsolete after Maimonides' modification of the Law.[2] There are indications that, wherever possible, communities preferred to build their synagogues on top of hills, in the open field, or near flowing water.[3]

In fact, however, a synagogue could be erected anywhere, since the emphasis was always on the assembly of men rather than on the structure. Any room could be turned into a synagogue if the need arose. Synagogues almost always adapted the building forms of their surroundings. They resembled Greek basilicas in the ancient world, as excavations and reconstructions of ancient houses of worship testify. In the Middle Ages they had the appearance of Romanesque or Gothic buildings in the West. From the sixteenth century on they assumed the shape of fortresses or double- and triple-roofed wooden structures in eastern Europe. After the Emancipation, a profusion of styles influenced the exteriors, among them the colonial, the Greek classical, and even Moorish and Byzantine, the last being especially favored in the United States during the nineteenth century. When it came to decorative elements that would further identify the building, architects tended to fall back on the shield of David or the Decalogue.[4] This was before the major archeological discoveries of ancient synagogue art had been uncovered, when Jewish sources did not

furnish clues for other possibilities. And, as we have seen, the second commandment was adhered to rather strictly.

It is a sign of freedom, confidence, and self assertion that many congregations and architects are willing to experiment imaginatively with modern forms for ideas rooted in Jewish tradition, so as to give their buildings a distinct character.

Today, sculpture in stone, concrete and metal, along with mosaics, murals, pylons, and inscriptions, are used on the exteriors of synagogues to identify the building to the community and to declare its purposes.

TEMPLE BETH EL, SPRINGFIELD, MASSACHUSETTS

An effective sculpture, the "Pillar of Fire," was produced by Ibram Lassaw out of hammered and welded bronze for Temple Beth El in Springfield, Massachusetts. Nineteen feet high, the sculpture rises from its low foundation to a point even with the tip of the synagogue roof. The relationship of the sculpture to the building is a complementary one: there is no competing element in sight. The architect has planned the brick façade so that the sculpture underscores the massiveness of the windowless wall and binds together its two deep recesses. The sculpture, situated in a shallow recess at the center of the wall which recedes in a continuous movement toward the corners, gains in effectiveness from its surroundings.

The "Pillar of Fire" recalls both a burning bush, whose branches spread curling and twisting as if caught in a conflagration, and tongues of fire that leap, divide, and join in all directions. The artist has introduced anthropomorphic forms here and there, such as we might perceive when we watch the ever-changing shapes produced by the flicker of flames. There is a strong impressionistic element in the sculpture. Its texture and structure create a vivid sense of movement and immediacy.

Temple Beth El, Springfield, Massachusetts, 1953. Architect, Percival Goodman. Sculptor, Ibram Lassaw. (Photo: Alexandre Georges.)

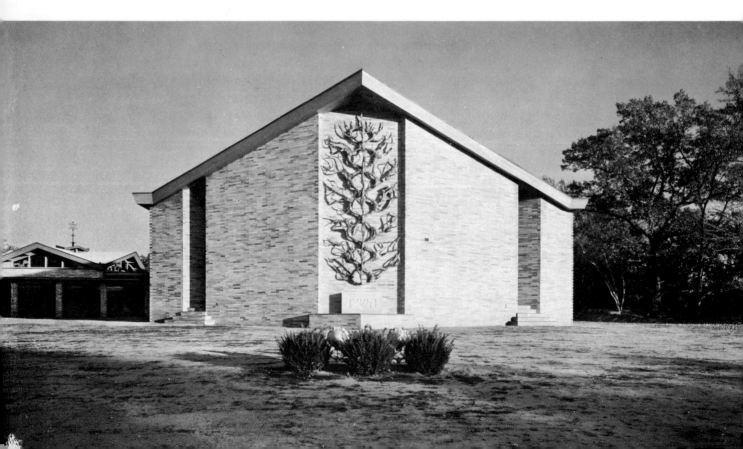

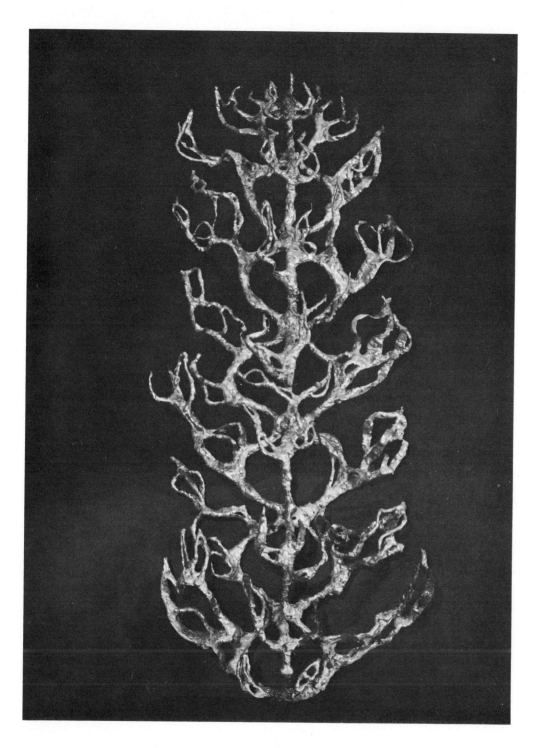

Pillar of fire, bronze, h. 19', 1953. Temple Beth El. Sculptor, Ibram Lassaw.

In contrast to Ferber's burning bush in Millburn (see p. 77), Lassaw accentuates the visual rather than the tactile elements. By combining the warm color and rough texture of the molten bronze, he achieves a play of light and shadow. The flames and their extensions form an interesting lace-like pattern suspended in space, a thin wiry structure, a synthesis of biomorphic and geometric forms. The work reveals a submission to the material, to its properties and possibilities. The artist is not representing reality, but creating it. The viewer senses a heightened participation in the act of creation akin to the intensity with which the mystic worships God.

Lassaw combines a commitment to modern technology in all its various forms—electronics, space physics, atomic science—with an intensely mystic conception of the universe which has led him to search the popular philosophies of Zen Buddhism, as expounded by Suzuki, and Chasidism, familiar to him through the writings of Martin Buber. All of these influences find their symbolic expression in his art. He allows them to determine the choice of his material, the process of his work, and the outcome. Lassaw also brings a spontaneous enthusiasm to his work. In the "Pillar of Fire" he has transformed his intellectual and physical environment into a non-static, ethereal sculpture.

TEMPLE ALBERT, ALBUQUERQUE, NEW MEXICO

In Albuquerque, New Mexico, the exterior walls of Temple Albert tell the story of creation and the Exodus in an abstract design of muted colors.

A distinguished young sculptor, Herb Goldberg, undertook this task after the building had been erected. He conveys the narration with precision and economy, and adapts his composition effectively to the requirements of the flat surfaces of two long temple walls which meet at a right angle.

With a variety of materials—terrazzo, concrete slabs, marble, stucco, cast bronze, stainless-steel rods, sgraffito, and color—Goldberg has enhanced a rather undistinguished exterior by giving its walls a unique decorative character. He fills the large surfaces with pleasing and alternating rhythms and imparts to them a subtle sense of color, everywhere preserving their essential flatness.

Temple Albert, Albuquerque, New Mexico, 1951. Architects, Flatow and Moore. Sculptor, Herb Goldberg.

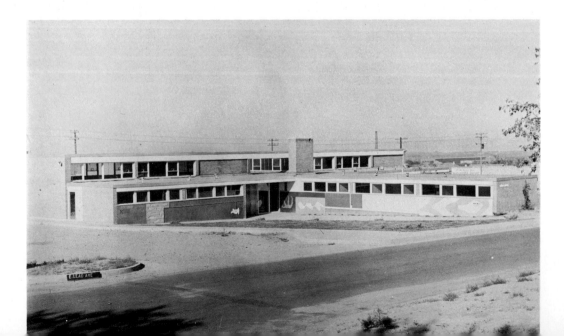

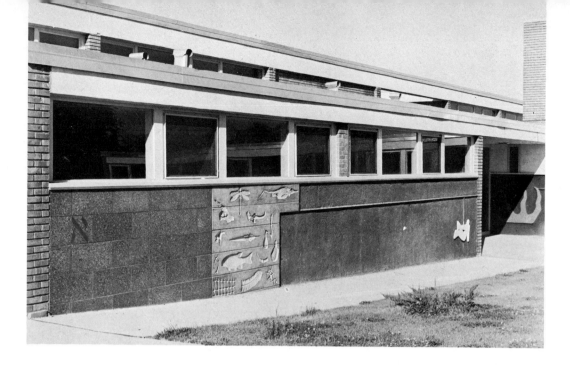

The Creation, terrazzo, concrete, cast bronze, stucco, marble, L. 45', 1952. Temple Albert. Sculptor, Herb Goldberg.

The wall depicting the creation starts with a single *aleph* cast in bronze set against a wall section which is faced with precast, highly polished, dark terrazzo tiles. The letter *aleph* stands for *Elohim* or *Adonai*, who created the world, and it also symbolizes the beginning of all things, including the Hebrew alphabet. The incomprehensible is represented by a single letter. By placing this isolated character against the large expanse of dark tile, the artist has pointed to its significance. This terrazzo section is followed by a panel of rough concrete into which the artist has impressed forms of plant and animal life—from the earliest, one-celled structures through the reptile. The eye then moves to the third section of the wall, a long, rough aggregate ground of wine-colored stucco, its bareness symbolically indicating the passage of time. Finally, at the far end of this section is placed the reclining figure of a man. This is a low relief sculpted in white marble whose form echoes the *aleph* placed at the very beginning of the wall. It also vaguely recalls the pose Michelangelo chose for the reclining Adam on the ceiling of the Sistine Chapel. A strip of bronze has been placed so that it moves from the protruding part of the concrete panel across the stucco section. Above the figure of the man, another strip descends vertically to connect the figure to the previous panel, thus tightening the organization of the whole.

Near the synagogue's entrance, a section depicting the burning bush introduces a series of reliefs which deal with the Exodus. The burning bush resembles the letter *shin* (or vice versa), and is made of red terrazzo mounted on black stucco. A large bronze inscription leads from the burning bush into the building itself: אהיה אשר אהיה ("I am that I am"). God speaks from the burning bush. On the outside, to the right of the bush, the theme of the bondage in Egypt unfolds. Treated in sgraffito, it presents a white coglike mass compressed by another grey mass. The white forms seem sluggish, resistant to the general direction of their movement, suggesting the rhythms of enslavement. The movement beneath the grey mass is equally sluggish, while repeated shapes convey an image of heavy links within a

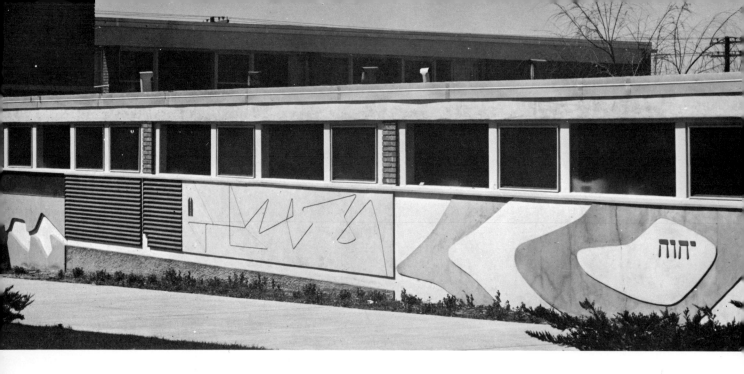

Exodus, Revelation on Sinai, concrete, sgraffito, bronze, stainless steel, L. 75', 1952. Temple Albert.
Sculptor, Herb Goldberg.

chain and a sensation of dragging or being dragged. The whole is a poetic and rhythmic expression of bondage.

An extension of the white forms leads us into the next wall section—a panel of horizontally-fluted, red stucco, divided vertically by a thin white line—the parting of the Red Sea. In reducing his idea to its simplest terms the artist has produced a highly stylized, mechanical, yet interesting metaphor. A segment of buff-colored wall follows. Cast bronze Tablets of the Law are introduced to mark the giving of the Torah at Sinai. A thin stainless-steel rod, winding a zigzag path through the buff-colored panel, tells in cryptic form of the wandering of the Hebrews in the desert. The white, coglike, resisting shapes which were born in the gray bondage have turned into an even-flowing, white band which continues along the lower part of the last two wall sections. In the final section, this narrow band fans out into expansive, free-flowing and joyous movements, creating harmonious white shapes alternating with similar gray forms. As the white shapes progress toward the right they become higher and narrower; the last and highest carries the Hebrew letters יהוה (Yahweh).

The treatment of the wall is very effective; it has a regional flavor, and reflects thoughtfulness, originality, and moderation. It is regrettable, therefore, that some details such as the Hebrew lettering were not more masterfully executed. The letters lack architectural distinction. They appear to have been almost naively lifted out of the prayer book, enlarged, and cast into bronze. Nevertheless, the total effect is that which could only be produced by an imaginative artist with a full knowledge of the possibilities and limitations of the materials he employed. It is worthwhile noting that Goldberg was concerned not only with retelling the story of creation and the Exodus according to the biblical myth, but also with enhancing the wall. By basing an abstract design on biblical narrative the artist has created an enlightened but unassuming interpretation of the beginning of life through its evolution to the creation of ethical concepts.

BALTIMORE HEBREW CONGREGATION, BALTIMORE, MARYLAND

The sculptures on the façade of the Baltimore Hebrew Congregation, created by George Aarons, consist of eight panels designed to express the ethical ideas of Judaism as conceived by the spiritual leaders of this community. The sculpture enlivens the wall above the main doorway and intensifies the meaning of the entrance. Among the panels inserted into the façade, the Tablets of the Law occupy the central position. They are also larger than the rest of the panels. The Decalogue is not decorated with letters from the Roman or Hebrew alphabets. Instead, taking his cue from an old interpretation, according to which the first five commandments are concerned with man's duty to God, Aarons has carved into the tablets rising flames. In accord with the same tradition, the second tablet concerns man's duty toward man; here the artist has stamped it with an earthy, clod-like texture. This second tablet is more imaginatively treated. Its visual richness (varied rhythmic shadows cast by a close-knit pattern of cracks) contrasts to the starkness of the building's surface. The rhythm of the sculptured cracks, like the flow of lava, seems to form a new and constantly changing landscape. The pattern on the panel suggests an attempt to rise out of inchoate form: the tablets are slowly forming out of the earth. Thus, the image refers to a time before the tablets were inscribed. They may be understood to constitute a vivid metaphor on folkways and customs before they assumed the definitive shape of the Law.

Below the Tablets of the Law is a panel which depicts the creation of man, who seems to spring forth from a wave pulled by the unseen hand of the Lord. The opposing rhythms of wave, moon, fire and man create a rich and pleasing design of sharp lines and smooth

Baltimore Hebrew Congregation, Baltimore, Maryland, 1952. Architect, Percival Goodman. Sculptor, George Aarons.

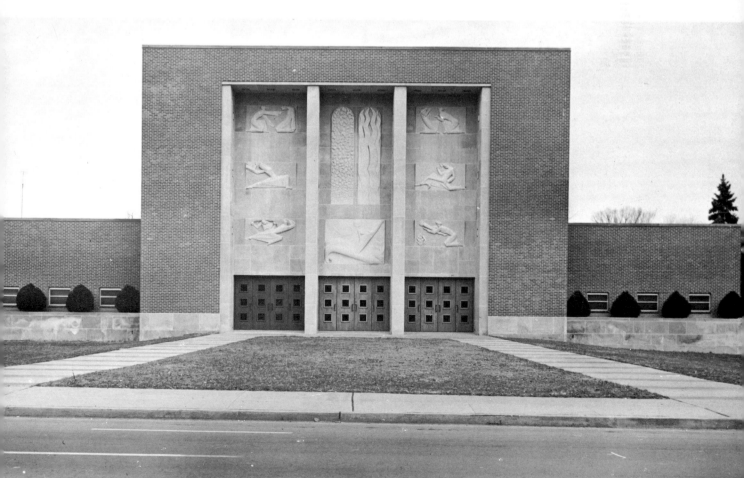

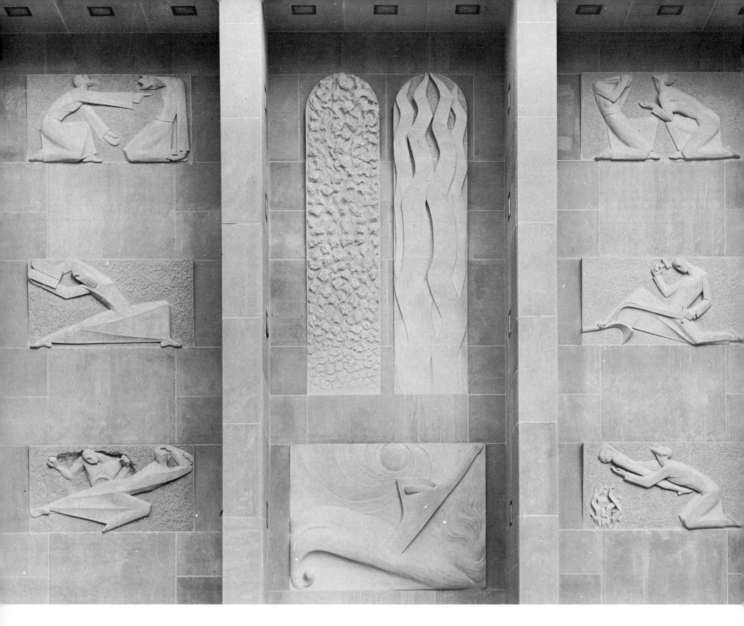

Sculptures of façade, based on biblical themes, 1953. Baltimore Hebrew Congregation. Sculptor, George Aarons.

slanted planes. The Prime Mover is indicated by the results of His action rather than by His presence, which would be totally incompatible with Hebraic tradition.

Into the six additional panels flanking the center Aarons has carved ethical concepts of the Jewish people—Ruth and Naomi representing loyalty, swords hammered into ploughshares as a vision of peace, Abraham and Isaac representing obedience to the Lord, Nathan reproaching David as justice confronting power, Moses receiving the Tables of the Law, and, finally, the Exodus.

The figures in the panels move alternately toward the center and away from it. At first glance they seem to be overdramatized and stylized by means of body movement and dated gestures comparable to the expressive forms of modern dance. There is too much stretching, leaning forward and backward, pointing and pleading. However, the forms,

with their clean, sharp lines and planes, are adapted amazingly well to the lines and surfaces of the building. If some of the figures appear to be squeezed into the panels—and practically all of them bend or crouch on their knees—it is due mostly to the fact that, as happens so often, the artist was called to submit his design after the panels had already been inserted into their places. Thus he was forced to adapt his composition to the size of the panels. Given the complexity of the relationship of art to modern architecture, his application of sculpture to the building, the choice of theme, and its execution have doubtlessly been very successful.

In the original plan certain panels were to deal with more abstract concepts such as liberation, mutual help, and justice. However, in the creative process of selection and refinement it was decided to represent these concepts in their concrete manifestations as they appear in the biblical narrative. Much, it seems, has been gained thereby. Because they are rooted in the congregation's tradition and lore, the themes are more easily understood.

Aarons has made the most of a confining situation. He has given a rough texture to the ground of the panels, while the figures raised in relief have a smooth finish. Their clear, energetic outlines echo some essential features of the building. The panels entitled "Exodus" and "Swords into Ploughshares" are especially noteworthy. In "Exodus" the escaping figure moves with powerful stride across the panel, crossing another figure which is in the process of wrenching itself free. The figures are compact and wrought with tension. Their movement alludes clearly to the historical Exodus as well as to the escape from the bondage which each man carries in his heart. The impetus of the escaping figure is checked by the figure still bound and struggling to become free. The opposing movements of their bodies, and the different directions in which they are pulled, may mirror different moments in the struggle for liberation.

Exodus, detail of façade, 8' x 4'. Baltimore Hebrew Congregation.

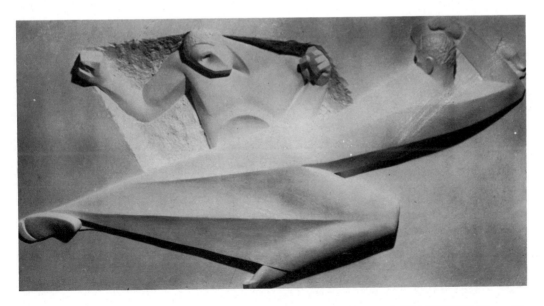

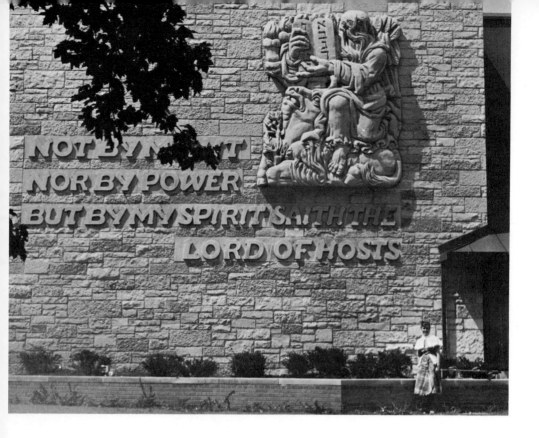

The Cherub Subduing Behemoth, limestone, 12' x 10', 1951. Temple Har Zion, River Forest, Illinois. Sculptor, Milton Horn. Architects, Loebl, Schlossman and Bennett. (Photo: Estelle Horn.)

HAR ZION TEMPLE, RIVER FOREST, ILLINOIS

At Har Zion Temple, River Forest, Illinois, Milton Horn carved a 12' x 10' relief in limestone, based on the prophet's passage "Not by Might nor by Power but by My spirit saith the Lord of Hosts" (Zech. 4:6). This inscription is carved on the temple wall beside the sculpture.

In order to overcome the problem of perspective, the sculpture projects twenty inches from the wall at its top and eight inches at the bottom. The general rectangular outline of the relief repeats the contours of the building. Within the sculpture itself, however, bold and energetic rhythms cross the relief vertically and horizontally, and divide and organize it into nearly geometric sections. Only its monumental scale prevents the work, rich in inner movement, from being neutralized by the vibrating pattern of the various shapes of rough limestone and their variegated tones of grays, buffs, and rusts.

The conception behind the composition is most interesting. Power is represented by behemoth, the hippopotamus—a bovine, primeval beast, brutish and ignorant—who, according to *Agadah*, is the king of all animals of the dry land and unconquerable by man. Behemoth was created with the leviathan, the archetype fish whom he matches in strength. He was so monstrous that he required the produce of a thousand mountains for his daily food, and all the water that flows through the bed of the Jordan in a year afforded him but one gulp. In fact, God had to deprive him of the desire to propagate, otherwise the world could not have continued to exist.

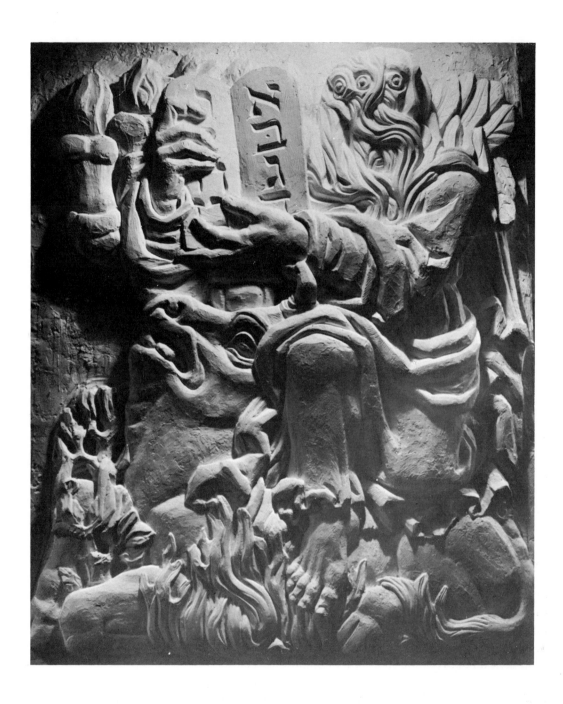

The Cherub Subduing Behemoth, model in plaster. (Photo: Estelle Horn.)

Milton Horn, however, took a slightly more poetic and charitable view from the Bible:

Behold now behemoth, which I made with thee,
He eateth grass as an ox,
Lo now, his strength is in his loins
And his force is in the stays of his body.
He straineth his tail like a cedar;
The sinews of his thighs are knit together.
His bones are as pipes of brass;
His gristles are like bars of iron.
He is the beginning of the ways of God;
He only that made him can make His sword to approach unto him.
Surely the mountains bring him forth food,
And all the beasts of the field play there.
He lieth under the lotus-trees,
In the covert of the reed and fens.
The lotus-trees cover him with their shadow;
The willows of the brook compass him about.
Behold, if a river overflow he trembleth not;
He is confident, though the Jordan rush forth to his mouth.
Shall any take him by his eyes,
Or pierce through his nose with a snare?

(Job 40:15-24)

In the sculpture the behemoth, symbolic of brutishness and ignorance, is lying among the lotus flowers, subdued by a mighty cherub who kneels on his body and prevents him from rising. The cherub's head is enveloped by the *Shekhinah* in the shape of flames with four all-seeing eyes. His powerful arms hold the Tablets of the Law. Revealed at the side of the tablets are the branches of the *menorah* with bud-like flames. From its hidden roots, the fires of the spirit are beginning to transfigure the behemoth.

It is interesting that the cherub is fashioned in the figure of man. In Jewish tradition, he is an attendant of God, a personification of cloud or storm-wind which brings God from heaven to earth (Ps. 18), or a composite figure in which real, symbolic and mythological elements mingle. Referred to originally in ancient near-eastern sources, cherubim were represented in the art of biblical times as winged creatures. These cherubim rested at both sides of the mercy seat in the Tabernacle, were deployed at the ark, and were embroidered on the curtain separating the Holy of Holies from the rest of the temple. They usually appear in pairs and are bearers of Deity and emblematic of God's immediate presence. God appears between the cherubim in Solomon's Temple.

In our case, the sculptor rejected the traditional artistic presentation and chose to depict a single cherub in the form of a man. This presentation of a single cherub may derive from Ezekiel (10:4), and its human form from the German Chasidic theosophy of the twelfth century, which still had some relation to Merkabah mysticism, in which God also appears through a mediary, a demiurge or a subordinate God.

The *Shekhinah* is the majestic presence or manifestation of God which descends sometimes to dwell among men. It is spoken of as a light which signifies His presence. When

Face of cherub, detail of Cherub Subduing Behemoth. (Photo: Estelle Horn.)

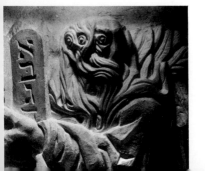

the anthropomorphic expressions for the biblical God are found unsuitable or improper, one speaks of the *Shekhinah*: it is a metaphor expressing God's eternity in the world, or His appearance to man. The artist has enveloped the cherub's head with the *Shekhinah* (flames with four all-seeing eyes, here), perhaps because the *Shekhinah* partakes of the omnipresence and immanence of God, or because the sculptor, who obviously is deeply fascinated by mythology and steeped in Jewish lore, had in mind the midrashic passage (Exodus R.2) which states: "Although the *Shekhinah* was enthroned in heaven, it observed and scrutinized mankind." In addition, he transferred to the *Shekhinah* some of the attributes of the many-eyed composite beasts from the vision of Ezekiel, and Zechariah's rich image of the seven lamps "which are the eyes of the Lord, that run to and fro through the whole earth" (Zech. 4:10). The same chapter contains the prophetic image: "not by might, nor by power, but by My spirit, said the Lord of Hosts" (Zech. 4:6). There is great latitude for imaginative interpretation of the *Shekhinah*. Rabbi Eliezar of Worms, in the thirteenth century, said:

> From the great fire of the *Shekhinah* not only the cherub emanates but also the human soul, which therefore ranks above the angels. The cherub can take every form of angel, man or beast; his human form was the model in whose likeness God created man.[5]

Together, the cherub and the *Shekhinah* represent the personification of the Spirit of the Lord. Perhaps it was the sculptor's feeling of the activist nature of the God of Israel, Who was mighty in battle and Who intervened in the affairs of nations, that made him endow the cherub—God's messenger and will—with great physical power. The cherub's feet and hands are battered and timeworn from constant engagement in the affairs of man.

The cherub's physical power has its celestial counterpart in the representation of the *Shekhinah*, which spiritualizes the cherub and is symbolized by fire. The ethereal quality of the fire and its continuous vibrating movement make it akin to the spirit, *Ruach* (Hebrew, "wind"). Both spirit and fire are self-moving. The Hebrew *Ruach* stands for wind and spirit and the higher faculties of man; it proceeds from an invisible God with Whom it shares the qualities of immateriality, transcendence and spirituality. Fire, like the spirit, fuses and transforms. The symbol of fire has been woven into a number of significant narrations and theophanies of the Old Testament.

The sculpture itself reflects the boldness, the sharp plasticity, the nervous and violent rhythms, for which the artist is known. It is marked with intensity and vehemence, as if the sculptor had extended an inner psychic agitation into his hammer and chisel. He articulates his figures forcefully, endowing the cherub and the *Shekhinah* with great physical power. He has avoided the aristocratic, idealistic tradition of representation as incompatible with the realities against which a more stubborn social-minded Hebraic tradition is pitted. The use of the primary forces such as those the artist incorporates into his work—man, beast, vegetation, and fire—gives rise to a sense of a continuous metamorphosis of nature, an idea which has deep roots in man's history and art. It also enables the work of art to transcend a narrow iconographic motif. The sculpture has force rather than grace, but it is the force, intensity and directness of the Old Testament's prophet.

TEMPLE ISRAEL, CHARLESTON, WEST VIRGINIA

Another sculpture by Milton Horn is mounted on the exterior wall of the prayer hall of Temple Israel in Charleston, West Virginia. The wall, built of Indiana limestone, is the highest part of a low-spreading structure situated between a river and a mountain. The wall is a large and simple form, made like a three-leaf screen. Its projecting center section has a shallow recess which gives the 8½′ x 5½′ bronze relief a handsome setting.

As the theme for his work, the artist has chosen Moses and the burning bush. He uses the figure of an angel, whose face, thinly shrouded by clouds, emerges from the burning bush as the vehicle for the voice of God which speaks to Moses. Moses, on the other hand, lies prostrated on the ground, covered with a mantle. At the lower right of the sculpture two goats gaze at the viewer.

By silhouetting and perforating the rich relief and by mounting it at some distance from the wall, the artist achieved a rich play of shadows. This is also the case with the Hebrew words אהיה אשר אהיה ("I am that I am"), which are mounted beneath the sculpture.

The artist brings to his work vast experience and great technical facility. He has enriched the wall by giving it focus, color and texture. However, the relief considered on its own merit does not measure up to Horn's work previously described at Har Zion in River

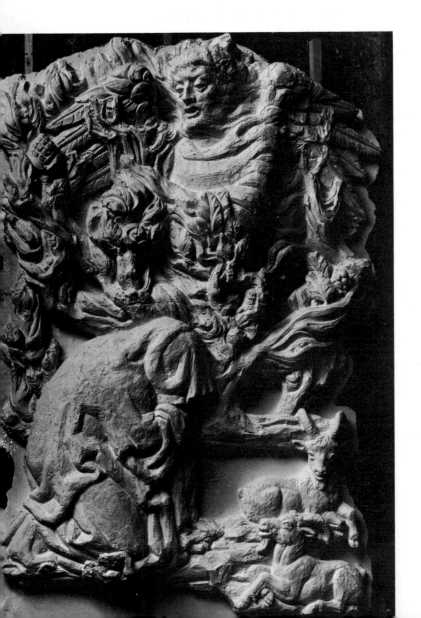

Moses and the Burning Bush, bronze, 8½′ x 5½′, 1960. Temple Israel, Charleston, West Virginia. Sculptor, Milton Horn.

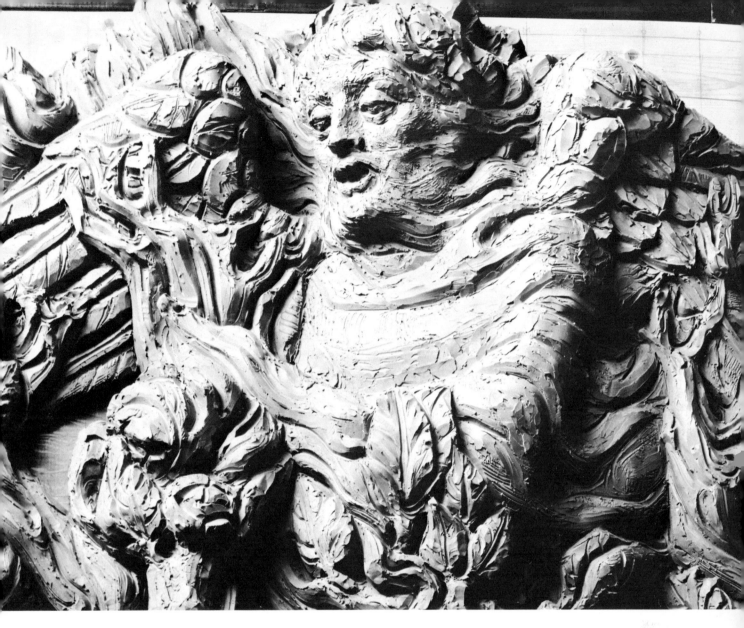

Angel, detail of Moses and the Burning Bush.

Forest, Illinois (see pp. 96-98). It lacks depth, imagination and mystery. The Moses relief neither puzzles nor irritates us, nor does it force any personal involvement. The theme is obvious. One understands it immediately. Moses, who dwarfed the mountains on which he stood, cringes before the messenger of the Lord. What Moses fears to look at—the awesome, the numinous —the viewer is allowed to perceive. The vigor of the execution of this sculptural statement is not matched by an equally strong and imaginative approach. The anthropomorphic conception of the heavenly voice is incapable of evoking that mysterious phenomenon which eludes apprehension, the meeting of man and God. The work does not clarify, expand, or deepen the biblical narrative.

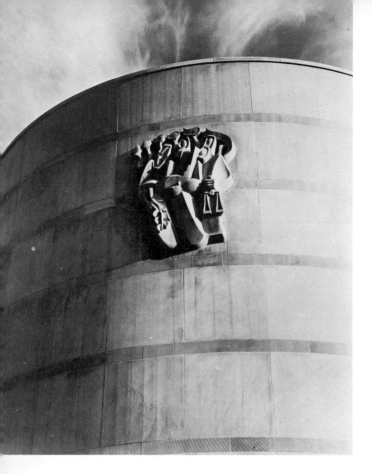

Detail of exterior of Temple Oheb Shalom, Nashville, Tennessee, 1955. Architect, Sigmund Braverman. Artists, A. Raymond Katz and Nathaniel Kaz.

TEMPLE OHEB SHALOM, NASHVILLE, TENNESSEE

A ten-foot-high limestone sculpture on the curved façade of Temple Oheb Shalom in Nashville, Tennessee, is effective because of its strong rhythm, its plastic conception and semi-abstract treatment. It is the cooperative product of two artists. Nathaniel Kaz was the sculptor, basing his work on a design by A. Raymond Katz, who apparently took his cue from Pirke Avot (ch. 1): "On three things the world is founded, on Truth, Justice and Peace." Three bearded rabbis in militant pose represent the principle which Rabbi Simeon ben Gamaliel taught. It appears from the sculpture that the three men not only represent and teach the principle, but are ready to uphold and defend it. To the traditional scholarly conception of the rabbis, the artists have added one of physical power. One is reminded of the talmudic saying that the book and the sword came down from heaven bound together (Sifre Deut. 40).

The figure on the right, who represents Justice, holds the balance as if it were the shaft of a sword. The rabbi in the center embraces the Tablets of the Law, which converge at an angle like the pages of a half-open book. The figure on the left holds a large olive branch in one hand and shields it with the other. The branch repeats the movement of the scales on the right and so balances the composition. The letters of the Hebrew word *Kodosh* קדש (holy) at the top of the sculpture boldly unite the figures as if capping them with a crown. These letters widen the composition at the top and give it a wedgelike shape,

which considerably strengthens the forceful expression achieved by the strong contours, the juxtaposition of convex, flat, and concave planes which remind one of Archipenko. The sharp angles, and the recurrence of protruding, recessing and unexpectedly interpenetrating planes are effectively brought out by the deep shadows cast by the strong southern light. Rich sculptural variations within the figures are a counterpoint to their compact and simple silhouettes. Details such as the heads, beards, arms and hands of the figures reveal different plastic organization. A balance has been created between abstract sculptural values and the requirements of common intelligibility. The work displays a clearly discernible content and a familiar frame of reference, both prerequisites for the enjoyment of art by most members of the congregation. But at the same time it reinterprets the familiar by a modern conception of form and space in which normally convex elements become concave and in which unusual rhythms are created by the juxtapositions of angular and curvilinear forms.

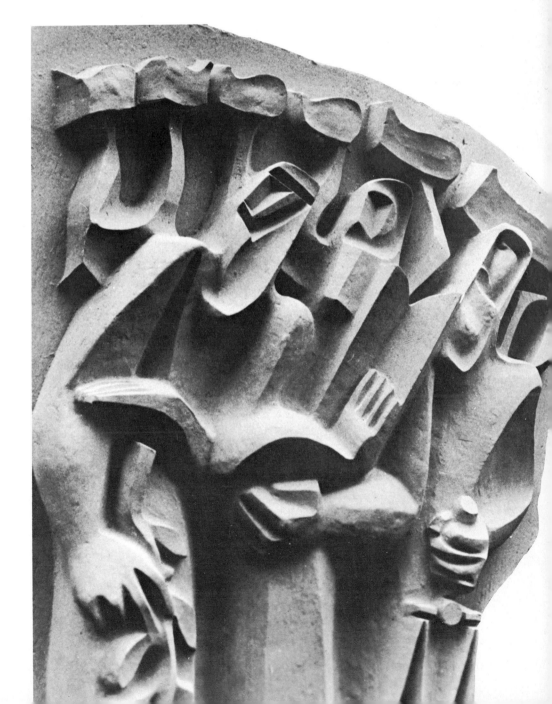

Truth, Justice, Peace, Alabama marble, h. 9', 1956. Temple Oheb Shalom. Design, A. Raymond Katz. Sculptor, Nathaniel Kaz.

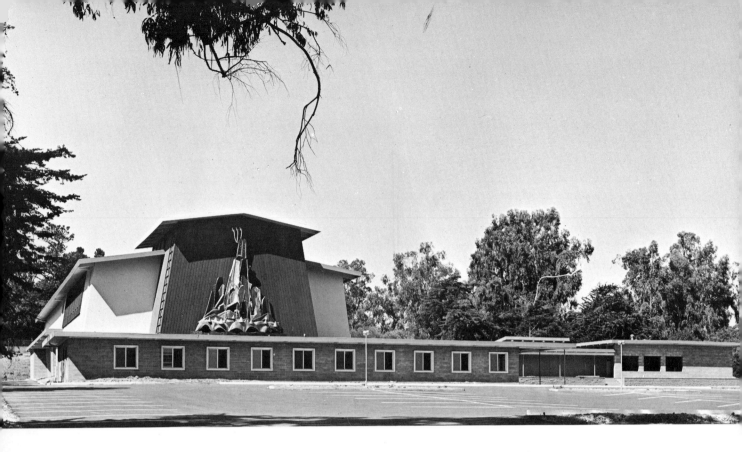

Temple Beth El, San Mateo, California, 1957. Architect, Leonard Michaels.

TEMPLE BETH EL, SAN MATEO, CALIFORNIA

Victor Ries set himself a difficult problem in constructing a sculpture of "The Holy Mountain" out of a variety of metals on the façade of Temple Beth El in San Mateo, California. The sculpture, symbolic of the birth of Judaism, is a rising triangular structure of elongated concave and convex metal sheets, depicting the ruggedness of Mount Sinai. The Decalogue appears on top of the mountains, and is itself surmounted by the Hebrew letter *shin* (standing for God). The sculpture is compressed between the overhanging roof and the projecting wing beneath its base. Sculpturing a mountain is hazardous, to say the least. The construction gives the appearance of a sailboat, with masts and ropes, its colored canvases swollen by the wind. Yet one feels that the full plastic possibilities inherent in the problem and in the material have not been realized. The conception is literary in essence. Nevertheless, the sculpture betrays a certain naive charm and grace.

INDIANAPOLIS HEBREW CONGREGATION, INDIANAPOLIS, INDIANA

At the Indianapolis Hebrew Congregation, a wrought iron sculpture of open Torah scrolls set against the Tablets of the Law is mounted on the curved stone façade. The lace-like quality of the treatment is extremely handsome in itself, but too light to assert itself effectively against the heavy stone, even though the dark color of the metal compensates for this to a certain extent.

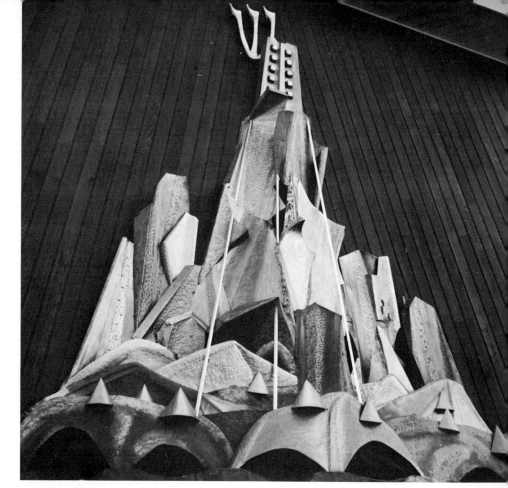

Mount Sinai and the Tablets, copper, bronze, brass, stainless steel, aluminum, 25' x 20', 1957. Sculptor, Victor Ries. (Photo: Ruth Bernhard.)

The Torah and Tablets of the Law, wrought iron, h. 9', 1957. Indianapolis Hebrew Congregation, Indianapolis, Indiana. Architects, C. Wilbur Foster and Son. Design, Rabbi Maurice Davis. Artist, Ray Craddich.

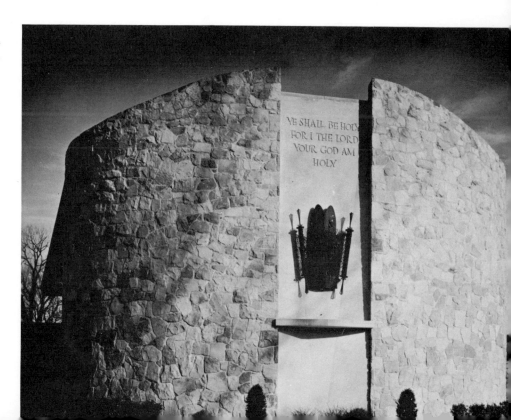

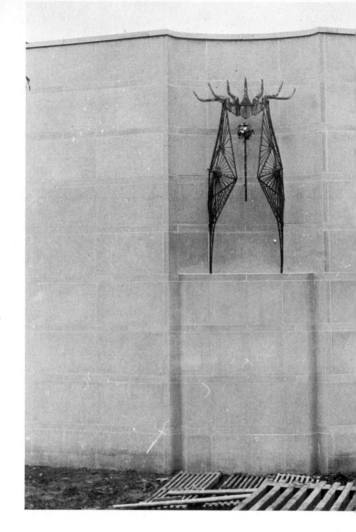

Menorah, bronze, h. 9', 1958. Temple Adath Jeshurun, Louisville, Kentucky. Architect, Sigmund Braverman. Sculptor, Henry Roth.

TEMPLE ADATH JESHURUN, LOUISVILLE, KENTUCKY

Much the same can be said for Henry Roth's sculpture in welded steel which is mounted in front of the massive plain stone façade of Temple Adath Jeshurun in Louisville, Kentucky. The *menorah* stands here in a shallow recessed niche, on a high square base. The artist was so concerned with adapting the sculpture to the space provided that he split the shaft of the *menorah* into two parts, providing it with two thin stems which fan out half way up into a pleasant, curved design, and narrow again as they move toward the top. Here the stems support the short arms of the *menorah* from the right and the left sides, rather than from the center. Reinterpretation of the *menorah* is extreme in its deviation from the traditional form. It does not give us any hint of its origin and seems to be a purely esthetic construct. The void between the two supports is the focal point of the composition and drains it of its power. Despite artistic liberties taken in the presentation of the *menorah*, the sculpture is still too airy and light for the massive stone façade. There is a lack of harmony between the material of the sculpture and that of the building. The sculpture could not exist independently of the building; nor has it any genuine connection with it. Moreover, its stark symmetry, its nearly uniform width, and its high and solid base, rob it of any effectiveness it might otherwise possess.

TEMPLE BETH EL, SOUTH BEND, INDIANA

A tree of life, created by Mitzi Solomon Cunliffe, appears above the entrance of Temple Beth El in South Bend, Indiana. In this limestone sculpture the accent is on the multiple roots of the tree, and on the spreading and intertwining of the branches. The roots stand for the ancient tribes of Israel, while the branches are the innumerable ties which bind the Jewish people together.

The small Tablets of the Law are neatly superimposed on the roots and branches. It is quite possible that the artist attempted to evoke the sense and significance of the moral law at the roots of all civilized life and its specific place within the Hebraic tradition.

However, the Tablets of the Law seem too narrow, and they lack an organic relationship to the rest of the sculpture. The tube-like roots and branches, although plastically undifferentiated, do create a rich and intricate pattern.

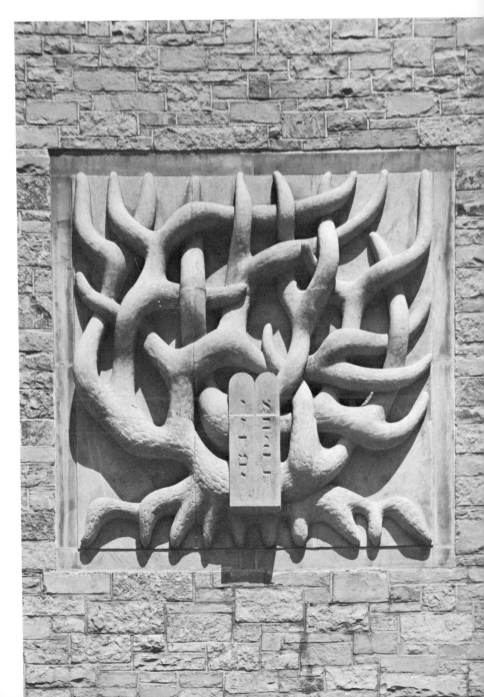

Tree of life, limestone, 9' x 9', 1947. Temple Beth El, South Bend, Indiana. Architects, Loebl, Schlossman and Bennett. Artist, Mitzi Solomon Cunliffe. (Photo: Bagby Photo Co.)

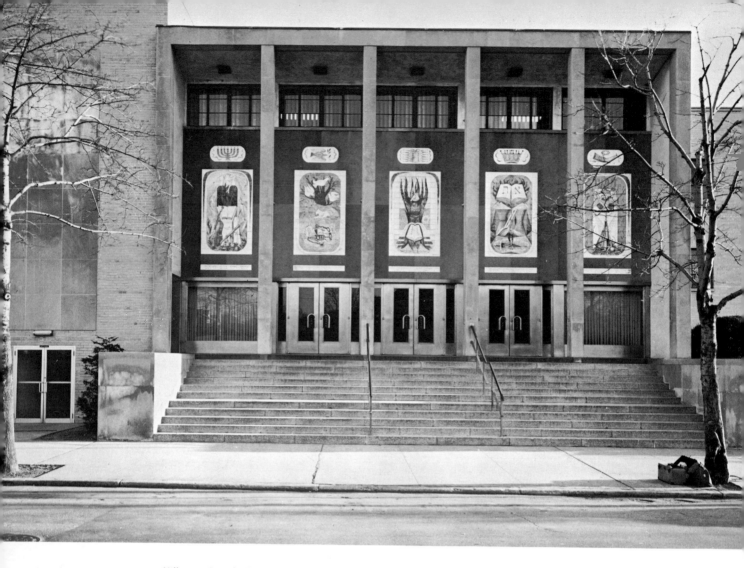

Hillcrest Jewish Center, Queens, New York, 1950. Architects, Glaberson and Klein. Artist, Anton Refregier.

HILLCREST JEWISH CENTER, QUEENS, NEW YORK

Into a checkerboard pattern of black and red concrete covering the large façade of the Hillcrest Jewish Center in Queens, New York, are placed five colorful oblong 20′ x 5′ tile murals.

They were designed and executed by Anton Refregier, an American painter of some renown whose art has largely been shaped by the dominant social trends of the thirties, and the W.P.A., which gave the artist experience with public commissions. The plan for the murals was conceived in consultation with the rabbi, who chose an important idea of the Jewish faith for each one of them.

The number of murals was determined by the presence of four columns in front of the building which created five wall spaces, and did not allow for a unified single composition. Beneath each of the five murals is a row of tiles bearing a Hebrew inscription from the Bible; above each is an oblong medallion representing a ritual object.

The arrangement is precise. Yet we may doubt whether the use of ceramic tile on so large a scale is effective. The over-all grid which is created by the visible joints of the tiles can be disregarded but it is harder to ignore the uniform size of the individual tiles, the evenness of their arrangement, and the sense of their weightlessness in relation to the heavy wall and the concrete pillars. Once again we find marked dissonance between the material of the building and the material used for the artwork.

The murals, executed with great technical facility and competence, express the ideals of the Jewish faith in the language of social realism. The stock themes and clichés of social realism appear to be derived more from the world of the painter than from the world of the congregation.

A representation of the Sabbath is at the extreme right of the façade. We see the covered table, at the foot of which rest the tools of labor: the pickaxe, the shovel, the knitting wool and needles, and the triangle of the architect. The table is literally loaded with the fruits of labor: the covered *chalah*, a bottle of wine, fish, chicken, fruit; on it there is also a seven-branched candelabrum. One may question the propriety of depicting the *menorah* on the Sabbath table, where it generally does not appear, especially together with the tools of labor which do not belong there either. Even the crowding of food diminishes, rather than increases, the feeling of Sabbath—of consecration. The exclusively social interpretation completely overlooks the lyricism and holiness which belong to the idea of the Sabbath. The Sabbath has a unique place in Jewish tradition, and its social values cannot be minimized. However, its meaning is not merely confined to the cessation of work and the enjoyment of the fruits of labor; it is also festive and joyful, a day of rest and study. It has cosmic, religious and social implications. This panel exhibits a lack of artistic intuition, and shows the pitfall of the dominance of conceptual knowledge in artistic creation. The affluence of the supermarket is heaped upon the table. The mural seems to allude to the proletarian theme of "those who produce shall eat." There is even a certain lack of realism in the tools of labor chosen by the artist. He has merely transposed the iconography of the W.P.A. to the portals of a synagogue. The other murals are more successful primarily because the vocabulary of social realism does not seem incongruent with the biblical passages selected, although here, too, one feels the artist's reliance on conceptual knowledge rather than on his immersion into biblical thought.

"They shall beat their swords into ploughshares," is presented by an open book which is elevated into the clouds. The first and last letters of the Hebrew alphabet are painted on its open pages. The pointer hangs down from the book between the standing sheaves of wheat and the plough, and breaks the sword which lies on the ground.

The next design is based on the biblical text: "It is a Tree of Life unto all who hold on to it" (Prov. 3:18). The Torah scroll is enveloped by the *talit* and embedded at the root of a mighty tree, in the midst of which nest pears and plums, pineapples, grapes and a pair of doves. The Torah, the life of faith, is equated with a great cosmic tree planted near the water's edge. The moon, the sun and the stars fill the background. Above this mural there is a small medallion of the Decalogue.

Isaiah's prophecies "... and the work of righteousness shall be peace ... the lion will dwell with the lamb ... they will not war anymore" are effectively represented in two parts.

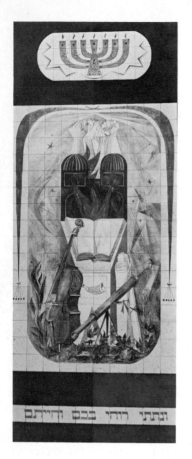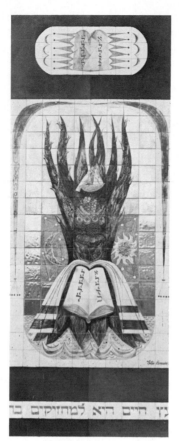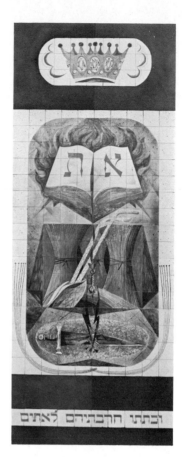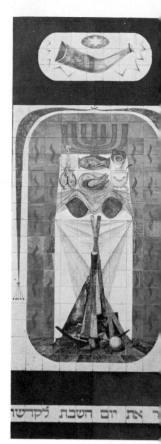

(From left) The Eternity of the People, The Torah and the Tree of Life, Swords into Ploughshares, The Sabbath, mural, ceramic tile in colored concrete, 15′ x 50′, 1953. Hillcrest Jewish Center, Queens, New York. Artist, Anton Refregier.

In the upper half, the lion and the lamb rest under a tree in which doves are nestling, and in the lower half the instruments of torture and the broken chain are partly buried in the ground. The medallion above the mural shows a dove.

The mural on the extreme left is taken from Ezekiel's vision of the dry bones coming to life again. "And I shall put My spirit unto you and ye shall live" (ch. 37). According to the rabbi of the congregation, the mural symbolizes the indestructibility and eternity of the Jewish faith and its divine precepts. To him it also represents the contributions made by the Jewish people to civilization.

The artist seems to have completely departed from the widely accepted meaning of the prophet's word and to have reinterpreted the passage in terms of the "will to survive." The upper half of the mural depicts a burning synagogue, with outstretched arms and clenched fists rising from the flames. In the lower part the synagogue merges into a book. A large cello, a telescope, an architect's triangle, a *shofar* and scrolls are standing on the grass. Like the other murals, the composition is crowded and suffers from a desire to say too many things at the same time in a relatively small space. This last mural seems particularly incongruent in its conception. It is difficult to reconcile the burning house of worship with a collection of musical and scientific instruments which weaken the forceful image above them.

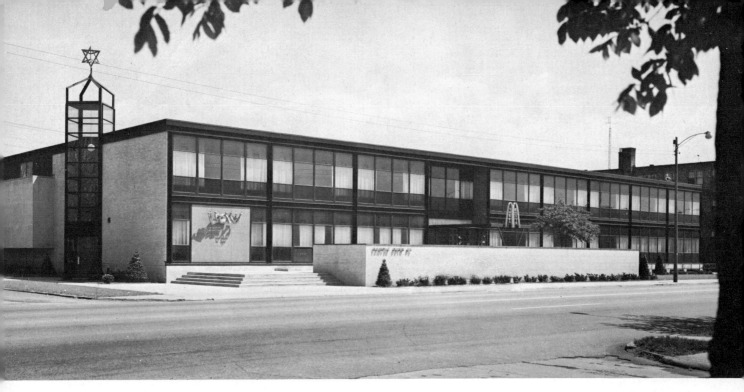

Temple Beth El, Gary, Indiana, 1954. Architect, Percival Goodman.

TEMPLE BETH EL, GARY, INDIANA

On a dark red granite panel within the steel and glass exterior of Temple Beth El in Gary, Indiana, is mounted a *menorah*-like sculpture. Executed in bright welded metal by Seymour Lipton, it is not a representation of the *menorah*, but rather a sculptural metaphor which derives its basic theme from the seven-branched candelabrum. The Lipton sculpture shows a marked contrast to two other metal sculptures on the building: the Tablets of the Law, which are hoisted above the canopy leading into the vestibule of the temple, and the three-dimensional Star of David which surmounts a glass tower on the side of the building. The contrast is both in the materials used and in the style of execution. The star and the tablets exhibit the significant general characteristics of the building in their mathematical precision, their sharp contours, and the mode of their construction. Alternating rhythms of steel and glass, or steel and void, predominate. Indeed, both pieces complement the building but do not relieve it of its factory appearance; on the contrary, they boldly emphasize it. The building is so strongly designed in the familiar Mies Van der Rohe style, with its alternating pattern of exposed steel frames and square glass panes, that it totally dominates the two symbols. However, the sculpture based on the *menorah* theme, mounted on the red granite panel, is a work of art in its own right. Although well integrated into the structure, it is materially and stylistically independent of the rest of the building and is not merely a decorative architectural detail. The highly polished red granite panel, with its light-reflecting capacity, re-echoes the glass around it and merges well into the general design; at the same time it provides the sculpture with an isolating background, freed from the forceful energy of the building's horizontal and vertical rhythms and the relentlessness of its functional design. The sculpture itself is an interesting work of art and deserves study.

ARTWORK ON SYNAGOGUE EXTERIORS · 111 ·

The branches of the *menorah* are intertwined in an irregular fashion, with sharp angular bends and soft flowing curves. The branches interlock and playfully shelter one another. They move from front to rear and back to the front, weaving an interesting pattern of void and solid. Not only does the metal describe a constantly changing pattern, but the space itself moves and turns, is arrested and changes direction as if it too were subject to the laws of matter. There is a strong rhythm of sharply pointed forms which recall, perhaps, the leaves of a thorny bush, or the spiked crown of a king. There is also a more gentle rhythm of sloping and convoluted forms which brings to mind the tenacious, persistent energy of roots, their resisting, struggling and readapting. One might say that the branches of this *menorah* are not derived from the branches of the tree of life but rather from its roots. Indeed, the artist is concerned in this as well as in his other works with basic life forces and movements. His forms spring from a deep feeling for growth and becoming. They hark back to the sources of life, to primal tensions, stresses and efforts, to the struggle of the plant or shell to unfold and to spread. This concern is compatible with the basic analytical disposition of the age, and stems from the artist's fascination with the life processes which take place simultaneously on the interior and exterior of organic forms. He thus alludes not only to the world of appearances but also to that which is hidden to the eye, to the throbbing pulse of life and to the constant transformation of all that exists. He suggests primal movements which are taking place under the protective arches of extant forms. All this does not mean that Lipton translates botanical forms into metal. For him, forms are a point of departure into the imaginative realm of art, into new materials and new shapes which correspond to his feeling about the world. He has forged a pantheistic conception. In addition (and contrary to other critical opinion), we find a well-concealed yet dimly visible anthropomorphic element in the work. Within the sculpture there can be seen a chain of arms, holding, embracing and protecting one another, and a series of heads reacting toward one another. We see a group of men, swaying rhythmically in different directions, expressing fellowship and togetherness. The sculpture is a tree of life bearing human sentiments.

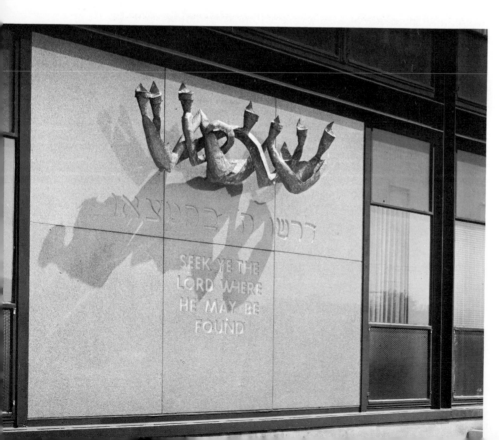

Menorah, nickel, silver, steel, 3' x 8', 1954. Temple Beth El. Artist, Seymour Lipton. (Photo: Hube Henry, Hedrich-Blessing.)

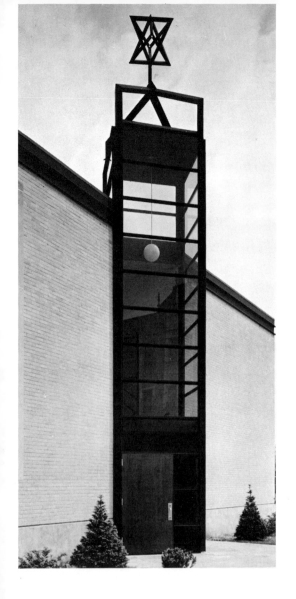

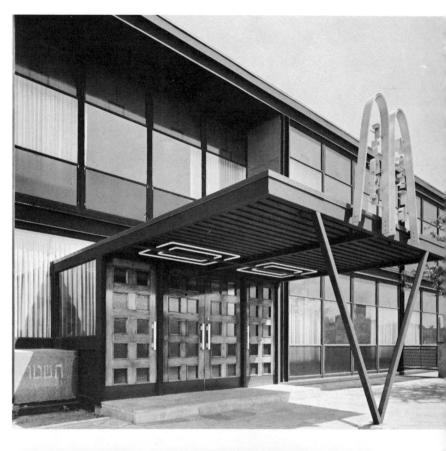

Temple Beth El, details: (*left*) *Pylon, h. 36'*
(*right*) *Entrance into the temple, 12' x 12'*
(*Photos: Hedrich-Blessing*); *Tablets of Law,*
h. 8'. Architect, Percival Goodman.

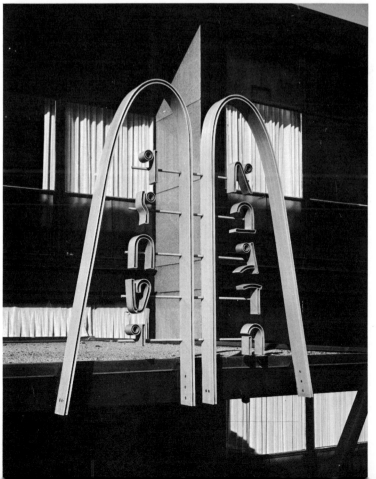

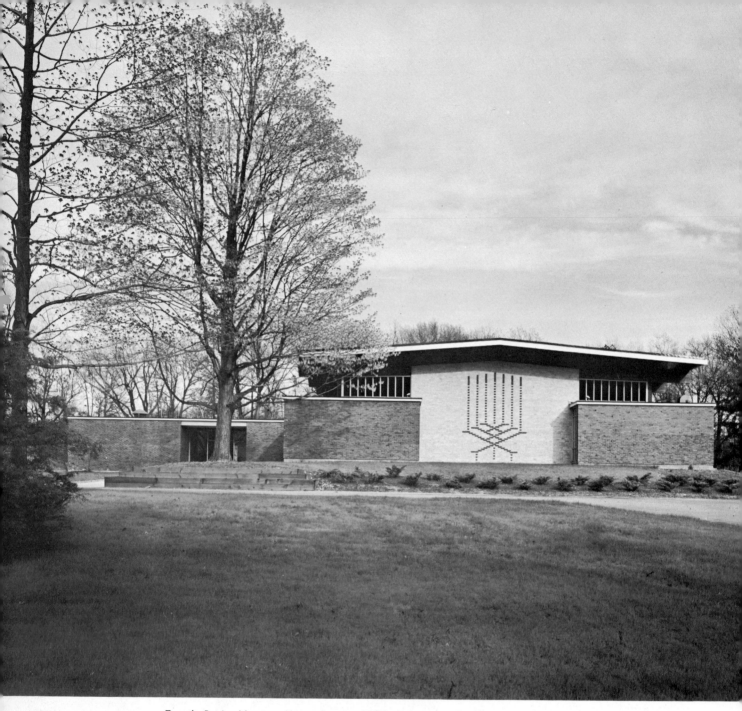

Temple Reyim, Newton, Massachusetts, 1958. Architects—Collaborative. (Photo: Joseph W. Molitor.)

TEMPLE REYIM, NEWTON, MASSACHUSETTS

In Temple Reyim, Newton, Massachusetts, the *menorah* is used as the identifying symbol, although here it has been integrated into the structure. Red water-struck New Hampshire brick is inlaid to form a linear staccato representation of the candelabrum. The size and design of the image are very well suited to the wall it decorates, and the result is one of great simplicity and extreme elegance.

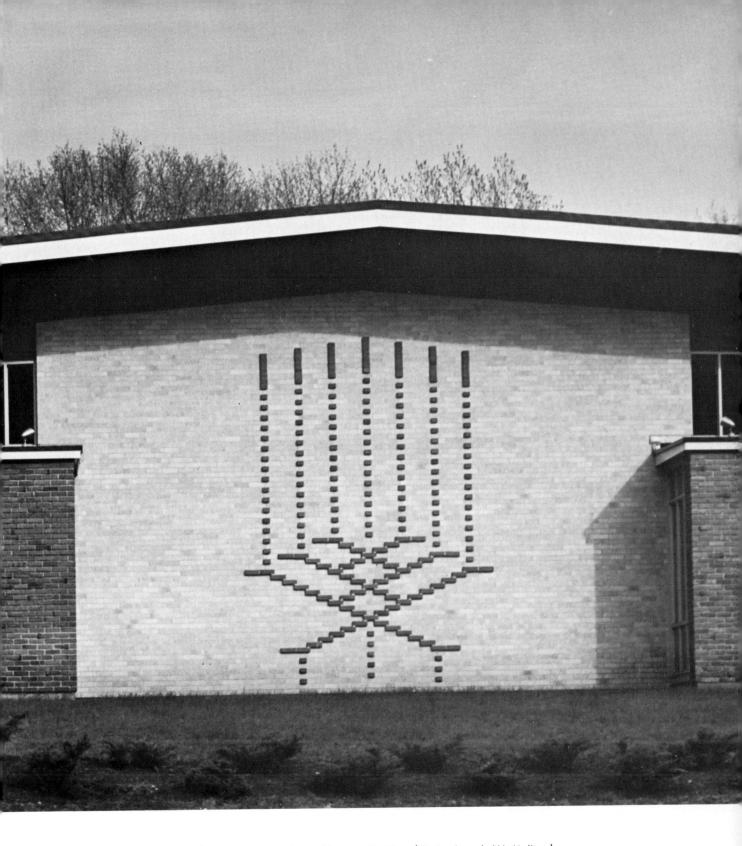

Menorah, inlaid brick, h. 12'. Temple Reyim. Artist, Norman Fletcher. (Photo: Joseph W. Molitor.)

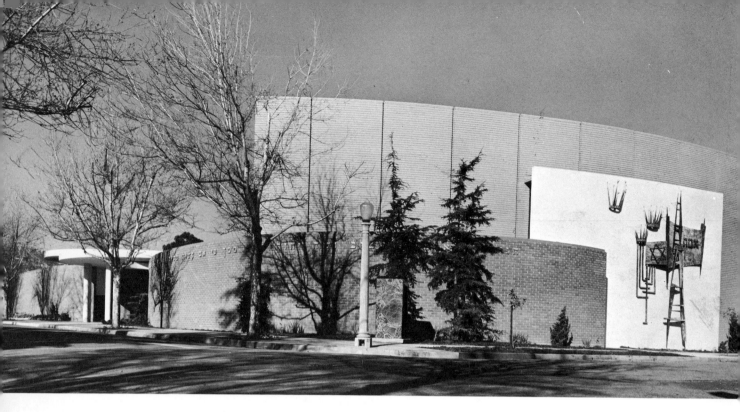

Temple Emanuel, Beverly Hills, California, 1955. Architect, Sidney Eisenshtat.

TEMPLE EMANUEL, BEVERLY HILLS, CALIFORNIA

Against the white curved wall of Temple Emanuel, Beverly Hills, California, Bernard Rosenthal created a sculptural composition containing Jacob's ladder, the open scroll of the Torah, a Magen David and three crowns. In spite of the large wall space, the composition appears crowded. A dominant sculptural or artistic idea is missing. The work does not seem to know whether to become sculpture or to remain decoration. There are too many sharp edges everywhere, and the composition does not go beyond being a tremendous collage in copper. It fails to move us or to pronounce itself significantly. As it is mounted against the rear wall of the temple, the sixteen-foot-high sculpture is lost to most visitors.

The word *Emet* (Truth), which is also included, is lost against the background of the open scroll. One has the impression that too many religious symbols have been thrown together at random as if they did not represent sacred objects. It is doubtful if the jumbling together of these symbols in such a composition can affect the viewer other than in that uncertain pleasure of mere recognition. It surely cannot evoke any genuine religious sentiment.

We can assume that these are the elements the artist was given to work with: a number of symbols, a number of shapes. He arranged them in what he considered a pleasing order; but he did not produce a work of art. Nor did he penetrate into the meaning of the symbols; he merely treated them as objects. Their assembly appears to make sense neither logically nor psychologically. Perhaps if the artist had been given less "freedom" and more direction he might have created a significant work of art. His craftsmanship is excellent.

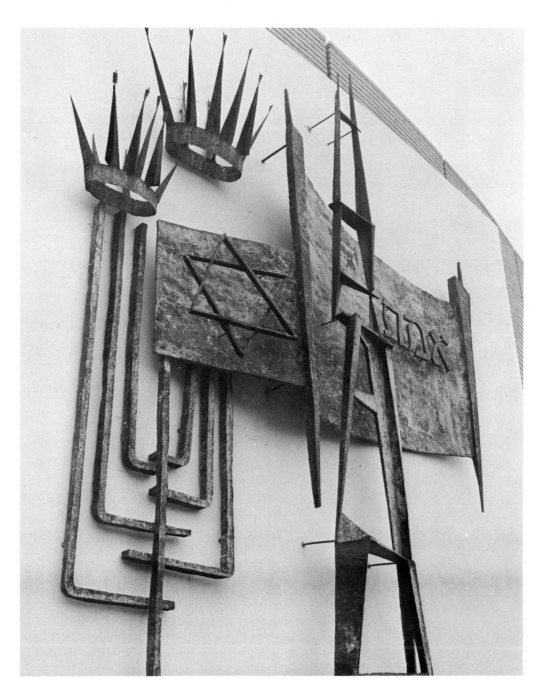

Detail of façade, bronze, h. 25', 1956. Temple Emanuel. Artist, Bernard Rosenthal. (Photo by Javno.)

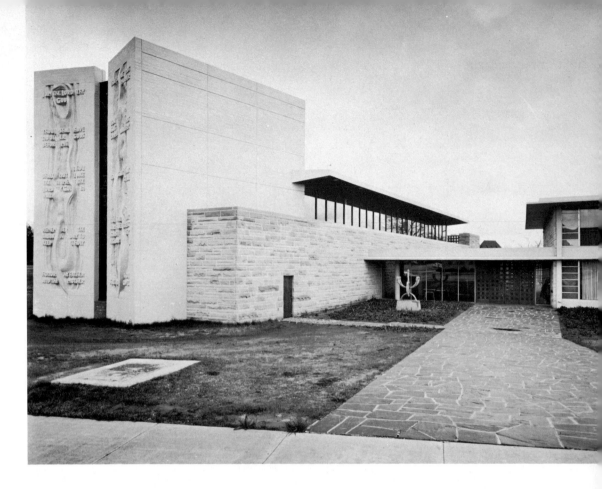

Temple Israel, Tulsa, Oklahoma, 1955. Architect, Percival Goodman. (Photo: Alexandre Georges.)

TEMPLE ISRAEL, TULSA, OKLAHOMA

Another attempt to impart distinction to the exterior of a synagogue is seen in Tulsa. Two concrete panels, about forty feet high, designed by Bernard Frazier and bearing a representation of the Pillar of Fire and the Pillar of Cloud, which guided Israel through the desert,cover the entire front of the building. The text of the ten commandments is superimposed on, and partially arrests, the sweeping vertical movements of the concrete masses which are ploughed, furrowed and creviced by the rising flames and smoke. The sculptured walls, which are higher than the rest of the building, locate and give external expression to the ark wall of the interior. The two panels are open like the pages of a book, standing at a slight angle to one another. Between them is a slender pattern of redwood and blue glass which forms a continuous vertical design of Stars of David. The towering panels dominate the horizontal masses of the building. The whole front identifies the building as the House of the Torah and a house of learning. The rough concrete wall is in marked contrast to the smooth limestone side walls and to the adjacent school wing with its generous stretch of glass.

One enters the vestibule from the receding wing, which is adjacent to the sculptured tower on the right. The area between the street, the side of the tower, and the path leading to the vestibule has been turned into a small garden in which the architect has created a setting for an eight foot *menorah* sculpture standing on a concrete base. The *menorah* can

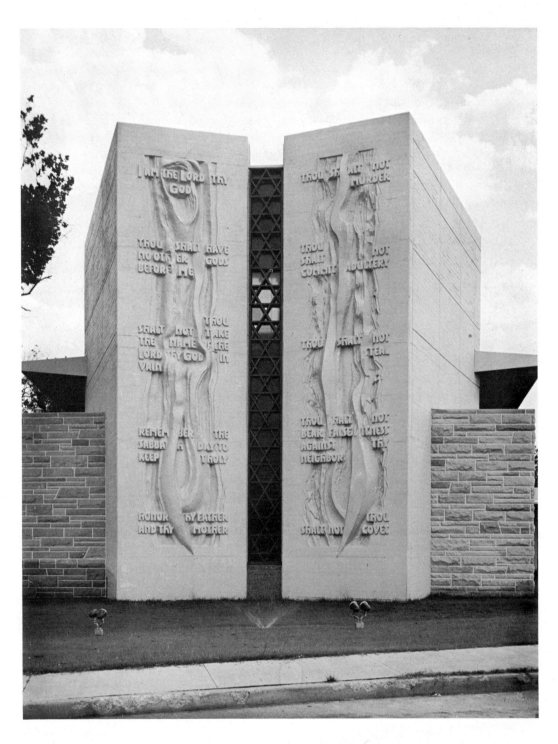

The Pillar of Fire and the Pillar of Smoke, exterior of wall sheltering the ark, concrete, h. 40'. Temple Israel. Sculptor, Bernard Frazier. (Photo: John W. Gough.)

be seen from all sides: from the main road, from the path leading into the vestibule and also through the glass walls of the vestibule itself. It is this setting which led Calvin Albert, the sculptor, to conceive of the *menorah* in depth, not in its customary two-dimensional horizontal and vertical form, so that by the increased volume and striking imagery it creates and surrounds itself with a significant ambiance.

As one walks past the sculpture, its structure changes continuously. The six arms which emanate from a central core spread and curve behind one another. The central seventh arm, which has been heightened considerably, springs from a circular motif which envelops the stem and forms a wheel standing at right angles to the arms and base of the *menorah*. This projects the candelabrum's structure both to the front and rear, and accelerates the rhythm of its curved movements. Thus conceived, it appears as if the *menorah* has the mobility of an ancient chariot and the strength of a powerful link in a chain.

Compositionally, the work mirrors the influence of Jacques Lipchitz's "Man" in the Museum of Modern Art in New York City. Two other works of Lipchitz, "Mother and Child" (also in the Museum of Modern Art) and the "Miracle" (see p. 139) have also had some impact on the artist's conception. From "Man" he absorbed the chain-like motif, while the raised arms of "Mother and Child" and the "Miracle" have left their traces in the curved linear branches of the *menorah*. Anthropomorphic elements can be noted. Wide spread legs, a torso, raised arms and a towering head can all be discerned. By a subconscious synthesis of the forms of another artist, and the use of a new type of material and technique, Calvin Albert has created an original and expressive work.

Technical principles similar to those we have noted in the *menorah* motif in Gary (p. 112) and the sculptures in Millburn and Springfield (pp. 77, 89) can also be found here.

The artist uses a process which he has invented and perfected. The sculpture has a rough finish which reveals some of the technical processes which went into its making. We can see through the material and observe its inner structure as though it were a skeleton. We can discover the armature, the thick stainless steel bars which are its core; the wide copper bands bent over the steel which give it volume; and finally the rough outer skin of the molten lead alloy which drapes itself across the central uneven armature and gives the sculpture its scorched, ragged appearance. The ragged and torn surface looks as if the *menorah* had escaped from a conflagration or from a raging battle with the help of the wheel. The lead cloaks the *menorah* with a silent sheen of metallic gray.

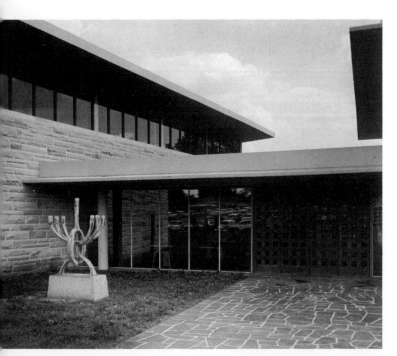

(Left) *Entrance to the temple*, with menorah, sculpture, pewter alloy, h. 8'. Temple Israel. Sculptor, Calvin Albert. (Photo: John W. Gough.)

(Right) *Model* for menorah sculpture, pewter alloy, h. 12". Temple Israel. Sculptor, Calvin Albert. (Photo: Lee Boltin.)

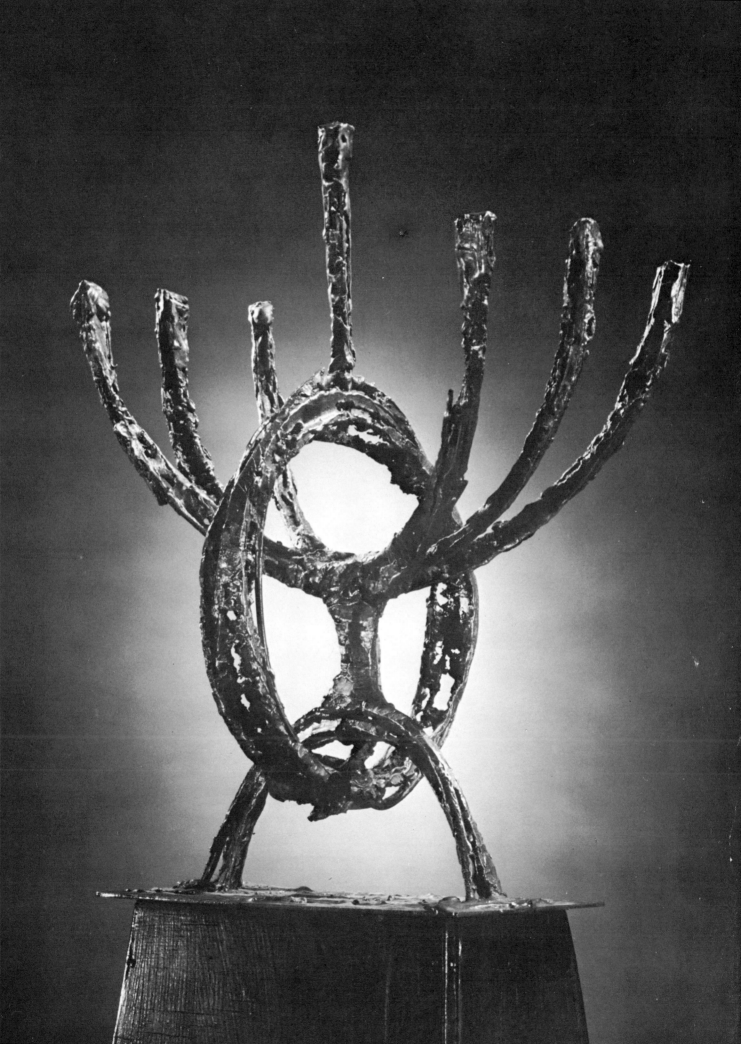

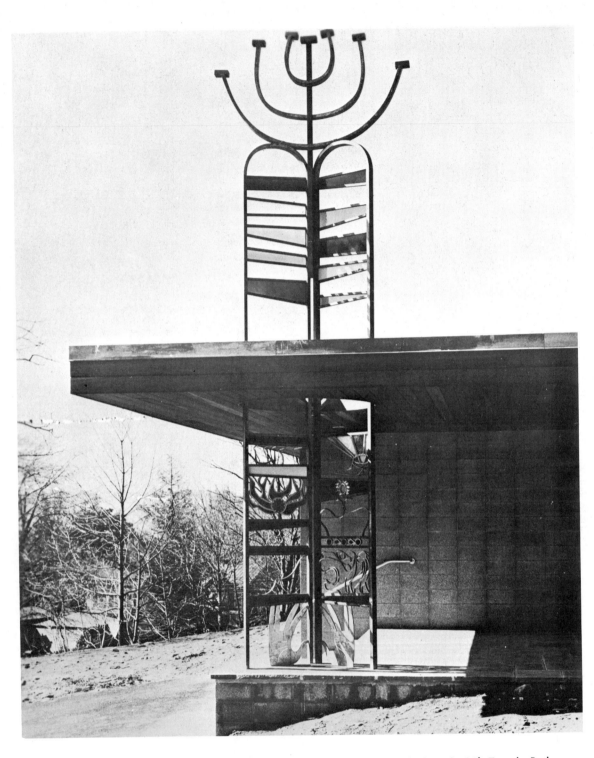

Ladder, Tablets of Law and Menorah, extruded bronze, steel, stained glass, h. 26'. Temple Beth Abraham, Tarrytown, New York, 1955. Architect, Robert Green. Artist, Sidney Simon.

TEMPLE BETH ABRAHAM, TARRYTOWN, NEW YORK

The wood-and-brick structure of Temple Beth Abraham in Tarrytown, New York, is situated on a hill overlooking the Hudson River. It is heightened and identified by a tall sculpture, created by Sidney Simon, which reaches far above its roof line into the sky and can be seen from a great distance.

Constructed out of extruded bronze, with set-in steel bars to carry the weight of the roof, the sculpture functions as a pylon. Where it pierces the large overhanging roof through a circular opening, a steel ring has been bolted to the main structural roof timbers and is reinforced by two horizontal interlocking triangles which form the Star of David. These triangles are welded to the five-foot ring and counteract the twist of the overhanging roof.

Aside from the structural problem created by the circular roof opening, the sculpture enhances the building immensely and offers a fresh, pleasing and unique sight. The idea for the sculpture was initially derived from the two columns, Boaz and Jachin, which stood before Solomon's Temple. But in the creative process of design the steel columns have turned into two ladders, recalling the ladder of Jacob, one end of which stood on the ground while the other reached toward heaven. These ladders, as they pierce the roof and continue upward, terminate in the curves of the Tablets of the Law. The tablets, in turn, are topped by a series of opposing curves forming the familiar *menorah*. There is the theme of the columns which turn into a pair of ladders, and again into the Tablets of the Law, and carry the *menorah* aloft. The shapes are familiar, but their combination, transformation, and rearrangement are unexpected and surprising. The two ladders have

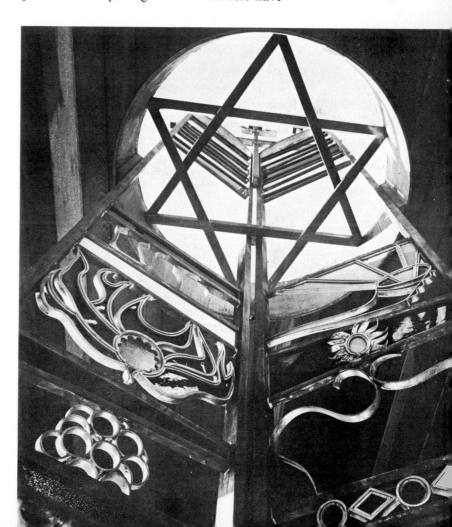

Detail of sculpture, view from below. Temple Beth Abraham.

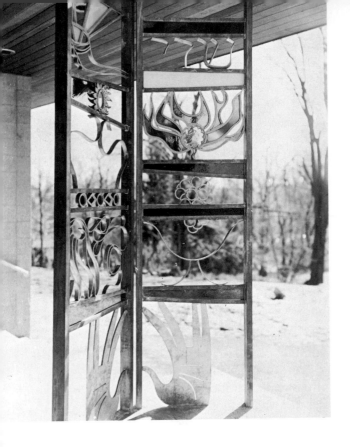

Detail of sculpture, Temple Beth Abraham. Artist, Sidney Simon.
(Photo: Paul Cordis.)

rungs of various widths set at uneven intervals, sometimes at an angle. The rungs consist of double bronze bars with colored glass placed in between. The lower sections of the ladders contain expressively-shaped symbols of Jewish tradition. At the bottom, two hands indicate the priestly benediction and create, with the thumbs and forefingers, the shape of a heart. On the right is the roaring lion of Judah, wearing a crown into which five blue and red elements are set, symbolic of the five books of Moses.

The space between the rungs on the right contains the Kiddush cup, a bunch of grapes, the burning bush and, the word *Shaddai* in Hebrew.

High above the roof, the two tablets of the Ten Commandments are seen, with their lines of script indicated only by bands of colored glass. Used in a very unorthodox way, the stained glass is exposed to light on both sides, surrounded by light, and not framed by lead. In order to avoid mirror effects reflecting the light of the sky, antique glasses, uneven in thickness and capable of capturing and holding the light rather than merely transmitting it, were chosen with great care for the intensity of their hue. The colors of the commandments themselves were selected on the basis of the psychological meaning they had for the artist, the interplay of tints, and their relation to the stained-glass sections in the lower part of the ladder.

Playful yet thoughtful, slender yet strong, the structure of metal, stained glass and space is surprisingly effective. It possesses a freshness, light grace and firm presence. The colored stained glass between the uneven sloping double rungs which climb through the roof towards heaven gives it a lyrical breadth. Prayer has traditionally been likened to Jacob's ladder. The sculpture has space around it to breathe freely and to act upon a landscape which it can dominate without effort, and the clear wide curve of the sky into which it can reach.

Artwork
in the
Vestibule

THE esthetic function of the vestibule is to assist the worshipper in his transition from the distractions of the mundane to a more serious and concentrated mood appropriate for the prayer hall. In the vestibule, members of the congregation gather in conversation before and after the services. Artists have been called upon to provide this area with mosaics, murals and sculpture stimulated by the lives and times of the congregation. In addition, the architect has often made provisions for an exhibition area available periodically to artwork, holiday displays, and religious school projects.

TEMPLE EMANUEL, BEVERLY HILLS, CALIFORNIA

The mosaic mural by Joseph Young in the vestibule of Temple Emanuel in Beverly Hills, California is set into a space planned for it in advance by the architect. Prayer, study and assembly, the three central functions of the synagogue, form its theme. The mosaic communicates a serious mood. The accent is on communality, with its emphasis on prayer and study, and on the continuity and sanctity of life represented by the family, the group, the Torah, the fruit and wine of life. The dominant vertical bands in the composition lend an unfeigned dignity and a certain tension to the subject. Colors are somber, with only occasional flashes of bright light. Any distortions in the figures are moderate, serving primarily to simplify the basic design.

The people represented are mature members of the congregation at the height of their mental and physical strength, yet clearly aware of life's limitations. They seem to be in an

attitude of inner prayer. They are conscious of the blessings they share together as well as of those they enjoy as individuals.

The artist has endowed the men and women with an austere uprightness and humble strength. They are aware of their responsibility toward one another, and to their children; they are willing to exercise it, and to transmit the values they live by to the young. Gestures are held to a minimum, but those shown are essential to the interpretation of the mosaic. In the lower left a child reaches toward the book. Both action and book are symbolic of continuity, freedom, and knowledge. The central figure holds an infant in his arms. The composition of the entire group is proud and heroic. One can assume that early Christian imagery has been influential in the vertical accent of the figures as well as in the infant who is reminiscent of the Christ child. But the symbolic meaning of the group and of the child has changed. The group is firmly rooted in the tasks of this world, while the child, held by his father, represents the succeeding generation, implying continuity and the survival of the religious community. Together with the other three children—the child on the left holding the book, the younger one reaching toward it, and the child on the right carrying a branch—the congregation faces its own future.

The composition possesses a firm structure with a rich rhythmic pattern woven throughout. Areas of dark and light are interestingly juxtaposed. The placement of the mosaic tiles reflects a sound understanding of the medium. Dark blues and yellows predominate, alternating with some highlights of gold sprinkled on the prayer shawl, the branch in the hand of the child, the Torah and the fruit. There is also a sprinkling of gold within the yellow vertical bands.

The facial expressions, where they are detailed, bespeak maturity, experience, and a knowledge of the real world and the place of value therein. The figures are marked by a seriousness, a consciousness of duty, a capacity for action and an inwardness which is, however, not melancholic.

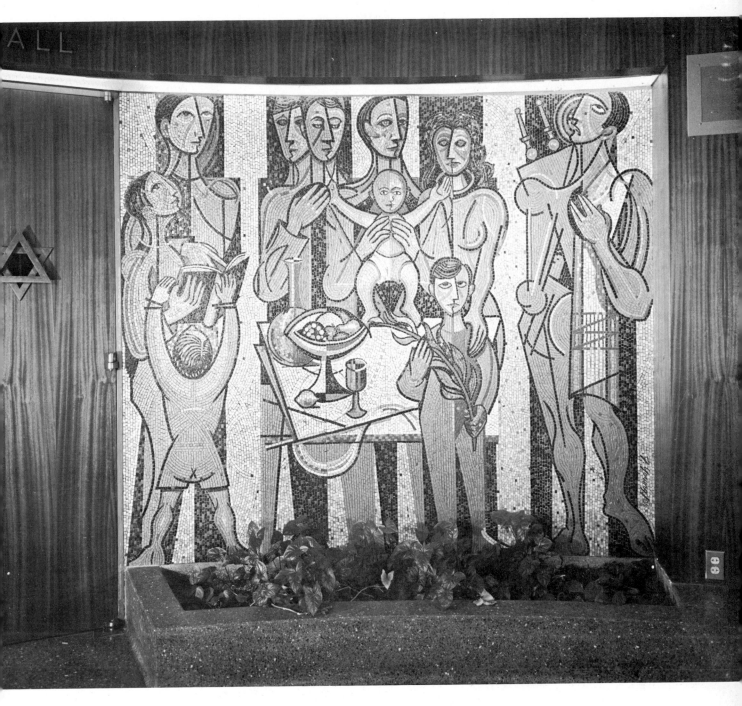

Prayer, Study and Assembly, mosaic, 9′ x 8′, 1955. Temple Emanuel. Architect, Sidney Eisenshtat.
(Photo: Julius Schulman.)

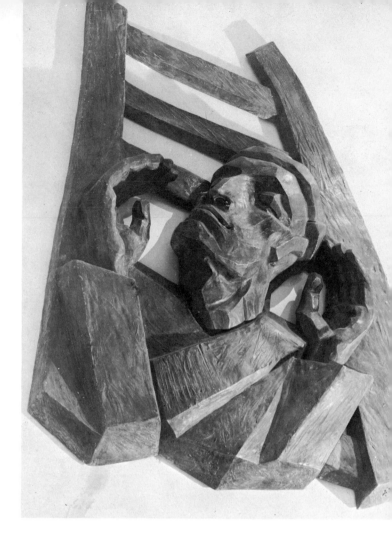

Jacob's Dream, cast bronze relief, h. 5′. Jewish Community Center, Teaneck, New Jersey, 1955. Architect, Max Simon. Artist, Erna Weil. (Photo: Adolph Studly.)

JEWISH COMMUNITY CENTER, TEANECK, NEW JERSEY

For the entrance to its prayer hall, the Jewish Community Center in Teaneck, New Jersey, commissioned Erna Weil to create a bronze relief.

On the wall above the doors which lead into the prayer hall, the artist mounted the 4′ x 5′ sculpture, "Jacob's Dream." The patriarch's head is thrown back and his arms are uplifted as he leans against the ladder, the subject of his dreams. His eyes are closed, his facial expression one of reverence. The ladder he leans against seems to be tied to his back, a heavy burden, not an ethereal structure spun out of dreams and made for a light angelic step. It is a yoke which he carries with submission and yet with willingness, in much the same way that pious Jews have carried the 613 *mitzvot*. The yoke of the Torah thus becomes the ladder of ascent to heaven.

The figure of Jacob, in spite of the sharp angular modeling, is not that of the patriarchal Jacob who herded Laban's flock. Instead, he resembles the emaciated, hollow-cheeked Talmud students of the Yeshivot of prewar eastern Europe who devoted their lives to the study of Torah, and conceived of learning as steps upon a ladder which led to knowledge of the Lord.

HILLCREST JEWISH CENTER, QUEENS, NEW YORK

Jacob's dream is also the subject of a mural in the vestibule of the Hillcrest Jewish Center in New York City. Anton Refregier, who created the tile murals on the outside of the building (see p. 108), was commissioned to do the painting for a 6' x 16' shallow recess which the architect had prepared in the curved wall.

The painting is kept flat. The forms are drawn in a simplified and realistic style, their starkness softened by fine rhythmic lines and scattered accents of detail. A cool harmony of blues and greens with muted yellow and red-browns as of desert rock predominates; a subtle play of light lends the mural a soft glow and dreamlike quality. Here the artist has given Jacob a noble, weathered face that reflects a melancholic and tired expression. Wrapped and hooded in a yellow mantle, Jacob lies against a pile of rocks, his arm thrown behind his head to cushion it against the stones. Near him is a body of water and at his feet burns a fire. In the distance rises a slim, silvery ladder, spun by the threads of his dream. It narrows as it disappears among the distant clouds which move through the star-studded desert sky. There are no angels ascending or descending the ladder. Instead, the stars have spread out "to the West and to the East, and to the North and to the South." They are interconnected in a delicate web of lines, and in each star a symbol of the twelve tribes is drawn.

The artist's reason for introducing the water and the fire is not quite clear. Fire, water, earth and air may refer to the elements of the world. The fire could also symbolically represent the Lord, Who appeared in Jacob's dream. The water may allude to a Midrash, taken from the story of Jacob, which the rabbi perhaps brought to the artist's attention, although the Midrash refers less to Jacob's dream than to his subsequent wandering. "Then Jacob went on his journey and came to the land of the children of the East. And he looked and beheld a well in the field" (Gen. 29: 1, 2). The Midrash (Gen. Rabbah 10:8) explains, "And he looked and beheld a well in the field. This (well) alludes to the synagogue."

Jacob's Dream, mural, 6' x 16'. Hillcrest Jewish Center, 1950. Architects, Glaberson and Klein. Artist, Anton Refregier. (Photo: Jonah B. Esakoff.)

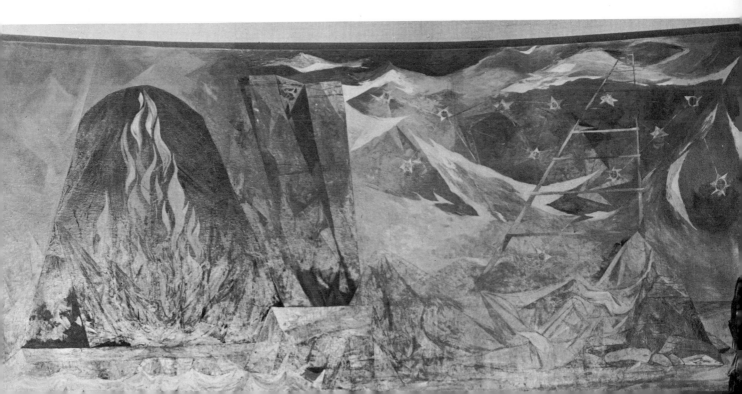

Jacob's Dream, detail. Hillcrest Jewish Center. (Photo: Jonah B. Esakoff.)

For the most part, the mural depends on the text of the Bible. Another observer has already pointed out that this is not an especially stirring work of art, but it is intelligently and skillfully executed.[1] It commands attention and achieves a symbolic expression which brightens the general tone of the vestibule.

BALTIMORE HEBREW CONGREGATION, BALTIMORE, MARYLAND

One of the first mural paintings in the postwar period to decorate an American synagogue vestibule was executed by William Halsey for the Baltimore Hebrew Congregation. It is painted beside and over the doors which lead into the prayer hall. The mural is divided into three parts. Each part exists independently of the other, and yet all three are tied together into one composition by a strong linear design and a complementary relationship.

On the left Halsey represents Moses at the burning bush. To the right of the doors he represents the fulfillment of Messianic hopes. Above, over both sides of the doors, the stream of the Jewish people delivered from bondage in Egypt. To the left is the confrontation of God and man—the birth of Judaism's covenant; to the right is the life of peace, work, harvest and harmony between men—the fulfillment of the covenant.

The mural analyzes carefully the beginning of Chapter 3 of Exodus:

> Now Moses was keeping the flock of Jethro his father-in-law, the priest of Midian; and he led the flock to the farthest end of the wilderness, and came to the mountain of God, unto Horeb. And the angel of the Lord appeared unto him in a flame of fire out of the midst of a bush; and he looked, and, behold, the bush burned with fire, and the bush was not consumed. And Moses said: "I will turn aside now, and see this great sight, why the bush is not burnt." And when the Lord saw that he turned aside to see, God called unto him out of the midst of the bush, and said: "Moses, Moses." And he said: "Here am I."And He said: "Draw not nigh hither; put off thy shoes from off thy feet, for the place whereon thou standest is holy ground." Moreover He said: "I am the God of thy father,

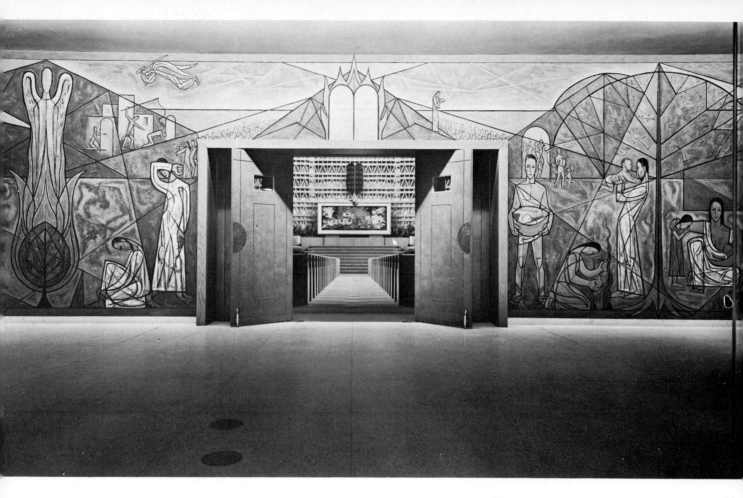

The Burning Bush and the Promise of Peace, mural, 9½' x 60', 1951. Vestibule, Baltimore Hebrew Congregation, Baltimore, Maryland. Architect, Percival Goodman. Artist, William Halsey.

the God of Abraham, the God of Isaac, and the God of Jacob." And Moses hid his face; for he was afraid to look upon God.

The four events described in this passage—the wandering of Moses with the sheep, the burning bush, the angel of God rising from within the flames, and the retreat of Moses—are represented in the mural by four separate but similar figures, each one depicting Moses in a different action. These actions, occurring in sequence and in different places, have been brought together into one composition of figures moving slowly and self-consciously. It is as if a scene of vivid action were shown in slow motion for close study. The knowledge of the biblical drama is presupposed; the separation of its elements is used to deepen their meaning.

In the same section, on the upper right, is a smaller scene of the bondage in Egypt also, a representation of the angel of death about to smite the oppressors. These themes continue to interpret the biblical passage quoted above:

And the Lord said: "I have surely seen the affliction of My people that are in Egypt and have heard their cry by reason of their taskmasters; for I know their pains; and I am come down to deliver them out of the hand of the Egyptians, and to bring them up out of that land unto a good land and large, unto a land flowing with milk and honey."

ARTWORK IN THE VESTIBULE · 131 ·

The right hand section of the mural deals with the Messianic promise of peace. Again the composition seems directly inspired by biblical quotations:

> And they shall build houses and inhabit them; And they shall plant vineyards, and eat the fruit of them. They shall not build and another inhabit, They shall not plant and another eat; For as the days of a tree shall be the days of My people, And Mine elect shall long enjoy the work of their hands. They shall not labour in vain, Nor bring forth for terror; For they are the seed blessed of the Lord, And their offspring with them (Isa. 65:21-23).

> For thus saith the Lord: Behold, I will extend peace to her like a river, And the wealth of the nations like an overflowing stream, And ye shall suck thereof; Ye shall be borne upon the side, And shall be dandled upon the knees. As one whom his mother comforteth, So will I comfort you (Isa. 66:12).

As a point of departure for the composition, Halsey uses certain images from the prophet's word. Again he deals with the representation of generalized attitudes rather than with individualized figures or scenes. The movements of the simplified figures are carefully posed and woven into the flat geometric design. The whole mural presents a colorful blue and green pattern with red and yellow accents. On either side of the door the grouping of the figures is similar. On the left the burning bush creates a vertical axis dividing the composition in half; on the right the design is divided by the tree of life. An upright figure stands on each side of the door.

The composition is united by a web of lines which tie the different planes and figures together, though in a somewhat forced manner. The lines converge on the Tablets of the Law, which are placed above the doors, before the symbolic Mount Sinai. While it may be customary in contemporary art to lay bare the design, the elaborate linear arrangement spreading all over the wall seems contrived and disturbing. The lines move with relentless predictability and the precision of a mechanical process. They become a major decorative element, criss-crossing the entire mural as well as creating rhythmic patterns within the figures, the tree, and the burning bush. Their uniform thickness and stark geometry are designed to reinforce the highly abstract symbolic level of the scenes and to counteract some of the gestures and realistic qualities of the subjects. Design and representation struggle for harmony but seldom achieve it convincingly. Rarely do we feel the personality and temperament of the artist, who seems to be guided almost exclusively by a literary document which he followed pedantically. If we find genuine lyricism in the figure of the woman picking the grapes—a section somewhat free from the all-pervasive linear pattern—it is immediately counteracted by figures like the basket-carrier to her left, who seems to be lifted out of an artist's anatomy book.

Yet one is still struck by the serene and austere quality of the work, and by its underlying thoughtfulness. Such passages as the large green leaf within the burning bush point to possibilities which have been sensed but never realized. It must be said that the planners of the mural, who had ambitions "to prove the value of religion especially to young people..." overreached themselves in trying to produce a didactic mural with a modern flavor.

(Right) *The Promise of Peace,* detail.
(Above) *Moses before the Burning
Bush,* detail. Baltimore Hebrew Con-
gregation.

TEMPLE OHEB SHALOM, NASHVILLE, TENNESSEE

For their new building the art committee of Temple Oheb Shalom in Nashville, Tennessee, has established a long range plan for the commissioning and acquisition of works of art for the vestibule, the prayer hall, the social hall, the hallways, the grounds, and for a small museum of ritual objects. As one enters the building one's attention is captured by the vestibule wall adjacent to the entrance into the prayer hall. This wall was entrusted to Ben Shahn who subsequently designed for it a mosaic, 8' x 14' in size.

Shahn is known in contemporary American art for the murals he executed for the Works Progress Administration and the former Congress of Industrial Organizations, along with his mosaics on public buildings. His work also includes illustrations of the Haggadah and a creative use of Hebrew calligraphy.[2] The art committee felt that he is committed to meaningful content and that his statements are forthright, provocative and filled with a sense of social responsibility. They also were aware of the highly original way in which his work has dealt with Jewish themes.

As a theme for his composition Shahn chose, from the various suggestions made by the rabbi, the quotation from Malachi (2: 10): "Have we not one father? Hath not one God created us? Why do we deal treacherously every man against his brother, to profane the covenant of our fathers?" The quotation, designed in Hebrew calligraphy and set in gold mosaic, runs across the entire length of the upper part of the mural. It is natural that these lines would appeal to an artist who emerged as a leading figure out of the stormy days of the depression.

Dominating Shahn's mural is a blue hand that emerges from a red flame. The flame symbolizes the presence of the Lord while the hand refers to His creative power and His intervention in the affairs of man. On the right of the mural we see the image of a man blowing a large *shofar* which spans the entire composition up to a large *menorah* that dominates the left side. Beneath the *shofar*, as if under a canopy, are five heads representing the different races of man.

The figure sounding the *shofar* is wrapped in what seems to be the traditional *talit* or prayer shawl. He is spiritualized by a severe distortion of the features and has a haunting ghost-like quality due to the ashy gray overtones of his skin and his enormous square pupiled eyes, staring at the beholder. The tension lines that surround these eyes are echoed in the many lines of the prayer shawl which envelop his head, and in the detached tense ceremonial position of the fingers that barely grasp the *shofar*.

The intricate black and white pattern within the *shofar* contrasts with the exaggerated extension of its own silhouette which draws the viewer across the mural toward the *menorah*. The tremendous *menorah* is in full bloom and richly adorned with gold. It rises from a base that is at once both a metallic stand and an earthen hill. The men beneath the *shofar* are differentiated in race, and contrast in their mundane individuality with the other worldly character of the figure that blows the *shofar*.

The men seem to be waiting for the great blast of the ram's horn. Waiting as one of the conditions of human existence is a theme that Shahn has frequently depicted and a con-

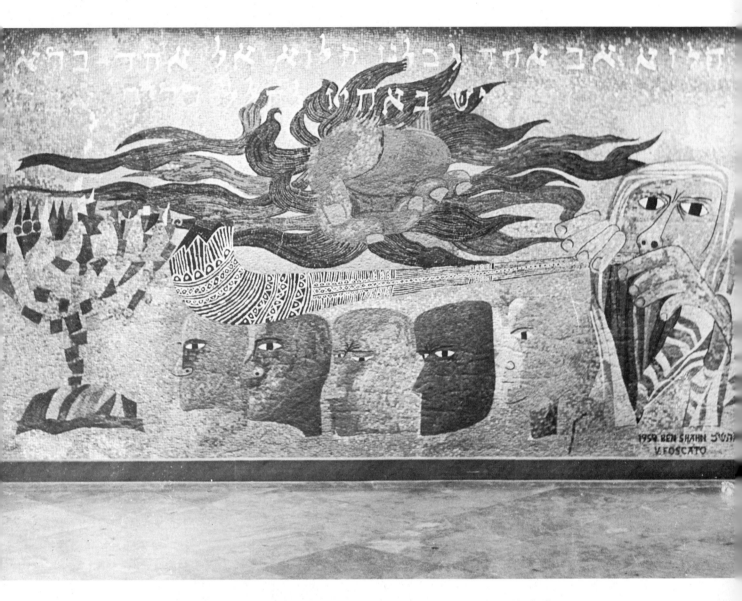

The Call of the Shofar, mosaic mural, 8' x 14', 1959. Vestibule, Temple Oheb Shalom, Nashville, Tennessee. Artist, Ben Shahn. (Photo: Bill Preston.) The inscription (Malachi 2:10) reads:

"Have we not all one father? Hath not one God created us? Why do we deal treacherously every man against his brother, to profane the covenant of our father?"

dition that has consciously been accepted by generations of Jews who elaborated it into a major cultural theme in their history.

The powerful hand which emerges from the red flames of the *Shekhinah* pleads, demands, even threatens. It is at once a hand of compassion that "uplifts those who fall," and a warning raised against those who deal treacherously with their brothers. The *shofar* and the Jew who sounds it are the instruments by which the will of the Lord is made known to man. It is an instrument of awakening; it indicates the presence of the word of the Lord in the midst of the congregation.

In a sensitive and forceful statement, Shahn has synthesized images born from the struggle of the working class with ideas and iconography of religious motives, pointing to their common ground in the words of Malachi. The image of a disembodied hand has precedents in synagogue art. It appears in the scenes at Dura Europos and at Beth Alpha where Abraham is restrained from making his sacrifice by the intervening hand of the angel of the Lord. Shahn has taken the form of the hand, a worker's hand, from the art vocabulary of twentieth-century social realism, the same source from which he borrowed the theme of different races dwelling together in peace. (The images employed in the mural appear also in Shahn's paintings.) These images are combined at Temple Oheb Shalom with symbols of the Hebraic tradition and made to elicit new feeling, impact, and meaning. The equality of man before God, man's hope for redemption, and the active nature of Hebraic tradition are articulated in the figures and objects contained in the mural, as well as in the mood that pervades it.

The mosaic reminds the worshipper who enters the vestibule of significant aspects of faith, and makes a statement strongly relevant to racial equality which this southern congregation had long ago courageously endorsed. Contrary to the technique most often used in making mosaics today, the artist has broken the flat surface, inlaying the tiles at varying depths and angles to intensify and multiply the refraction of light. In the part depicting the red flame, the mortar holding the tesserae in place is utilized as an important decorative element. The artist has inserted the tiles so as to achieve broad, unbroken bands of mortar which firmly articulate the sweeping rhythm of the flames.

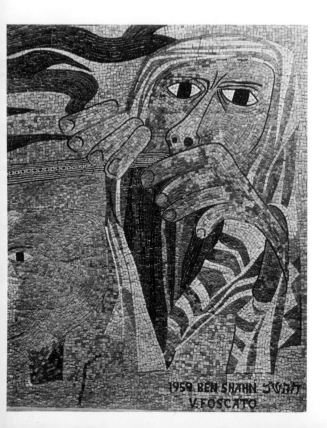

The Call of the Shofar, detail. (Photo: Bill Preston.)

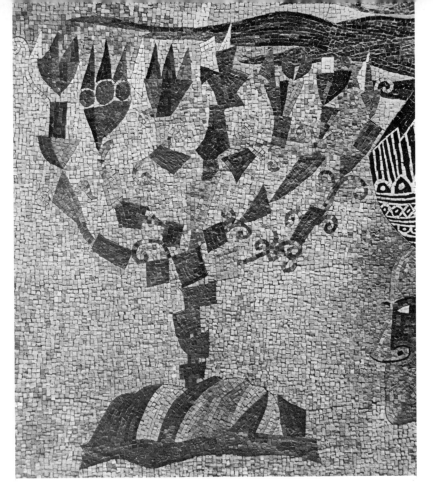

The Call of the Shofar, details. (Above)
Menorah; (Below) center section. (Photo:
Bill Preston.)

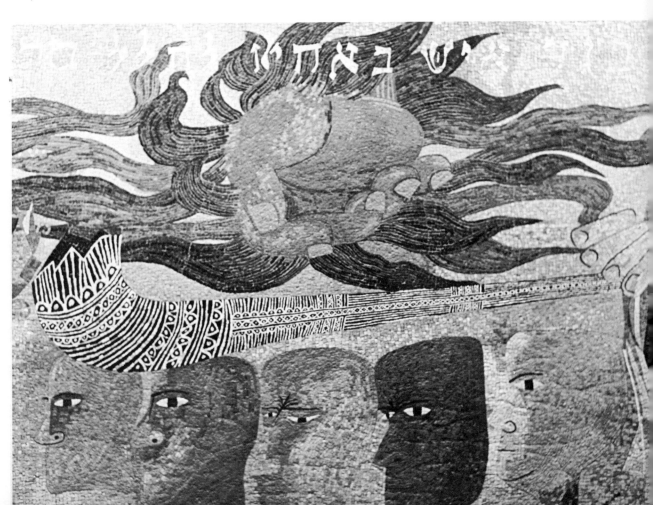

Another significant work in the Oheb Shalom vestibule is the bronze sculpture, "Miracle," created by Jacques Lipchitz. It was acquired from the artist by means of a special fund which the synagogue had established for its long range art program.

"Miracle" is but one of many sculptures of Jewish motifs this artist has created. It is a work which speaks to the senses, the mind, and the heart. Built upon the theme of the *menorah*, it evokes with forcefulness and poetic sweep the *menorah's* origin in the cosmic tree, its transformation by Judaism, and the miracle of Israel's struggle for freedom. The miracle is equated with the ability of the ancient tree to continue bringing forth blossoms. The *menorah* has returned to its original source, a spreading tree, whose trunk has been opened to reveal the book of the Law. A man kneels before it simultaneously imploring, supporting, and protecting it. This triple role is brought out by the merging of the man's legs with the roots of the tree. Man, Torah, tree and *menorah* are one and all derive sustenance from each other. The miracle does not occur by itself; it is man who produces it by his mighty effort. It is relevant that the sculpture is dated 1948, the year the State of Israel was established.

"Miracle" also offers a striking analogy to the man in armor carrying the *menorah* on his head in the catacomb of Beth Shearim, Israel (see ill. below). It is a companion piece to an earlier Lipchitz work, "Exodus," also based on the motif of the *menorah*. (There the shaft of the *menorah* is turned into the mast of a weary ship, its arms into the sails to which men cling in desperation.)

The associations evoked by "Miracle" stem from its form and its organic sculptural unity. The arms of the *menorah* rise in V-like shape to both sides of the Tablets of the Law. The branches are deeply cut, and the buds repeat their shape, as do the arms of the man, his hands and the sharp folds in his garment. The shape of the V is further repeated in horizontal form in the Tablets of the Law which recede and meet at an angle. It is inverted in the man's spread-out feet and in the larger folds of his garment as they fall from his shoulders to his sides. The texture of the whole is rough, leaving a strong imprint of the artist's modeling.

"Miracle" is one of the most impressive works to be found in a contemporary synagogue. Unlike the mosaic, the sculpture was not commissioned and was not acquired with any reference to the architecture of the vestibule or any other specific space. It was brought to the synagogue because its relevance to the synagogue was recognized. The vestibule thus became the shell which houses it.

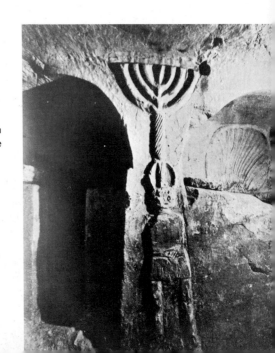

Man in armor carrying menorah on his head, carved in stone. Catacomb Beth Shearim, Israel, second cent. C.E. (The Jewish Museum, New York. Frank J. Darmstaedter.)

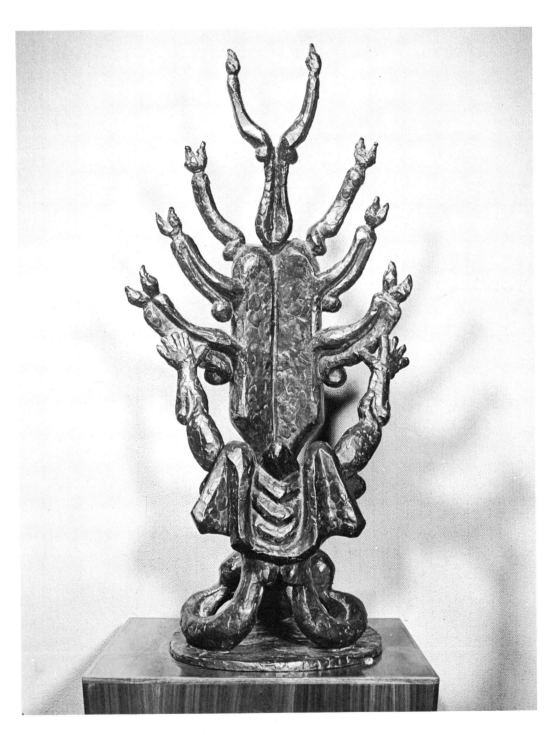

"*The Miracle*," cast bronze, h. 30½", 1948. Vestibule, Oheb Shalom Synagogue, Nashville, Tennessee. Artist, Jacques Lipchitz. (Photo: Jimmy Holt.)

Artwork
in the
Prayer Hall

Part I

THE Torah scroll contains the five books of Moses, or the Pentateuch, which are, according to Jewish tradition, the words of God as revealed to Moses. It is written by hand upon parchment, following exact rules. It is the most sacred ritual object within the synagogue. The Torah is kept within a chest called Holy Chest (ארון קדש) or Holy Ark. The ark is derived from the biblical ark, the movable, gold-faced chest built of acacia wood by Bezalel, and contains the Tablets of the Decalogue (Exod. 37:1-9). Because the congregation faces the ark during prayer, the latter assumes a commanding position. It is usually built against or into the wall which faces Jerusalem, though quite many Reform congregations have ignored this tradition.

On the *bimah* stands a desk upon which the Torah scroll is unrolled, read, and interpreted. Because the readings from the Torah and from the Prophets, together with the interpretation of these readings, are an essential part of the service, an elevated platform for the desk has been a basic requirement of the synagogue from its inception. This platform is called the *bimah*. It expresses most deeply the rational elements of Judaism. Naturally, it also assumes a commanding position.

The existence of two such important elements within the prayer hall, the ark and the *bimah*, required the early establishment of a satisfactory spatial relationship between them, and with the total space of the prayer hall. Much synagogue architecture of the past involved an attempt to find a solution for such an arrangement. The quest for dominance of one element over the other, and the quest of each for a focal position conceals, as Kraut-

Bimah, Spanish-Portuguese Synagogue, Amsterdam, 1675.

heimer has already indicated, a struggle between the magical and the rational elements within the Jewish faith.[1]

None of the ancient *bimot* have been preserved; they were made out of wood, as talmudic sources indicate. The arrangement of the *bimah* may have been taken from the model of the ancient basilica which the synagogue adopted for its use, and which had an elevation near the apse where the judge held court.[2] But the provision for a *bimah* is most natural in any situation in which instruction is involved, and therefore might go even further back into antiquity. Thus, the Bible tells of Ezra the Scribe, who read the Torah to the people gathered at the broad place before the water gate, that he "stood on a pulpit of wood, which had been made for the purpose" (Neh. 8:4). The provision for a *bimah* stems then, from the need to gather around the person who interprets the Torah. The elevated platform is not a sacred ritual object; its holiness is the holiness of the synagogue. It forms a natural physical and spiritual center for the prayer hall and is the purest expression of its function.

As long as rational elements dominated the synagogue, as they did in the ancient world, the *bimah* was its spiritual center. According to the Talmud, it stood in the middle of the great synagogue in Alexandria.[3] Illuminated Hebrew manuscripts from the Middle Ages also document the centrality of the *bimah* and its dominance over the ark. It held its separate and prominent position in the great synagogues of Spain, Germany and Poland well into the eighteenth century. In square prayer halls the center was the logical choice for the *bimah*. The ark stood at the wall which faced Jerusalem.

From a simple square platform, the *bimah* developed in time into an elaborate structure. It assumed an octagonal or circular shape. In some instances, its front or back was curved. A balustrade was added around the sides of the *bimah* and sometimes a canopy was placed over the entire structure. Steps, often as many as twelve, led up to the *bimah* from one side and down from the other. It was fashioned of stone, wood, bronze, marble and wrought iron. In Poland during the seventeenth century, it often developed into a monumental structure; it was united with the four pillars which supported the vaulted ceiling. It thus became a uniquely symbolic architectural expression of the central place of the reading of the Torah in the service, and of the faith which believed that the world existed because of the Torah. In Italy, attempts were made to resolve the tension between the placement of ark and *bimah* through the adoption of the broad room type of prayer hall (which, incidentally, was also used in Dura Europos), which made it possible to put the entrance in the center of one of the long walls. A natural division of the space into two parts was thereby achieved and the *bimah* and the ark were placed opposite each other along the short walls to assume an equal position.

We are not in possession of any of the arks of the ancient synagogues. But from pictorial representations on gilt glass found in the Jewish catacombs of Rome, from a mosaic representation on the floor of the synagogue of Beth Alpha, from a sculptured bas relief at Capernaum, and from the murals of the synagogue at Dura Europos, we have a fairly good idea of their appearance. The ark was a rectangular structure, richly ornamented with a gabled or rounded roof and a double door. It was frequently decorated with such features as guarding lions, birds, *shofar*, trees and the *menorah*.

Inside the ark there were horizontal and vertical shelves. Scrolls rolled around a rod were placed horizontally on the shelves. They were not wrapped in a mantle. The Torah ornaments we have today are not shown.

Archeological and literary evidence points to the early mobility of the synagogue ark.[4] In the oldest excavated synagogues, no architectural remains point to any structure made to house the ark. After the congregation had assembled for the service, the ark was carried into the prayer hall from one of the adjoining rooms where it was kept behind a veil. It was carried back at the end of the service, before the congregation left the prayer hall. Its mobility is also supported by the evidence we have that at a time of public mourning or fasting, it could be carried into a public square.

In time, a recess or apse to permanently accommodate the ark was constructed in the wall the congregation faced as it turned toward Jerusalem in prayer. To further emphasize its significance, the ark was flanked by two columns which evoked an association with Boaz and Jachin, the columns which stood before the Temple of Solomon. An analogy was drawn between the ark itself and the Holy of Holies of the destroyed Temple, and a curtain was hung before the apse to emphasize this relationship.

Whether free-standing or set into the wall, the architectural frame of the ark was enlarged as major historical styles affected its appearance. Thus at one time it resembled a dignified Renaissance cupboard; later it was related to elaborate Baroque altars of churches and monasteries. The ark was flanked in some instances by twisted columns similar to those Bernini designed for the altar at St. Peter's in Rome. It exhibited Moorish influences in some cases and later adapted itself to rococo forms. A flight of steps led up to the ark in order to carry out the words of the Psalmist: "Out of the depth have I called Thee, O Lord" (Ps. 130:1). Landings were added to the stairs, and the whole was surrounded by a balustrade closed with a small gate. The ark was raised to monumental scale in the wooden and stone synagogues of Poland, and adorned with intricate carvings of animal and plant motifs. The Tablets of the Law became a permanent feature of the ark. Musical instruments, signs of the priestly benediction, and crowns, were favored motifs of the carvers.

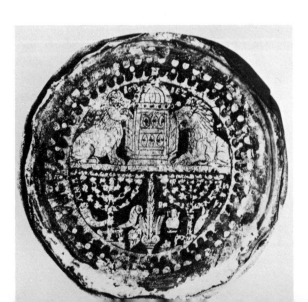

Glass with open ark and scrolls, third cent. C.E. (The Jewish Museum, New York. Frank J. Darmstaedter.)

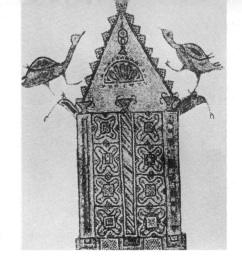

Ark from mosaic floor, Beth Alpha Synagogue, sixth cent. C.E. (The Jewish Museum, New York. Frank J. Darmstaedter.)

The ark was covered by a curtain: "And thou shalt make a curtain of blue and purple, and scarlet and fine twined linen. . . . The work of the skillful workman shall it be made . . . and thou shalt put the ark cover upon the Ark of the Testimony in the most holy place . . ." (Exod. 26:31-34). The curtain (*Parokhet*) was hung in ancient times in front of the recess or apse which contained the ark. Today, in congregations which follow the Ashkenazic rite, it is in front of the ark with a valance (*Kaporet*) which covers the traverse rod and cords. Congregations following the Sephardic rite put the curtain behind the doors of the ark. Conservative and Reform synagogues in the United States, all Ashkenazic in derivation, mix the two traditions indiscriminately. Many ark curtains have come down to us from the sixteenth, seventeenth and eighteenth centuries. They are, as a rule, made out of velvet or silk, richly embroidered with gold or silver threads and often appliquéd. The rich decorative motifs consist of quotations from *Pirke Avot* (Ethics of the Fathers), arabesques and floral designs, as well as the lions of Judah, the three crowns, the *menorah*, olive trees, columns entwined by foliage, and often the names of the donors. Then, as now, it was the custom to have one curtain throughout the year, but a different white curtain for the High Holy Days and a black curtain for the Ninth of Av, traditionally a day of mourning for the destroyed Temple. It has been customary to hang the Eternal Light in front of the ark to which reference may be found in the Bible: "Command the children of Israel, that they bring unto thee pure olive oil beaten for the light, to cause a lamp to burn continually" (Exod. 27:20). The biblical passage refers to the Tabernacle. The synagogue adopted the Eternal Light as a symbol of the Divine Presence (God appeared to Moses in the burning bush) and also interpreted it as symbolic of the permanence of the Torah and its teachings.

Eternal Lights are represented on the mosaic floor of the synagogue in Na'aran, constructed in the fifth century C.E. They have the shape of a vase and are suspended from the candelabra which flank the ark. Another vase-shaped lamp may be seen in a fourteenth-century Spanish Haggadah, now in the British Museum (*cod. or.* 2884). It is similar to the seventeenth-century Eternal Light made out of glass, from the synagogue in Damascus, now in the Jewish Museum in London (see ill., right). They were suspended on chains from the ceiling as were later Eternal Lights. Sometimes there were several hanging side by side. They consisted of clear or green glass which held the oil and were kept level by a ring-like armature. The armature, made of gold-plated silver or silver-plated copper, was richly adorned. The artist always enjoyed great freedom in determining the shape and the material of the armature. In Poland, we often find the Eternal Light recessed in a wall behind an iron grid or glass.

Eternal Light from the Synagogue of Damascus, 1694. The Jewish Museum, London. (The Jewish Museum, New York. Frank J. Darmstaedter.)

ARTWORK IN THE PRAYER HALL · 143 ·

The *menorah*, the seven-branched candelabrum, also harks back to biblical times:

> And thou shalt make a candlestick of pure gold: of beaten work shall the candle-
> stick be made, even its base, and its shaft; its cups, its knops, and its flowers,
> shall be of one piece with it. And there shall be six branches going out of the sides
> thereof: three branches of the candlestick out of the one side thereof, and three
> branches of the candlestick out of the other side thereof; three cups made like
> almond-blossoms in one branch, a knop and a flower; and three cups made like
> almond-blossoms in the other branch, a knop and a flower . . . And thou shalt
> make the lamps thereof, seven . . . (Exod. 25:31-37).

These were the instructions according to which Bezalel made the *menorah* for the
Tabernacle in the desert. According to tradition, it was permanently installed with the
other cultic elements which he produced, in the Temple of Solomon.

This *menorah* could not have survived the destruction of the First Temple by Nebu-
chadnezzar, nor the desecration of the Second by Antiochus. It is possible that the famous
menorah, depicted on the Arch of Titus as being carried off with other Temple vessels as
spoils of victory by Roman legionnaires, is an actual replica of the *menorah* Judah the
Maccabee brought into the Temple. There is general agreement however, that the base of
this *menorah* is a product of the sculptor's fancy.

How the seven-branched *menorah* came into the synagogue is still somewhat puzzling,
since the Talmud explicitly forbids the imitation of Temple vessels. It permits construc-
tion of a *menorah* of five, six or eight branches, but not of seven, and Orthodox Jews still
adhere to this prohibition.

Archeological evidence points to the fact that the seven-branched *menorah* was a
favored emblem of Jews after the second century C.E. and that it can be found very often
on graves in catacombs, on gilt glass and in mosaic, mural and sculptural decorations of
ancient synagogues. In addition, the *menorah* was actually in use in synagogues. Thus
at Hammat, near Tiberias, when a synagogue was unearthed, a *menorah* was found made
out of a single block of limestone. It had seven branches and floral decorations cut in
relief, with a hollow receptacle for a lamp in each branch.

The *menorah* as an artistic motif is probably derived from an ancient Babylonian
tradition of the tree of life, and had a prominent place in the mythology of the people
of the Near East.[5] (Goodenough reproduces interesting photographs which show the

*The menorah carried by Roman legionnaires from the
Temple of Jerusalem,* detail from the Arch of Titus, 94
C.E., Rome. (The Jewish Museum, New York. Frank J.
Darmstaedter.)

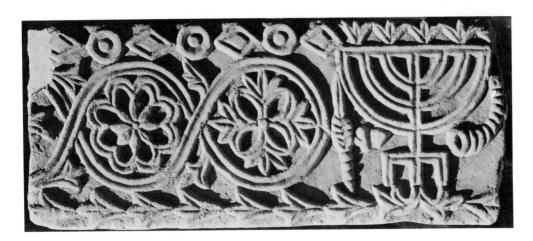

Screen from the Synagogue of Askalon with menorah, shofar and lulav, sixth cent. C.E. (Courtesy Department of Antiquities, Israel.)

similarity between the *menorah* and the Cosmic Tree of the Sumerians, and a sacred tree from Susa and Khafaje, going back to the fourth millennium B.C.E.[6])

There is some evidence, including biblical references, that the *menorah* was at times assigned various astral and mystical meanings. The prophet Zechariah sees a golden candlestick with seven lamps on top of it, which are fed oil by two olive trees. The seven lamps are identified with the eyes of the Lord "that run to and fro through the whole earth" (Zech. 4:10).

Josephus saw in the seven flames of the candelabrum the symbol of the seven planets. Mystics, who read in numbers a key to the comprehension of a superior reality, easily found significance in the number seven.[7] To Philo, the seven lamps represented the planetary system, the central lamp being the sun which gave light to the other planets. The *menorah* then became "a mystic symbol of Light and Life, of God present and manifest in the world."[8]

The motif of the ancient tree of life has been transformed by Judaism into the *menorah*, two of which flank the ark in many synagogues. (Many contemporary synagogues limit themselves to one *menorah*, variously placed on the *bimah* or on one of the walls.) The *menorah* is the symbol most often found in antiquity, and it can be easily traced through the illuminated manuscripts and documents of synagogue archives to actual *menorot* which have come down to us from the recent past. The image of branches which spread out from the stem of the *menorah*—the trunk of a tree—but are firmly attached to it (a tree precariously poised) constitutes a forceful analogy to the basic historic experience of the Jewish individual and the Jewish people; they are spread and scattered like branches of a tree, yet related to the trunk, the central ancestral tradition.

Light is also interpreted as a symbol of the departed soul when a light is kindled in memory of a deceased parent. The Bible (Prov. 20:27) alludes to the lamp as a symbol of the spirit of man, although it is questionable if the memorial light in the synagogue derives from this source. Rather, it is assumed that this practice became part of the ritual in the

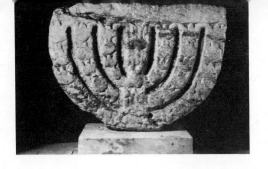

Menorah, stone, second cent. C. E., synagogue, Tiberias. (Courtesy Bezalel Museum. Photo: Bernheim.)

sixteenth century in central Europe. The Shulhan Arukh does not mention the custom at all. It may have started in the home and probably was suggested by the Catholic custom of burning candles to the saints. It became manifestly popular because it furnished a clear and easily secured sign of reverence for the dead.

For these memorial lights, simple wax candles were kindled. The flicker of the flame produced a warm and moving experience. The candles were often placed on the parapet surrounding the wall of the synagogue, sometimes fastened at certain intervals on the side near the door or in the middle of the long wall. Very often, a stand made of wrought iron, which could hold many candles, was placed to the left of the ark.

The Torah ornaments customarily employed today did not originate in biblical times but in the Middle Ages, when Jewish liturgy had achieved a stable form. Literary evidence for their use is available only after the year 1000,[9] and existing artifacts stem mostly from the seventeenth, eighteenth and nineteenth centuries, although there are a number of extant specimens from the sixteenth century. Like the ark and the Torah curtain, they reflect the styles of their times. So far as ornamentation of the Torah mantle is concerned, they "are only variations of the Torah curtain"[10] with inscriptions of donors, motifs of lions, deer, eagles, crowns, and implements from the Temple, embroidered with gold and silver threads on silk and velvet mantles. These motifs may be traced back to illuminated Hebrew manuscripts of the Middle Ages. In the Jewish communities of the East, and in Algeria, the Torah was put into a richly ornamented wooden or metal case, which could stand upright and be opened when the Torah was read without removing the scrolls from the case.

The Torah mantle was put over the Torah after its scrolls had been tied with a long narrow ribbon. The ribbon was often embroidered with the name and birth date of the child whose circumcision swaddling clothes were used to make the wrapper. When the boy grew up and visited the synagogue for the first time, he presented the wrapper in a

Torah binder, Poland, eighteenth cent. (Courtesy Bezalel Museum. Photo: Alfred Bernheim.)

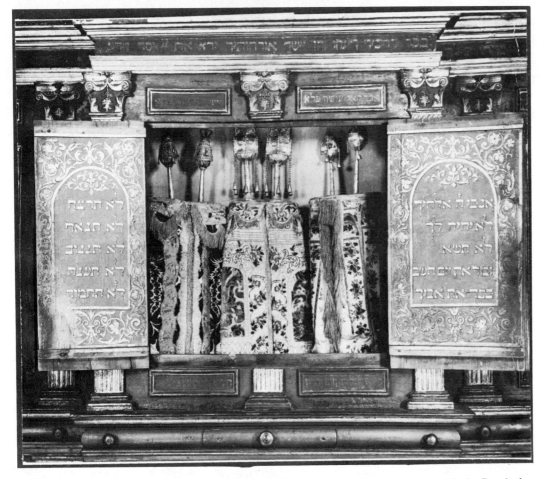

Ark, Urbino, Italy, 1551. Benguiat collection. (The Jewish Museum, New York. Frank J. Darmstaedter.)

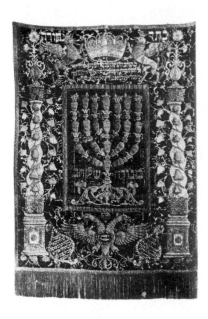

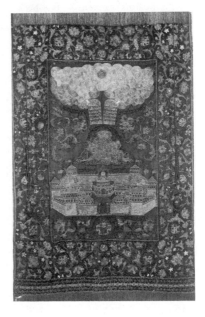

(*Left*) Torah curtain, southern Germany, 1772. Embroidery by Jacob Koppel Gans. Harry G. Friedman collection. (The Jewish Museum, New York. Photo: Ambur Hiken.)

(*Right*) Torah curtain, appliqué embroidery on silk, Italy, 1681. Harry G. Friedman collection. (The Jewish Museum, New York. Photo: Ambur Hiken.)

small ceremony. When he became a Bar Mitzvah, the Sefer Torah used at the service bore the wrapper which the boy had presented to the synagogue. It is not quite clear how long ago the Torah scroll began to be rolled on two rods. We have observed that in early artifacts the Torah scrolls appear to be rolled on one rod only. Some time during the early Middle Ages it became customary to roll the Torah on two rods, each of which was called *Etz Chaim* or Tree of Life (עץ חיים). Their handles were sometimes inlaid with ebony and faced with silver. Then Torah head pieces, *rimonim* (literally pomegranates), developed, which were preferred in the Sephardic tradition; and the crown, preferred in the Ashkenazic tradition. In Italy both traditions often merged and the Torah crown was put on top of the *rimonim*, or else a separate crown was made for each tree of life and a third crown put on top of these two.

There are many regional variations in the design of the *rimonim* and the crown. In eastern countries the *rimonim* retain their original round form. In the West, they frequently assume the shape of a two- or three-storied tower. Richly engraved, embossed, hammered and cut out, they resembled crowns and were often fitted with bells, an allusion to the garment of the high priest (Exod. 28:34).

The origin of the Torah shield (*hoshen*) or breastplate which is hung over the Torah mantle may be traced to sixteenth-century Germany. Early pieces had a provision for a small plate bearing the name of a holy day, which could be inserted into the breastplate and so mark the specific occasion on which a particular Sefer Torah was to be taken from the ark to the reader's desk. In time, the shield lost this calendar function and came to symbolize the biblical *hoshen*, the breastplate of the High Priest Aaron, and was accordingly studded with twelve precious stones symbolic of the twelve tribes. It is interesting to observe that the figures of Moses and Aaron often appear on the breast plates in high relief.

To prevent damage to the scroll during the service, a pointer (יד, hand) usually made of silver and terminating in a representation of the human hand was used. The pointer appears to have originated in the sixteenth century.[11]

Torah pointer, silver, Germany, ca. 1700. (The Jewish Museum, New York.)

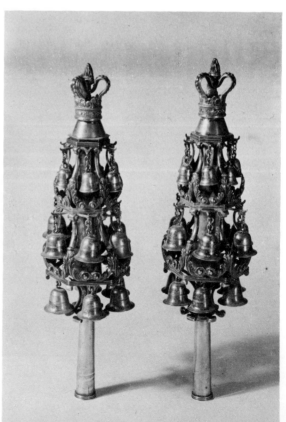

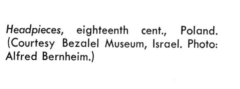
Headpieces, eighteenth cent., Poland. (Courtesy Bezalel Museum, Israel. Photo: Alfred Bernheim.)

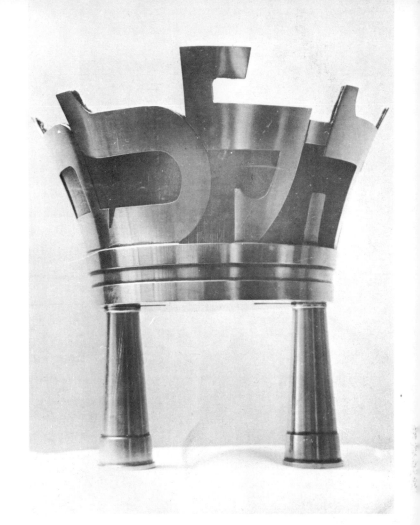

Torah crown, sterling silver, h. 12",
1945. Congregation Temple Eman-
uel of Great Neck, New York.
Artist, Ludwig Wolpert.

Torah shield, sterling silver, and
enamel, h. 8", 1947. Temple Beth
El, West Hartford, Connecticut. Art-
ist, Ludwig Wolpert. (Photo: Frank
J. Darmstaedter.)

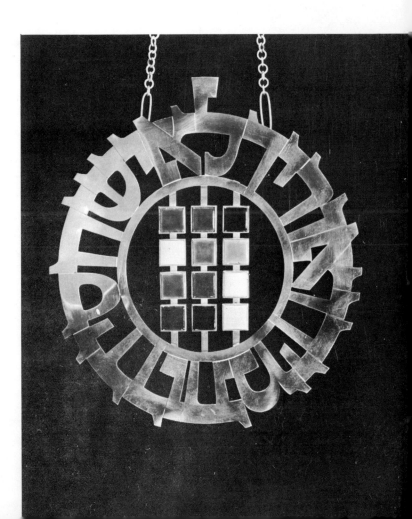

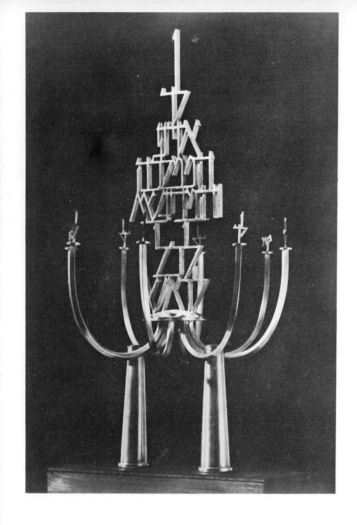

Torah crown, sterling silver, h. 17″, 1953. Temple Beth El. Artist, Ludwig Wolpert. (Photo: Frank J. Darmstaedter.)

Headpieces, sterling silver, h. 10″, 1953. Temple Beth El. Artist, Ludwig Wolpert. (Photo: Frank J. Darmstaedter.)

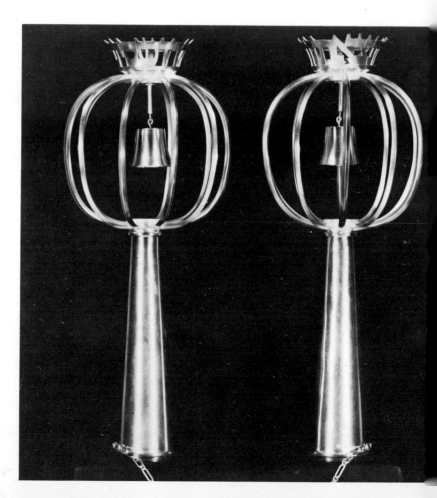

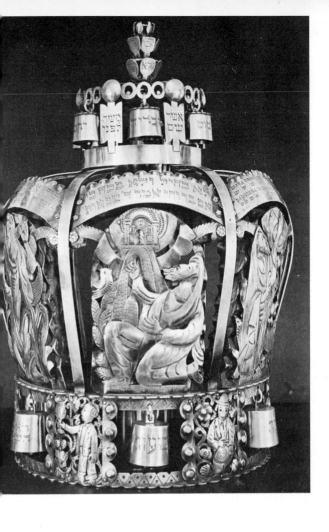

Torah crown, silver, h. 16″, 1957. Temple Oheb Shalom, Nashville, Tennessee. Artist, Ilya Schor. (Photo: J. J. Breit.)

Torah shield, silver, 9″ x 7″, 1955. Temple Beth El, Great Neck, New York. Artist, Ilya Schor.

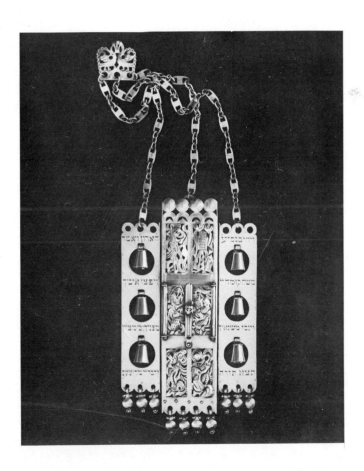

Torah shield with symbol of letter shin, brass, nickel, silver, semi-precious stones, 11″ x 9″. Temple Emanuel, San Francisco, California. Artist, Victor Ries.

Torah binder, wool, 1961. Artists, Belle Quitman and Evelyn Applebaum. Arigah Workshop. (The Jewish Museum, New York. Photo: Frank J. Darmstaedter.)

Torah shield with symbols of pomegranates, brass, nickel, silver, semi-precious stones, 7" x 9", 1953. Park Synagogue, Cleveland, Ohio. Artist, Victor Ries.

Torah mantle with symbol of fig tree, appliqué, felt on brocade, 1958. Temple Oheb Shalom, Nashville, Tennessee. Artist, Ayalah Gordon.

Formerly, the ark and the *bimah* were separated from each other. The space between was left free. During the service the scrolls were carried in a solemn procession from the ark to the *bimah*. After being placed on the *bimah* the Sefer Torah was relieved of its crown, the *rimonim*, the shield, mantle and the Torah band. It was placed on the heavily embroidered cloth covering the large table, or reading desk, and the weekly section was chanted by a reader as someone else followed the lines with a silver pointer. After the reading, as the congregation rose, the Torah was lifted, dressed, and returned in procession to the ark.

Today, only the newly constructed prayer halls of Orthodox congregations or of congregations following the Sephardic custom have built the *bimah* in the center. Almost all Reform and Conservative congregations have enlarged the *bimah* and placed it at one end of the prayer hall. The ark, the reading desk and the pulpit are placed on this enlarged platform, sometimes on different levels. The worshippers' chairs, which were formerly mobile, have become fixed pews and are now turned toward the *bimah*, from which the

service is conducted. The prayer hall has a definite direction and focus. The arrangement is not unlike that in theaters or Protestant churches. It has resulted from liturgical and ritual changes, from the worshippers' lack of knowledge of prayer and Torah, from the increasing importance of the sermon, and from the casting of the rabbi in a quasi-priestly role. Such changes in orientation have also resulted in an increased emphasis on the ark, to which have now been ascribed overtones of sanctity essentially incompatible with the traditional spirit of Judaism.

It is hard to imagine that the arrangement which gives the *bimah* the central position will reassert itself in the near future. However, there is evidence of growing dissatisfaction with those arrangements which do not reflect the fundamental nature of the synagogue, and in which the essential face-to-face relationships distinguishing congregations from other associations and religious groups are not expressed in the basic architectural form.

Sensitive rabbis and architects urge solutions which promise a greater intimacy. Thus at Temple Beth El, in San Mateo, the *bimah* protrudes toward the center of the hall and is surrounded on three sides by the members of the congregation. In Temple Israel, Swampscott, Massachusetts, Pietro Belluschi, by building a balcony in the small round prayer hall, made it possible to achieve the required seating capacity without sacrificing intimacy. Here, too, the *bimah* protrudes far into the center, with the congregation seated on three sides. A centralized roof breaks the longitudinal direction of the prayer hall. However, a central *bimah* has not been accepted by members of most Reform and Conservative congregations, although some architects advocate it.[12]

The problem of function and expression is as difficult in the interior of the building as it has been on the exterior. This is most apparent in the prayer hall. The type of space enclosed, the basic dimensions of the room, the materials employed, the color, texture and light used by the architect and artist, the shape and integration of the *bimah*, ark, and other ritual objects, and the design of the seating and furniture all reveal to us what kind of conception, if any, the architect and his clients have of the Jewish religion and the synagogue.

It must be said that the generally favored solution of the expandable prayer hall for the High Holy Day overflow may force the architect to become merely a builder and make compromises which are esthetically indefensible.

What kind of expression is desired in planning the prayer hall? The traditional directives for the inside of the synagogue are no more numerous than those concerning the outside, although the ritual objects and their positioning are predetermined. The Talmud, which devotes hundreds of pages to details concerning the reading of Torah lessons, says about the appearance of the interior only that it ought to have windows. Even this directive was modified by Maimonides (see p. 87).

It was stated at the outset that the synagogue has been a house of prayer, study and assembly. Do the architect and the artist aim for a unified conception of these three roles, toward a hall where the world of today and that which transcends it meet? Is this possible now, at a time when the synagogue itself has brought about some differentiation of these functions? Is it essential to evoke the sacred, the awesome, the remote and inaccessible,

the greatness of Israel's God concept? Is it essential to express the conception of an historic community, its closeness and intimacy? Is it necessary to invite restful and mysterious elements which summon retreat and contemplation, or should the prayer hall be flooded with the full light of day and invite meeting and discourse? Should the accent be placed on a conception of God or a conception of the community?

The attitudes of those who have concerned themselves with these problems are by no means unified, as their different solutions show. In fact, there are many indications that too often little thought is given to these questions. The absence of a clear conception of the synagogue forces the architect to concentrate on the congregants' more mundane demands for physical comfort, instead of seeking to create a specific atmosphere. The creation of such an atmosphere is left to chance or to the work of the artist.

In 1958, Dr. Eugene Mihaly, a noted Jewish scholar, attempted to evolve an answer to these questions from a consideration of the structure of the Jewish liturgy and of a philosophy of Jewish religion and history.[13]

Dr. Mihaly observes and richly documents a basic tension and polarity in major eras of Jewish religious thought. He recommends not to attempt to resolve these tensions, but to maintain them as a guiding line for the architect and artist.

Dr. Mihaly points out that the very silence of the Talmud on synagogue architecture stems from the fact that the individual Jew is considered the central vehicle of Judaism, and that the concept, "God stands in the midst of the Congregation," as well as the prophetic distrust of imposing buildings (Jer. 7:4), suggest the design of a synagogue "which will not overwhelm, nor draw primary attention to itself,"[14] but will create instead an atmosphere which intensifies the worshipper's awareness that *he himself* is potentially the temple of the Lord.

In examining the Jew's traditional relationship to the Torah and other ritual objects, Dr. Mihaly points out a determination in the past to avoid assigning absolute value to that which has only relative value. In spite of the directive of Hiddur Mitzvah, there is a persistent refusal to assign an absolute value to the Torah scroll or to the ark,[15] since the scroll in itself is only lettered parchment, while the Torah is indestructible. Between the symbol and what it stands for is a gap only the consciousness and actions of the believer can bridge. "Fast on Yom Kippur but know while doing so that the real fast is 'to let the oppressed go free.'" (Haftarah for Yom Kippur, Isa. 58:6).[16] As others have already pointed out, there is a tension between the ideal and the real which is basic to Judaism,[17] and which the synagogue must embody.

Mihaly detects a similar polarity in Jewish tradition between passive submission to God on the one hand and man's creatively assertive nature on the other.

Seeing man as possessing these two opposing qualities of self-negation and self-assertion, Mihaly finds a polarity in the liturgy also. Starting with praise and ending with petition, the liturgy presents a submissiveness to God and yet a commitment in the tasks of the world. He finds sensible the talmudic notion that a synagogue ought to have windows. Isaiah's dictum: "I have not spoken in secret, in a place of the land of darkness" (Isa. 45:19) supports this position. The worshipper, he writes, "should feel removed

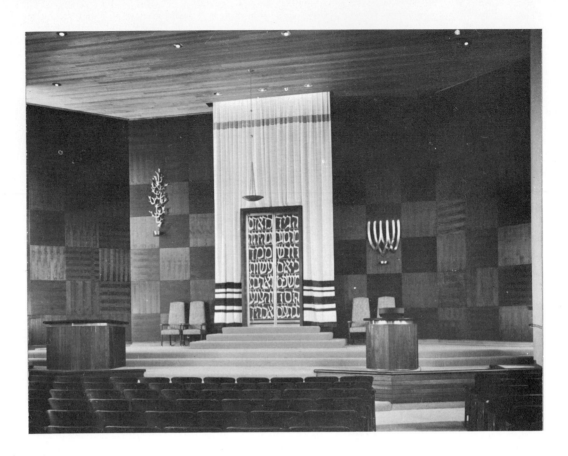

Ark with Hebrew calligraphy, doors 10' x 6', 1957. Temple Beth Abraham, Oakland, California. Architect, George E. Ellinger. Artist, Victor Ries.

yet in touch with his environment; that he is in the presence of the sacred but not in a cloistered sanctuary . . . that it evoke serenity and sanctity yet not withdrawal."[18] A paradox is also found in the awareness of the numinous which the liturgy evokes, even as it affirms the worshipper himself: Man is everything and man is nothing in the presence of his Maker. He is overwhelmed by the awesome yet he affirms his existence by petition. Therefore, while it is the function of synagogue design and art to evoke the numinous, done traditionally in religious art by the allusion to darkness, silence and emptiness, the worshipper and his prayers must be affirmed in terms of light. Jewish sources insist on it in the synagogue.[19]

Finally, Mihaly points to the tension in the concept of a universal God, the God of all men, Who is simultaneously the God to Whom Jews bear special witness. Israel is like any other people and yet different. Therefore, the synagogue ought to embody this element too. His suggestions are summed up in the following:

> We would ask the architect that he design a structure which would enhance the feeling that the synagogue is but a means, but a necessary means; that it is of the past yet of the present and future; that one is removed within the synagogue yet deeply involved in the world, its problems and tasks; that one is part of a group without losing the sense of individuality; that one stands in God's presence but with the dignity of one who is worthy of His concern and who is created in His image; that the Jew is of the total community, yet bears special witness.[20]

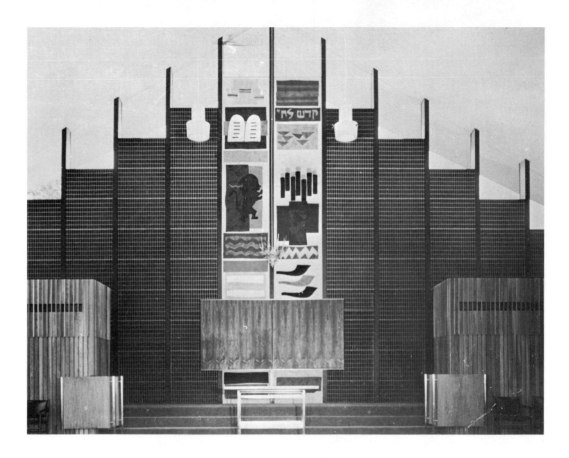

Ark with Tablets of Law, tapestry, 15', 1958. Temple Beth El, South Orange, New Jersey. Architects, Davis, Brody, and Wisniewski. Artist, Samuel Wiener, Jr.

The above is in essence a classic exposition of the synagogue as a house of prayer, study and assembly, all in one room. This goal, because of the differentiation within the modern synagogue complex, is difficult and, for some, even undesirable to attain. However, the prayer hall is, in essence, a blend of all three. Discourse and study have always been an integral part of Jewish worship. Its functions cannot be completely separated because the whole is greater than any of its parts could ever be. The synagogue is an idea which cannot be understood through its parts.

The classic expression of the inherent tension in Judaism is, of course, the traditional distance between *bimah* and ark which can be observed even today in many Orthodox synagogues. The full artistic development of this relationship can be sensed, for instance, in the religio-poetic rationalism which pervades the space, frieze, ceiling, and fenestration of the El Transito Synagogue in Toledo, Spain.

Architects and artists can attempt either to minimize the one-directional movement of the prayer hall, or to accept it as an expression of today's religious sentiment and leader-centered service. Thus they either follow intuitively the meeting-house conception of the synagogue or cast it away in favor of their own personal ideas, or ideas which they feel will best meet the actual Jewish religious situation of today.

There are then as many conceptions of the prayer hall as there are architects and artists. There are those who enclose the space in a manner which dwarfs the worshipper and

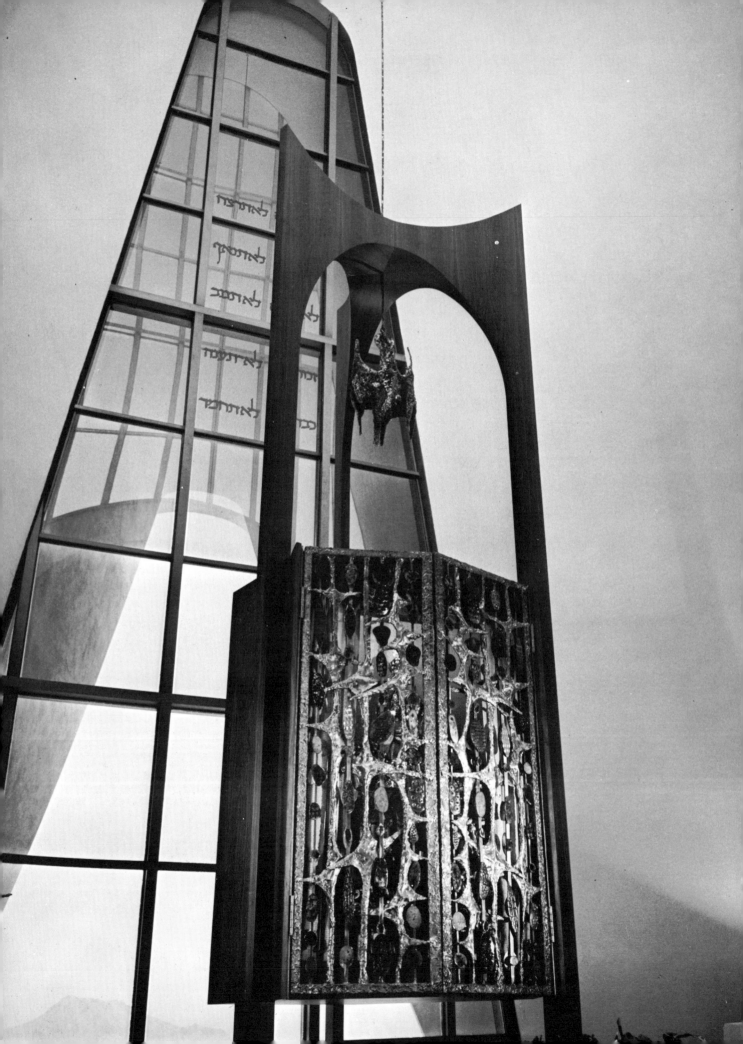

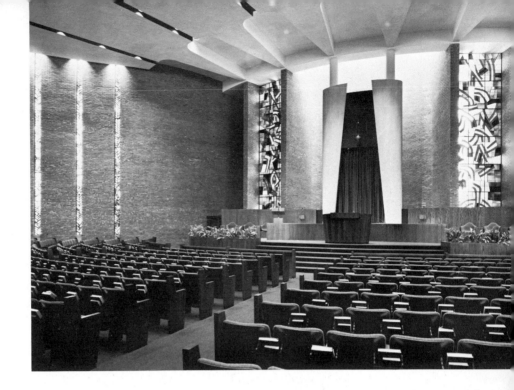

Interior, Congregation Beth El, Rochester, New York, 1962. Architect, Percival Goodman. *Ark*, marble, h. 29′. Stained-glass windows, 27′ x 6′. Artist, Samuel Wiener, Jr. (Photo: Paul L. and Sally L. Gordon.)

makes him feel humble and insignificant; others who make him feel a vital part of an historical religious community; still others who aim for both. Within the prayer hall the creator searches for the expression of the divine in a variety of ways through an impersonal and mathematical order; through a universally valid harmony; through great spaciousness carved out of the cosmic space; through great voids; through darkness, or through the flicker of light over a huge expanse of baked clay. The divine is sought in a space which echoes a universe filled with the mighty, overpowering demands of ethical monotheism. There are intimations of the divine in the creation of the beautiful, in the expression of the force of nature, and in the domed ceiling which curves like the sky and shelters the community.

Where the artist has been given an opportunity to work out a solution in harmony with, yet independent of, an overriding conception, he has brought forth the sacred from the buried treasure of Hebrew folklore. He has evoked the primitive, the ancient, the beautiful, the poetic, the word of the Bible, or he has taken a leaf from recent history and shown his concern for the physical survival of the people.

Now that the *bimah* has become a huge stage at one end of the prayer hall, its backdrop is of great importance, since the ark, however tall or wide, is only one item of the setting. As a rule, windows have disappeared from the ark-sheltering wall, facilitating planning. A screen which conceals the choir and organist is used with varying degrees of success as

Ark, wood, h. 18′. Artist, Sidney Eisenshtat. *Ark doors*, bronze, h. 7′. *Eternal Light*, bronze, h. 15″. Temple Sinai, El Paso, Texas, 1962. Architect, Sidney Eisenshtat. Artist, Wiltz Harrison. (Photo: Julius Schulman.)

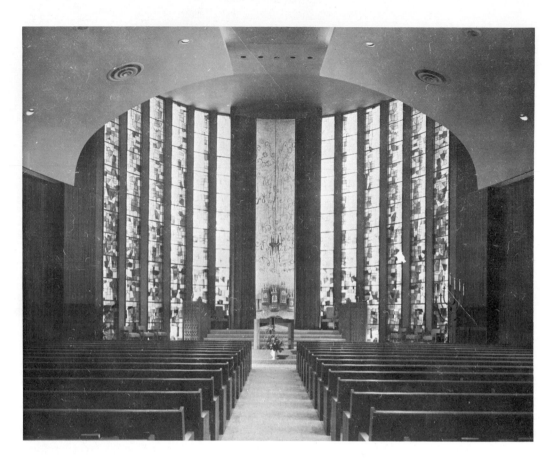

Interior, Temple Mishkan Israel, Hamden, Connecticut, 1960. Architect, Fritz Nathan. *Stained glass, 2'6" x 34'*, Robert Pinart. *Mosaic design for ark, 12' x 33'*, Ben Shahn. *Eternal Light*, bronze, 2' x 2', Anne Lehman.

Interior, B'nai Israel Synagogue, Woonsocket, Rhode Island, 1962. Architect, Samuel Glaser Associates. *Stained glass on the theme of the seven days of creation, 7½' x 22'*. Artist, Avigdor Arikha.

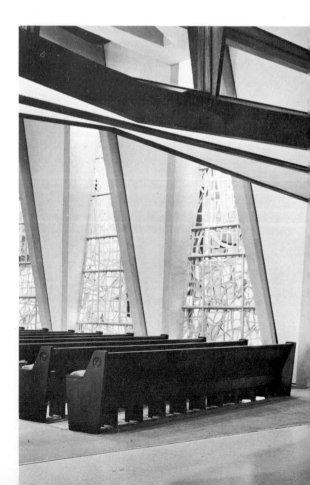

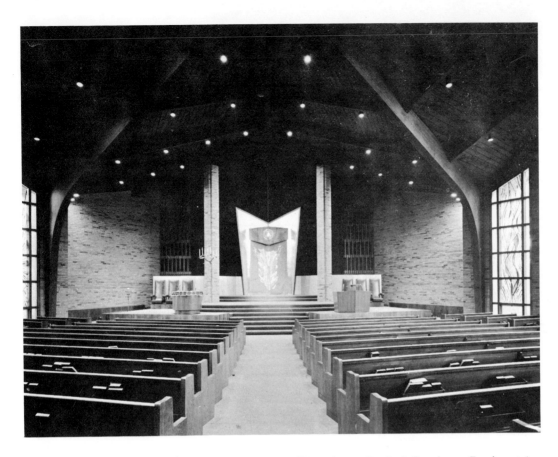

Interior, Temple B'nai Aaron, St. Paul, Minnesota, 1957. Architect, Percival Goodman. *Torah curtain with pillar of fire and pillar of cloud*, appliqué, 10' x 6'. Artist, Helen Frankenthaler. (Photo: Alexandre Georges.)

a backdrop. Constructed out of wood, marble or metal, it often expands and covers the whole or a good part of the rear wall. At times the screen flanks the ark on both sides and thus becomes an extension of it. Other ritual objects as well are set against the screen. The *menorah*, the pulpit and the reading table, usually designed as modern pieces of furniture, also stand on the *bimah*. Sometimes there is only one pulpit-reading desk, centrally placed, but more often there are two: one for the rabbi, and the other for the cantor and/or Torah reader. In addition, a number of chairs are usually set against the wall or the screen. These are for rabbi, cantor, officers, and guests of the congregation.

The artist is concerned not only with the design of the ark and the other ceremonial objects, but also with their integration into the total space and the background, the ark-sheltering wall. For this latter problem, solutions other than those of constructing screens of wood or marble have been tried. The ark has at times been set effectively against a white curtain with blue or black stripes, evoking a strong association with the traditional Hebrew *talit* (prayer shawl), or against colorful stained-glass windows; other decorative backgrounds have also been used to offset and emphasize the color and shape of the ark.

Some architects have been more concerned with the preservation of the architectural

Ark, metal, 4'6" x 9'6", 1955. Congregation Beth Abraham, Tarrytown, New York. Artist, Sidney Simon.

Ark, bronze, approx. 9' x 16', 1964. Chapel B'rith Kodesh, Rochester, New York. Architect, Pietro Belluschi. Artist, Richard Filipowsky.

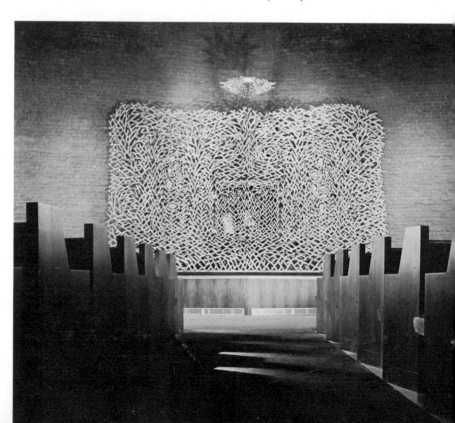

space than with the ark as a free standing piece of furniture. They have recessed the ark into the wall, have made the wall flow around the ark, or have treated the whole wall as an extension of the ark. Architects and artists have successfully used plain brick, rough textured mortar, fluting, and other material or designs for this purpose. At no time, however, can the ark be divorced from its setting. Even though specific items may be singled out for discussion, it is important to remember that objects function in an over-all setting and that the *bimah* must be conceived as a unity. No single feature can determine its over-all expression.

The great freedom and variety of modern design and the great number of available materials have left their impact on the design of the ark. We find arks made of wood and of bronze, with doors and curtains; arks made of clear, fused or stained glass, of concrete and mosaic, of silver, enamel, marble, copper, lead and brass, in every conceivable combination. Since modern art has invaded the synagogue, it is only natural that the stately arks, with their elaborate architectural masks, are disappearing. Gone are the cornices, pediments, pilasters and columns, although Boaz and Jachin, the biblical columns, still appear in current designs.

Stark functional design, which seemed for a while to replace the traditional ark types, has been strongly modified by a more sensitive use of natural material, a more organic and plastic sense of form, and more intimate and expressive approaches on the part of artists.

Ark on staves, wood, carved and painted, 6′ x 9′, 1954. Temple Emanuel, Chicago, Illinois. Architects, Loebl, Schlossman and Bennett. Artist, Edgar Miller. (Photo: Oscar and Associates.)

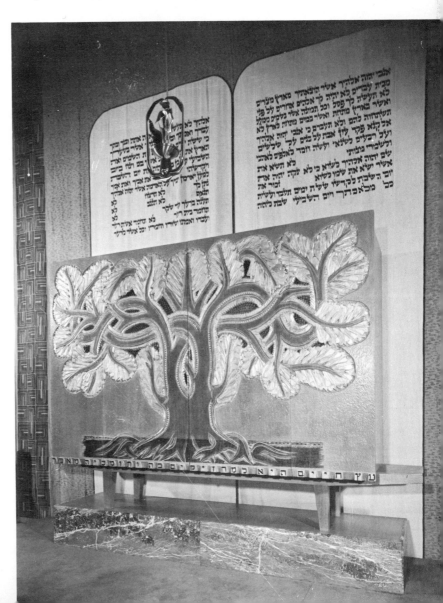

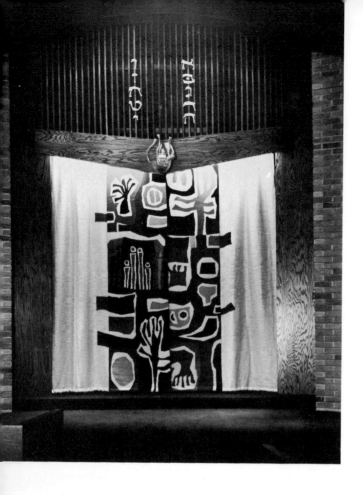

Torah curtain, appliqué, 15' x 12', 1959. Congregation Adath Yeshurun, Manchester, New Hampshire. Artists, Harris and Rose Baron. (Photo: Eric M. Sanford.)

Tapestry for ark doors with design of Jacob's Dream, 14' x 9', 1959. Temple Adath Jeshurun, Louisville, Kentucky. Artist, L. Gordon Miller.

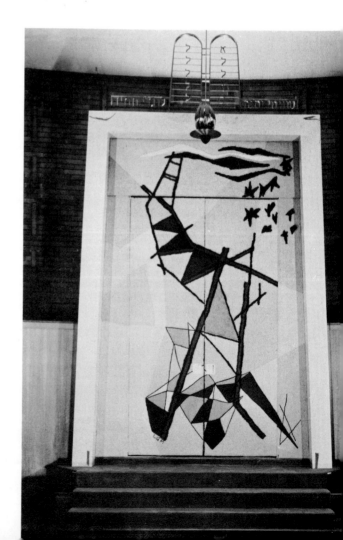

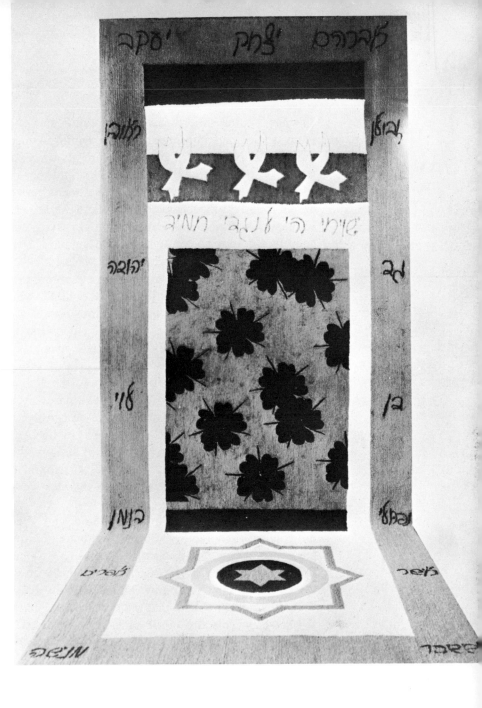

Tapestry for ark, 18' x 5'10", 1953. Congregation Beth El, Springfield, Massachusetts. Artist, Robert Motherwell.

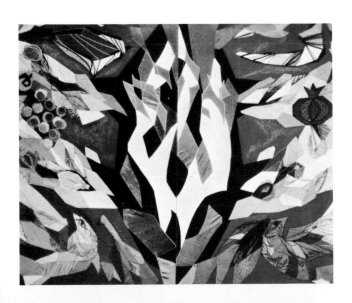

Torah curtain, silk and wool appliqué, 8' x 10', 1962. Mt. Kisco Jewish Center, Mt. Kisco, New York. Artist, Sophia Adler.

The ark is either subordinated to the total conception of the *bimah* or becomes itself the main carrier and interpreter of a prevailing conception. Sometimes the ark's ancient mobility, appealing strongly to the artist's imagination, is emphasized by being set on staves, or by becoming free-standing. Its bold shapes and energetic lines sometimes allude to the wings of the cherubim or to the ancient horned altar. It may be fashioned after the design found on the mosaic floor of Beth Alpha, or become a clear lined bronze or glass cabinet. The traditional artistic motifs, carved, woven, painted, embroidered, and re-conceived in terms of contemporary design are often adhered to, though not rigidly, and have sometimes even been expanded. Occasionally, the Decalogue has been fully spelled out or has been enlarged to give the ark a monumental scale. In some synagogues the traditional lions guarding the ark are omitted, while in others they are combined with traditional symbols into a major composition to crown the ark. Wooden arks are often carved and perforated, the burning bush or the tree of life being favorite themes for such work. Bold figurative designs also appear on arks, to further expand the range of motives.

Modern painting has deeply influenced the design of the ark curtains. Ark doors have been effectively covered by fabrics sometimes woven by the women of the congregation. Equally effective design has been achieved through the use of Hebrew calligraphy, which serves significant didactic purposes. With the great variety of designs and materials used for the ark, there have been a number of designs which evoke associations normally inappropriate to arks—for example, strict horizontal bars resembling a jail cell, or heavy metal doors which seem to be opened and closed by pushbutton remote control, like the heavy doors of a bank safe.

There is no one best solution for the design of an ark; no one material is necessarily more suited than another. From an esthetic point of view, the discussion of a curtained ark versus an ark with doors, or a recessed ark versus a free-standing one, is meaningless. From the point of view of tradition, a good case could be made for the use of fabric and of wood. By the same reasoning, a case can be made for separating the ark and *bimah* entirely. It would also seem that the use of wood and fabric is usually more satisfactory than the use of marble and fabric or marble and brass or glass. These latter materials have seldom been successfully used in the construction of an ark. Their hardness, definitive silence and coldness, so difficult to modify, can barely compete with the richness and warmth of wood or fabric.

The final work however depends mostly upon the skill of the artist, his understanding of the synagogue, the richness of his conception, and his over-all design, rather than on the material itself. The same can be said for other parts of the prayer hall. The material is determined by the over-all esthetic and religious conception, which must be arrived at before the work is started.

In their treatment of the Eternal Light, artists have taken full liberty in the creation of interesting and sometimes expressive shapes to envelop and enhance the light. Sometimes it appears as a spheroid sculpture constructed of wire or narrow bands of metal. The motif of the biblical cherubim is a starting point for some artists in their search for an appropriate form; the light is sheltered between their folded wings, or held in the arms of

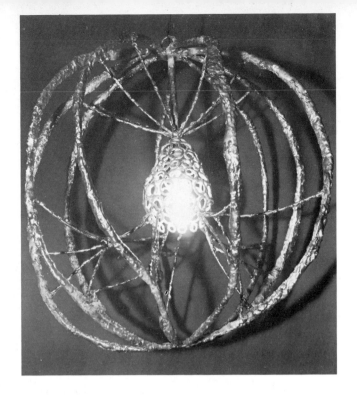

Eternal Light, bronze, h. 20″, 1957. Temple B'nai Aaron, St. Paul, Minnesota. Artist, Ibram Lassaw.

Eternal Light, metal, h. 30″, 1953. Temple Beth El, Providence, Rhode Island. Artist, David Hare.

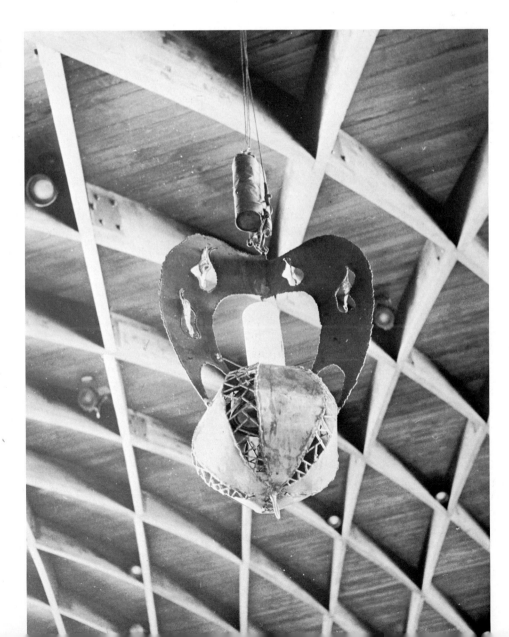

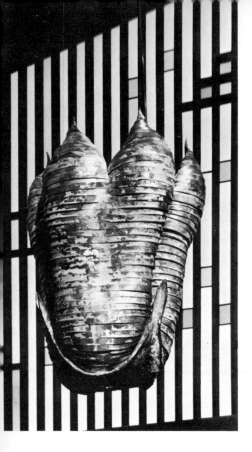 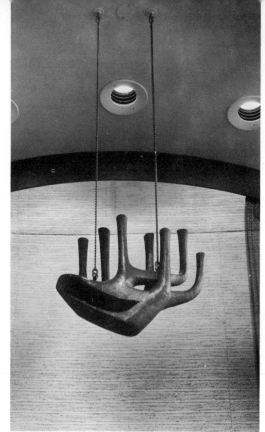 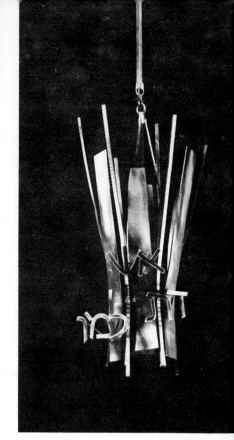

(Left) *Eternal Light*, hammered silver, copper, copper bands, h. 20″, 1954. Temple Israel, Swampscott, Massachusetts. Artist, Richard Filipowsky. (Center) *Eternal Light*, cast bronze, h. 24″, 1961. Congregation B'nai Jacob, Woodbridge, Connecticut. Artist, Helen Beling. (Photo: Louis Reens.) (Right) *Eternal Light*, bronze, h. 26″, 1959. Congregation Covenant of Peace, Easton, Pennsylvania. Artist, Hans Rawinsky. (Photo: Frank J. Darmstaedter.)

faceless cherubim. Sometimes an irregular heap of torn metal, thrown together seemingly at random, re-echoes the shape of the Star of David, the points of which have become warriors' swords. Eternal Lights assume sometimes the shapes of a pine cone or a sun disk; a suspended wheel with a bell-like nickel hub against which an open flame plays; a winged harp in which the Decalogue has taken the place of the strings; a stately Tabernacle which is an organic part of the ark; a golden wiry shape reminiscent of the galaxy of stars; a composition of rectangular forms; a heavy rounded mass recalling a diver's bell.

The esthetic and ritual value of the electric bulb, now in general use, has been sharply challenged. Some architects recognize the value of the act of actually kindling a light, and of the deeper effect of a moving, flickering flame.[21] Can payment of the electricity bill be an adequate substitute for what could be a meaningful ritual? Can the light of an electric bulb offer the same sensuous quality, deeply symbolic of time and of life, as the more magical and ethereal flickering of a wick or a burning candle?

The *menorah* in the contemporary synagogue is often more than a statement of functional form, clean lines and uncluttered metal. It is an object designed and executed by a sculptor with the same care and involvement he devotes to any other sculpture. Traditional

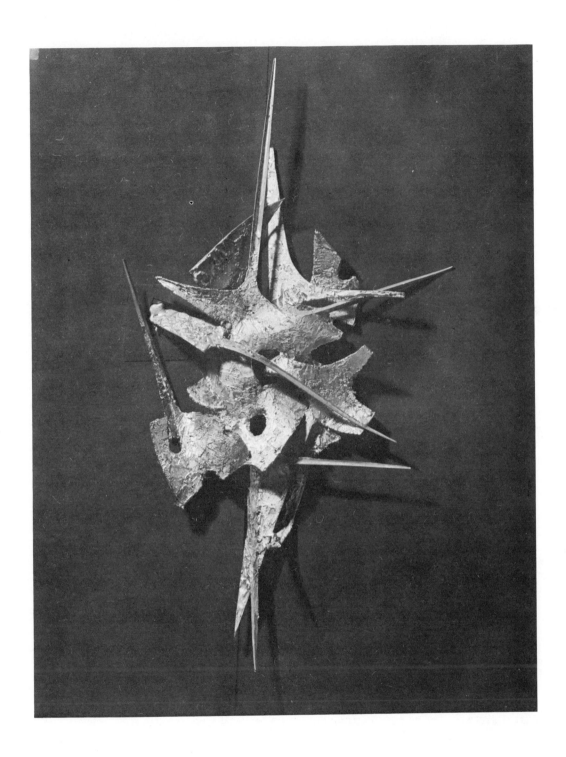

Eternal Light, pewter alloy, h. 21½", 1955. Artist, Calvin Albert. (The Jewish Museum, New York.)

symmetrical balance between the arms and both sides of the shaft has often been abandoned in the quest for an asymmetrical balance and a profounder expressive effect. There have been attempts to relate the *menorah* to its surrounding space by projecting its arms forward or backward, or by grouping them around its central shaft. The formal possibilities which the structure of a seven-armed candelabrum contains have been widely explored and expressed in a variety of materials such as lead, wood, brass, cast and hammered bronze, silver, nickel and wrought iron. *Menorahs* embody the different conceptions of the artist, who at times has re-endowed them with their ancient astral and mystical power and at other times has penetrated into the myth of the tree of life whence originated the *menorah*. It may be rendered as an object of robust massive strength or one of ethereal lightness. It may derive from folkloristic elements.

Attempts to find new, esthetically satisfying ways to honor the deceased have been few. Placing the memorial tablets outside the prayer hall, has been a practice which deprives the interior of an adequate sense of the communal unity of the living and the dead. Very often one finds unattractive commercially produced bronze tablets, with sockets for electric bulbs beside each name. However there are isolated cases where more imaginative approaches are being developed.

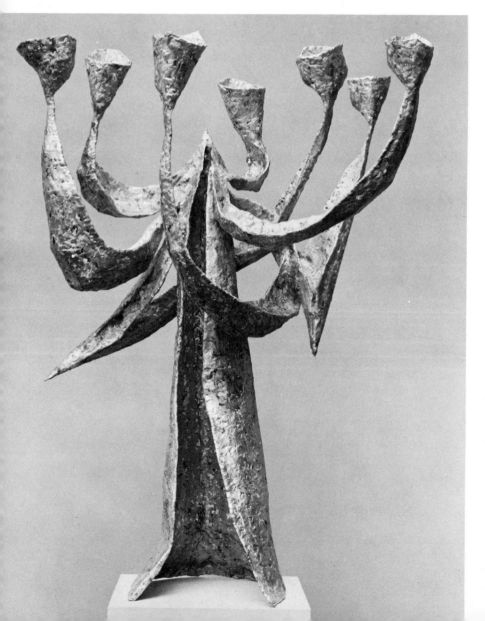

Menorah, nickel, silver, steel, h. 30", 1954. Temple Beth El, Gary, Indiana. Artist, Seymour Lipton. (Photo: Oliver Baker.)

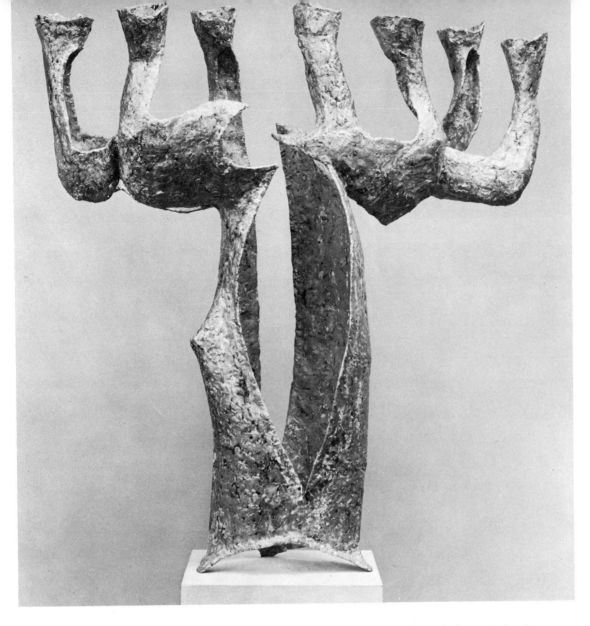

(Above) *Menorah*, nickel, silver, steel, h. 30″, 1954. Temple Beth El, Gary, Indiana. Artist, Seymour Lipton. (Photo: Oliver Baker.) (*Below*) *Menorah*, bronze, 19″ x 24″, 1953. Temple Beth El, Springfield, Massachusetts. Artist, Ibram Lassaw.

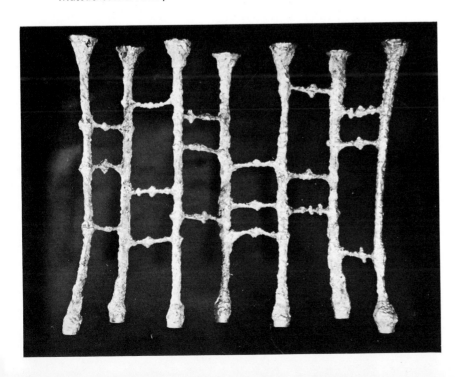

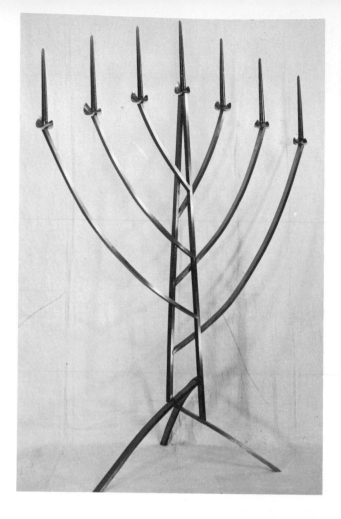

Menorah, bronze, h. 5½', 1957. Congregation Rodeph Shalom, Philadelphia, Pennsylvania. Artist, Ludwig Wolpert. (Photo: Frank J. Darmstaedter.)

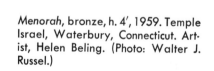

Menorah, bronze, h. 4', 1959. Temple Israel, Waterbury, Connecticut. Artist, Helen Beling. (Photo: Walter J. Russel.)

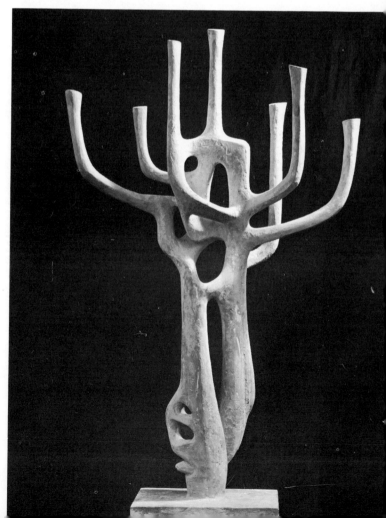

Memorial alcove, 7'2" x 10'4", 1953, with memorial book, lamps and inscription:

"The Lord gave, and the Lord hath taken away; Blessed be the name of the Lord." (Job 1:21)

Baltimore Hebrew Congregation, Baltimore, Maryland. Architect, Percival Goodman. Artist, Arnold Bergier. (Eastern Photos.)

(Left) *"Seraph"* memorial light, cast bronze, h. 20", 1957. Temple Beth Emeth, Albany, New York. Artist, Nathaniel Kaz. *(Right)* *Memorial candle holder,* bronze, h. 16", 1957. Temple Shalom, Newton, Massachusetts. Artist, George Aarons.

Artwork in the Prayer Hall

Part II

To each of the synagogues he designed, Erich Mendelsohn brought a dramatic, daring and lofty conception. In the domed Park Synagogue of Cleveland, he alluded to the tent of meeting when he erected a metal canopy over the *bimah*. In B'nai Amoona in St. Louis, he designed the ark as a separate structure. It is a rich and intricate shrine set into the center of the east wall and accentuated by the long monitor window, which continues the recess into which the ark is placed and sweeps through the center of the huge parabolic roof. When the afternoon sun shines through the monitor window and plays over the winged Decalogue and the ark doors, the illumined shrine calls to mind the biblical passage: "For out of Zion shall go forth the Torah and the word of the Lord from Jerusalem" (Isa. 2:3; Mic. 4:2).

The tall, narrow ark doors are made of four slightly convex open grillwork panels. The curtain, handsomely designed by Louise Kayser, is woven in various shades of golden yellow and is placed behind these doors, re-echoing the grilled metal through which it is visible.

The *bimah* extends to both sides of the ark and has one *menorah* at each end standing at right angles to it. Their strong vertical branches counter the horizontal grills of the ark. Two niches, which are recessed into the wall, were each intended to receive a mural, but this plan has not materialized.

In Cleveland, the accent was on the community united under the dome; in St. Louis, on the word of the Torah which is a light to the world. Mount Zion, St. Paul, dramatizes

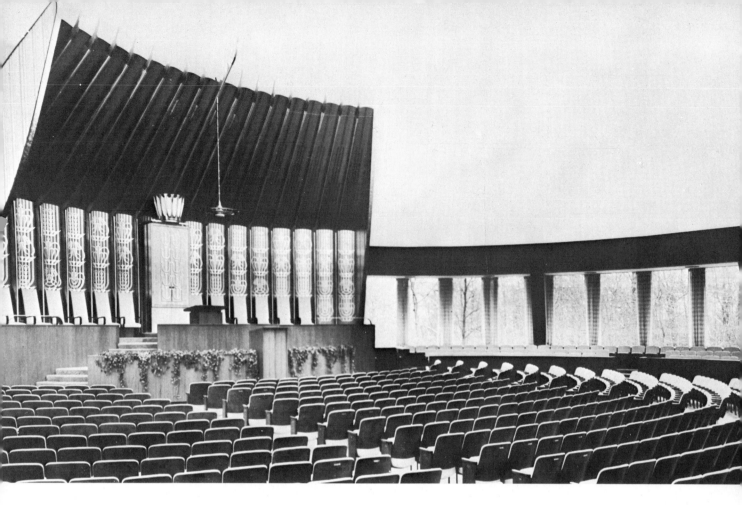

Interior, Park Synagogue, Cleveland, Ohio, 1952. Architect, Erich Mendelsohn. (Photo: Frank J. Darmstaedter.)

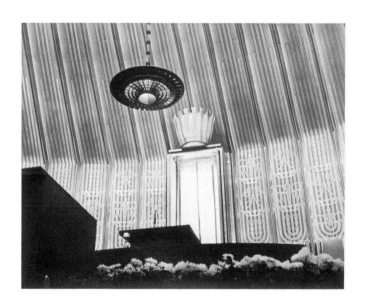

Detail of bimah, Park Synagogue. (Photo: Fred Gerard.)

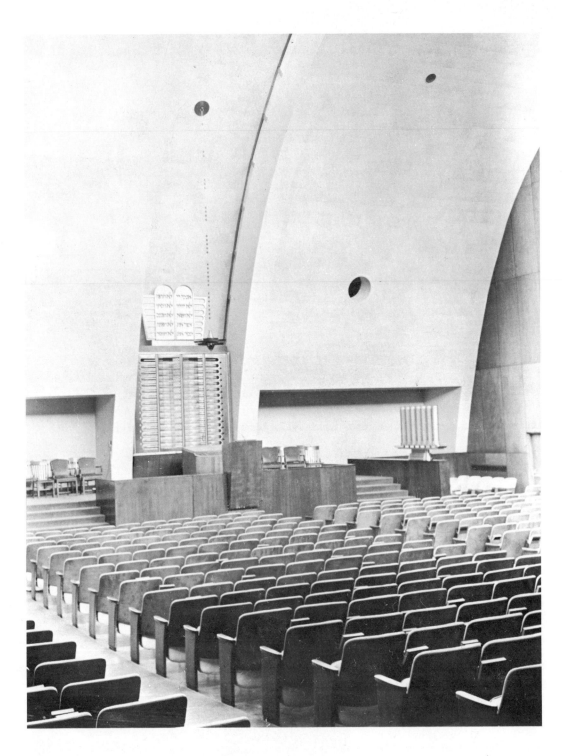

Interior, Congregation B'nai Amoona, St. Louis, Missouri, 1950. Architect, Erich Mendelsohn. (Matson's Photo Service.)

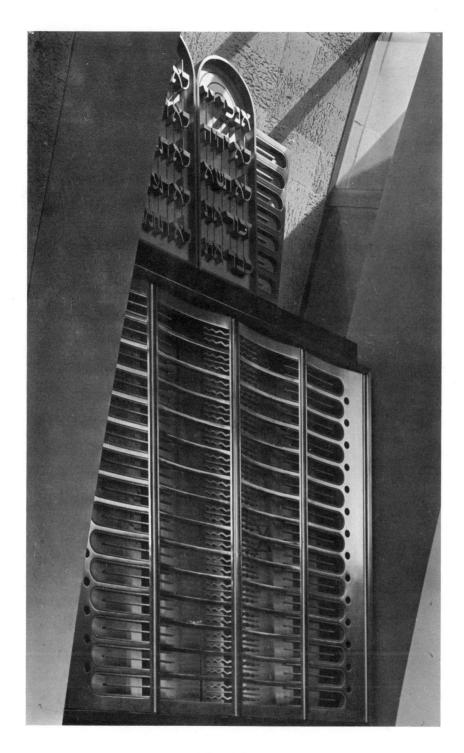

Ark with Tablets of Law, bronze, 9'4" x 8'8". Congregation B'nai Amoona. Design, Erich Mendelsohn. (Photo: Hans J. Schiller.)

Mendelsohn's conception of the One Mighty God of Israel, Who has created heaven and earth, Who is powerful in battle and awesome in His judgment. Even if one is dismayed by this conception and may wish for a more humble one, he cannot deny the power of the architect's statement.

It is a humbling experience to enter this place of worship. The dramatic space moves the worshipper to a serene contemplation not of the good in life, but of the Deity's might and power. One stands in awe, feeling for the moment disturbed, insignificant, minutely human. No division is felt between the *bimah* and the congregation. The space unites and dwarfs both those who conduct and those who participate in the service. Here architecture speaks through the void it has created, through the sudden ascent of the bare side walls which play against the gradual measured steps leading up to the *bimah* and against the fluted east wall. The power of this surface, which transforms itself into the Tablets of the Law, derives from its immense scale. The wall seems to recreate the drama of Sinai.

An Eternal Light bursting into flame from a vessel, is mirrored in a metal sphere which is the hub of a wheel. This wheel is suspended on a thirty-foot-long chain from the ceiling. The same object is also employed in the Mendelsohn synagogues we discussed previously (see p. 174). For the architect it was symbolic of the world. The wheel is divided into four-fold repetitions of the Hebrew letter *shin*, which stands for God, and which points to the four directions of the compass. The omnipresence of God in the universe is thus indicated. As man kindles a light that reaches toward God, so also is the world illumined and man's own efforts reflected. The chain itself is wrought on the theme of the number seven. The architect's conviction, his concept of the God of Israel, is felt throughout. The rabbi's pulpit, the *menorah*, and the cantor's pulpit, as well as the vessel containing the flame for the Eternal Light, are grouped on the widened sixth step on both sides of the *bimah*. They all repeat the straight vertical and horizontal features of the building and support the monumental conception of the architect. Six more steps lead to the ark and further accentuate its centrality. The ark rests on a bas relief of a *menorah*, its metal doors grilled in a succession of *shins*. It is hard to imagine that any of Mendelsohn's stark, massive metal constructions—*menorot*, Eternal Lights or arks—would be admired as beautiful objects if isolated from their setting. But within the building, their strength and simple lines are so much a part of the architecture that the eye cannot, for example, divorce the *menorah* from the fluting of the wall. This wall provides a marked contrast to the plain and austere side walls. The fluting is evenly spaced, except at the sides of the ark doors where the spacing suddenly narrows, creating two vertical bands reaching from floor to ceiling. Superimposed on the upper parts of these bands are the ten commandments, in exquisite architectural lettering.

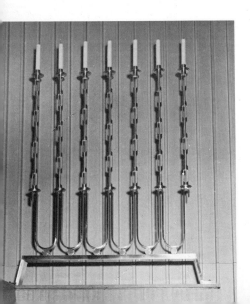

Menorah, bronze, 5'6" x 5'8". Temple Mount Zion, St. Paul, Minnesota, 1954. Design, Erich Mendelsohn. (Photo: Harvey Fenick.)

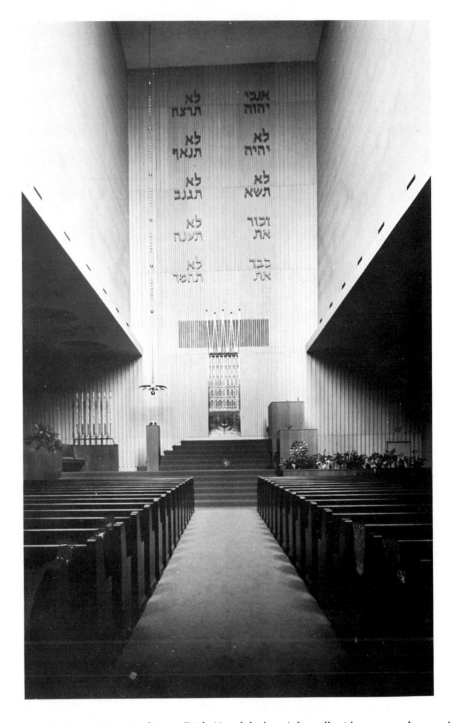

Interior, Temple Mount Zion. Architect, Erich Mendelsohn. Ark wall with commandments, h. 46'.
(Photo: Hans J. Schiller.)

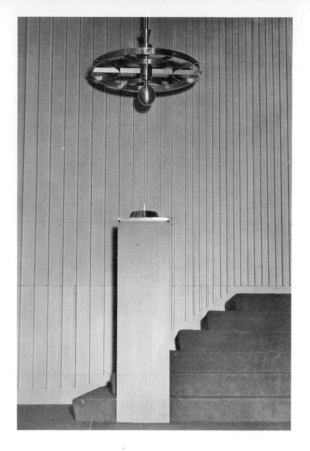

Eternal Light, stainless steel. Temple Mount Zion. Design, Erich Mendelsohn. (Photo: Harvey Fenick.)

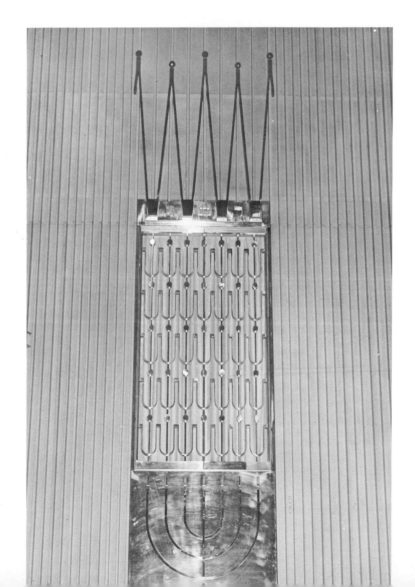

Ark, bronze, 3'9" x 15'. Temple Mount Zion. Design, Erich Mendelsohn. (Photo: Harvey Fenick.)

TEMPLE EMANUEL, DALLAS, TEXAS

At the Temple Emanuel in Dallas, Texas, Gyorgy Kepes designed the interior of the domed prayer hall, which rises over the square masses of the auxiliary buildings. An atmosphere has been created in which light, color, void and texture form an unusual and somber effect. The interior of the prayer hall is dominated by a huge expanse of Mexican

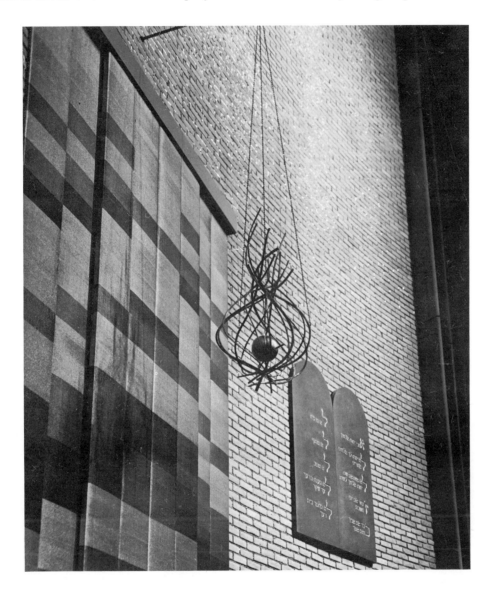

Eternal Light, bronze, h. 3′6″, 1957. Artist, Gyorgy Kepes. *Cover for ark doors*, weft-faced non-tarnishing metallic thread, gold, silver, blue and green, 17′ x 9′. Artist, Anni Albers. Temple Emanuel, Dallas, Texas, 1957. (Photo: Hank Tenny.)

brick into which the ark is set. From the dark ceiling of the high dome, pipe-shaped lamps are suspended at uneven heights. They are cut open on the side facing the *bimah*, and thus cast a strong light onto the brick wall. Light, dark, void, brick and the scintillating effect of the mosaic-dotted mortar forcefully evoke the sensation of heat, of sun, sand, and the hardships of the desert—in short, the distant memory of a people who once wandered in the desert and there received the Torah. The gold mosaic which is inlaid into the mortar reflects light and creates over the expanse of the brick surface the flickering design of a seven-branched *menorah*.

The ark doors are covered with a woven fabric designed by Anni Albers. The design of blue, ochre, and yellow squares of this fabric re-echoes and yet contrasts with the horizontal and vertical lines of the brick. The design is repeated in small square openings which are found near the top of the dome, mirroring the blue of the sky, and which maintain a dialogue with the stained-glass walls. Made with identical shapes in light and dark shades of blue, the stained glass becomes richer and denser as it moves toward the ark.

The bright brick wall also contrasts with the dark, fluted wood which covers the upper part of the interior. Yet these panels harmonize with the elongated pipelike shapes of the suspended lamps. The balance of horizontal and vertical lines is also subtly maintained in the design of the *menorah* created by Richard Filipowsky. Although eight feet high and four feet wide at its base, it is hardly visible. This delicate construction consists of a net of vertical bronze rods braced with angled silver ones which create an unequal pattern of voids and solids—a thicket of rods.

The Eternal Light, shaped of bronze rods, echoes the dome above it. The Tablets of the Law are made from wood, with gold engraved letters, and are mounted on the brick wall to the right of the ark.

If the goal here was to create an atmosphere of mystery, solemnity, and memory of the distant past, it has been achieved.

(Below) *Interior*, detail, stained glass. Temple Emanuel. Artist, Gyorgy Kepes. (Right) *Temple Emanuel*. Architects, Howard K. Meyer and Max M. Sanfeld. Consulting architect, William Wurster. Artists, Gyorgy Kepes, Anni Albers, and Richard Filipowsky.

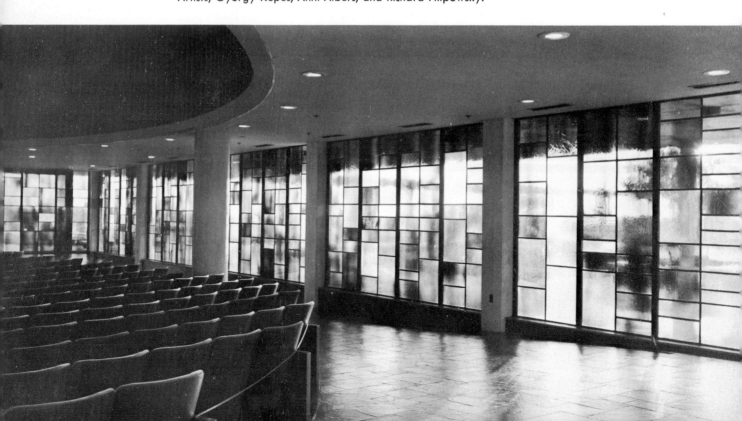

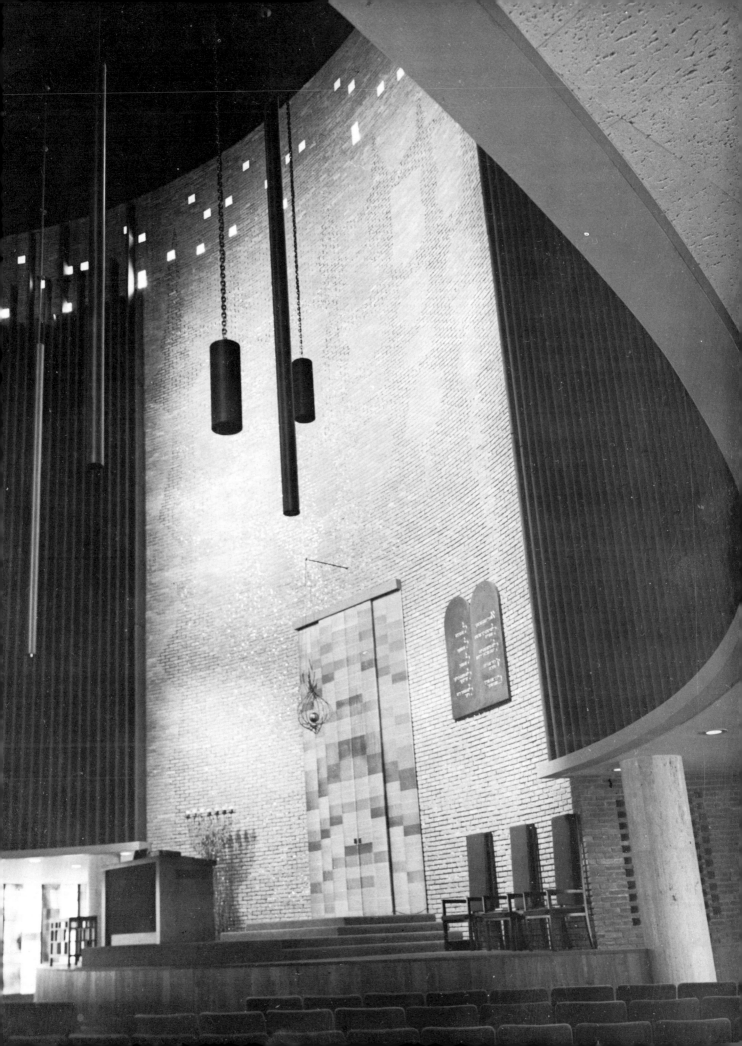

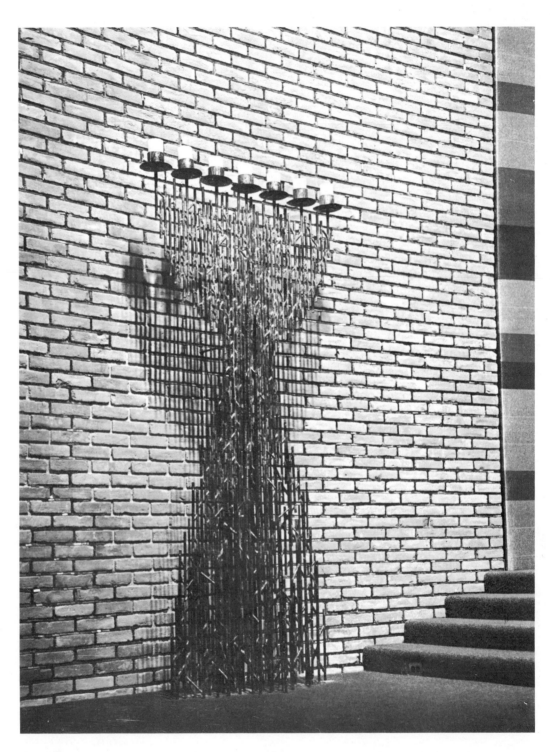

Menorah, bronze and silver, h. 8′, 1958. Temple Emanuel. Artist, Richard Filipowsky. (Photo: Hank Tenny.)

CONGREGATION B'NAI ISRAEL, BRIDGEPORT, CONNECTICUT

The intimate tentlike structure of the prayer hall of Congregation B'nai Israel in Bridge-
port, Connecticut, is dominated by an ark which rises from the floor of the *bimah* to the
ceiling. The upper part of the ark curtain is stationary. The lower part is embroidered and
appliquéd with a colorful design of the twelve tribes, the work of Robert Pinart. He has
created a composition of oblong shapes of different sizes on a yellow background. By
embroidering with rough textured, thick black, gray and white wool—a successful meta-
morphosis of the spirited pen and ink line—he "carved" into the upper part of the design a
mighty letter *shin*, by only a slight encroachment of the wool on the yellow ground. Onto
the lower part he appliquéd a series of alternating rectangular shapes made of colorful
silk. Blue, red, green and violet and the sparkle of metallic thread predominate. Each of
these is in turn itself appliquéd with cotton and silk of different colors and embroidered

Interior. Congregation B'nai Israel, Bridgeport, Connecticut, 1958. Architect, Percival Goodman.
(Photo: Alexandre Georges.)

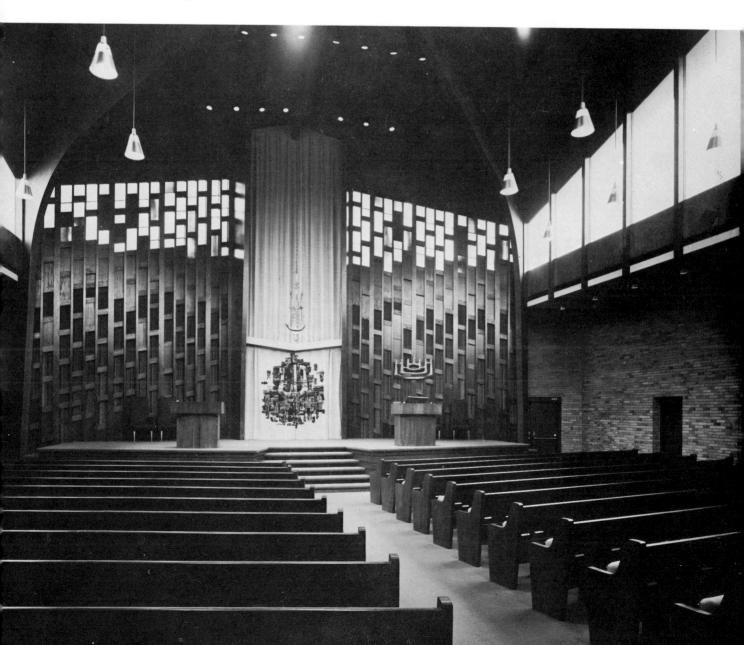

with wool in imaginative representations of the symbols of the twelve tribes. The total effect is stunning. The restful yellow ground is animated by a design which moves slowly from the outer edges of the cloth and becomes more dense, and alive with brilliant color as it approaches the center.

The bronze Eternal Light, designed by Calvin Albert, is suspended from the ceiling and forms a winged lyre whose strings recall the design of the Tablets of the Law. The *menorah*, mounted on the screen to the right, exhibits a rough texture as does the Eternal Light. Its central stem has been omitted. The arms of the *menorah* are interconnected by horizontal links.

An interesting solution has been advanced for the screen which forms the background of the *bimah*. The screen is erected on both sides of the ark and reaches from floor to ceiling. By alternating its vertical beams so that the narrow edges of some project while the flat surfaces of others recede, the artist has added plasticity and a third dimension to the screen. The resultant sculptural effect is heightened by the repeated horizontal sections which move from the sides of the *bimah* in a slight upward slant toward the ark, thus echoing the movement of the roof. The screen, with its three-dimensional appearance, is composed of alternating sections of beam, rung, void, solid and fabric. In the upper region, stained glass is set between the rungs: green, dark blue and amber. The screen might evoke an association with Jacob's ladder.

Eternal Light, h. 6', *Menorah*, 3' x 6', bronze, 1958. Temple B'nai Israel. Artist, Calvin Albert. (Photo: Alexandre Georges.)

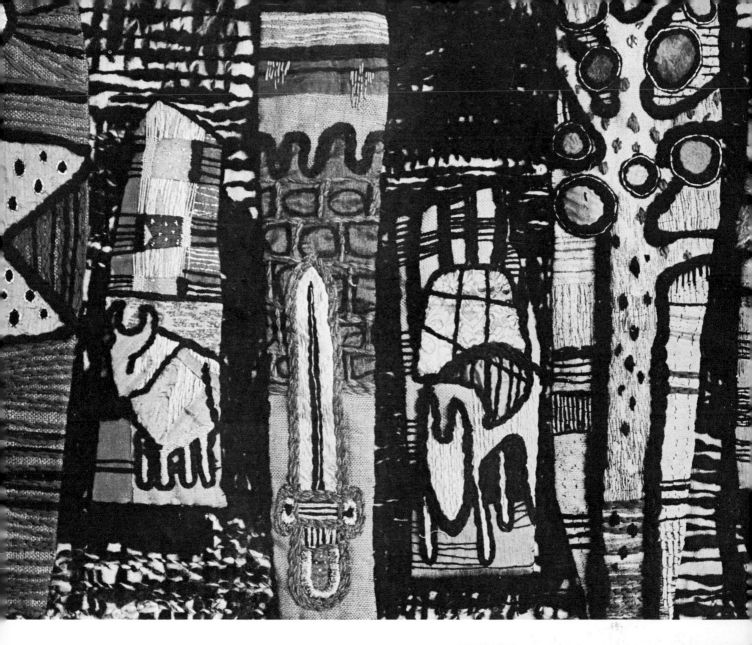

(Right) Ark curtain, wool and embroidered silks appliquéd, 9' x 7', 1958. Temple B'nai Israel. Artist, Robert Pinart. (Above) The Twelve Tribes of Israel, ark curtain, detail.

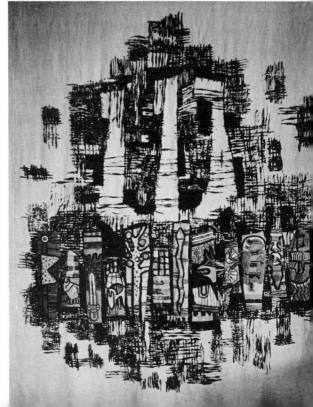

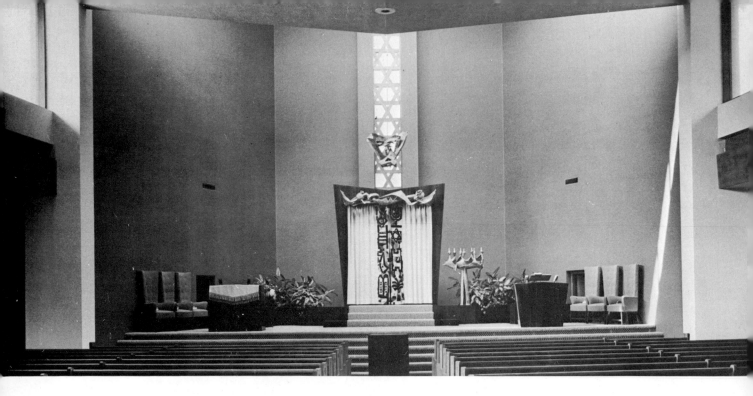

Interior. Temple Israel, Tulsa, Oklahoma, 1955. Architect, Percival Goodman. (Photo: John W. Gough.)

TEMPLE ISRAEL, TULSA, OKLAHOMA

The impressive interior of Temple Israel in Tulsa, Oklahoma, brings into sharp relief the relation of esthetics to the modern synagogue. In this structure, artist and architect have outdone each other in their efforts.

The elemental, almost discordant quality which we noted in the work on the exterior of the building and especially in its huge concrete relief sculptures of the pillar of fire and pillar of smoke and the *menorah* chariot (pp. 120-21), has given way in the interior to a rather festive atmosphere.

The area of the *bimah* is pronounced both in structure and color. The ceiling of the prayer hall declines gently from the sides to the middle in the manner of a tent, and comes to an abrupt stop above the steps of the *bimah*. The *bimah* itself forms the inside of a tower which rises to great height. Its scarlet painted rear wall is divided through the middle by a vertical pattern of Stars of David designed in redwood against dark-blue glass. The carpeting of the *bimah* is deep yellow, the ark structure redwood, the curtain white, with heavy black and polychrome decoration. The *menorah*, the Eternal Light, and the sculpture which is placed along the top of the ark are made of nickel, silver and steel.

The ark's walls incline slightly outward, and its roof slopes from both sides toward the center in a shallow butterfly shape, echoing the slant of the ceiling and alluding to the biblical theme of the horns of the altar. Three steps lead to the ark from the *bimah*. The curtain design done in embroidery and needlepoint consists of two rows of symbols which descend at the center of the curtain where the two parts meet. To the left are the Tablets of the Law, the *shofar*, Jacob's ladder, and an *etrog* and *lulav*. To the right are a *menorah*, a Star of David, a Torah, and a palm tree. The black lines are heavy, their width varies, and their contours are often broken. The total effect of the curtain is a very rich one, since the

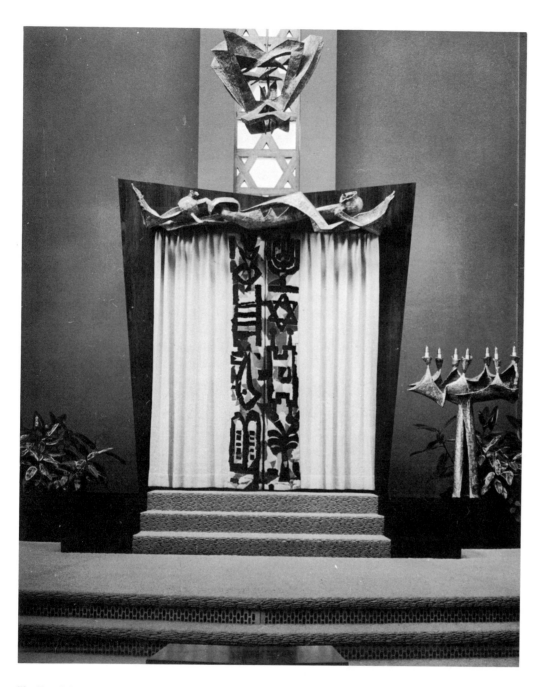

The Fruitful Vine, detail of bimah, sculpture, L. 6'. Artist, Seymour Lipton. *Torah curtain*, 6' x 8', designed by Hans Moller. (Photo: John W. Gough.)

white areas to the left and right of the design create a large, expansive, and contrasting background.

The *menorah*, the vine branch on top of the ark, and the Eternal Light, created by Seymour Lipton, form a sculptural triad, adding plasticity and a metallic glow to a stirring combination of colors.

Somewhat earlier we had the opportunity to study closely the sculpture on the theme of the *menorah* on the outside walls of Temple Beth El in Gary, Indiana (see p. 112). Some features which we discussed there are also apparent in the three sculptures in Tulsa: the interlocking and intersecting of forms; their sheltering, protective, playful character; the juxtaposition of sharp angles and sloping curves; the alternating rhythms of voids and solids; and the effect of exposing interior and exterior surfaces by the involution and slow spread of forms.

The fertile branch on top of the ark is a horizontal elongated sculpture charged with energy, recalling the tenacious struggle of plant life. One is struck by the intertwining long, drawn-out forms that spread in both directions toward the extreme points of the ark. Their alternating thinning and swelling, twist and tension, leanness and ripe fullness is expressed in the form of a branch which becomes a leaf, a leaf which becomes a swelling fruit, a fruit which in turn brings forth the branch again.

The sculptural form of the Eternal Light suspended from the ceiling is based on the wings of the cherubim, which spread out and fold to form a protective enclosure for the flame: an image that evokes the word of the Psalmist: "Hide me in the shadow of Thy wings" (Ps. 17:8).

The light repeats the movement of the ark, since the point at which the wings fold is higher than the center point at which they meet. The feeling produced is indeed one of shelter. That which the fearless lions once guarded has become an open and closed pattern of wings or branches that bow to each other over the light blue flame.

The *menorah* to the right of the ark is one of the most interesting examples of contemporary synagogue art. Its base resembles the split trunk of a tree. Nevertheless its whole being evokes the fullness of youth and the coming of spring. The stem is burst open at the base by an energy it can no longer contain. There is a lightness and grace about the branches which unfold in a rhythmic, ringing, bell-shaped movement and give forth their blossoms. A *menorah*, a tree of life, blooms again. But if one looks carefully one sees not the tree or the branch, but a draped figure, carrying a set of lighted candles in her outspread arms.

The total effect of the *bimah* is stunning. The expressiveness of the shapes, materials, and colors makes the area unique, set apart, a sanctuary for the God of Israel. The historic element has become submerged in the esthetic element. Beauty exists for its own sake. The God Who met Israel in the desert has, by the unpredictable ways of history, become the God of the good and, therefore, of the beautiful. He Who once manifested Himself in thunder on Sinai, in the fire of the burning bush, in His terrible wrath, now manifests Himself in an environment of affluence, even opulence, in a pleasant, highly esthetic setting which seems, however, incongruous with the commanding, almost puritan, simplicity of the Hebraic tradition.

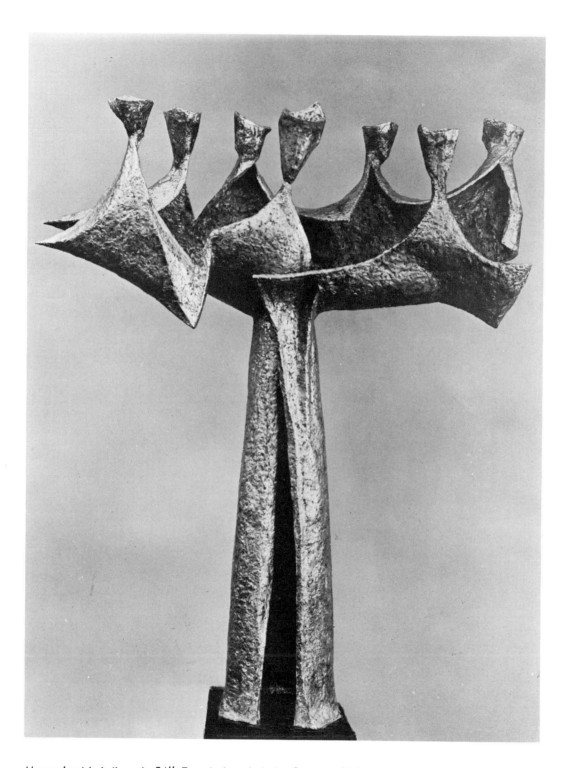

Menorah, nickel-silver, h. 54''. Temple Israel. Artist, Seymour Lipton.

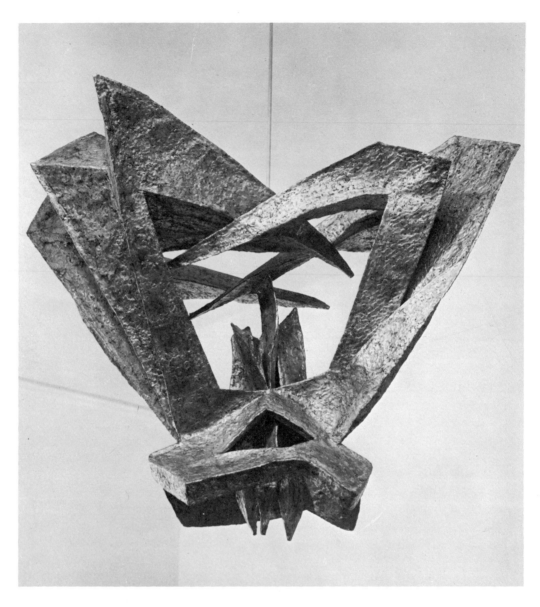

Eternal Light. Nickel-silver and steel, h. 4'. Temple Israel. Artist, Seymour Lipton. (Photo: Oliver Baker.)

KNESES TIFERETH ISRAEL, PORT CHESTER, NEW YORK

The synagogue of Kneses Tifereth Israel, Port Chester, N.Y., is most appealing because of its handsome proportions, its spaciousness, and its precise craftsmanship. We are also impressed by its intellectual clarity, and the severity of its line which is softened somewhat by the gentle glow of sensuous light breaking through long stained-glass openings. These are inserted between man-sized white stone slabs, and form a clear pattern of penetration. Within, the ceremonial objects and the screen of the *bimah* have been fashioned by Ibram Lassaw.

The ark in the center is a wooden chest mounted with flat bronze Hebrew letters. The *menorah* is the most primitive we have ever encountered. It stands, like a stage prop, waiting for the drama to begin. The artist shaped the *menorah* out of hammered bronze, drawing forth all the metal's sheen and glitter. It evokes an image of the first *menorah* fashioned by the biblical sculptor Bezalel, who used a crude mallet and still cruder cutting tools. Like his *menorah*, this one is expressed in a form that is stark and striking. It reflects the light of the desert, the burning sun, the texture of the sand and the scorching wind. It contains traits of the work of both a slave and a free man; it is spiritualized by the very excesses of its primitiveness. It has cutting edges, an unrefined, barbaric heaviness, a wild, almost pugnacious appearance. It is bizarre, frenzied, possessed. Bezalel's *menorah* like this one must have elicited an immediate unrestrained response from its beholders. The divine is evoked by the grotesque.

The Eternal Light is also rude and powerful and appears to be a primitive attempt to suspend the glowing sun from the ceiling. Its roundness was shaped as if the compass had not yet been invented. It hangs like a sun from the set of a futuristic play of the twenties. The airy screen behind the *bimah* ties the cult objects together but is essentially architectonic: its pattern of squares and rectangles and the spaces they enclose, its lightness and delicacy re-echo the spaciousness of the interior, felt in the gently curved vaults of the plaster canopy.

But the props on the stage intrude upon the lofty space. They are meant to embarrass; they disturb; they sting and blind the visual sense. The artist willed them so. An ancient tribal note is struck. Again the divine is evoked by the grotesque.

Congregation Kneses Tifereth Israel, Port Chester, New York, 1956. Architect, Philip C. Johnson.

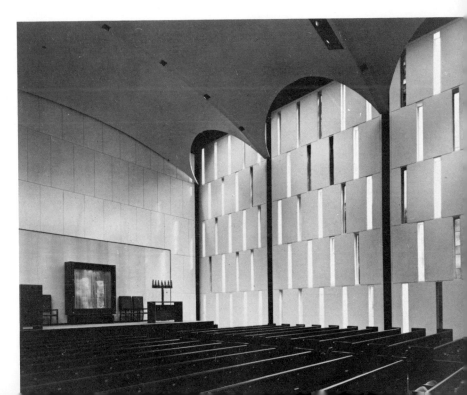

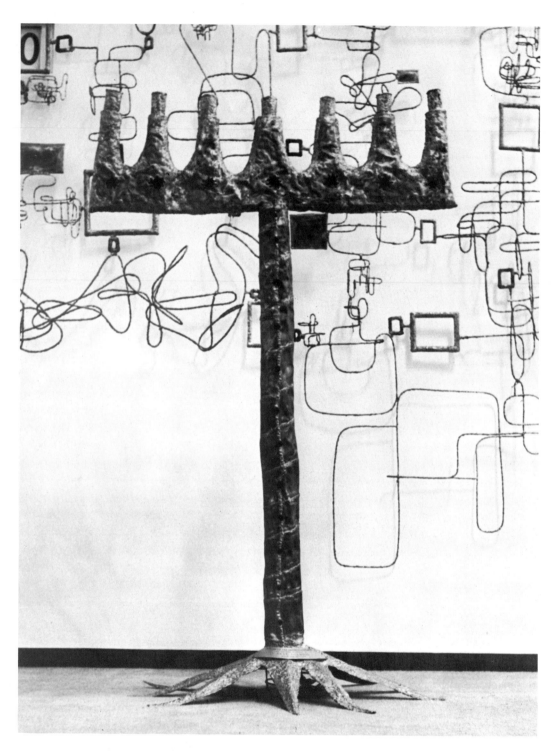

Menorah, hammered bronze, 4' x 6'10''. Congregation Kneses Tifereth Israel. Artist, Ibram Lassaw. (Photo: Ralph Davis.)

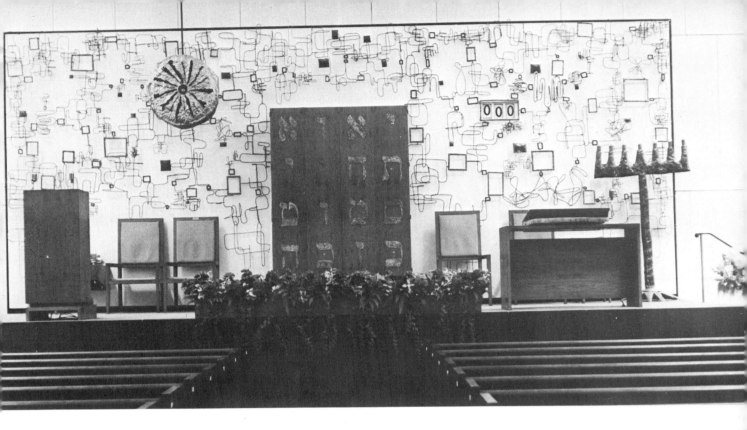

Bimah. Congregation Kneses Tifereth Israel. Architect, Philip C. Johnson. (*Below*) Menorah, detail, hammered bronze. Artist, Ibram Lassaw. (Photos: Ralph Davis.)

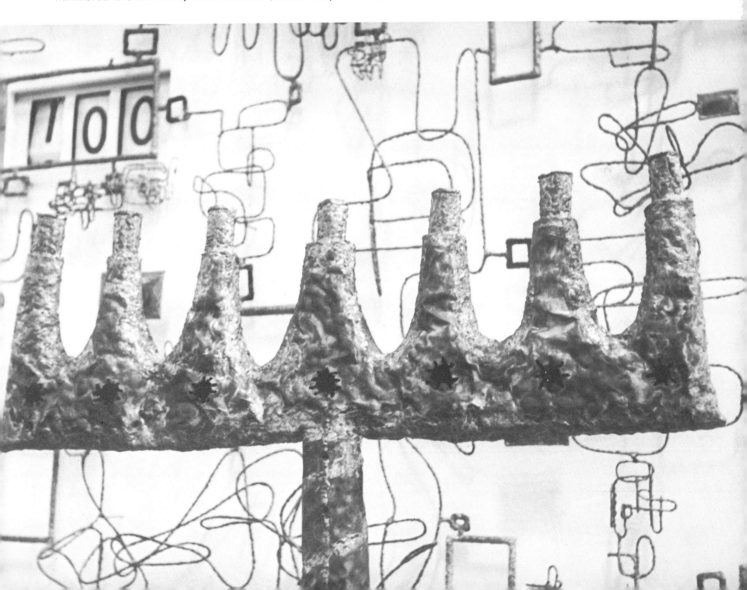

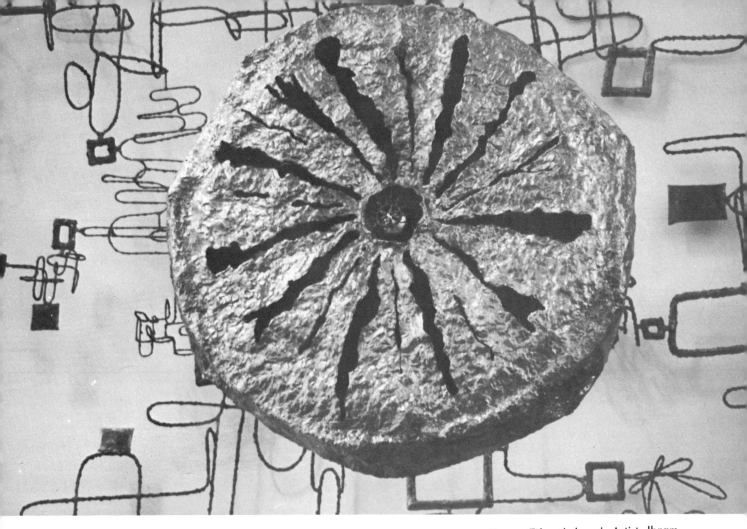

Eternal Light, hammered bronze, h. 3', 1956. Congregation Kneses Tifereth Israel. Artist, Ibram Lassaw.

(*Below*) *Eternal Light*, detail. (Photos: Ralph Davis.)

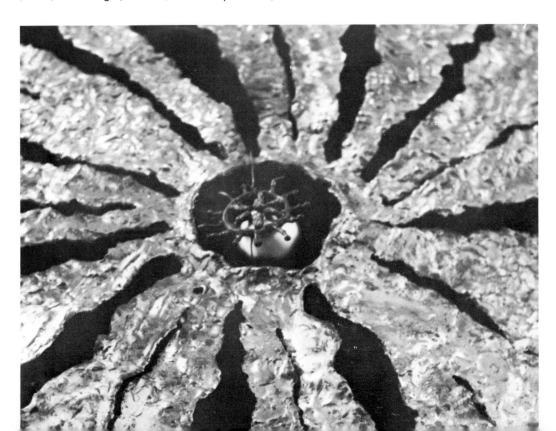

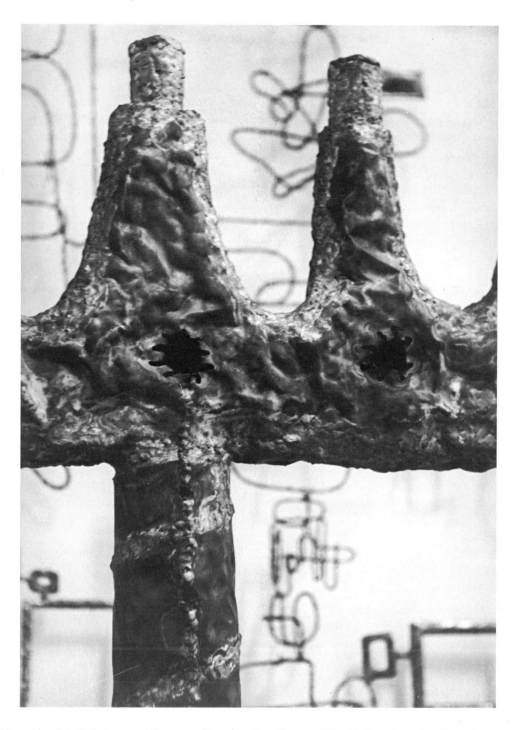

Menorah, detail, hammered bronze. Congregation Kneses Tifereth Israel. Artist, Ibram Lassaw. (Photo: Ralph Davis.)

TEMPLE BETH EL, SPRINGFIELD, MASSACHUSETTS*

A major artistic effort went into the interior design of Temple Beth El in Springfield, Massachusetts. Here the ark, *menorah* and the Eternal Light are seen against a large rose-colored marble screen which consists of four intersecting planes.

The 12′ square ark curtain is of exceptional richness. Its valance, 12′ x 4′, is compartmentalized like the curtain in the Millburn synagogue (p. 85). Decorated with traditional Jewish symbols, in massive sculptural shapes, the design of the valance is woven with a wide range of brilliant colors. The general effect, however, remains subdued and conveys a sense of impressive solemnity. The technique resembles the hooked-rug method of weaving, which results in a handsomely varied surface. Some portions of the valance are sheared to produce an almost smooth texture while others are cut and sculptured or left in full tuft. It is further enhanced by gold, silver and other colored threads which spatter the dominant blacks, deep reds, whites, and yellows.

Both the Eternal Light and the *menorah* are superior works of art. They are conceived with originality, and possess a lightness which gives them an ethereal and poetic quality but which is unfortunately detracted from by the huge bulky wooden pillars on which they are mounted.

The structure of the *menorah*, created by Ibram Lassaw, is unique. Only the rhythmic widening and narrowing of its branches dimly recalls the traditional *menorah*. Everything else has been modified. The branches have been rearranged so that instead of emanating from a central trunk, they are tenuously tied by horizontal bands to form a colorful net of bronze strings. Each branch is composed of a group of undulating strands moving up and down on an imaginary axis. Each varies slightly from the other.

The Eternal Light is a wiry, weblike structure of geometrical forms. It resembles a distant galaxy of stars, for it encloses a cluster of calcite crystals and emits a dim light. Constructed of tiny pieces of copper which are joined together to form an armature, the form is strengthened by coats of unevenly applied molten bronze. In addition the artist has also added stainless steel, chromium, bronze, and nickel-silver in order to achieve a richer texture.

We have here an assembly of a number of fine works of art within a handsome architectural space. However, their integration leaves much to be desired. The Eternal Light is hardly felt, and the *menorah* is overpowered by the wooden beam to which it is fastened. One may also question the formal arrangement of the marble screen, as well as the use of the material itself. The screen has a cold, smooth surface which is not in tune with the warm tan wood, the colorful curtain and valance, the immaterial qualities of the Eternal Light and the shining bronze *menorah*. The seats for the congregational officers do not add character to the *bimah*, although the pulpits of the rabbi and the cantor are very much within the spirit of the building. Their bold distinct shapes and clear lines fully express their purpose. Their position on the two elevations at the sides of the *bimah* was well chosen in that they further accentuate the ark as a central element.

*This building was recently destroyed by a fire.

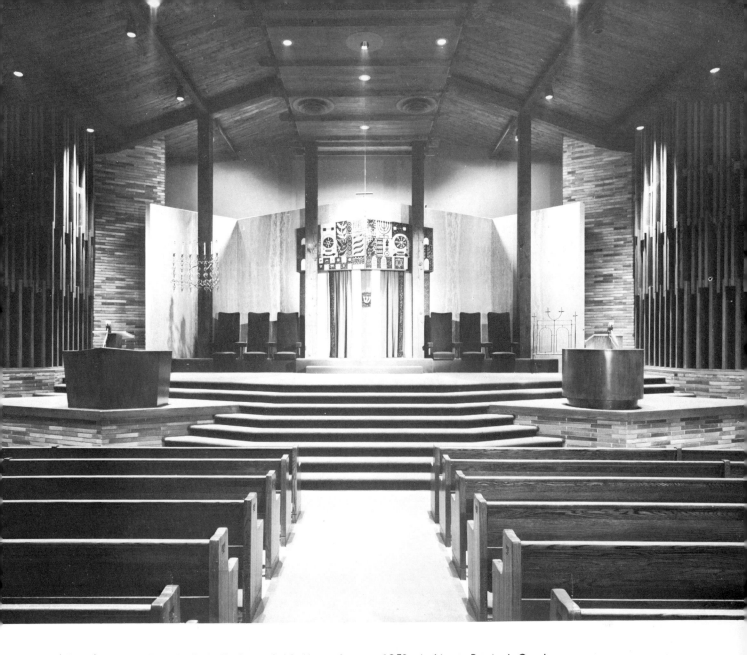

(*Above*) *Interior*, Temple Beth El, Springfield, Massachusetts, 1953. Architect, Percival Goodman. (Photo: Alexandre Georges.) (*Below*) *Valance of ark curtain*, hand-tufted, multi-level, wool and metallic thread, 4' x 12'. Temple Beth El. Artist, Adolph Gottlieb.

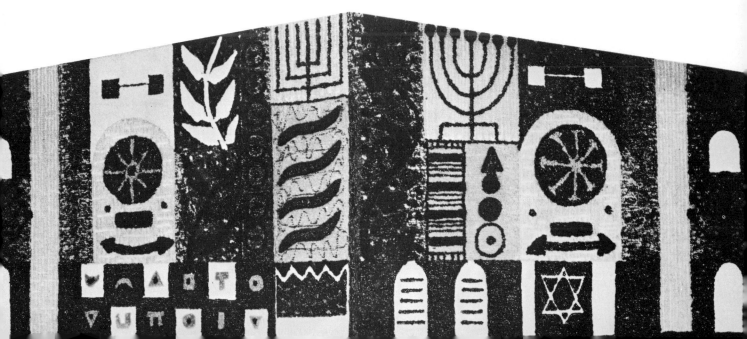

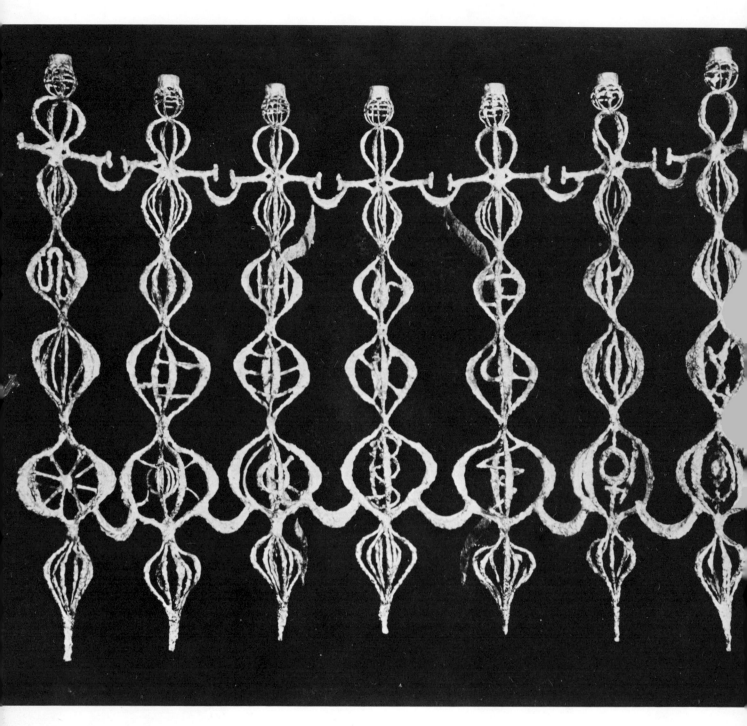

Menorah, bronze, 35″ x 36″ x 30″. Temple Beth El. Artist, Ibram Lassaw.

Eternal Light, bronze, calcite crystal, 2′ x 3′. Temple Beth El. Artist, Ibram Lassaw.

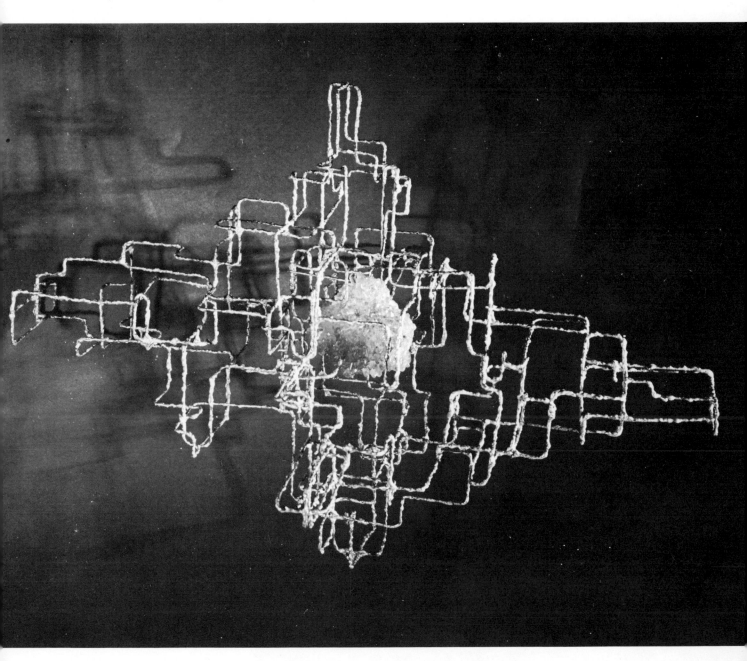

INDIANAPOLIS HEBREW CONGREGATION, INDIANAPOLIS, INDIANA

Rustic, bright Indiana fieldstone creates the curved background for the impressive, tall, free-standing ark, the blue, gold and silver striped curtain, and the light and spacious prayer hall of the Indianapolis Hebrew Congregation. The screen on either side of the ark is divided into two parts, one receding behind the other, thus creating greater linear and spatial complexity without disturbing the vertical dominance of the ark.

The inside of the ark is faced with blue mosaic tiles and a large threefold inscription with the word קדש (holy). The inscription on the lowest level is made out of fossilized stone to signify things below the earth. The middle inscription is modeled out of clay, signifying the things of the earth, and the upper word is carved out of wood, symbolic of the things above the earth.

A restrained and rational approach, with universal and pantheistic overtones, is carried consistently throughout. There are no stained-glass windows in the prayer hall. Instead, a continuous band of translucent panes underneath the roof line floods the building with clear daylight. Stained glass was purposely avoided. An undramatic, rational approach pervades the entire conception of the structure.

An educational approach is carried into the youth chapel adjacent to the prayer hall. The idea of historic time is evoked by the ark, which is a chest made of natural oak wood, sanded down so that the sharp linear flow of the grain speaks to us of its inner growth. The ark rests on long bars which are sparsely decorated with a coil of rope on each end. The bars, kept about three feet high, are in turn supported by wrought iron legs which rest on a large slab of rock. The ark is opened by two small bronze knobs in the form of the Tablets of the Law.

There is a stark quality in the entire arrangement which may well have an important long-term effect on the youth who worship there. The original mobility of the ark is dramatized by the bars and the coiled rope. The contrast of plain oak to bare rock evokes for the youth a sensuous image of the wandering Tabernacle in the desert.

Ark for youth chapel, wood, 1957. Indianapolis Hebrew Congregation, Indianapolis, Indiana. Artist, Ray Craddich.

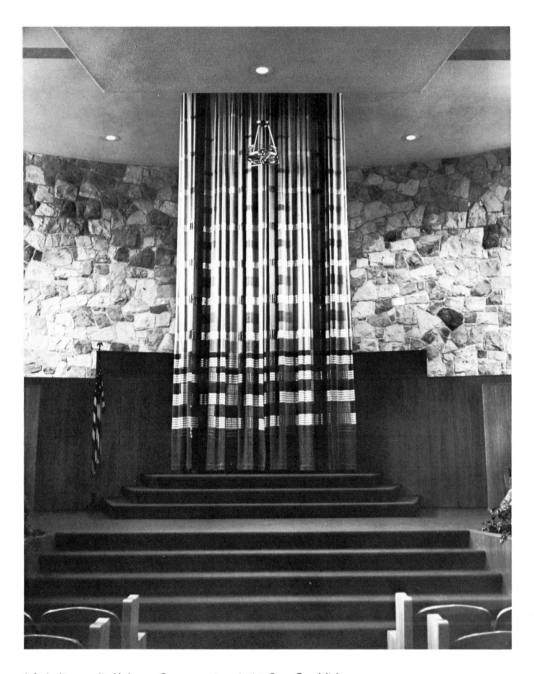

Ark. Indianapolis Hebrew Congregation. Artist, Ray Craddich.

TEMPLE BETH EL
GREAT NECK, NEW YORK

For Temple Beth El in Great Neck, New York, the late Ilya Schor designed and executed two silver ark doors in repoussé. They represent a unique work in contemporary synagogue art.

The doors are six feet high and contain thirty-six panels, each 10 by 5.5 inches. There are eighteen panels on each door. Called the "Doors of the Thirty-Six," they refer to the Chasidic legend of the *Lamed Vav* (36). According to this legend, in each generation live thirty-six exceptionally wise and good men, who are unknown to their fellows or even to themselves, and by whose grace the world can continue to exist.

Schor takes the artistic liberty of applying the legend of the thirty-six to biblical heroes. He divides his theme into six parts. The first part consists of the patriarchs: Abraham pleading with God not to destroy man; Isaac blessing Jacob; Jacob's dream; Abraham and the three angels; the sacrificing of Isaac; and Jacob wrestling with the angel (panels 1-6). The matriarchs fill the first four sections of the second row. Sarah holds Isaac, Rebecca serves Abraham and his camels, Rachel draws water from the well, and Leah appears as a weeping bride (panels 7-10). Panels 11 to 18 are devoted to the bondage in Egypt and the liberation. They depict Joseph's dream in which the sheaves of wheat bow down to him, the finding of Moses, the burning bush, Moses receiving the Tablets of the Law, the song of liberation, Miriam's dance, the blessing of Aaron, and Bezalel creating the first *menorah*. The leaders and judges of ancient Israel follow: Joshua commands the sun to stand still; Deborah sings of victory; Eli teaches the child Samuel; Samuel anoints Saul as king; the daughter of Jephthah rushes to greet her returning father (panels 19-24). Then four panels on kings of ancient Israel follow: David plays his harp for Saul; David slays Goliath; David writes the Psalms; and Solomon judges between the two women (panels 24-27). The remainder of the panels deal with the prophets: Elijah fed by ravens; Elisha mocked by the children; Isaiah receiving the gift of prophecy; Jeremiah cast into prison; Zechariah recounting his vision of the *menorah*; Amos envisioning the basket of fruit; Ezekiel's vision of the Second Temple; Job visited by his three friends; and finally, Daniel in the lion's den (panels 28-36).

The didactic value of this kind of work has already been observed.[22] In its depiction of historical events of the Bible, the work continues the ancient narrative tradition of the Hebrew arts. The design of the panels is abstract but does not obscure the meaning of each one. In the same way, the narrative element has not affected the quality of the design. The faces of the figures are only indicated. Most of the panels exhibit a genuine synthesis of form and content and the over-all effect is extremely pleasing. The metal gives off a muted glow. The panels reflect genuine feeling for the human quality of the biblical narrative—its drama and its literary and artistic values.

(*Opposite page*) *The Doors of the Thirty-Six*, ark doors, silver repoussé, 6½' x 3½', 1955. Temple Beth El, Great Neck, New York. Artist, Ilya Schor.

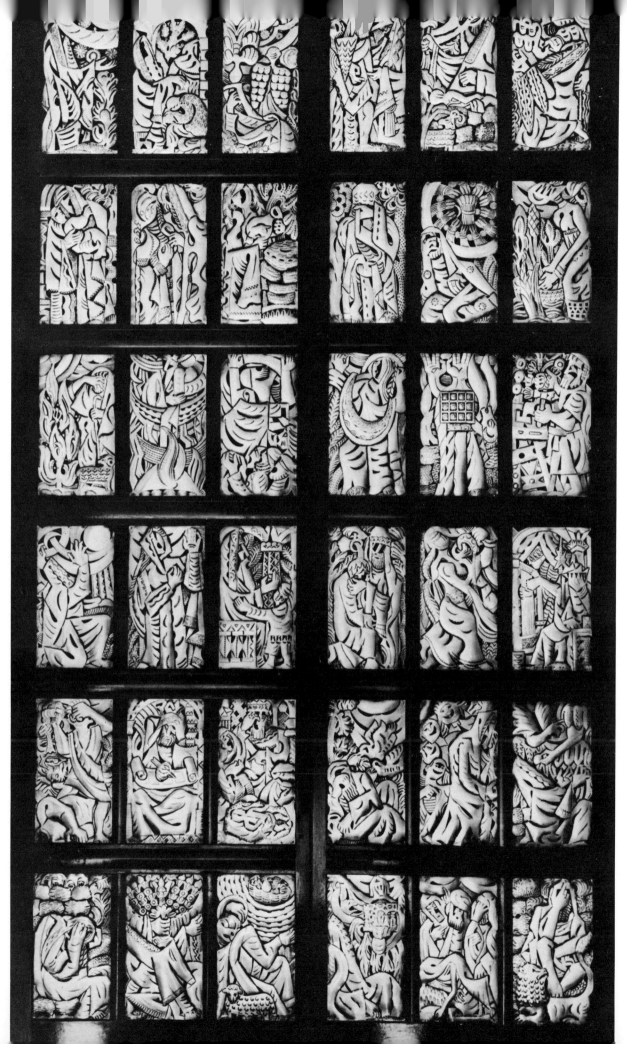

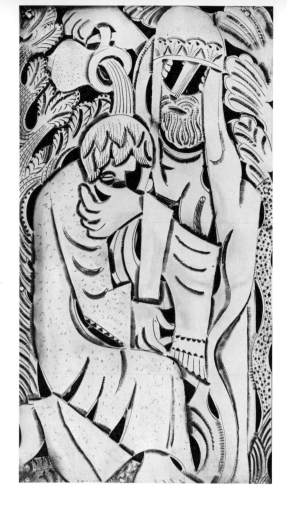
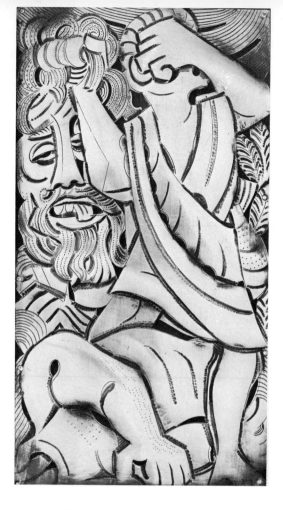

Ark door, details, (above) *Samuel Anoints Saul, David Slays Goliath.* (Below) *David Plays for King Saul, Joseph's Dream.* (Photos: J. J. Breit.)

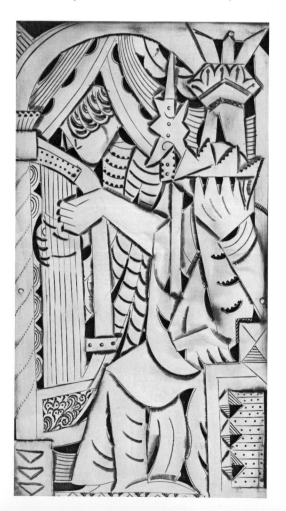
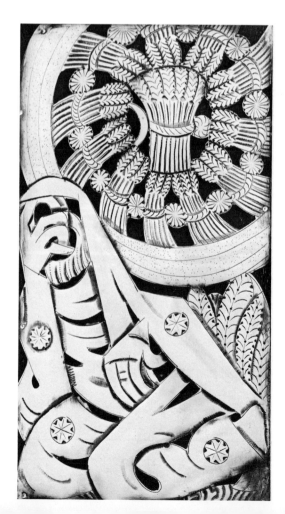

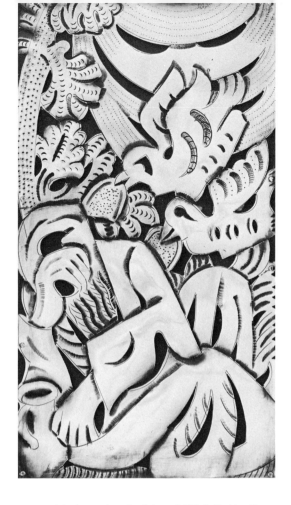
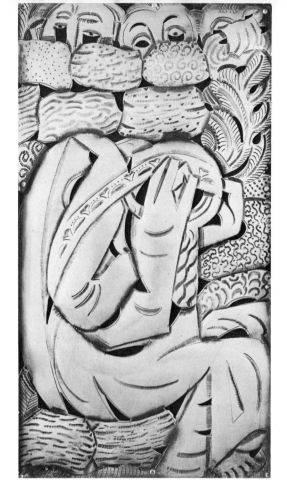

Ark door, details, (above) *Elijah Fed by Ravens, Jeremiah in Prison.* (Below) *Elisha Mocked by Children, Job Visited by Friends.* Size of panels 10″ x 5½″. (Photos: J. J. Breit.)

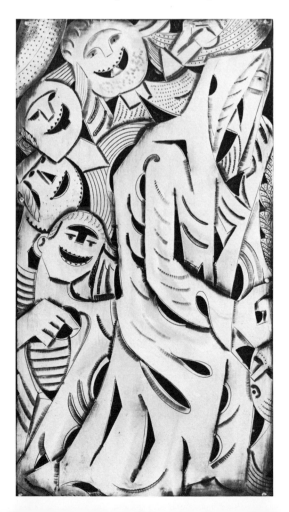
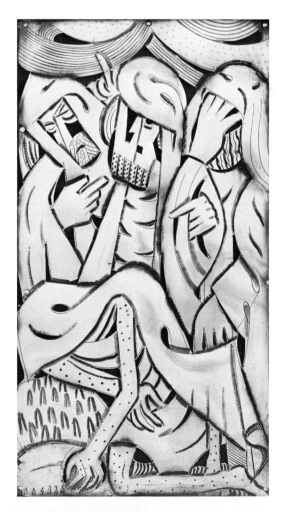

PARK AVENUE SYNAGOGUE
NEW YORK, NEW YORK

The pewter-like lead alloy which Calvin Albert used in the chariot *menorah* in Tulsa, Oklahoma (pp. 120-21), he again used in the chapel of the Milton Steinberg House of the Park Avenue Synagogue in New York City. Here the molten lava-like mass has cooled to form battered ark doors. The execution of the imagery is among the most meaningful to be found. The lion and the *menorah*, the eagle and the crown, the moon and sun have all been worked with passion. Ripped, burned, and still seething in appearance, as if they had been just taken from the crucible or saved from the burning ghetto, the doors bear the evidence of pain and fury. The ever-continuing inner combustion of the ark doors points to the fact that they derive from the age of the gas chamber and atomic slaughter. Art has adjusted them to the world we live in. The mighty lion is wounded and burned. The *menorah* is disintegrated. There remains only a trace of its shape. Its branches, molten from the heat, contain a bubbling volcanic mass which has suddenly frozen. The eagle is on top of what is left of the crown, both near remnants of their original shapes. The eagle hovering over the debris has scorched wings. Out of the furnace, from the pitted surface of the leaden doors issues doom.

The vitality and expressiveness of the work derive from the artist's understanding and use of the material. He actually molds the lead like clay. He has shaped it with blow torches, disk grinders, rotary files and rasps. With a variety of soldering irons he has incised and drawn on the lead to achieve a wide range of textures. There is no separation here between the mechanics of the work and its esthetics. Albert, like many of today's artists, mistrusts the smooth finish and seeks here to unite the work process with the creative act.

The over-all effect of the work remains subdued. By the mysterious alchemy of beauty, the ark doors become restful and instill a mood of revery and contemplation in the viewer. Their silvery blue sheen suggests the surface of a lunar landscape, whose smooth surfaces and deep ragged crevices are both dramatic and infinitely calm.

It is questionable whether the *menorah*, which stands to the left of the *bimah*, keeps the promise of the ark. It lacks the consistency of design which the ark exhibits. The movement of the stem expresses the force, age, and energy of the roots. The long sinuous and petrified skeins cling to each other in their rising. Yet the *menorah's* arms, in their delicate balance, contradict the force of the roots and the twisting stem.

(*Opposite page*) *Ark doors, pewter alloy, 5' x 4', 1954. Park Avenue Synagogue, Milton Steinberg House, Chapel, New York, New York. Architects, Kelly and Gruzen. Artist, Calvin Albert. (Photos: Oliver Baker.)*

Ark and Eternal Light, white Appalachian wood, 12' x 8', 1960. Temple Israel, West Virginia. Architects, Moses and Hancock. Artist, Milton Horn. (Photo: Estelle Horn.)

TEMPLE ISRAEL, CHARLESTON, WEST VIRGINIA

Milton Horn, whose limestone sculpture on the exterior of Temple Har Zion in River Forest, Illinois, has already been explored (pp. 96-99), carried figurative representation into vigorously carved ark doors for Temple Israel in Charleston, West Virginia, and Temple Isaiah in Forest Hills, New York.

In Charleston, the sculptor has chosen white Appalachian oak for the ark and left the wood in its natural color, in order to contrast it with the dark brown louvered screens which flank the ark on both sides and conceal the organ and choir.

The ark, resting on a pedestal and mounted by an Eternal Light made out of wood, gives the feeling of being portable. The seven-foot doors, carved and perforated, slide in front of two panels which bear the first ten letters of the Hebrew alphabet carved in relief.

The theme of the ark doors is *Agadah* and *Halakhah* (Legend and Law, Imagination and Deed). According to tradition, before God gave Moses the Tablets of the Law, He instructed him to create the sculptured cherubim, the curtain and the *menorah* (Exod.

25:31), symbols to summon forth the imagination. The artist felt that this appeal to the imagination is the essence of *Agadah*. He therefore portrayed Bezalel, the biblical artist, "the son of Uri and the son of Hur of the tribe of Judah," with chisel and mallet in hand carving the cherubim for the ark from a tree trunk. In the upper right of this panel is the carved *menorah*, the forms of which were shaped in accord with the organic lines of the almond tree. Above the figure of the biblical artist there appears the open hand of the Lord, indicating the divine force which inspired the labor. The biblical passage tells us that the Lord filled Bezalel "with the spirit of God, in wisdom and understanding, and in knowledge and in all manner of workmanship, to devise skillful works, to work in gold and in silver, and in brass, and in cutting of stones for setting, and in carving of wood, to work in all manner of workmanship." Every sculptor must feel some identity with his biblical brother. Indeed, the artist appears to have sculptured the face of Bezalel, which dominates the composition of the right door, in his own likeness. The tree trunk on which Bezalel carves is at the left edge of the right door, while on the left door the tree has caught fire and has partly turned into a burning bush out of which the ascending figure of Moses receives the Torah. Both *Halakhah* and *Agadah* are thus interpreted as divinely inspired, a notion which *Agadah* endorses.[23] Lawgiver and artist are given equal status.[24]

The two ark doors are treated as a unit. When they are closed, a plant stands between the figures of Bezalel and Moses. On the side facing Moses the tree is aflame, and on the side facing Bezalel it is growing foliage. The carving is energetic and vigorous. The wood has been roughly hewn, neither rasped nor sandpapered. The gouge strokes play with the light and give to the whole a vibrating surface; they animate the doors and activate the figures, giving them an impressionistic quality. Here and there, the doors are perforated. The Eternal Light, too, is carved in the shape of a portable ark, with its curtains parted. The amber glass behind the perforated relief of the Eternal Light creates a soft glow in the interior of the ark, which can be seen through the perforations in the door even when the ark doors are closed.

TEMPLE ISAIAH, FOREST HILLS, NEW YORK

In Temple Isaiah, Forest Hills, New York, the black walnut ark doors have been impressively carved. The theme of fire and plant are again combined in a vigorous sculptural metaphor on the primal force of nature. Vigorously carved the branches, or flames, shoot up from the ground, and can be neither contained by the door frame nor consumed by the fire. They bear blossoms and leaves striving to unfold. Against the strictly rectangular door frame and its smooth finish, the artist has set the struggling movement of a plant which turns and twists in its efforts to grow. Without arresting the force of the upward thrust, he has inserted into the frame the Hebrew words heard from the bush: "I am that I am."

In both works, the artist has attempted, in the use of images of fire, plant and figure, to transcend the images themselves and to penetrate their elemental symbolism.

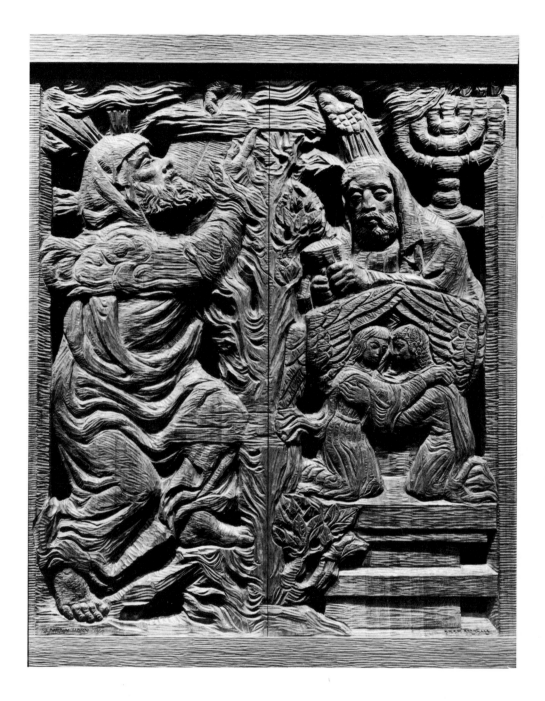

(Left) Moses receiving the Law; (Right) Bezalel carving the Cherubim, white Appalachian wood, 6½'
x 3'4", 1960. Temple Israel, Charleston, West Virginia. Artist, Milton Horn. (Photo: Estelle Horn.)

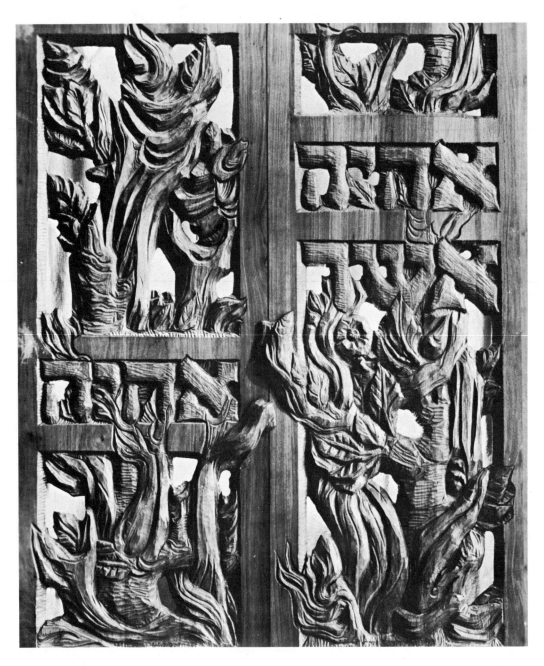

(*Above*) *Ark doors,* black walnut, 6' x 4', 1953. Temple Isaiah, Forest Hills, New York. Artist, Milton Horn. (*Opposite page*) *Sketch for ark,* pen and ink, 1958. Artist, Boris Aronson. Courtesy the artist. (Photo: Robert Galbraith.)

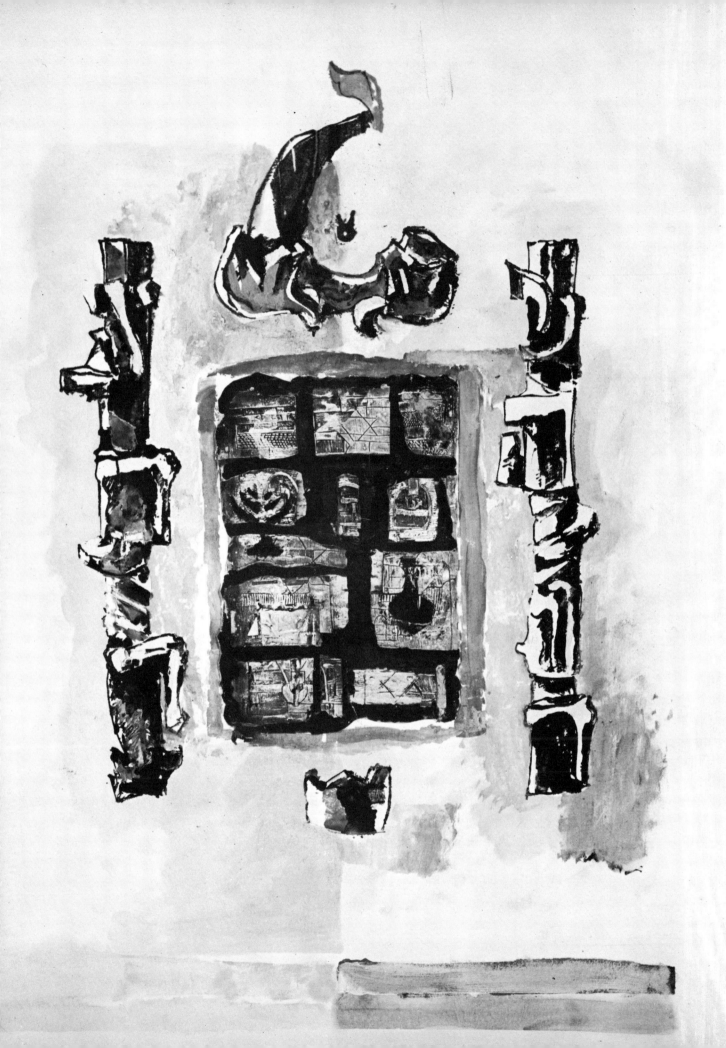

TEMPLE SINAI, WASHINGTON, D.C.

For the ark of Temple Sinai, Washington, D.C., Boris Aronson has rendered the Hebrew *Aron Kodesh* (ark) in its most literal sense as a holy chest. The artist feels that the most spiritual objects should be hand-made without mechanical parts. The holy demands that one become aware of the inner life of an object. For Boris Aronson, religion is essentially a fundamental, primitive and personal experience. It includes faith, trust, and reverence; its forms and artifacts must bear corresponding traces of these feelings. The cuts, incisions and marks of the artist's hand and tool leave evidence of his time and thought, of his own immersion in the work, the intensity of his effort. The artist should not attempt, Aronson feels, to be overly-clever about an ark. It ought to open simply, like a box, without any tricky innovations or push-button gadgetry.

The eight-foot columns on the side of the ark give it frame and accent. Together with the ark, they hint at an open Torah scroll. They represent something dignified; they bring to mind designs on the opening pages of old Hebrew manuscripts. But the manuscript pages too, were merely a point of departure for the artist. He dematerializes the columns to such an extent that there remains only an imaginary axis. He carves a pattern of hollows into the wood, thus showing us simultaneously its inside and outside. By creating a rhythm of void and solid, he evolves an imaginative shape—the idea of a column rather than the column itself. Just as a student explores a question in the Talmud from every conceivable angle, so the artist examines the possibility of the old book design motif for the shape of the ark. He probes the wood, bringing forth its essence as he advances toward the solution of the problem he has set for himself: to accept the concreteness of the symbol, evoke its shape, accept the limitation it imposes, and to arrive at the inner meaning of the ark by way of its design.

One significant aspect of the columns is the Hebrew lettering יהוה אחד (God is One), which is an integral part of the columns' shape and substance. The letters are not superimposed on the columns but form an organic part of them; they participate in the columns' formation. They are so native to the structure that those ignorant of Hebrew do not realize they are letters, but the knowing derive pleasure from them. As the letters grow out of the column, they vary in proportion and widen and narrow in conformity with the shape of a column, project forward and recede into its interior, or move around its axis.

The design, therefore, is neither totally abstract nor burdened by calligraphy. The shapes of the letters constitute the design of the columns. And yet the total pattern rises above the structural limitations of the letters, their horizontal and vertical (except for the *aleph*) linear elements.

Below the chest the artist has carved a single crown, symbol of the authority of the Torah. Above the chest he has carved the Hebrew letter *yod*, which stands for the name of God. The letter terminates in a *shofar*—a ram's horn—which curves down toward a pair of hands in the position of the priestly benediction. Hidden within the triangular shape formed by the design is the Eternal Light, a flame enveloped within a sculptured pomegranate which is cut open to show its seeds. The accent is placed once more on concrete

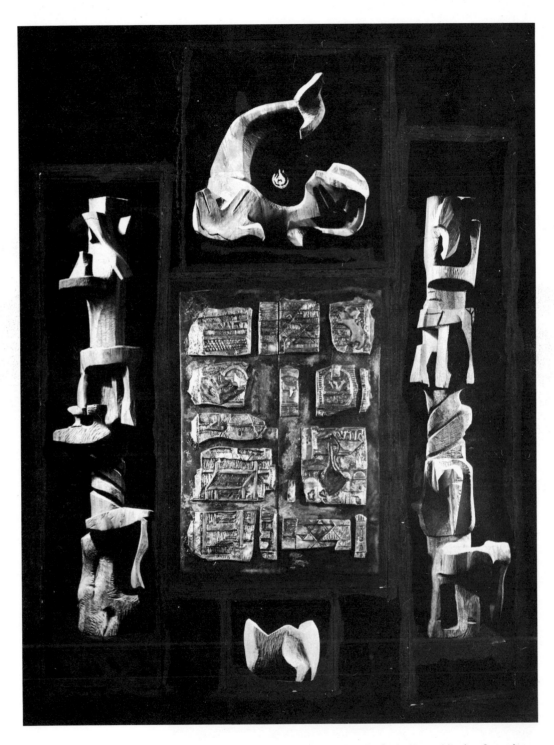

Ark, wood, metal, enamel, 11′ 3″ x 8′. Temple Sinai, Washington, D. C. Architect, Nicolas Satterlee. Artist, Boris Aronson. (Photo: Robert Galbraith.)

traditional symbols. The over-all sculptural shape stems from the organization of these symbols into a rhythm of opposing movements.

The doors of the chest are covered with a variety of uneven silver and enamel panels which project at different distances from the background. They create an impression of cracked clods of soil or an assembly of fragments of a long-buried treasure. The surfaces are encrusted like an old wall, sculptured and incised with a variety of traditional symbols: the lion, the *menorah*, the pitcher, the Star of David, the *chuppah*, the Hebrew word *Shaddai*, an ancient name for God. The color is muted but has rich accents. The eye constantly discovers new formal relations and hidden continuities in the design which is constantly active. The letters of the word *kadosh* (holy) are grasped for a moment before they submerge again into the richly worked surface.

The *menorah*, made of hammered bronze, is consistent with the over-all design. Its geometry echoes the square forms of the ark. The arms are combined in an unusual arrangement—the pattern of void and solid is highly imaginative. Spiraling shapes in the solid upper parts of its arms recall the movement within the columns and also remind us of the ceremonial Sabbath bread. The gnarled texture of the *menorah* corresponds to the texture of the doors, the sculpture always revealing the expressive touch of the artist. The severe discipline of *Halakhah* mingles with the poetic lightness of *Agadah*. Traditional symbols have become expressive contemporary sculpture evoking a memory of the loving craftsmanship and bizarre rhythms of folk art—of wood carvings in the destroyed eastern European synagogues.

(*Below*) *Sketch for ark doors*, Temple Sinai. Artist, Boris Aronson. (Photo: Robert Galbraith.) (*Opposite page*) *Columns flanking ark with inscription* יהוה אחד (God is One), detail of ark, teak wood, h. 8'. Temple Sinai. Artist, Boris Aronson. (Photo: Robert Galbraith.)

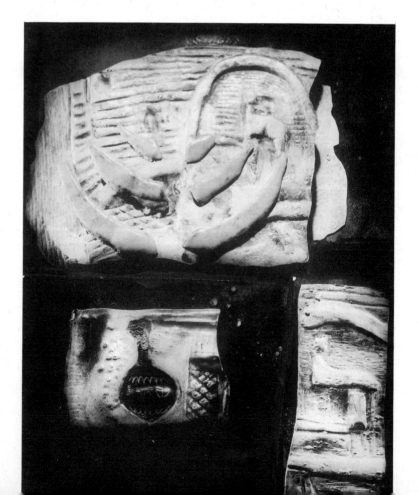

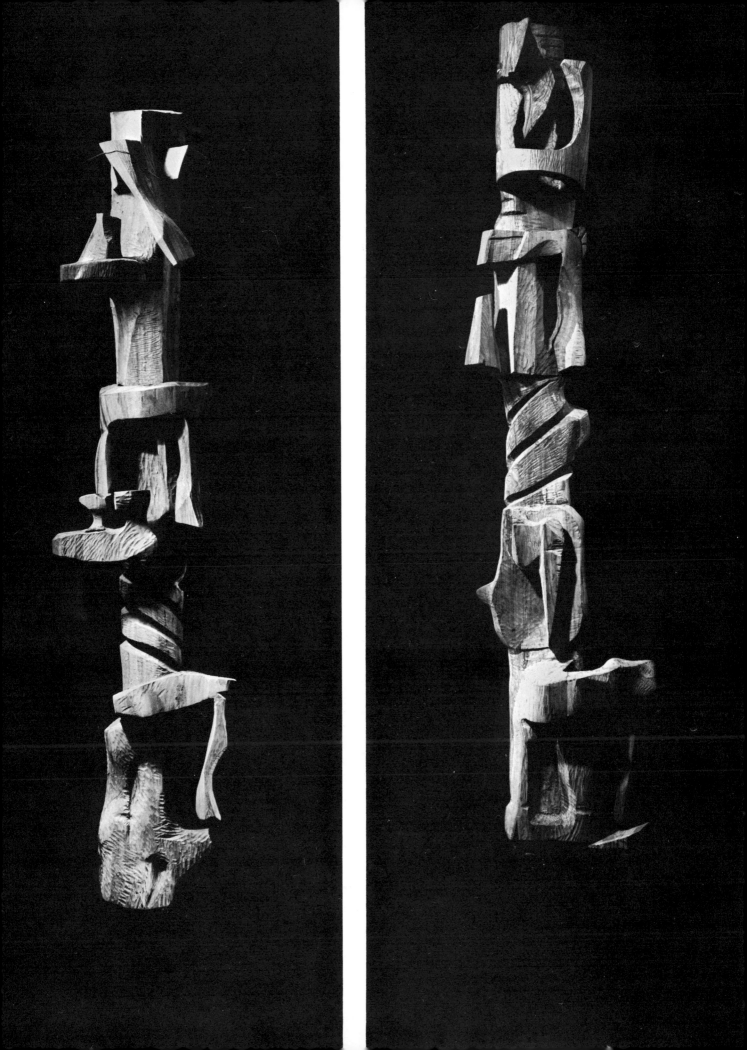

Ark doors, metal and enamel, 5' x 3'6''. Temple Sinai. Artist, Boris Aronson. (Photo: Robert Galbraith.)

Benediction, detail of ark, teak wood, h. 3'. Temple Sinai. Artist, Boris Aronson. (Photo: Robert Galbraith.)

(*Above*) *Eternal Light*, bronze, h. 6″, 1961. Temple Sinai. Artist, Boris Aronson. (Photo: Robert Galbraith.) (*Opposite page*) *Menorah*, bronze, 8′6″, 1961. Temple Sinai. Artist, Boris Aronson. (Photo: Robert Galbraith.)

BERLIN CHAPEL AT BRANDEIS UNIVERSITY, WALTHAM, MASSACHUSETTS

At the Berlin Chapel of Brandeis University, designed by Max Abramowitz, a sculpturesque ark with high pitched roof and smooth surfaces receding backward and downward faces us at an acute angle. As its doors open sidewards from the rear, the gold-leafed ark assumes a winged appearance. It reveals a two-part brightly woven and embroidered curtain that moves from the left and right rear to the center following the projected angle. The combined effect of the gold-leafed structure and bright curtain is stunning. It imparts a light, airy and buoyant quality to the free-standing ark, which rests on a small and narrow marble base. Its ancient mobility is dramatized by the speed of the sharp angular oppositions, the slant of its dynamic lines in a subtle and delicate balance effortlessly held.

The application of the gold leaf in small square sections gives to the surface of the ark a scintillating effect and rich linear pattern akin to the design of the spattered gray brick walls at the sides of the *bimah*. The ark stands against a white curtain the black stripes of which are reminiscent of the traditional Hebrew prayer shawl.

The ark curtain delights the eye with its bright dazzling color, the rhythm of the linear movement of the yarn, and the rich variety of shapes. The impressionistic quality of the sketch, designed by Mitchell Siporin, and executed by Helen Kramer, was beautifully transmitted to the curtain by the hooked rug and embroidery technique. Each shape on the sketch was treated with a multitude of shades of the same color. The yarn moves in a closely knit, linear, straight, or concentric pattern. Each strand is different in shade from the others, as is each linear movement within an area. Red metallic yarn spattered throughout the whole makes the colors sparkle like a Monet canvas. A crown and *menorah* pattern are woven into the design.

The *menorah* created by Herbert Ferber stands between the *bimah* and the first row of benches (not on the *bimah* as is usual). Treelike, its branches shoot upward, interlace and fan out, weaving a pattern of curved and vertical lines into the high elliptical space of the chapel. When observed closely, the crown reveals the outlines of the Hebrew word אמת (truth). In its position in front of the *bimah* the *menorah* adds depth to the space behind.

The artist created the Eternal Light as a wire spheroid, pierced by strips of metal which are braced with copper, as if he had foreseen the coming of the man-made moons.

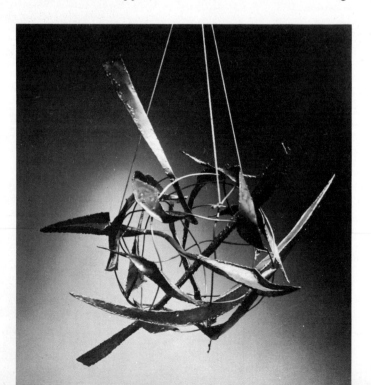

(Left) *Eternal Light*, brazed, h. 2', 1955. Berlin Chapel, Brandeis University, Waltham, Massachusetts, 1955. Artist, Herbert Ferber. (*Opposite page*) *Ark*, wood, h. 10', Max Abramowitz; *Torah curtain*, embroidery, 4' x 5', Mitchell Siporin; *Menorah*, bronze, h. 5'; *Eternal Light*, Herbert Ferber. Berlin Chapel. (Photo: Ezra Stoller.)

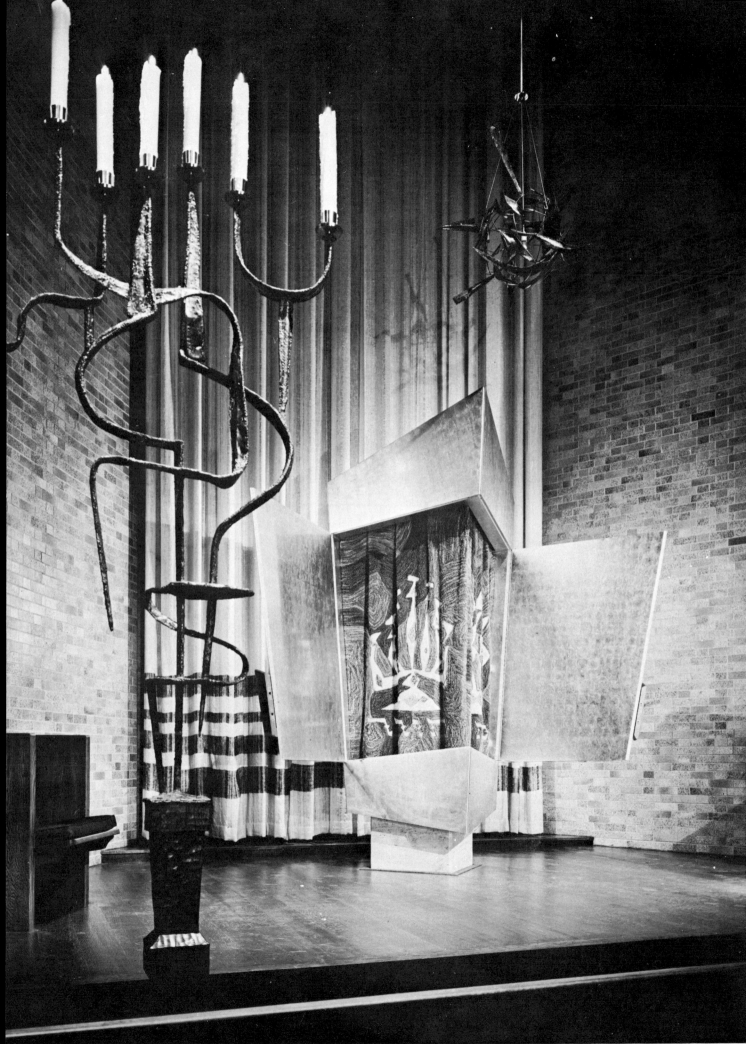

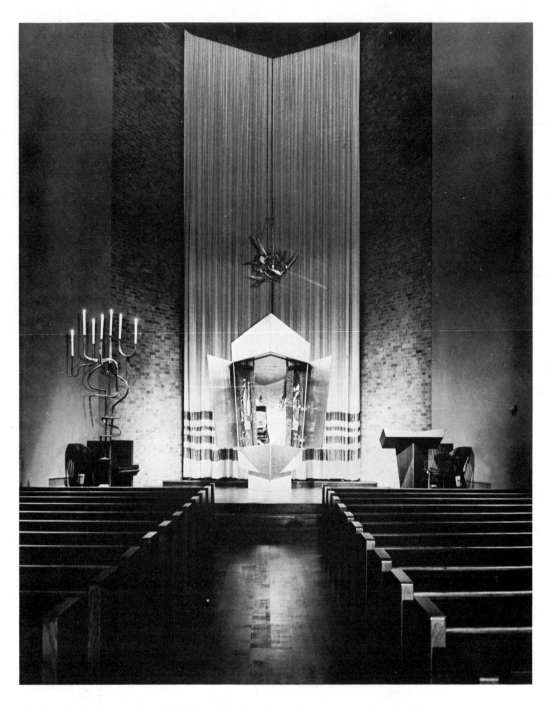

Interior, Berlin Chapel, Brandeis University. Architects, Harrison and Abramowitz.

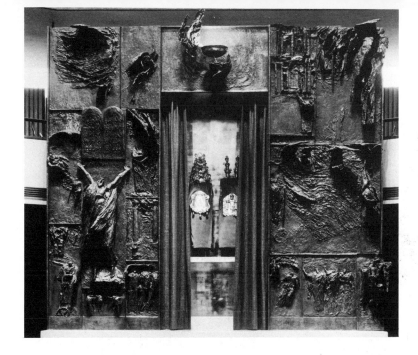

Ark, bronze, 13'6" x 16'6", 1964. Temple B'rith Kodesh, Rochester, New York. Architect, Pietro Belluschi. Artist, Luise Kaish.

TEMPLE B'RITH KODESH, ROCHESTER, NEW YORK

Man's encounter with God, his struggle with Him, his rebellion, flight, submission, exile and redemption are the subjects which have preoccupied Luise Kaish in her monumental bronze cast ark for Temple B'rith Kodesh in Rochester. This ark, 15'6" x 13'6", stands in the lofty yet intimate prayer hall under an immense twelve-sided wooden and glass dome designed by Pietro Belluschi.

Kaish's ark is unique in contemporary synagogue art due to its bold representation of the human form. It is cast in high and low relief and includes a massive five foot figure of Moses.

Kaish embarked on an ambitious program in the monumental tradition of Ghiberti and Rodin. She selected those aspects of the Bible which seemed both the most personally significant to her and the most relevant for the twentieth century. Her representation follows biblical imagery. God appears to man through an angelic messenger, in a voice calling from the fire; in the song and prayer of the harpist; through the appearance of miraculous signs such as a cloud.

The tension and elemental experience of the encounter between man and God is expressed in the poetic handling of the bronze. The surface is roughened by the spirited touch of the artist's hand which leaves its mark in the sharp cuts, deep incisions and nervous penetrations. The surfaces tremble as light breaks over the raked, hollowed and furrowed metal. As light advances and recedes, it alternately hides and reveals the wing of an angel, the leaf of a plant, the strings of a harp, a row of mourning men, or a figure blown by a gust of wind. All emerge from the agitated surface and disappear into it again. The composition is divided into eighteen panels of uneven size which are combined in an asymmetrical arrangement. The left side and to a certain degree the entire ark is dominated by the large figure of Moses who stands stretched to his full height with upraised arms ready to receive the Tablets of the Law. Enveloped by his winglike garments, Kaish conceived him as an ecstatic and inspired prophet rather than as a stern leader of men.

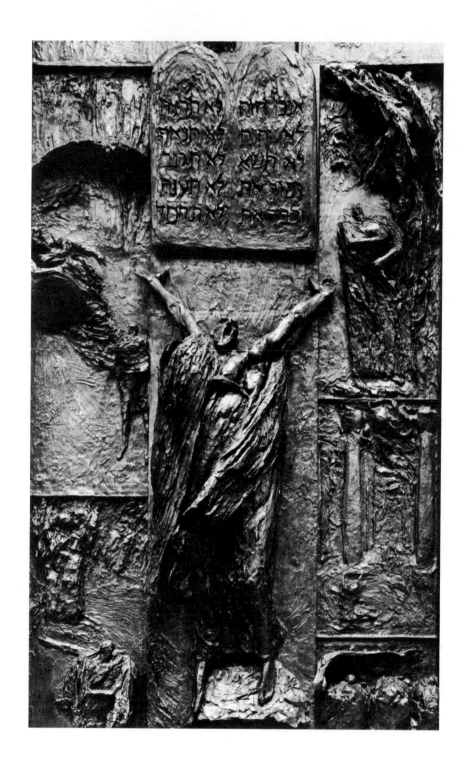

Moses Receiving the Tablets of the Law, detail of ark.

At the upper left an angel, his wing projecting like a sail from a stormy sea, sweeps down to stay the hand of Abraham. In the adjacent panel Jacob wrestles with the angel of the Lord. To the left of the figure of Moses are two panels. In the upper one, David, the poet of the Psalms, plays his harp before the ailing Saul, who reclines behind his shield. In the lower panel, Elijah, who has challenged the priests of Baal on Mt. Carmel, stands on a chariot pointing to the fire which the Lord has sent to consume his offering. To the right side of the Tablets of the Law, Moses is seen again, leaning dazed against the side of the hill as he is being called to from out of the burning bush. His dread is echoed by the vigorous handling of the bronze. In the lower panel beneath a cloud signifying the presence of God, Solomon dedicates the First Temple. In the lower right corner exiles lament, "If I forget thee, O Jerusalem." Their shrouded backs turned to us, they face the wall into which they seem to merge. In the small composition beneath the figure of Moses, the prophet Amos is driven from the city of Beth El.

The upper section of the right side of the ark contains the most daring and interesting conception. Seraphim purify the lips of Isaiah with glowing coal and Jeremiah laments over the destruction of Jerusalem. Both panels are perceived as one; the vigorous modelling of vertically razed walls on the left fuses into the projecting seraph's wing which shelters the figure of Isaiah. The center is dominated by Ezekiel who is carried in a turbulent whirlwind over the Valley of Dry Bones as he prophesies: "Behold I will cause breath to enter into you, and ye shall live . . . and ye shall know that I am the Lord" (Ezek. 37: 1-3). In the narrow panel directly to the left, Ezra brings the Torah before the congregation; to the right, Isaiah summons the people to be "a light unto the nations." On the lower left section, Jonah rests beneath the gourd, pleading with God; in the center, Nehemiah leads the people in rejoicing after the rebuilding of Jerusalem; and to the right a *menorah* made in the shape of seven horns projects from the ark.

In the center of the panel which bridges the two wings of the ark, is the vessel of the Eternal Light with two winged cherubim converging on it from above and below. There are in this ark sections of unusual expressiveness, which reveal the profound depth of the artist's own vision of the transcendent vision of the prophets. Her work is animated by a personal religious sentiment which is reflected in the bold choice of the theme of the encounter of man with God. It seems that behind this choice lies the conviction that personal religious experience is the core of religious faith. It is a pity that the bronze doors which had been planned for the ark were not incorporated in the final design but were replaced instead by a curtain with metallic thread. It is perhaps the absence of a strong center, which the doors might have provided, that leaves the artistic unity of the work open to question. The panels, though carefully planned and related to each other in subject matter, do not always play into each other in terms of their formal continuity. Their marked angular divisions intrude upon the flow and movement of the masses. As the ark stands now, each panel is superior in its own composition to the arrangement of the whole. The plastic possibilities which are indicated in the upper right section are not carried through consistently. Yet despite these shortcomings there is no question that the ark takes an important position among the works of art for the contemporary synagogue.

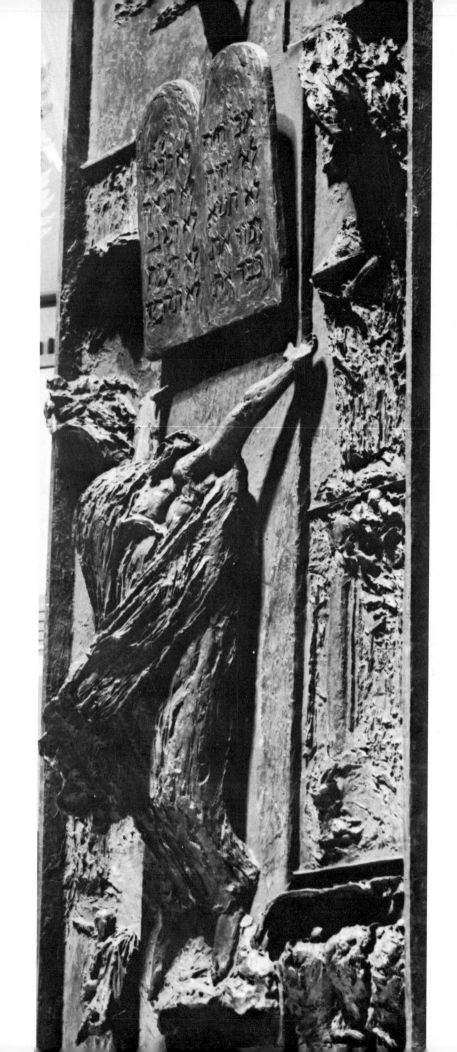

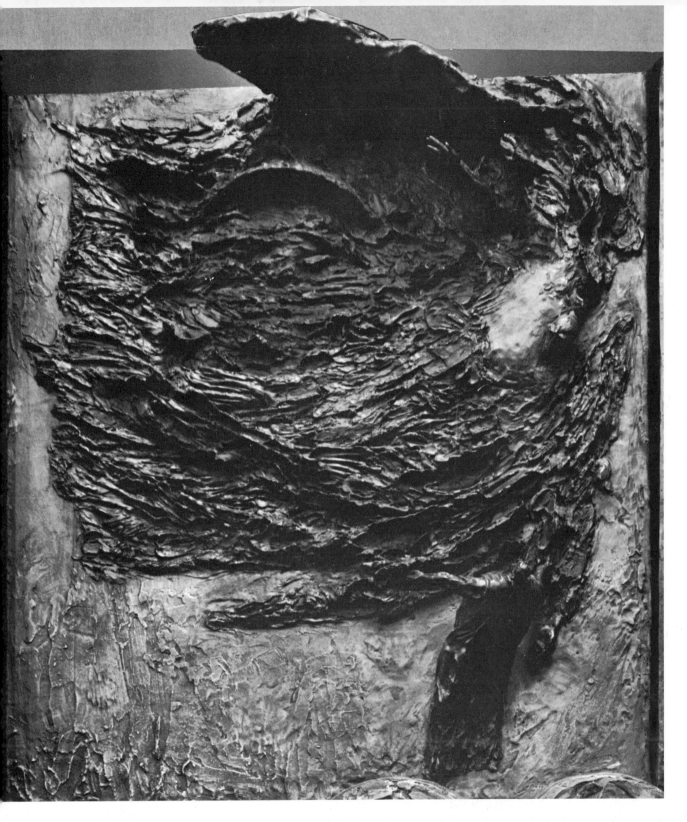

(Left) Moses receives the Tablets of the Law, detail of ark, side view. *(Above) An angel stays the hand of Abraham*, detail of ark.

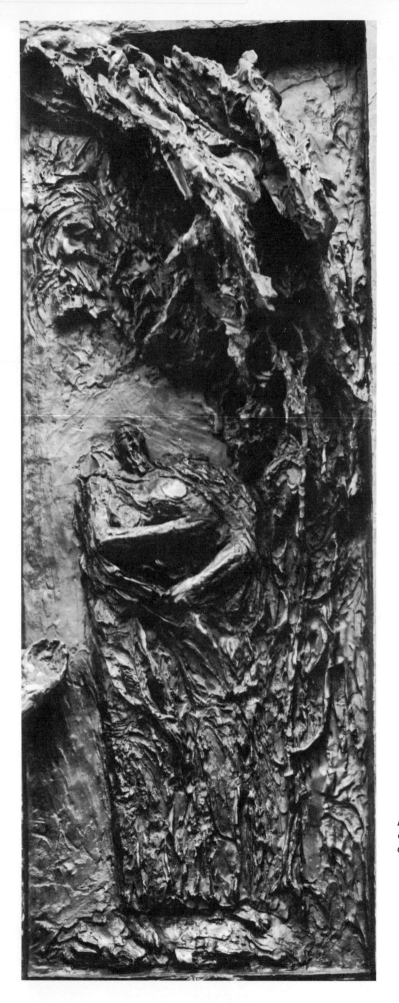

Moses Called from the Burning Bush,
detail of ark. (Opposite page) *Moses
at the Burning Bush,* detail of ark.

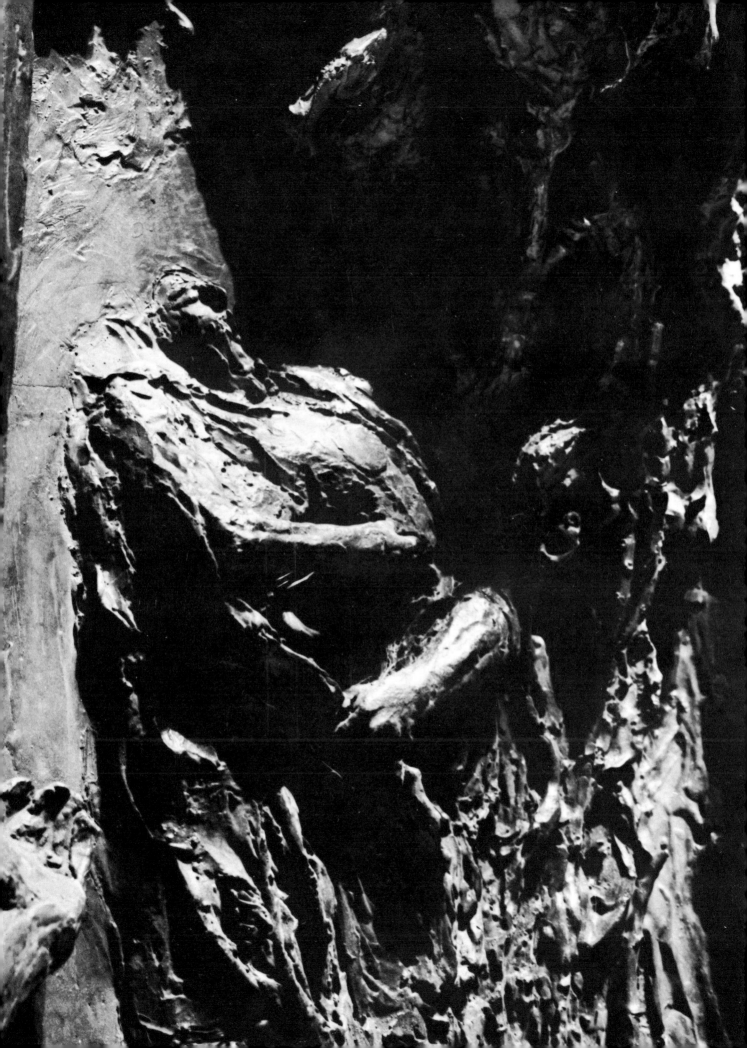

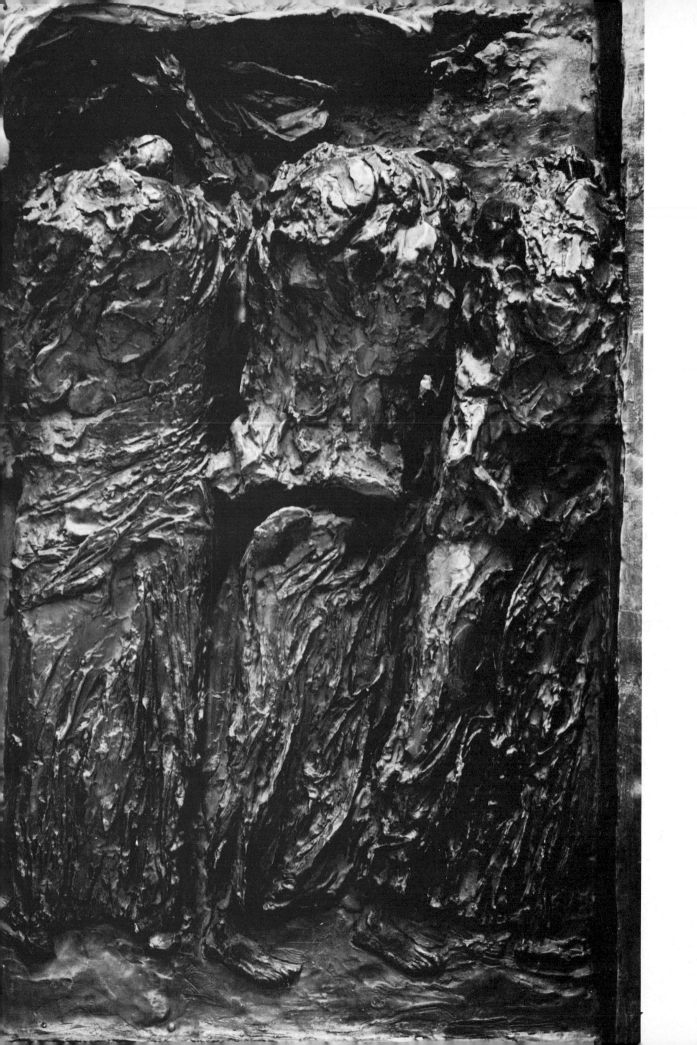

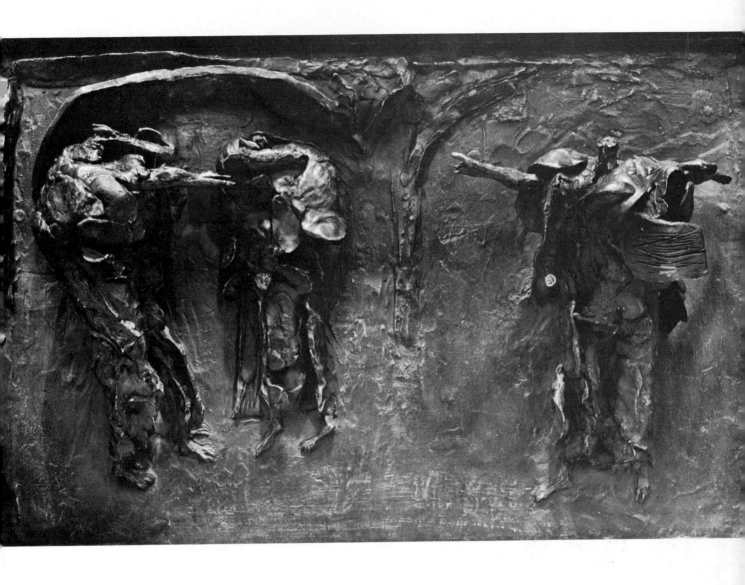

(Left) *The Lament of Exiles*, detail of ark. (Above) *Amos Driven from the City of Beth El*, detail of ark.

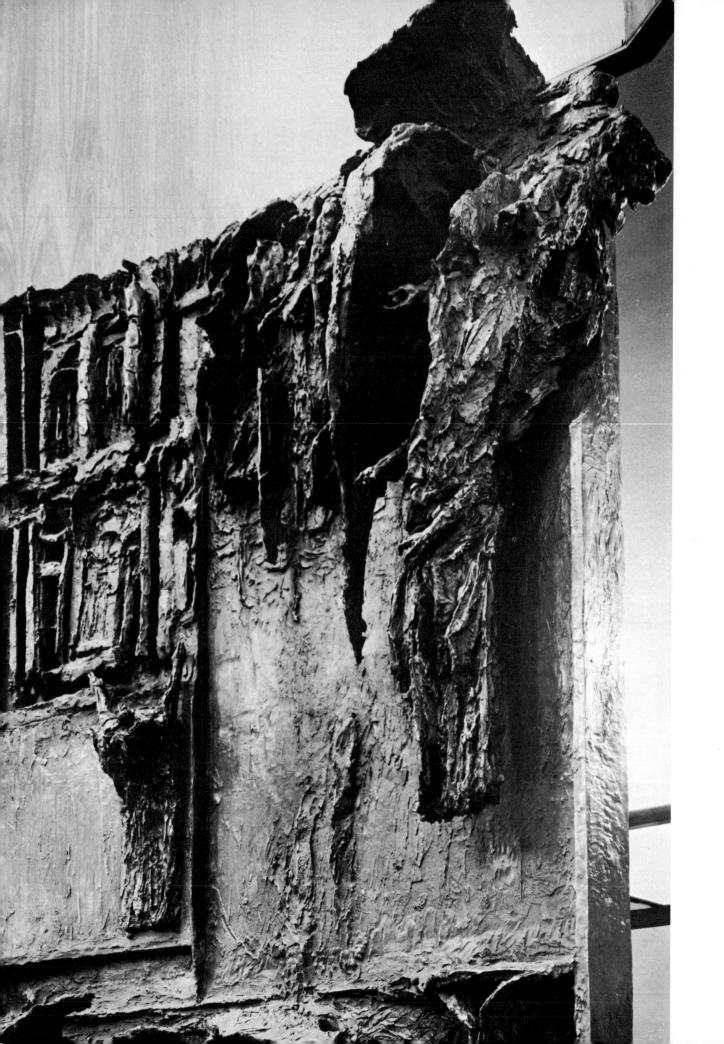

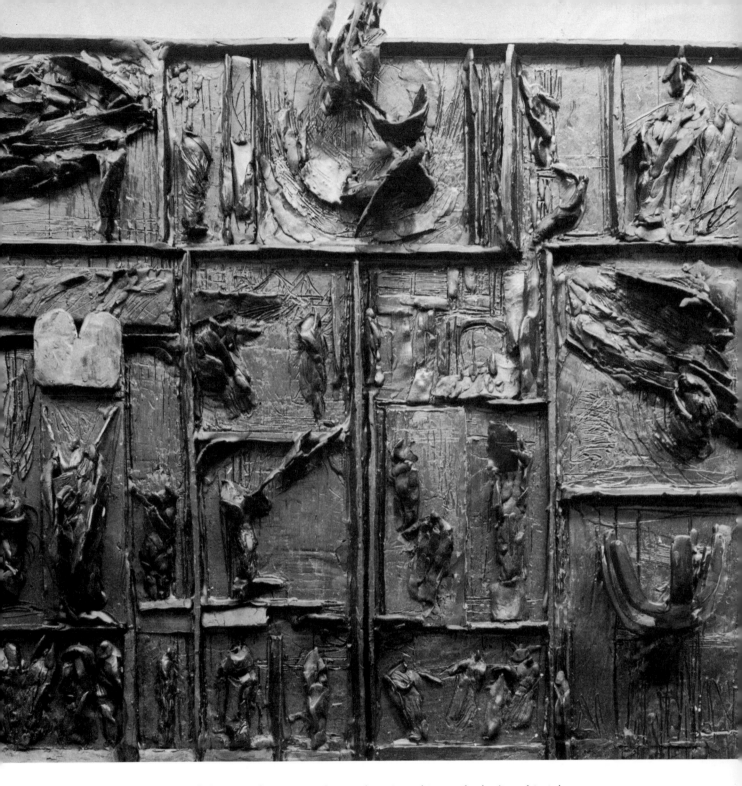

(Opposite page) *Jeremiah laments destruction of Jerusalem, Seraphim purify the lips of Isaiah,* details of ark. (Above) *Sketch for ark,* bronze, 16″ x 14″, 1961. Artist, Luise Kaish. (Courtesy the artist.)

Stained-glass Windows

THE essence of stained glass lies in its capacity to conduct and modify light. Its use demands the ability to control highly elusive effects. Light radiates differently through different colors. In addition, in stained glass, even more than in painting, the value of any one tone is determined by its relationship to another. To add to the complex factors in the balancing of the radiational properties of the colors themselves, the window is not a static thing. It cannot be designed in the studio and installed in the building before the artist studies the location and the light received. It reacts differently to eastern or northern light, against brick or tree, cloud or direct sunlight, in winter or summer, morning or afternoon.[1]

The use of thick pieces of chipped stained glass set in moulded reinforced epoxy resin or concrete, the infinite variety of stained glass colors and the various textures and densities in which they may be used, allow them to function either as solids or as colored dematerialized voids, as surfaces for decorative painting or as immense jewels, as a shield cutting out an undesirable view or as a slightly-transparent veil bridging inside and outside. These many possibilities have resulted in an increased use of the medium. Recent developments in the field have added such new techniques as "aciding," embossing and plating, which when used singly or in combination, can produce a great variety of effects within a single leaded area.[2] While we still find too many stained-glass windows which are only transpositions of paintings[3] and which do not take into account the intrinsic properties of the materials, many handsome and expressive exteriors and interiors have been created through the medium of stained glass.

The conception of the prayer hall largely determines the way stained-glass windows will be used. If it is thought of as a self-contained place, shut off from the outside world, conducive to introspection and contemplation, stained glass will be used to create a subdued, mysterious atmosphere. However, if the threefold function of the synagogue—house of prayer, assembly and study—with its need for light, is considered, light-modifying stained glass will be employed only slightly or not at all.[4]

TEMPLE B'NAI AARON, ST. PAUL, MINNESOTA

Temple B'nai Aaron in St. Paul is an important achievement in an architect's search for a structure which will adequately express the religious concept of a synagogue.

The effectiveness of the building is largely enhanced by the use of stained-glass windows. Executed by William Saltzman, they are abstract and of a dominant brown and yellow color which merges into the atmosphere of the building in its re-echoing of the brick and wood. The stained glass does not cover the entire window area, but is framed within a narrow strip of transparent glass. By admitting some clear daylight it establishes a visual

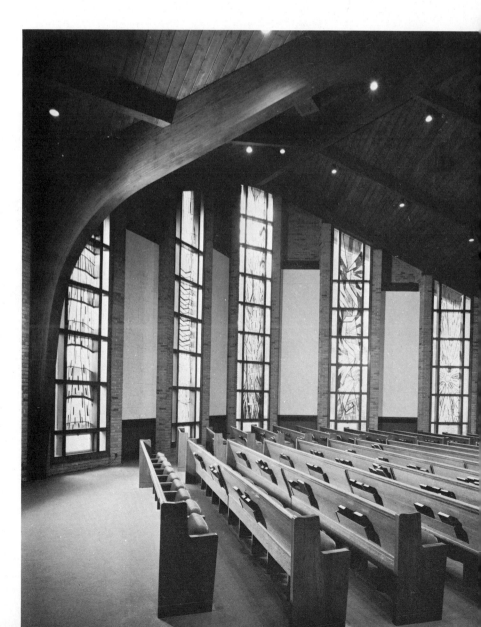

(From right) Birth, First Steps, Hebrew Education, Bar Mitzvah, Bat Mitzvah; stained glass, 20' x 3', 1957. Temple B'nai Aaron, St. Paul, Minnesota. Architect, Percival Goodman. Artist, William Saltzman. (Photo: Alexandre Georges.)

link with the outside. A fine balance is struck: one feels removed from the world, yet in touch with it. There is an absence of the mystifying and mystical, but the familiar and home-like are strongly felt. One experiences the sacred without withdrawing; one is conscious simultaneously of the world of today and the world of the past. This effective use of stained glass combines with the ark a focal point balanced by the centralized roof to create something akin to a מקדש מעט (small sanctuary), a holy place which does not overwhelm the worshipper.

In bold varied rhythms, Saltzman designed ten stained-glass windows conveying experiences both universal and pertaining specifically to the life of the congregant. The over-all theme is "The life cycle of a Jew." The windows, in their abstract design, suggest: birth, the first steps, Hebrew education, Bar and Bat Mitzvah, marriage, parenthood, community responsibility, old age, and immortality. Their relationship to one another is logical and together they create an esthetically pleasing effect. In a number of cases a talmudic idiom has been employed by the artist as an idea for the design. For example, the Talmud relates that at every birth a shout echoes through the entire cosmos. The mystery of creation is renewed again and again. The artist has transformed this idea into a design based on the diagrams of a splitting atom, but endowed with warmth and color in a setting of human hope and prayer. The abstract motif is easily understood by the beholder. Yet although it is possible to recognize, in the finished work, the original talmudic source, the viewer must reconstruct and reorganize some of the details in order to comprehend the meaning because the artist has simplified and condensed his theme.

"Train up a child in the way he should go" (Prov. 22:6). The unsteady steps of the little child who falls down and gets up again are conveyed in the zigzagging white path which weaves through the red and yellow composition. In the window representing education, the Hebrew letters are fully integrated into the design without being distorted. In the Bar and Bat Mitzvah section, elements of the *talit* and the *t'filin* have been selected to create a pattern of interlacing bands that convey the idea of initiation into religious rites. The basic experiences of man—birth, marriage, parenthood and death—are interspersed with windows dealing with those institutions of the congregation which assure its survival— Bar Mitzvah, Hebrew education, and social responsibility. The accent throughout is on the relationship of the individual to the community. The designs consist predominantly of linear bands which suggest the ties individuals have to one another or to large social bodies. The individual is represented as a nucleus or a center of a larger field from which forces emanate and upon which forces impinge. Bands, ever widening circles, and ever diminishing lines of force are narrowly condensed where the impact is heavy and dispersed where it is slight. The concept underlying the theme and designs themselves reflects both the age of psychology and the age of the atom. Such concepts as belonging, relatedness, lines of force, and nuclear energy have found their graphic expression in the design of the windows. These represent a work of art which incorporates significant aspects of the synagogue today and reality as we experience it. They reflect the quest for community which the religious institution, with its rites, customs, history and tradition, promises its members.

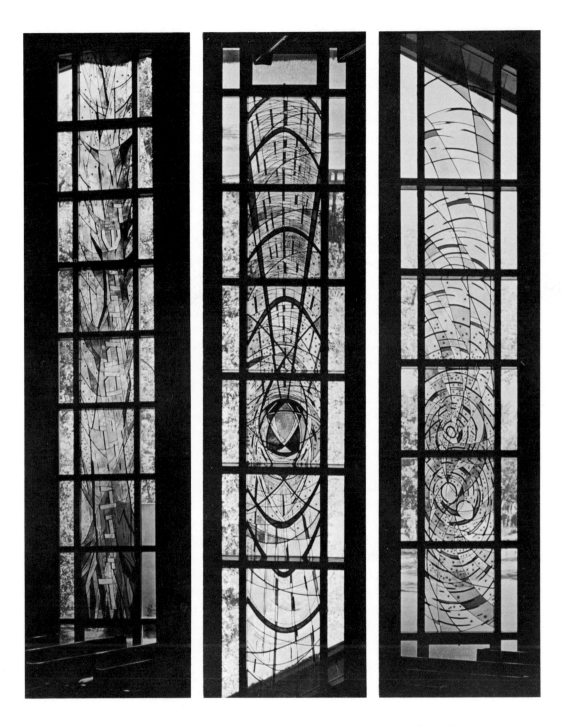

(*From Left*) *Hebrew Education, Marriage, Parenthood;* stained glass, 20′ x 3′, 1957. Temple B'nai Aaron. Artist, William Saltzman.

STEINBERG HOUSE, NEW YORK CITY

The Milton Steinberg Memorial House (although it contains a small chapel of its own), is designed to serve the extensive civic and educational activities of the Park Avenue Synagogue in New York City. The building houses a library, music room, classrooms, and some offices. Its entire façade of stained glass was designed by Adolph Gottlieb. It is thirty-five feet wide and four stories high.

Here the integration of art and architecture have been fairly well achieved. Cantilevered construction, which transfers the weight of the various floors to remote supports, makes it possible to eliminate the spandrels, to reduce the visible floor construction to two and half inches, and to mask it with the aluminum grill which acts both as support and decorative element for the lead-webbed windows.

The stained glass functions as a translucent wall which separates the interior of the building from the street outside. The design had to take into account the fact that the building is hemmed in by neighboring structures and stands in a busy and narrow street. No unified theme stretching over the whole façade was called for, since it could not have been perceived from the outside without great effort. From the inside of the building, only one fourth of the façade or one floor can be seen at one time by the viewer. A single, unified design would have lost its effect there also. Finally, the fact that at night only certain floors are lit further militated against a single over-all design.

Gottlieb designed twenty-one different compositions which are repeated in ninety-one panels of the façade and interspersed in a checker-board pattern with neutral panels of pale stained-glass panes. The latter are delicately tinted diamond shapes of pale amber, yellow-green, and pink selected to give a warm and neutral light against which the deep and resonant panels function.

By day from the outside, the façade looks like a huge, soft, and richly decorated eastern rug, while from the inside the intense and glowing colors held together by the lead outlines give it the intensity of jewels set into a wall.

Gottlieb employs the same method on the window panels as he once did in the designs for his painting, and for the ark curtains for the synagogues of Millburn, New Jersey and Springfield, Massachusetts (pp. 85, 199). He makes full use of the meager pictorial motifs which the Hebraic tradition offers, and invents some of his own. He also convincingly expresses the religious and educational sentiment which the Milton Steinberg House embodies.

The individually designed colored panels consist of a number of compartments. Each compartment has a different color and contains one symbol. The colors used are deep and light reds, blues, purple, gold, white and shades of green. In their purity and directness they remind us both of the stained-glass windows of the Middle Ages and some of the works of Léger and Matisse. The latter comparison especially comes to mind because of both the rich decorative use of the black line that divides and unites the various compartments and the simple decorative use of silhouette and flat intense color.

A well known art critic has put it succinctly: "Coming into the interior one no longer sees color, one experiences it, startling but subdued as an environment. Besides the deli-

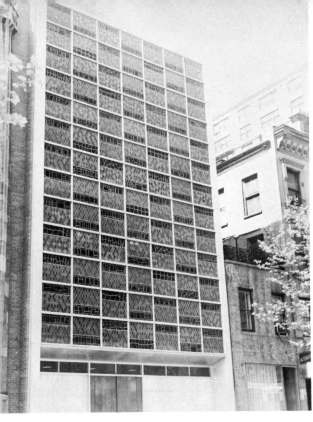

Facade with stained glass, 50' x 30'. Park Avenue Synagogue, Milton Steinberg House, New York, New York, 1954. Architects, Kelly and Gruzen. Artist, Adolph Gottlieb. (Photo: Olympic Press.)

Section of stained-glass wall with panels of holidays. Milton Steinberg House. Artist, Adolph Gottlieb.

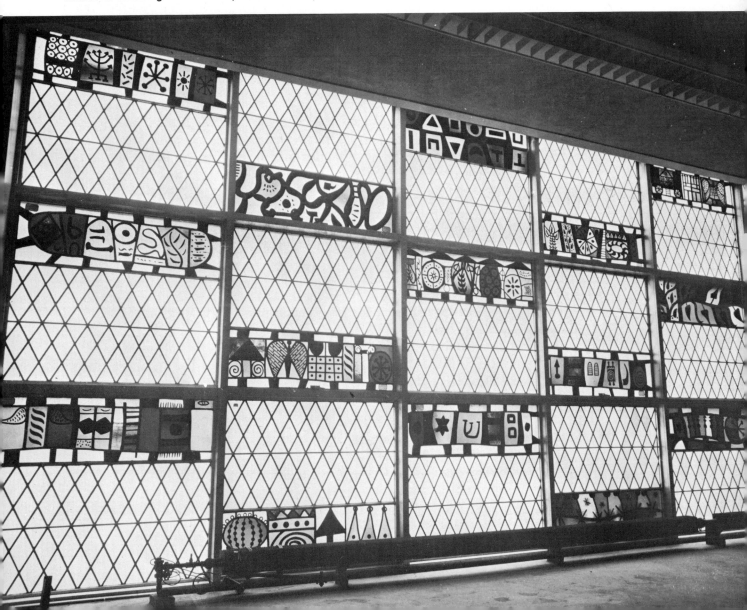

cate, suffused light of the diamond shaped panels, the panels concentrate light with electric force, without harshness. Here is stained glass that excites wonder, but with none of the wistfulness of the traditional types."[5]

The twenty-one individually designed units reappear four or five times within the façade. They do not represent one unified theme. Therefore, their position within the façade is based on purely esthetic grounds rather than on the logic of a narrative sequence. The themes of the units can be classified in four categories: symbolic emblems, biblical incidents, religious rituals, and holidays.

Though many of the symbols are familiar to the Jewish worshipper, some can be identified only with considerable effort. Several symbols are clearly adopted from Gottlieb's canvases but their meaning has changed within the new context. The arrow in his Indian themes becomes the Torah pointer; the spiral becomes the Torah scroll seen horizontally; the serpent becomes the phylacteries; the magic eye becomes the eye of the inner dream. Some symbols are taken from ancient Hebraic motifs brought to light by archeological discovery, while some are invented for the occasion. For example, the panel on Purim shows the unrolled Scroll of Esther. It follows the rectangular shape of the panel, and is compartmentalized like the columns of the scroll. Within each compartment is an image which brings to mind the story of Purim: the roulette wheel, symbol of the lots drawn for the date of Jewish extermination; the noose which ended the plot of Haman; the noisemaker which resembles the gallows; and an array of *hamantaschen*, a traditional three-cornered cake which is prepared for this holiday. Except for the roulette wheel, all the symbols are rooted in the Judaic tradition. We accept the wheel, which unfolds like a Japanese fan, because it is assimilated by the surrounding symbols and can easily be associated with them.

For the same psychological reason, alien forms within a known context will assume meaning from their familiar surroundings. We accept the abstract design for Yom Kippur, the Day of Atonement—the holiest day in the Jewish calendar year—because of its inclusion among other panels of more familiar ground. Neither the image of a Torah, a *shofar*, or an equally holy object from the ritual is chosen, but a meandering line turning back and forth on itself against dark green and blue glass. The line intimates the act of a person who examines his innermost self. The signs spread throughout the loops of the line are obscure, like the depths of each man's soul and the subjective nature of each man's search. The whole panel is a humanistic interpretation of the Day of Atonement.

The window panel in memory of the late Rabbi Milton Steinberg is moving in its stark simplicity. One branch of the tree of life is cut off and fills the major part of the panel. While the image of the broken branch is a familiar one, Gottlieb's unique style makes the image singularly fresh.

The panel of the twelve tribes is abstract, composed of twelve calligraphic signs. These emblems consist of squares, triangles, circles, half-moon shapes. Each of these signs set against a unit of color emanates an enigmatic and primitive yet sophisticated quality.

The introduction of new and unfamiliar elements enriches the traditional imagery and demands the active involvement of the beholder. The seemingly total or partial unintel-

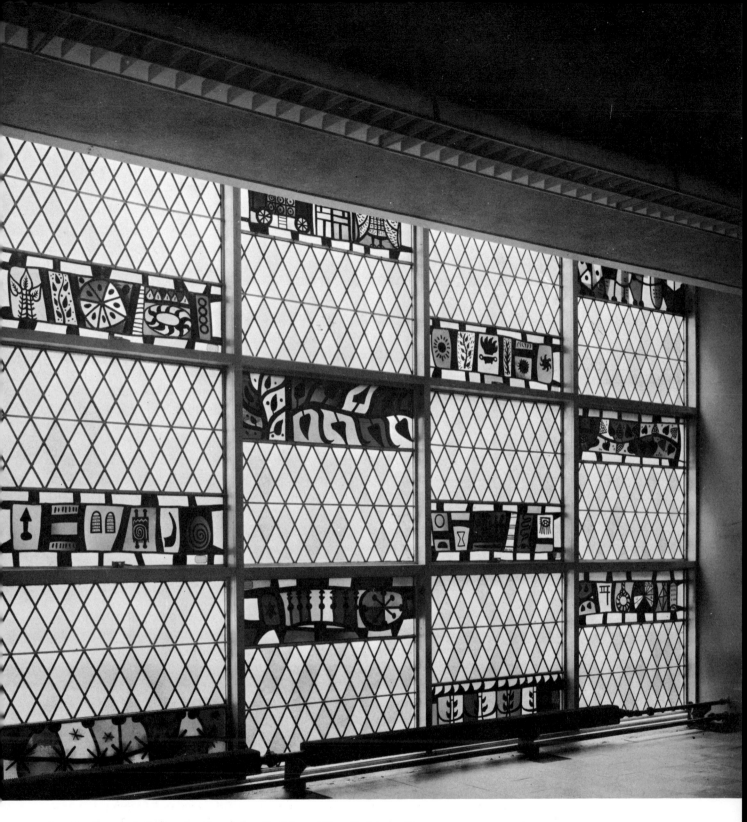

Section of stained-glass wall with panels of holidays. Milton Steinberg House.

Purim, stained glass, 13″ x 44″. Artist, Adolph Gottlieb.

ligibility of these elements is intriguing; it creates a perplexity for the observer which is resolved only after he has succeeded in uniting the various images and establishing their meaning through the process of association.

There is a Byzantine splendor in the golden pointed crowns of the Torah, which alternate with golden globe-shaped crowns heavily jewelled with reds, blues and greens.

A panel dedicated to Sukot, the Festival of Booths, abounds with floral and fruit motives, seen, as it were, from the top. Branches, twigs, palm leaves, flowers and the seeds of opened fruits create a lively circular design.

The artist has made use of the archeological evidence of ancient Hebrew art and adapted some of its images into his design. The panel of Simchat Torah shows the open ark on wheels, recalling the sculptured reliefs of the synagogue of Capernaum or the Dura frescoes (pp. 13, 22). The winged cherub with the high priest's breastplate might be a creative adaptation both of the wings from the seasonal figures in the centerpiece of the Beth Alpha Synagogue floor (p. 14), and of a section from the pointed ark in the southern part of the same mosaic (p. 143). The grapevine panel, which consists of strands of alternating dense and spattered leaves, an old Jewish symbol, may also have been inspired by the grape motif on the margin of the Beth Alpha floor.

The panel of Sabbath candles made up of seven verticals united by a gently modulated line is particularly brilliant. Stars are spread at the intersections between the verticals and horizontals, with smaller stars in the spaces in between. The firm composition bends and softens under a genuine lyrical sentiment which the artist evokes. He achieves a similar expression by subtle stylization of the theme of young trees for the panel on Tu Bi-Shevat, the Festival of Trees. Gottlieb is capable of abstracting an object and laying bare its structural elements without impairing its freshness, lyricism and poetry.

A further step in the poetry of construction, color and imagery is undertaken in the panel of Medieval Lights, which represents the eight-branched candelabrum seen from above, the seven-branched candelabrum seen from the side, and the silhouette of the Star of David. They are all powerfully integrated and seem to create a compound image of a caged lion trying to set itself free, with the branches of the *menorah* forming the cage. A curious sense of power, pent-up energy, and strain pervades the image. The artist has struck a fine balance between the inventive, expressive and purist tendencies of modern art and the traditional Hebrew motifs required by the educational program.

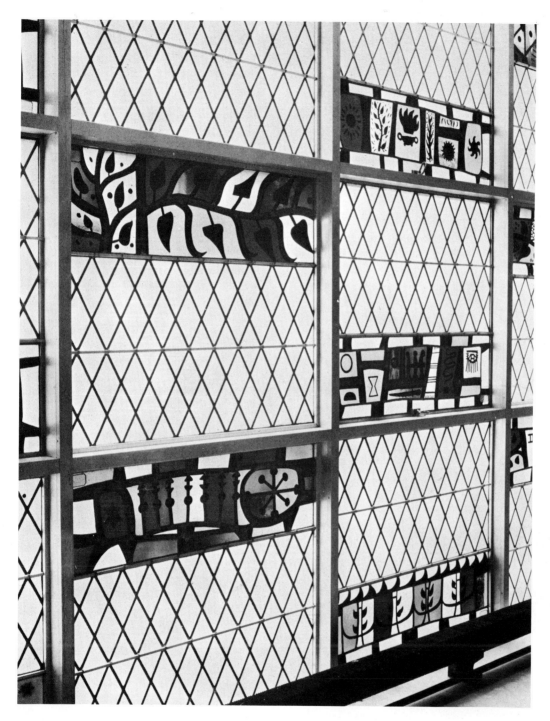

(Left) Milton Steinberg memorial window medieval lights. (Right) Symbols of light, Bar Mitzvah, Festival of Trees. Stained glass, 1954. Park Avenue Synagogue, Milton Steinberg House. Artist. Adolph Gottlieb.

STAINED-GLASS WINDOWS · 247 ·

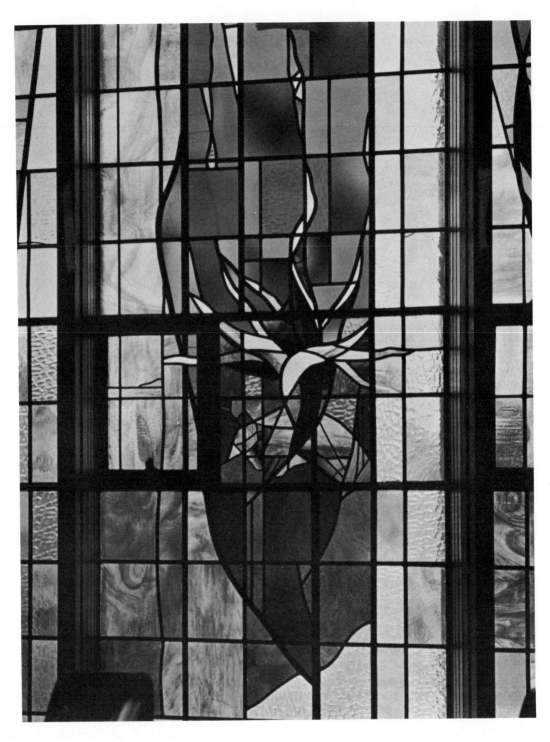

The Burning Bush, detail, stained glass. Temple Shalom of Newton, West Newton, Massachusetts. Artist, Napoleon Setti.

TEMPLE SHALOM, NEWTON, MASSACHUSETTS

Another major attempt to integrate the art of stained glass with architecture is found at Temple Shalom in West Newton, Massachusetts. Here, too, the stained glass forms the two translucent side walls of the prayer hall. There is an area of nearly six hundred square feet per wall. Each wall is compartmentalized into eleven sections by baffles, and designed with motifs derived from the prophetic books. The stained glass is predominantly blue, and the work represents a blend of large abstractly-designed areas into which objective and figurative elements have been woven in an unobtrusive manner. These elements in no way dominate the design, as they do in the Tree of Life Synagogue in Pittsburgh or Har Zion Temple in Philadelphia (see pp. 250-252). They are submerged to such a degree that the eye must often exert itself to isolate the symbolic elements.

While each panel consists of an autonomous design, the sections are tied together by an intelligent use of color. There is more than a decorative quality to the work. The subtle handling of his material has enabled Napoleon Setti, the artist, to achieve a specific mood and an expressive quality derived from the glass, which speaks to us as if through its own essence.

Striated pieces and cast glass are juxtaposed with blown glass which, with its beautiful luminosity, slightly distorts and blurs the outline of objects behind the windows. Flashed glass, with its different intensities and tints, is adjacent to the rich-textured Flemish glass. The shifting movement of the light and the trees outside silently animates its color. Some sections of the windows light up brilliantly at a particular moment, while others become muted and quiescent.

The understanding which the artist brings to stained glass as a material with definite properties, is not matched in quality by the design of the figurative elements he worked into the composition. The latter at times give a stereotyped impression. The long garments and headdresses, the attitudes of walking, standing or praying, are derived from all too familiar and long-established conventions. They do not surprise, they do not move, they are not deeply felt. In general, they are inferior to the abstract parts or to the other elements found in the design, and seem to be intruders on the scene. Moreover, one does not feel that much thought was expended on a coherent general plan. Perhaps the artist was not adequately assisted by the leaders of the community in those areas where his knowledge may have been insufficient.

*Stained-glass wall, 16′ x 44′, 1957.
Architect, Samuel Glaser. Artist, Napoleon Setti.*

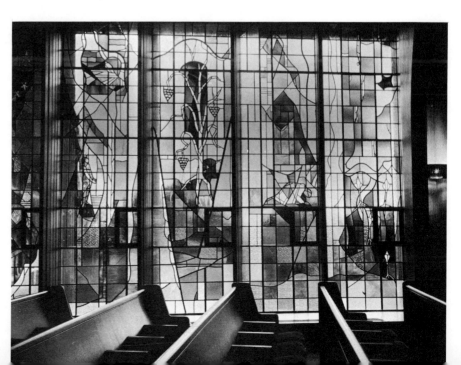

HAR ZION TEMPLE, PHILADELPHIA, PENNSYLVANIA

In some way, the twelve stained-glass windows at Har Zion Temple in Philadelphia are a manifesto of Conservative Judaism. In this work an attempt has been made to recognize every significant factor which has shaped Jewish history anywhere. The windows first take cognizance of the ancient literature: the Torah, the Prophets, the writings and the Talmud each occupy one window. They are followed by sections devoted to the Middle Ages, to Spanish Jewry, to East European Jewry and to the emancipation in western Europe. Three hundred years of American-Jewish history, the State of Israel, and a window dedicated to the idea of one world and the brotherhood of man complete the series.

The work represents a vast didactic effort based on exhaustive research, careful selection, and meticulous attention to detail. The main theme is generally expressed in the wide central panel of the window, flanked by two narrower sections which carry the supporting theme. Figures of prophets, rabbis, poets, heroes and modern political leaders, as well as Sayings of the Fathers, and quotations from other important books, fill the window. There is reference to the mysterious Urim and Thummim, to the six-winged seraph who appeared to Isaiah, to Psalms, illuminated Haggadot, the hanging Sabbath lamp, the traditional central *bimah*, the letter of George Washington to Moses Seixas, Lincoln's Gettysburg Address, the Dreyfus affair, Jewish scientific scholarship, Theodor Herzl, and what seems to be an idyllic scene of farming on an Israeli kibbutz.

The windows are noteworthy for their direction and planning if not for their esthetically satisfactory solutions. They are overladen with 4,000 years of Jewish history. They reflect love and reverence, and an immense schema to which the late Professor Louis Ginzberg contributed a great deal of knowledge. However, the work lacks artistic soundness: scholarship has encroached on art and robbed it of its capacity to evoke the mood and spirit of significant phases of Jewish history through single, well-chosen images. Instead, it has heaped upon the windows merely the scholar's data and footnotes.

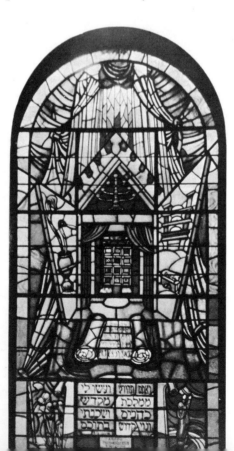

The Torah, stained glass, 17' x 6¾', 1951. Temple Har Zion, Philadelphia, Pennsylvania. Architect, Abraham Levy. Artist, Louise Kayser.

TREE OF LIFE SYNAGOGUE, PITTSBURGH, PENNSYLVANIA

Less ambitious but artistically more successful are the stained-glass windows of Tree of Life Synagogue in Pittsburgh created by Helen Carew Hickman. The flatness of glass has been respected. The color scheme is held within a manageable range and is well controlled. The representations have convincing architectural form; the theme is instructive, well chosen and dealt with in a straightforward and simple manner. The four windows deal with Jewish contributions to American civilization: religion, philanthropy, public service and American economic development. Each is divided into a wide central section flanked by two narrow bands. These are in turn trifurcated horizontally, giving the whole a firm architectural frame.

The window which deals with religion takes note of the three major religious expressions within American Jewry. All confirm the unity of God and base themselves on Torah. The central section presents known leaders of the respective groups. The side panels treat the direct or indirect influence of Judaism on early Americans. Thanksgiving is related to Sukot, the Liberty Bell to its biblical quotation, and Roger Williams, the New England reformer, to the notion of religious freedom. On the right side appear Isaac Pinto, who translated the Hebrew prayer book into English, Thomas Jefferson and the Declaration of Independence, and a commemoration of the first Jewish service held in Pittsburgh in 1844. The inscription reads: "For unto Me are the Children of Israel slaves; they are not slaves unto slaves."

The window dealing with "philanthropy" צדקה shows the figure of Elijah giving bread to the widow's son, and Jonah, against the shape of a whale, pleading for the inhabitants of Nineveh. The legend reads: "Give unto Him what is His, for thou and what thou hast are His." The panels on the side recall the landing of twenty-three Jews in New Amsterdam in 1654, the establishment of an orphan home, and the giving of relief for war victims. On the right-hand panels, Judah Touro, immigrants receiving help and philanthropic activities are portrayed.

The third window takes its text from Jeremiah: "Seek ye the peace of the city whither I have caused you to be carried away" (Jer. 29:7). The American eagle and the Hebrew—שלום—(peace), figures of Jeremiah, Haym Salomon and Jacob Schiff, fill the central section. The panels on the left show Uriah P. Levy, Henrietta Szold and Justice Frankfurter; those on the right, Mordecai M. Noah, Herbert Lehman and Henry Morganthau.

The last window deals with economic activity, and depicts in its central section a biblical figure bearing the products of his labor. The inscription is taken from the prayer of the high priest on Yom Kippur: "May it be Thy will, O Lord, that this year may be a year of plenty and happiness—a year of abundance—a year of peace and tranquility." The side panels present some of the industries and arts in which Jews have engaged in America. The garment worker, the film cutter, and the musician are on the right; the trader, the farmer and the dramatist on the left.

The window design is not free from stereotyped figures and representations. However, the viewer is immediately confronted by a well-planned theme, an orderly, easily comprehensible composition, and a rich reference to American Jewish settlement. A youngster

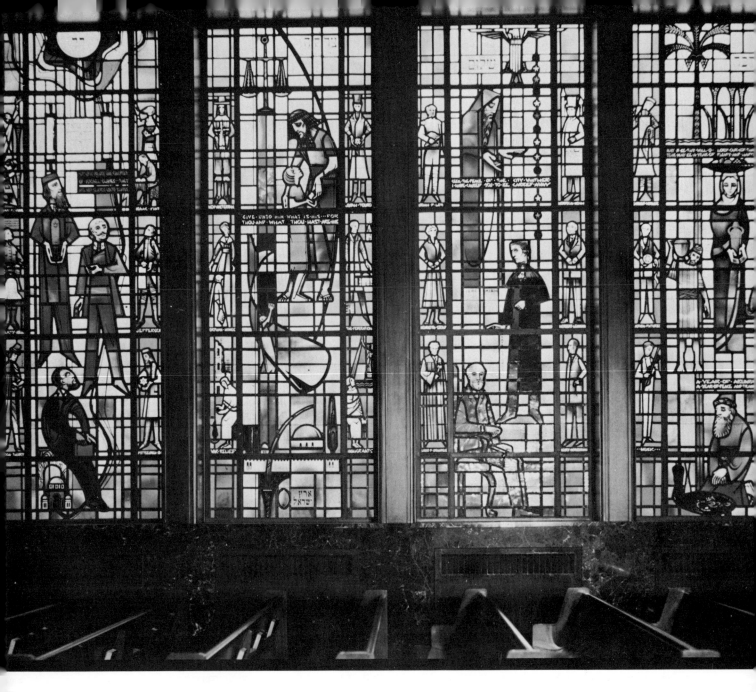

Religion, Philanthropy, Public Service, Economic Activity; stained glass, 20' x 25', 1952. Tree of Life Synagogue, Pittsburgh, Pennsylvania. Architect, Charles Spotz. Artist, Helen Carew Hickman.

attending the services may easily become aware that his grandfather might have been a scholar, a presser, a tailor or all three together. There is significant allusion here to Jewish pioneering activity in social welfare and unionism. An interesting yet serene and unassuming world unfolds within the windows.

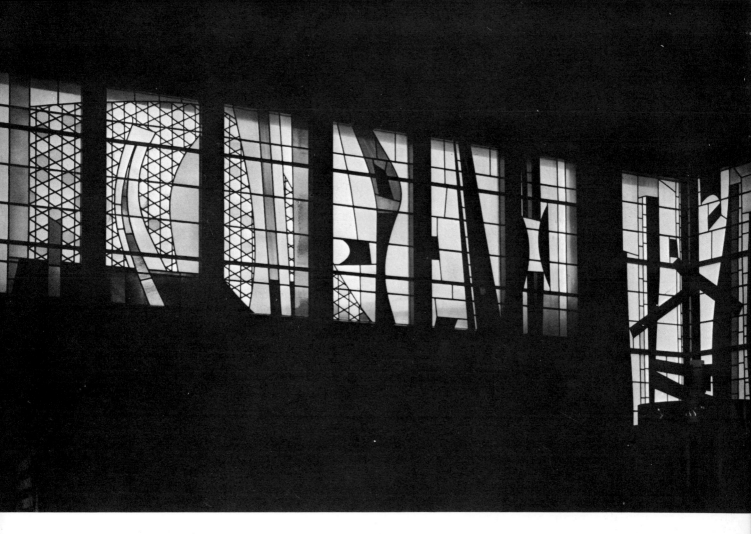

Section of stained-glass window, 14'6" x 48' center height, 1958. Congregation Habonim, New York, New York. Architect, Stanley Prowler. Artist, Robert Sowers. (Photo: Whitestone.)

CONGREGATION HABONIM, NEW YORK, NEW YORK

Robert Sowers, who designed the light stained-glass windows of Congregation Habonim in New York City, thought above all in terms of colors which would be effective in a section of the city which does not receive direct sunlight. The windows also function as backdrop for the *bimah* and represent a handsome design in which large areas of uniform colors alternate with smaller, concentrated design units. Translucent whites contrast with strong bright reds; sky blues and greens with somber yellows, creating a pleasant harmony. The strong horizontal and vertical movement of the windows is relieved by oblique and modulated rhythmic sections which weave themselves through the design. One is conscious mainly of the presence and unique quality of the tinted glass, although designs of the shield of David and the Hebrew letter *aleph*, and a suggestion of the Tablets of the Law, are unobtrusively introduced. The artist has made interesting use of large bronze areas which he designed into the stained-glass pattern. Their opaqueness and bold design serve to accentuate the lightness and delicacy of the colors. On the inside of the building they function as a heavy black line, while on the outside they enrich the surface of the exterior and help make the windows a major aspect of the architectural design.

TEMPLE BETH EMETH
ALBANY, NEW YORK

Robert Sowers solved a familiar problem in Temple Beth Emeth in Albany, N.Y. He integrated sections of the handsome stained-glass windows of an older temple which dealt with the holidays into the larger windows he designed for the congregation's new building. The old windows were well worth saving, although they predetermined to a certain extent the contents of the new design. In the new design, Sowers made the old windows function foremost as dense concentrated areas, and set them against a less crowded abstract design.

The abstract sections with their deep cool blues emphasize the warm translucent glow of the old sections. Within the prayer hall, single stained-glass windows are placed among several clear glass windows.

Behind the ark seven stained-glass windows create a colorful translucent curtain which the congregation faces in prayer.

The seven windows deal with the seven days of creation and contain a number of newly designed motifs. Each window is not limited to portraying the events of a specific day; a number of aspects are often anticipated or carried through several windows. There is a series of circles, for example, beginning in the left hand window and terminating in the center window, which is intended to suggest both the void and the emergence of light. The light begins in the second window and separates into night and day in the third window. In the center window, the circle dissolves in the firmament of light that is crowned by the Star of David.

Since the figures of the original windows have had their names removed, they function in the new context as symbols for all men and women in the Bible. The figure of man taken from the windows of the old temple appears in each of the seven windows. The figure is seen in the lower section of the first panel, which deals with the day of creation, in the midst of chaos and violent rhythms of directionless infinitude. The figure of man is inserted both to save a part of the old temple windows and to anticipate the final act of creation. This kind of limitation has interesting results in the fifth window. God's word, "Let the waters swarm with swarms of living creatures, and let fowl fly above the earth in the open firmament of heaven" (Gen. 1:20) is represented by the figure of Elijah, placed among the birds.

Movement and color indicate the separation of the waters, the appearance of plants and the creation of sun and moon. For the creation of man in the sixth window, King David is made to stand for all men, and the figure of Ruth carrying sheaves of grain for all women. Basic elements of man's existence are brought to mind by a number of blade and lever forms, a goblet and *chalah* along the borders of the window.

The Seven Days of Creation, stained glass, 24'6" x 40'6" center height, 1957. Artist, Robert Sowers. Ark, wood, 6' x 12'. Artist, Nathaniel Kaz. Temple Beth Emeth, Albany, New York. Architect, Percival Goodman.

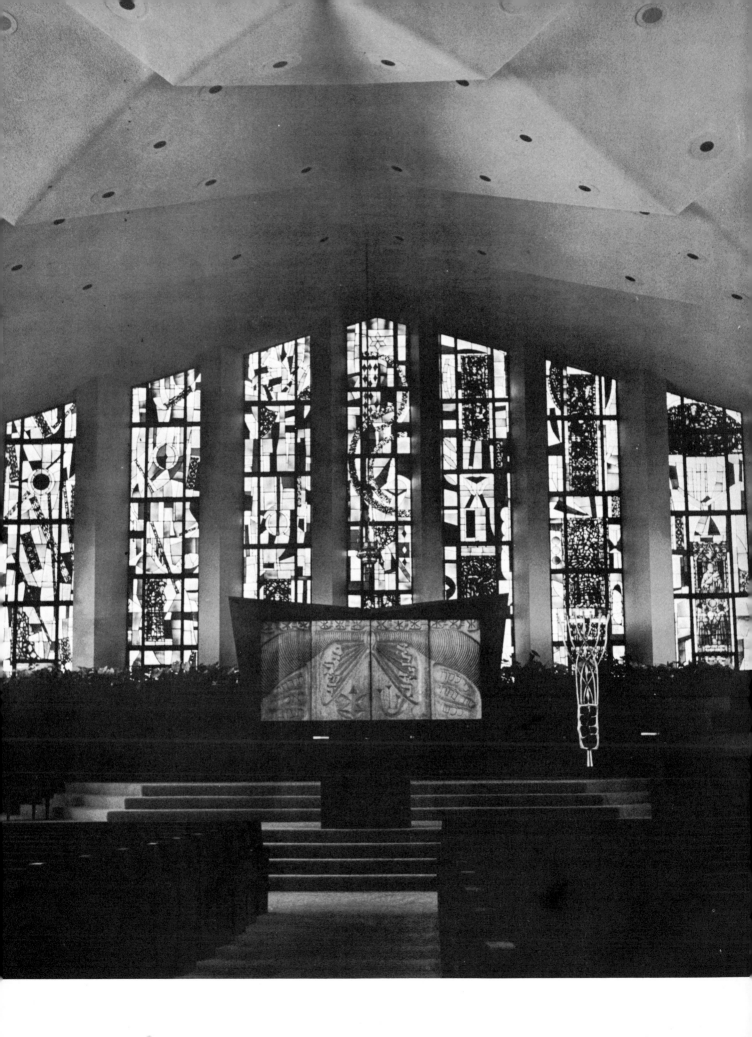

THE LOOP SYNAGOGUE, CHICAGO, ILLINOIS

The unity of Man, God and the Universe, or The Journey of a Mystic would be appropriate names for the 40' x 30' stained-glass window which Abraham Rattner designed for the New Synagogue in the Chicago Loop. The window is a translucent wall which turns toward the street and effectively isolates the quiet and serene interior from the noise of the churning city. The ark, uniquely placed at a right angle to the *bimah*, stands in front of the window and is effectively integrated into its design. The window's large composition is built up of small units of sharp angular sections which create a rich spectrum of cool blues, dark greens, and violets. Brilliant yellows blaze through the blue like heavenly bodies, lighting up a never-ending fathomless expanse.

Red flames emanate from the top of the ark and touch the yellow hexagonal form which dominates the left side of the window. A large source of energy, it is activated by a strong spiral at its center and encased within concentric hexagonal frames. From this center, as though issuing from a deep well, another movement radiates in all directions. It seems to set in motion a whole series of lesser sized lights which surround it. Lines of force drive in all directions and emit large curved trajectory paths through the whole expanse of glass. The bright yellow hexagon is balanced on the right side by a succession of seven Hebrew *shins*, interlocked and ascending from the bottom of the window. The letters, which diminish in size as they rise, are placed on dark blue horizontal planes that are suggestive of steps or rungs of a ladder.

Between the succession of *shins* and the great light on the left, the eye discerns seven celestial lights set like diamonds into a mold which resembles an architect's square. These are the lights of the *menorah*, carried aloft on the branches of the tree of life. They have the same shape as the twelve satellites surrounding the great light above the ark, and are located in the path of the trajectory lines which emanate from the center of the spiral. These lines blaze across the window like shooting stars, pass the sun surrounded by seven planets in the upper right, and seem to ignite it. Next, they loop downward and illuminate a succession of six pointed stars which echo the shape of the bright light on the far left. As they return to their source they blend with the letter *shin* after merging into the curve of the intricately designed *shofar* in the lower section. Along the bottom of the stained-glass window runs a Hebrew inscription in splendid calligraphy:

"Hear, O Israel: The Lord our God, the Lord is One."

While some of the symbols described must be familiar, their arrangement does not derive from a purely decorative motive, but from the desire of the artist to express the faith that God, the universe and man are one. He boldly based his design of common iconographical elements on his knowledge of ancient and medieval mystic Judaic conceptions of the origin and structure of the universe, God's relation to it and man's place within it.

Absorbing influences from Babylonian thought and later from Pythagorean Platonism and other Greco-Oriental syncretisms, ancient Jewish visionaries developed an intricate system through which they believed they could penetrate the secrets of the cosmos which, it was thought, were reflected in the movements of the heavenly bodies. This Merkabah

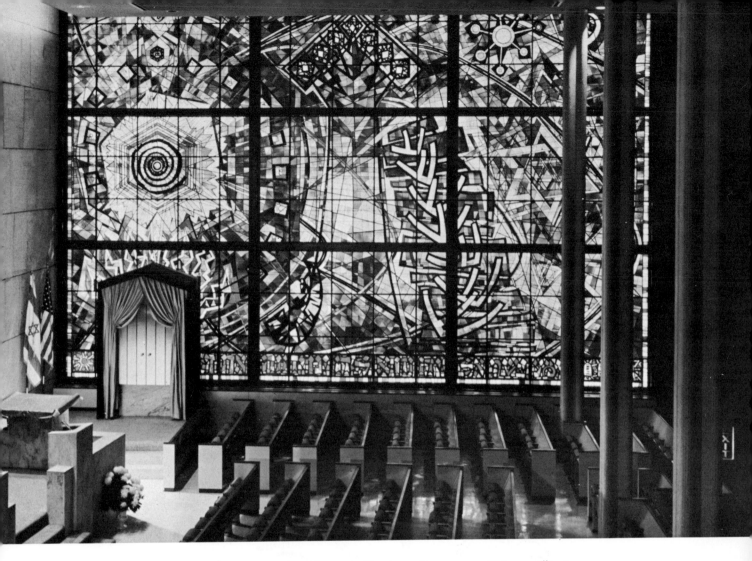

The Journey of a Mystic. Stained glass, 30' x 40', 1960. The Loop Synagogue, Chicago, Illinois. Architects, Loebl, Schlossman and Bennett. Artist, Abraham Rattner.

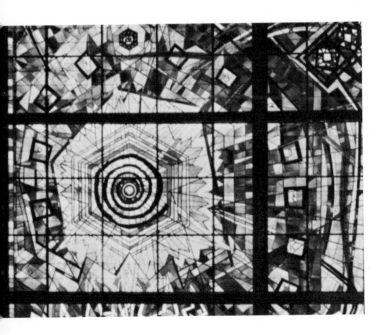

The Journey of a Mystic, detail, *Or Ein Sof* (The Unending Light).

mysticism, detailed in the Hekhaloth, speaks of heavenly palaces through which the mystic wanders in his journey as he rises from sphere to sphere until reaching the Throne of Divine Glory. Building on such texts as the Book of Enoch and the Book of Creation, the cabalist Zohar of the Middle Ages equated God with the *Ein Sof*—the absolute infinite, the unending, the boundless. All heavenly bodies and all finite things are to them emanations of the *Ein Sof*. The *Ein Sof* is the First Cause, and the Primal Will, which the cabalists also called the Unending Light—(*Or Ein Sof*). Like a seed, this great light contains the outline of all the physical and intellectual world and determines the time of its own florescence. It contains the entire plan of the universe in its infinity of space and time, and holds within itself the most complete and infinite wisdom. The power which resides in the First Cause the cabalist called *Kav*, the line, which runs through the whole universe and gives it form and being.

The Sefirot in Relation to One Another (from "Asis Rimonim," 1601).

The *Ein Sof* makes its creation known by means of the ten *sefirot*, emanations which flow from it directly, and partake of its perfection but are also the ten principles which mediate between God and the universe. God is imminent in the *sefirot*. He manifests Himself in them. The *sefirot* have many names in the cabalistic literature such as "crowns," "attributes," "steps," and "principle names." Emanations are symbolically spoken of as a soaked sponge, a gushing spring or a sunbeam sending forth its rays. According to the mystic tradition, out of the last of the *sefirot* developed the letters of the Hebrew alphabet which constitute a bridge between the world of the divine and the finite world. These letters, which also have numerical value, are dynamic powers. The knowledge of their right combination is a key which might unlock the mystery of the universe.

Even the six pointed star had a unique position in the literature of the cabala. It was a combination of equilateral triangles which were the alchemists' sign for fire and water. Furthermore, according to the cabala the principal consonants of the Hebrew words "fire" and "water"—מים ,אש—produced the word for Heaven (שמים) which was the equivalent of God. Thus the hexagram was not only the synthesis of fire and water, but the logical symbol for heaven and God.

The artist has creatively synthesized the teachings and intuitions of the mystics. Himself drawn toward a vision of a cosmic and moral order, he has taken freely from the persistent images which pervade various trends of Jewish mysticism: the unending light source of the *Ein Sof*, its constant emanations, the *sefirot*, the *Kav* (the line which runs through the universe), the astral aspects of Hebrew symbols and the magic power of letters. These symbols of a solar tapestry give expression to the mystics' myriad quests for the absolute; their feeling for the unity of all that exists; and their yearning to understand the universe and our own awareness of its unity. With great creative insight almost comparable to a state of mystic ecstasy, the artist has sustained an intense rhythm in colors symbolic and deeply resonant, glowing, vibrating and changing constantly as the day wears on and fades into dusk.

Relation of the Cabalistic Spheres (from Horowitz, "Shefa Tal," 1612).

THE kind of synagogue art we have described in the foregoing chapters continues to evolve. It is evident by now that its development is not due to an experiment or to the whim of a particular congregation or individual architect. It is a response to deeply felt needs. Art has found a home within the synagogue, which has become an important and often enlightened patron, affording the artist a wide range of opportunities. In turn, synagogue leaders know that the work of the artist can express and help sustain religious and communal life. The synagogue asks nothing of the artist that the serious artist will not ask of himself—an understanding of the institution, its purpose and meaning; a profound immersion in his work so that he may bring his gifts fully to bear upon its life; and that his art be honest, expressive, and of its time.

The synagogue art program, we have seen, raises not only technical problems but fundamental questions as to the nature of the synagogue, the vitality of Jewish tradition, and the consciousness and values of the Jewish community today. These questions must be faced squarely by those who would meaningfully engage in this artistic effort.

There is no formula for determining the relationships among those who are involved in the synagogue building process. A high degree of cooperation, mutual understanding, and mutual respect must be achieved. More is called for than an amicable division of labor.

It is only fair to expect the architect and the artist to be aware of the realities of Jewish history and tradition. By the same token, congregational leaders will do well to respect the artist's freedom of thought and creativity. The enlightened rabbi will find himself able to bridge the gap between the world of the artist and the world of the congregation.

Vasari tells us that the Jews of sixteenth-century Rome used to come every Sabbath to see the statue of Moses carved by Michelangelo. A few years ago, thousands of people daily crowded the Museum of Modern Art in New York City to catch a glimpse of the twelve stained-glass windows which Marc Chagall designed for a synagogue in Jerusalem. Today as in the past, many come to marvel at the work of an artist who, like the biblical Bezalel, stands "in the shadow of the Lord," and by his work in glass, stone, wood, and metal brings them into closer touch with themselves and illuminates their lives.

BIBLIOGRAPHY

Ameisanowa, Anna, *The Tree of Life in Jewish Iconography*, Journal of the Warburg Institute, Vol. 2, No. 4, April, 1930.

Ashton, Dore, *The Reverend Comments*, Art Digest, October 15, 1951.

Avi-Yonah, M., *The Ma'on Mosaic Pavement*, The Ancient Synagogue of Ma'on (Nirim), Bulletin III of the Louis M. Rabinowitz Fund for the Exploration of Ancient Synagogues, Jerusalem, 1960.

Baron, S. W., *A Social and Religious History of the Jews*, Philadelphia, The Jewish Publication Society, 1952.

 The Jewish Community, Philadelphia, The Jewish Publication Society, 1942.

Berkovitz, E., *From Temple to Synagogue and Back*, Judaism, Vol. 8, No. 4.

Bevan, Edwyn, *Holy Images*, London, 1940.

Bittermann, Eleanor, *Art in Modern Architecture*, N. Y., Rheinhold, 1952.

Blake, Peter, *An American Synagogue for Today and Tomorrow*, Union of American Hebrew Congregations, 1954.

Buber, Martin, *Moses*, Oxford, East and West Library, 1947.

Cohen, Boaz, *Art in Jewish Law*, Judaism, Vol. 3, No. 2.

Cohen, Hermann, *Die Religion der Vernunft*, (second edition), Köln, 1959.

Cohn-Wiener, Ernst, *Die Jüdische Kunst,* Berlin, 1929.

Damaz, Paul, *Art in Latin American Architecture,* N. Y., Rheinhold, 1963.

Elbogen, Ismar, *Der Jüdische Gottesdienst in seiner geschichtlichen Entwicklung,* (third edition), Frankfurt am Main, 1931.

Filson, Floyd V., *Temple, Synagogue and Church*, The Biblical Archeologist, Vol. 7, No. 4.

Fingsten, Peter, *A New Definition of Religious Art*, College Art Journal, 1950.

Finkelstein, Louis, *The Origin of the Synagogue*, New York, Proceedings of the American Academy for Jewish Research, 1928-30.

Fitch, J. M., *Architecture and the Esthetics of Plenty*, N. Y., Columbia University Press, 1961.

Fitzsimmons, James, *Artists Put Their Faith in New Ecclesiastical Art*, Art Digest, October 15, 1951.

Frauberger, H., *Über Bau und Ausschmuckung alter Synagogen*, Frankfurt am Main, Mitteilung der Gesellschaft zur Erforschung Jüdischer Denkmäler, October, 1901.

 Über Alte Kultusgegenstände in Synagoge und Haus, Mitteilung der Gesellschaft zur Erforschung Jüdischer Denkmäler, 3/4.

Freehof, S. B., *The Patron Synagogue*, Union of American Hebrew Congregations, N. Y., Commission on Synagogue Activities (pamphlet).

Geiger, Abraham, *Das Mosesbild in einem Synagogfenster,* Breslau, Jüdische Zeitschrift für Wissenschaft und Leben, 1864-65.

Gill, Eric, *Beauty Looks After Herself*, New York, Sheed and Ward, 1933.

Glazer, Nathan, *American Judaism*, University of Chicago Press.

Goodenough, Erwin R., *Jewish Symbols in the Greco-Roman Period*, New York, Pantheon Books, Bollingen Series, 1953.

Goodman, Percival and Paul, *Modern Artists as Synagogue Builders*, Commentary, Vol. 7, No. 1, January, 1949.

Gradenwitz, P., *The Music of Ancient Israel*, Norton, 1949.

Grätz, H., *Die Konstruction der Jüdischen Geschichte*, Berlin, Schocken, 1936.

 Geschichte der Juden, (German edition).

Grotte, Alfred, *Die Kunst im Judentum und das 2. Mosaische Gebot*, Berlin, Der Morgen, June, 1928, Jahrg. 4.

 Deutsche, Böhmische und Polnische Synagogentypen vom lx bis Anfang de xlx Jahrhunderts, Gesellschaft zur Erforschung Jüdischer Kunstdenkmäler, Mitteilung, 7/8.

Grunwald, M., Breier, A., Eisler, M., *Holzsynagogen in Polen*, Vienna, 1934.

Hacohen, Mordechai, *Beth Haknepseth*, Jerusalem, 1955, (Hebrew).

Haftman, Werner, *Malerei Im 20. Jahrhundert*, München, Prestel Verlag, 1957.

Halpern, Ben, *The American Jew*, Theodor Herzl Foundation, 1956.

Hamlin, Talbot, *Forms and Functions of Twentieth Century Architecture*, Columbia University Press, 1952.

 Toward a Living Architecture, American Architect and Architecture, January, 1938.

Herberg, Will, *Religious Trends in American Jewry*, Judaism, Vol. 3, No. 3.

 Protestant, Catholic and Jew, Doubleday, 1955.

Hess, Thomas, *Abstract Art*, Background and American Phase, New York, Viking Press, 1951.

Hitchcock, Henry-Russel, *The Place of Painting and Sculpture in Relation to Modern Architecture*, London, Architects' Yearbook, Vol. 2, 1947.

Hitchcock, H.-R. and Johnson, P., *The International Style: Architecture since 1922*, N.Y., 1932.

Huxtable, Ada Louise, *Art in Architecture, 1959*, Craft Horizons, Vol. 19, No. 1.

Kallen, H. M., *Judaism at Bay*, New York, Bloch Publishing Company, 1932.

Kaplan, Mordecai, *Judaism as a Civilization*, New York, Reconstructionist Press, 1957.

 Judaism Without Supernaturalism, Reconstructionist Press, 1958.

Kaufmann, David, *Gesammelte Schriften*, M. Brann (ed.), Frankfurt am Main, 1908.

 Die Haggadah von Sarajevo, D. H. Müller and J. V. Schlosser (ed.), Vienna, 1898.

Kaufmann, Yehezkel, *The Religion of Israel*, University of Chicago Press, 1960.

Kayser, Stephen, *Visual Art in American Jewish Life*, Judaism, Vol. 3, No. 4.

 Jewish Ceremonial Art, Philadelphia, The Jewish Publication Society, 1955.

Klein, S. Alexander, *Contemporary Development in American Synagogue Art*, CCAR Journal, 1956.

Kohl and Watzinger, *Antike Synagogen in Galilãea*, Leipzig, 1916.

Kräling, Carl Hermann, *The Excavation at Dura Europos*, Final Report, VIII, Part I, The Synagogue, Yale University Press, 1956.

Krauss, Samuel, *Synagogale Altertümer*, Berlin-Vienna, 1922.

Krautheimer, Richard, *Mittelalterliche Synagogen*, Berlin, 1927.

Landsberger, Franz, *Einführung in die Jüdische Kunst*, Berlin, 1935.

 A History of Jewish Art, Union of American Hebrew Congregations, 1946.

 The Origin of the European Torah Decorations, Hebrew Union College Annual, Vol. 24.
 Old Time Torah Curtains, Hebrew Union College Annual, Vol. 19.

Leaf, Reuben, *Hebrew Alphabets*, New York, R. Leaf Studio, 1950.

Lescaze, William, *The Arts for and in Buildings*, Liturgical Arts, Feb. 1954.

Leveen, Jacob, *The Hebrew Bible in Art*, London, 1944.

Lissitzky, Eliezer, *The Synagogue of Mohilev*, Rimon, No. 3, Berlin, 1923, (Hebrew).

Löw, Leopold, *Graphische Requisiten und Erzeugnisse bei den Juden*, Leipzig, 1870.

 Der Synagogale Ritus, Szegedin, 1875.

Lukomski, G., *Jewish Art in European Synagogues*, London, Hutchinson, 1947.

Mihaly, Eugene, *Jewish Prayer and Synagogue Architecture*, Judaism, Vol. 7, No. 4.

Mumford, Lewis, *Toward a Modern Synagogue Architecture*, The Menorah Journal, June, 1925.

Museum of Modern Art, *Symposium on How to Combine Architecture, Painting and Sculpture*, Published in Interior, May, 1951.

Novicki, M., *Origins and Trends in Modern Architecture*, The American Magazine of Art, November, 1951.

Otto, Rudolf, *The Idea of the Holy*, Oxford University Press, 1925.

Piechotka, Maria and Kazimierz, *Wooden Synagogues*, Warsaw, Arkady, 1959.

Pinkerfeld, Jacob, *Synagogues in Italy*, (Hebrew).

Reifenberg, Adolf, *Ancient Hebrew Arts*, New York, Schocken, 1950.

Roth, Cecil, *Ha'omanut Ha'yehudit*, Jewish Art, Tel Aviv, Massada, 1959.

 The Problem of Jewish Art, Judaism, Vol. 6, No. 2.

 The History of the Jews in Italy, Philadelphia, The Jewish Publication Society, 1946.

Saarinen, A. B., *Art as Architectural Decoration*, Architectural Forum, June, 1964.

Schack, William, *Modern Art in the Synagogue*, Commentary, Vol. 20, No. 6, and Vol. 21, No. 2.

Schapiro, Meyer, *The Liberating Quality of Avant Garde Art*, Art News, June, 1957.

Schoen, M. and E. J. Lipman, *Proceedings of the Second National Conference on Synagogue Art and Architecture*, Union of American Hebrew Congregations, 1957.

Seckler, Dorothy, *Gottlieb Makes a Façade*, Art News, March, 1954.

Sklare, Marshall, *Conservative Judaism*, The Free Press, Glencoe, Ill.

 The Jews, Social Patterns of an American Group, The Free Press, Glencoe, Ill., 1958.

Sowers, Robert, *The Lost Art*, New York, Wittenborn, 1954.

Sukenik, E. L., *Ancient Synagogues in Palestine and Greece*, London, 1934.

Thiry, P., Bennett, R. M., and Kamphoefner, H. L., *Churches and Temples*, New York, Rheinhold, 1953.

Urbach, E. E., *The Rabbinical Laws of Idolatry in the Second and Third Centuries in the Light of Archeological and Historical Facts*, Jerusalem, Israel Exploration Journal, Vol. 9, Nos. 3 and 4, 1959.

Viollet-le-Duc, *Medieval Stained-Glass Windows*, translated by F. P. Smith, Atlanta, Georgia, 1946.

Watzinger, *Denkmäler Palestinas*, Leipzig, 1933.

Weisman, Winston, and Fogel, Seymour, *Architecture and Modern Art*, College Art Journal, Summer, 1952.

Whittick, Arnold, *Erich Mendelsohn,* New York, Dodge, 1956.

Wischnitzer, Rachel, "Judaism and Art," in *The Jews, Their History, Religion and Culture*, J. F. Finkelstein (ed.), Philadelphia, The Jewish Publication Society, 1949.

 Symbole und Gestalten der Jüdischen Kunst, Berlin, 1935.

 Synagogue Architecture in the United States, Philadelphia, The Jewish Publication Society, 1955.

 The Messianic Theme in the Paintings of the Dura Synagogue, University of Chicago Press, 1948.

 The Wise Men of Worms, Reconstructionist, Vol. 25, No. 3.

Wright, Ernst G., *The Significance of the Temple in the Ancient Near East*, The Biblical Archeologist, Vol. 7, No. 4.

Zeitlin, Solomon, *The Origin of the Synagogue,* New York, Proceedings of the American Academy for Jewish Research, 1930-31.

NOTES

The Synagogue

Cf. Simon Dubnow, *Weltgeschichte des Jüdischen Volkes* (Berlin, 1925), p. 335. Heinrich Grätz, *History of the Jews* (Philadelphia, 1891), p. 401. Samuel Krauss, *Synagogale Altertümer* (Wien, 1922), pp. 52-66. Krauss discusses various theories about the origin of the synagogue. He believes that it was founded in Babylon.

2. Leopold Löw, *Der Synagogale Ritus*, Vol. IV, p. 4, (Gesammelte Schriften, Szegedin, 1889).

3. *Ibid.*, p. 3. Löw also points to the fact that Targum and Rashi, two significant commentaries of the Bible, explain *Bet Am* as *Bet K'nesset* (synagogue).

In recent years, there have been two interesting contributions to the problem of the origin of the synagogue. Louis Finkelstein agrees with Löw on the pre-exilic origin of the synagogue. However, he sees it as having a religious, rather than a political, basis. Its religious roots, he feels, were the holy convocations set at certain appointed seasons (Lev. 23:4); the practice of visiting a prophet on Holy Days (II Kings 4:23); and the gathering of prophets on Sabbath and new moons. See *Proceedings of the American Academy for Jewish Research*, New York, 1928-30.

S. Zeitlin would attribute the origin of the synagogue, as Löw does, to the socio-political bases of community life. However, he feels these factors became influential only after the return of the exiles from Babylonian captivity. The returning exiles convened an assembly to arbitrate economic and social problems and called the participants בני כנסת (Sons of the Assembly), the head of it ראש כנסת (Head of the Assembly), and the house in which they gathered בית כנסת — *Bet K'nesset* — (House of Assembly), Synagogue in Greek. These assemblies became permanently established, and finally resulted in the institution of the synagogue. See *Proceedings of the American Academy for Jewish Research*, New York, 1930-1.

4. Salo W. Baron, *The Jewish Community*, Vol. I (Philadelphia, 1942), chaps. II and III, and pp. 87-93.

5. Baron, *A Social and Religious History of the Jews*, Vol. 2 (Philadelphia, 1952), pp. 280-286.

6. Philo, *Life of Moses*, III, 27, translated by C. D. Young (London, 1854).

The Interpretation of the Second Commandment

1. Ernst Cohn-Wiener, *Die Jüdische Kunst* (Berlin, 1929).

2. The full text reads as follows: "Thou shalt not have other Gods before Me. Thou shalt not make unto thee a graven image, nor any manner of likeness, of any thing that is in heaven above, or that is in the earth beneath, or that is in the water under the earth; thou shalt not bow down unto them, nor serve them; for I the Lord thy God am a jealous God, visiting the iniquity of the fathers upon children unto the third and fourth generation of them that hate Me"(Exod. 20:3-5).

3. Yehezkel Kaufmann, with his unusually sharp insights, comments on these seeming contradictions as follows: "Moses did not repudiate the accepted belief of his age that man's relation to God expresses itself through a cult. To be sure, Mosaic religion did not have images of YHWH, but this is not owing to a radical rejection of images. The fact is that neither in the Torah nor in the prophets is the matter of representing YHWH a crucial issue. Both the desert calf and the two calves of Jeroboam are considered by their opponents to be fetishes, not images of God. The ban on making idols and other fixtures follows as a separate prohibition from the ban on having other gods. The images are thus not conceived of as representations of other gods, but as objects which themselves belong to the category 'other gods'; they do not symbolize, they *are* other gods. Israelite religion never knew of nor had to sustain a polemic against representations of YHWH. Intuitively, it rejected representations of God because such images were regarded in paganism as an embodiment of the gods, and as such, objects of a cult. This idea was

to Israel the very essence of idolatry; hence from the very onset it rejected without a polemic representation of YHWH. This tacit decision was the crucial moment in the battle against idol-worship.

"But the biblical objection to the employment of figures in the cult is not primary or fundamental. Later zealots objected to every sort of image, but this was evidently not the early position. Israelite religion rejected from the first figures worshipped as gods; it did not forbid cultic figures which were not objects of adoration." *The Religion of Israel* (Chicago, 1960), pp. 236-237.

Buber agrees essentially with Kaufmann, but approaches the problem from a different angle. See Martin Buber, *Moses*, Oxford, East and West Library, 1947, pp. 124-127.

The Hebrew God was originally called a "god of way" differing from all other solar and lunar "gods of way" in Mesopotamia in that He guided only Abraham and his own group and that He was not regularly visible in heaven, but permitted Himself only occasionally to be seen when He willed so. Various natural processes were sometimes seen as a manifestation of this God.

Moses revived this conception of the God, which had been forgotten by the Hebrew tribes in Egypt. "Thus it can be understood that clouds, and smoke, and fire, and all kinds of visual phenomena are interpreted by Moses as visual manifestations from which he has to decide as to the further course through the wilderness. . . . But always, and that is the fundamental characteristic, YHWH remains the invisible One. . . . For this reason He should not be imaged, that is, limited to any one form; nor should He be equated to one or other of the 'figures' in nature; and precisely because He makes use of everything potentially visible in nature. . . . The prohibition of 'images' and 'figures' was absolutely necessary for the establishment of His rule, for the investiture of His absoluteness before all current 'other gods.'

"No later hour in history required this with such force; every later period which combatted images could do nothing more than renew the ancient demand. What was immediately opposed to the founder-will of Moses makes no difference; whether the memories of the great Egyptian sculptures or the clumsy attempts of the people themselves to create, by means of some slight working of wood or stone, a reliable form in which the Divinity could be taken with them. Moses certainly saw himself working a contrary tendency; namely, that natural and powerful tendency which can be found in all religions, from the most crude to the most sublime, to reduce the divinity to a form available for and identifiable by the senses. The fight against this is not a fight against art, which would certainly contrast with the report of Moses' initiative in carving the images of the cherubim; it is a fight to subdue the revolt of fantasy against faith. This conflict is to be found again in more or less clear-cut fashion, at the decisive early hours, plastic hours, of every 'founded' religion; that is of every religion born from the meeting of a human person and a mystery. Moses more than anybody who followed him in Israel must have established the principle of the 'imageless cult,' or more correctly of the imageless presence of the Invisible, who permits Himself to be seen."

Hermann Cohen takes a different view. See footnote 30, same chap.

4. David Kaufmann, *Gesammelte Schriften*, edited by M. Brann (Frankfurt am Main, 1908), "Zur Geschichte der Kunst in den Synagogen." Also see his very important article, "Die Löwen unter der Bundeslade von Ascoli und Pesaro," which appeared in 1897, in the *Erster Jahresbericht der Wiener Gesellschaft für Sammlung und Konservierung von Kunst und Historischen Denkmäler des Judentums.*

5. *Ibid.*

6. Kaufmann, *Die Haggadah von Sarajevo*, edited by D. H. Müller and J. V. Schlosser (Wien, 1898), "Zur Geschichte der Jüdischen Handschrift Illustration"; *Gesammelte Schriften*, Vol. III, "Die Bilderzyklen im deutschem Typus der alten Haggadah Illustration" and "Beitrage zur Jüdischen Archäologie."

7. "The Italian Synagogue of Padua contains such an abundance of magnificent silver work that its description and reproduction would justify a special undertaking." "Etwas von Jüdischer Kunst, Aus der Pariser Weltaustellung," *Israelitische Wochenschriften*, Jahrgang 9, 1878.

8. Kaufmann, *Gesammelte Schriften*, Vol. III, "Beitrage zur Jüdischen Archäologie."

9. Löw, *Graphische Requisiten und Erzeugnisse bei den Juden* (Leipzig, 1870).

10. Abraham Geiger, *Jüdische Zeitschrift für Wissenschaft und Leben* (Breslau, 1864-65), "Das Mosesbild in einem Synagogfenster."

11. *Ibid.*

12. M. Grunwald, Breier and Eisler, *Holzsynagogen in Polen* (Vienna, 1934). G. Lukomski, *Jewish Art in European Synagogues* (London, 1947). Reifenberg, *Ancient Hebrew Arts* (New York, 1950). Kräling, *The Synagogue* (New Haven, 1956). Sukenik, *Ancient Synagogues in Palestine and Greece* (London, 1934). Jacob Leveen, *The Hebrew Bible in Art* (London, 1944). R. Wischnitzer, *Symbole und Gestalten der Jüdischen Kunst* (Berlin, 1935). E. Goodenough, *Jewish Symbols in the Greco-Roman Period* (New York, 1953). M. Avi-Yonah, "The Ma'on Mosaic Pavement," *The Ancient Synagogue of Ma'on* (Nirim), Bulletin III of the Louis M. Rabinowitz Fund for the Exploration of Ancient Synagogues (Jerusalem, 1960).

13. Geiger points out that the trust Halakhah has in the community is unconditional.

14. C. Roth, Ha'omanut Ha'yehudit Massadah (Tel Aviv, 1959), p. 19. Samuel Krauss, *Synagogale Altertümer* (Vienna, 1922), p. 348.

15. S. Baron, *A Social and Religious History of the Jews*, Vol. II (Philadelphia, 1952), p. 13.

16. *Ibid.*, pp. 13-14.

17. E. E. Urbach, *Israel Exploration Journal*, Vol. IX, Nos. 3 and 4 (Jerusalem, 1959), "The Rabbinical Laws of Idolatry in the Second and Third Centuries in the Light of Archeological and Historical Facts." In this paragraph his account is closely followed. Urbach cites Talmud Yoma 69 and Sanhedrin 64 as well as the apocryphal Book of Judith for the weakening of idolatry: "For there has not arisen in our generation, nor is there today, a tribe, a family, a clan or a city that worships idols made by human hands as there was once in olden times" (Judith 8:8).

18. There was a widespread feeling that idolatry did not constitute a danger to the people, since it was so obviously false. A pagan gave expression to this view in a discussion with R. Akibah. "You know in your heart as I know in mine that there is nothing real in idolatry" (Avodah Zarah 55a). Urbach, *loc. cit.*

19. "The Jewish craftsmen based the defense of their professional activities on the well-known fact that the Gentiles themselves considered the idols to have no efficacy. Their arguments were acceptable to the authors of the Agadah and Halakhah, who expressed them in their own peculiar way. Recounting a conversation between Moses and God after the incident of the golden calf, the Tanna Rabbi Nehemia puts the following words into the mouth of the collocuters: (Moses) said: Lord of the universe they have provided assistance for You, how can You be angry with them? This calf which You have made will be Your assistant. You will make the sun rise and it the moon, You the stars and it the constellations, You will make the dew fall and it the wind blow, You will bring down rain and it will cause plants to grow. The Holy blessed be He answered: Moses can you be as misguided as they?! See, it is worthless! Moses retorted: Then why are you angry with your children? *Exodus Rabbah* 43:6, quoted from Urbach, *loc. cit.*

20. Rachel Wischnitzer, "Judaism and Art," *The Jews, Their History, Religion and Culture*, edited by J. Finkelstein (Philadelphia, 1949). Bevan comments on the attitude of Maimonides: "This reason is plainly an afterthought, in order to provide a justification for a feeling which has originally been created by the prohibition, authoritative in earlier generations, and which remained instinctive in the Jewish community, when the condemnation could no longer be based on the original ground. Some other ground had to be found for it. The new ground is really absurd. Ordinary psychology would tell us that a detail of decoration repeatedly before the eyes of the worshippers would become unnoticeable with familiarity." E. Bevan, *Holy Images*, London, 1940, p. 63.

21. Löw, *Graphische Requisiten und Erzeugnisse bei den Juden* (Leipzig, 1870), p. 33. Löw presents many other examples of conflicting attitudes.

22. *Ibid.*, p. 38.

23. *Ibid.*

24. Franz Landsberger, *Einführung in die Jüdische Kunst* (Berlin, 1935), p. 34. Cf. Cecil Roth, *The History of the Jews in Italy* (Philadelphia, 1946), p. 391.

25. Alfred Grotte, *Der Morgen*, Berlin, Jahrgang 4, No. 2, June, 1928, "Die Kunst im Judentum und das 2. mosaische Gebot."

26. "Rabbi Dober Minkes of Zitomir tells us: Many pious men from the synagogue in which I pray asked me to explain whence the permission derives to paint, in the synagogues of the big cities, paintings of animals and birds in low relief and high relief around the Holy Ark. Doubtlessly, it was done according to the wishes of the great scholars of the past who were (holy) like the angels (ראשונים כמלאכים). There are also synagogues which have all their walls covered with paintings of birds, animals, and the zodiac. It is also an everyday occurrence for them to embroider the *Parokhet* for Sabbath and festivals and the Torah covers with silk, gold and silver threads, and all kinds of designs of animals, and birds, lions, and eagles. It would seem that they transgress the commandment prohibiting images and pictures and that they may open themselves to suspicion of idolatry. And how do they bow down to the Holy Ark? And how do they kiss such a *Parokhet*? Might one not surmise that they bow down and kiss an image? And if, God forbid, this would be prohibited, the great ones of our own generation and of former generations, who did not do things according to their own understanding but followed their teachers, would not have allowed this. Doubtlessly it is a *mitzvah* to do paintings and decorations to elevate the synagogue (מקדש מעט), and there is no fear that they act according to alien custom." Quoted from Yizchak Z. Kahana, "The Art of the Synagogue in the Literature of the Halakhah," *The Synagogue*, edited by Mordechai Hacohen (Jerusalem, 1955), in Hebrew.

27. "The auditory sphere may claim an exceptional position in the development of the superego of the individual. In the building of that new agency of the superego, certain experiences and impressions are necessary. Purely optical impressions without words by themselves would be insufficient for the establishment of ethical judgments. For the preliminary stages of superego formation, language audibly perceived is indispensable. The nucleus of the superego is to be found in the human auditory sphere." Theodore Reik, *Mystery on the Mountain* (New York, 1959), p. 168.

28. Talmud, Megillah 32a, quoted from Peter Gradenwitz, *The Music of Ancient Israel* (Norton, 1949), p. 83. A rabbi of the third century demanded that the ears of those listening to secular music should be cut off.

29. Grätz, *Die Konstruction der Jüdischen Geschichte* (Berlin, 1936), pp. 13-14.

30. Hermann Cohen, *Die Religion der Vernunft* (Köln, 1959), second edition, pp. 61-63.

"The contrast between the One God and the many gods is not confined to the difference in numbers. It expresses itself in the difference between an unperceivable idea and a perceptible image. And the

immediate response of reason to the concept of the One God is confirmed in this antagonism to the image. Every image is a reflection of something. Of what primal image can the image of God be a reflection?

"Is there then such a thing as a primal image of God in an image? The images of God must be images of something else to which they assign the significance of a god. Here again, there arises the contradiction between the single being of God and all the alleged beings. The images of God cannot be reflections of God, they can only be reflections of objects of nature.

"Thus, of necessity, there arises within prophetic monotheism the opposition to art, which is the primal activity of the human spirit, namely the creation of images which are reflections of natural objects filling the universe. This is the process of art among all peoples. Let us ask ourselves how we can understand the anomaly which exists between the monotheistic spirit and all human consciousness at this turning point of culture.

"The question does not only concern the original tendency of monotheism, but also the anomaly of historical influence. No people in the history of the world, not even the most developed, ever withdrew from it. How can we grasp the fact that the prophets resisted the glorious creations, the magic art of Babylon and Egypt, and mockingly derided it? In all other instances, art is a universal tendency of man, and stands in effective reciprocal relationship to poetry. How could the monotheistic spirit develop its might in poetry while maintaining a resistance toward the plastic arts?

"We cannot solve this question here fully. Only when we discuss the monotheistic concept of man, can we attempt to do so. Here, our question concerns only the single God who represents the only Being. Therefore, no image of Him is allowed. It would have to be a primal image; furthermore, *the* primal image; therefore, an image which must be a reflection of something.

"The gods must be destroyed because they are not beings but images. To serve such gods is to serve images. The service of God is, however, the service of the true Being. The fight against the gods is, therefore, a fight against appearance, the fight of primal Being against images which have no being.

"Thus the Decalogue progresses from the prohibition against other gods to the prohibition against images. And this prohibition does not confine itself to the sentence: 'Thou shalt not bow down unto them, nor serve them,' nor to: 'Thou shalt not have other gods before Me,' but the attack on art becomes a direct one: 'Thou shalt not make unto thee a graven image, nor any manner of likeness, of anything that is in heaven above, or that is in the earth beneath, or that is in the water under the earth.'

"Polytheism is attacked at its roots, and these are not seen in the immediate sanctification of natural phenomena, but only in the worship of that which man's mind produces with man's hands. Only through art can that 'which is in heaven above, or that which is in the earth beneath, or that which is in the water under the earth,' become a misleading primal image. 'Thou shalt not make unto thee a graven image,' means: the picture must be a reflection of God. However, there is no image. He is at most but a primal image of the spirit, of the love, of reason, but not an object of representation" (pp. 61-63).

"It is a futile objection that the one who worships the image does not mean the image, but only the object it represents. This objection betrays a misunderstanding of true monotheism. Since it differentiates itself from all image worship, the single God cannot be thought of as an object in a picture. Even if worshippers of images mean only the object represented in the image, monotheism teaches that God is not an object who can be imagined. *AND IT IS THE PROOF OF THE REAL GOD THAT THERE CAN BE NO IMAGE OF HIM.* He can come into consciousness through reflection only as primal image, as primal thought, and primal Being" (p. 66).

31. "In the ancient world there were on the evidence of Pliny more gods than human beings, or as Rabbi Isaac put it: If they wrote down the names of every single one of their idols, all the hides in the world would not suffice them." E. E. Urbach, *loc. cit.*

32. Bevan, *Holy Images*, p. 13.

33. Grätz, *Geschichte der Juden*, Introduction. (The English translation omits the introduction.)

34. *Ibid*. See also Hermann Cohen, *Die Religion der Vernunft, ed. cit.*, p. 43.

"Plastic art becomes the analogy to nature. Poetry, on the contrary, becomes the primal language of literature and, through its forms, makes the spiritual thought more inward, as plastic art could never do."

35. Quoted from Wischnitzer, *The Messianic Theme in the Paintings of the Dura Synagogue* (Chicago, 1948), p. 9.

36. Quoted from Baron, *A Social and Religious History of the Jews*, II, p. 284.

37. *Ibid.*

38. See also Nazir, 2b.

39. Megillah, 27a.

The American Synagogue Today

1. Mordecai M. Kaplan, *Judaism as a Civilization* (Reconstructionist Press, 1957), p. 425.

2. Nathan Glazer, *American Judaism;* Marshall Sklare, *Conservative Judaism* and *The Jews, Social Patterns of an American Group;* Albert Gordon, *Jews in Suburbia;* Will Herberg, *Protestant, Catholic and Jew;* Ben Halpern, *The American Jew.*

3. Kaplan, *Judaism as a Civilization*, p. 435.

4. *Ibid.*, p. 458.

5. The idea of the Holy, or the numinous, is, according to Rudolf Otto, an essential element underlying all religious evolution. It is at the very essence of all religion and exists before it becomes rationalized, moralized and charged with ethical import. It is a unique response, which can be ethically neutral in itself, and claims consideration in its own right. It stands above and beyond the meaning of goodness. It is a category of value, a state of mind which can be discussed but not defined. "It is the emotion of a creature, abased and overwhelmed by its own nothingness, in contrast to that which is supreme above all creatures." One of its significant manifestations is the *Mysterium Tremendum*. "The feeling of it may at times come sweeping like a gentle tide, pervading the mind with a tranquil mood of deepest worship. It may pass over into a more set and lasting attitude of the soul, continuing as it were thrillingly vibrant and resonant, until at last it dies away and the soul resumes its profane, non-religious mood of everyday experience. It may burst in a sudden eruption up from the depths of the soul with spasms and convulsions, or lead to the strangest excitements, to intoxicated frenzy, to transport and ecstasy. It has its wild and demonic forms and can sink to an almost grisly horror and shuddering. It has its crude barbaric antecedents and early manifestations and again it may be developed into something beautiful, and pure, and glorious. It may become the hushed, trembling, and speechless humility of the creature in the presence of—whom or what? In the presence of that which is a mystery, inexpressible and above all creatures. . . ." *The Idea of the Holy* (Oxford, 1925), pp. 12-13.

6. "The paintings of Mondrian and Nicholson, the sculptures of Domela or Gabo, are for the architect exercises in pure form, the principles of which they hope to apply at large scale and in terms of real space in the buildings they build. Their devotion to these arts, in other words, is in the esthetic field somewhat like the devotion of technicians in science to the work of pure mathematicians and theoretical physicists." Henry-Russel Hitchcock, "The Place of Painting and Sculpture in Relation to Modern Architecture," *Architects' Yearbook*, Vol. II (London, 1947).

7. "The sculptor is no longer one of the people the architect calls in. The only sculptor employed in the building is the architect himself. The building as a whole is a work of sculpture, and any detail or part is in itself a piece of sculpture. The steel frame work is precisely the armature, the stone or concrete is the modeled body." Eric Gill, *Beauty Looks After Herself* (New York, 1933), p. 77.

8. Lewis Mumford, "Toward a Modern Synagogue Architecture," *The Menorah Journal*, Vol. XI, No. 3, June, 1925.

9. *Ibid.*

10. *Ibid.* Mumford puts the dilemma poignantly: "It is absurd to expect a successful esthetic expression when the architect has the alternative of designing a whole building anew, or of taking over dismembered details from existing buildings. The perfection of the Greek Temple was achieved by using a single architectural form and refining every detail by repeated experiment, until each part was in mathematical harmony with every other part and the whole building sang the 'music of the spheres.' Tradition used in this fashion is the very key to freedom of expression, even as a consistent grammar leaves the mind to deal more lucidly with ideas. Within such a tradition the place of experiment is large."

11. "One might say that this architecture became a decoration of function. The period of functional exactitude looked for its inspiration toward the physical function. The psychological one was not considered in its philosophy. The concept of controlled environment resulted, and the main purpose of architecture was to control the physical environment to the physical satisfaction of its user." Novicki, "Origins and Trends in Modern Architecture," *The American Magazine of Art*, November, 1951.

12. Ben Shahn expresses the view held by many artists: "To create something ornamental but nothing more he (the painter) is in effect asked to take leave of himself for a period, to depart from his role." Symposium at the Museum of Modern Art on "How to Combine Architecture, Painting and Sculpture." Printed in *Interior*, May, 1951.

13. The need for art in contemporary architecture is by no means taken for granted by all architects. In *Building's Forum*, June, 1951, twelve architects were asked to comment on the question: "Are there new opportunities for integrating sculpture and painting with architecture?" Some of the answers are revealing:

Jack Hillmer: "Neither painting nor sculpture has a very important place in our life today . . . the best way of 'integrating' sculpture with contemporary architecture is to melt them down and make bronze hardware out of them."

A. Q. Jones: "The question probably should have been . . . Do you believe that sculpture and painting will cease to exist? Seriously I believe they will."

William McMaster: "Architecture, sculpture and painting are entities in themselves and cannot be integrated."

Breger and Salzman: "Integrate painters with paintings, sculptors with sculpture, and architects can go on from there." Winston Weisman and Seymour Fogel, "Architecture and Modern Art," *College Art Journal*, Summer, 1952.

See also: J. M. Fitch, *Architecture and the Esthetics of Plenty*, (New York, 1961). "Views on Art and Architecture," a conversation arranged by J. Burchard and "Alienated Affections in the Arts," Burchard. Both appeared in *Daedalus*, Journal of the American Academy of Arts and Sciences, edited by Gyorgy Kepes, Winter 1960.

14. For a different approach see: Ada Louise Huxtable, "Art in Architecture," *Craft Horizons*, Vol. XIX, No. 1 (1959).

15. Oscar Niemeyer in the preface to Damaz's *Art in Latin American Architecture*, 1963, and "Views on Art

and Architecture," a conversation arranged by Burchard, op. cit.

16. William Lescaze, "The Arts for and in Buildings" *Liturgical Arts* (February, 1954). Aline B. Saarinen, "Art as Architectural Decoration," *Architectural Forum*, (June, 1954).

17. Talbot Hamlin, *Forms and Functions of Twentieth Century Architecture* (New York, 1952), p. 746.

Art for Today's Synagogue

1. Rachel Wischnitzer, *The Wise Men of Worms*, Reconstructionist, Vol. XXV, No. 3.

2. Eliezer Lissitzky, a founder of the modern constructivist movement who investigated the paintings in the Polish synagogues in 1907, draws our attention to this fact. He also points out that manuscripts illuminated with ancient Hebraic pictorial themes, which were transmitted over the centuries and could always be found among the books in these synagogues, influenced some of the pictorial motives on their walls. Eliezer Lissitzky, "The Synagogue of Mohilev," *Rimon*, No. 3 (Berlin, 1923), in Hebrew.

3. Paul and Percival Goodman, "Modern Artists as Synagogue Builders," *Commentary*, Vol. VII, No. 1 (January, 1949).

4. Symbols such as, for instance, the pelican, the squirrel, or the salamander are not found in contemporary synagogue art. For an excellent account of motives and iconographical symbols of Hebrew art, see Rachel Wischnitzer, *Symbole und Gestalten der Jüdischen Kunst* (Berlin, 1935).

5. Meyer Schapiro, "The Liberating Quality of Avant Garde Art," *Art News* (June, 1957).

6. Reuben Leaf, *Hebrew Alphabets* (Reuben Leaf Studio, New York, 1950).

7. See Ben Shahn's use of the Hebrew letter in his books: *The Alphabet of Creation* (New York, 1954). *Love and Joy about Letters* (New York, 1963). *Haggadah* (Boston, 1965). Illustrated by the artist.

8. Thus, for instance, *The Torah*, a painting by S. Menkes which was once acclaimed as a most important artistic expression of Jewish sentiment, is still stored in a New York City cellar.

Congregation B'nai Israel in Millburn, New Jersey

1. From the congregation's booklet explaining the artwork of the temple.

2. *Ibid.*

3. For Motherwell's and other artists' reactions see: James Fitzsimmons, "Artists Put Faith in New Ecclesiastic Art," *Art Digest*, October 15, 1951. The point of view of the rabbi is put forth in the same issue by Dore Ashton.

Artwork on Synagogue Exteriors

1. Talmud, Megillah, 4, 22.

2. *Teshuvot Ha'Rambam*, Freiman edition (Jerusalem, 1934), Siman 21, p. 20.

3. Samuel Krauss, *op. cit.*, p. 273.

4. Frauberger, in the second pamphlet of the German Society for Research on Jewish Art, mentions the frequent invitations to architects to submit designs for synagogues. "As a rule, these competitions bring no satisfactory results because on the one hand, the officers of the congregation are not sure about their own requirements, and on the other hand, architects do not know the ritual and its development. There are some architectural manuals to be had in which one may get some important technical hints. However, when it comes to decorative elements these manuals fall back on stereotyped suggestions: 'To crown the top of the synagogue one uses mostly the hexagram or the shield of David; to crown the main portal one uses the Decalogue with the initial letters of the alphabet.' These have become very hackneyed and are mostly used as a sign which identifies the building as one used for Jewish services, because in all other ways the building resembles exactly a Catholic church, including the cruciform ground plan." *Über Bau und Ausschmückung alter Synagogen*, Mitteilung der Gesellschaft zur Erforschung Jüdischer Denkmäler (October, 1901, Frankfurt am Main), p. 3.

5. Gershom Scholem, *Major Trends in Jewish Mysticism* (Schocken Books, New York), pp. 113-114.

Artwork in the Vestibule

1. William Schack, "Modern Art in the Synagogue," *Commentary*, XX, 6 (1955); XXI, 2 (1956).

Artwork in the Prayer Hall

Part I

1. "This battle between the *bimah* and the Holy Ark, which till the seventeenth and eighteenth century made the building program of the synagogue waver with uncertainty, is the expression of a deeper struggle between sacred magic and the rational elements of the service." Richard Krautheimer, *Mittelalterliche Synagogen* (Berlin, 1927), p. 98.

2. Samuel Krauss, *op. cit.*, p. 384.

3. Tosefta Sukah, 4, 6.

4. Eliezer Sukenik, *op. cit.*, p. 52.

5. Rachel Wischnitzer, *Symbole und Gestalten der Jüdischen Kunst*, p. 127. See also A. Ameisanowa, "The Tree of Life in Jewish Iconography," *Journal of the Warburg Institute*, Vol. II, No. 4 (April, 1939).

6. Erwin R. Goodenough, *op. cit.*, Vol. IV, p. 71, ills. 2, 3, 4.

7. Wischnitzer, *op. cit.*

8. Goodenough, *op. cit.*, p. 95.

9. Roth, *op. cit.* See chapter, "Art of Holy Jewish Utensils."

10. Stephen S. Kayser, *Jewish Ceremonial Art* (Philadelphia, 1955).

11. For a detailed discussion, see Franz Landsberger, "The Origin of the European Torah Decorations," *Hebrew Union College Annual*, XXIV, and "Old Time Torah Curtains," *ibid.*, XIX.

12. "Today, we build with a distant stage and a passive audience. As an architect who creates space for use and life and whose plan cannot come alive until the people move in it, I feel that the plan with the central *bimah*. the plan which invites participation and which serves to increase the sense of oneness of the congregation, the sense of seeing one's fellow men (instead of the backs of their heads), the plan which increases the sense of community which we are working to foster, is the better plan to use. Yet building committees of Reform and Conservative congregations have invariably turned down the plan of community for the plan of separation." Percival Goodman, "The Sanctuary," *The American Synagogue; A Progress Report*, ed. Myron E. Schoen and Eugene J. Lipman (New York, 1958), p. 134.

13. Eugene Mihaly, "The Implications of the Jewish Concept of Prayer for Synagogue Architecture," *The American Synagogue; A Progress Report*, pp. 90-126. See also *Judaism*, Vol. VII, No. 4.

14. *Ibid.*

15. *Ibid.*

16. *Ibid.*

17. Thus Israel Wechsler points to the existence within Jewish culture of an idealism which never assumed a pure symbolic structure, but was always in touch with the issues of life and created within the Jewish individual a particular sensitivity to social and moral issues. See "Nervousness and the Jew, An Inquiry Into Racial Psychology," *The Menorah Journal*, Vol. X (April, 1924).

18. Eugene Mihaly, *op. cit.*

19. *Ibid.*

20. *Ibid.*

21. Percival Goodman states the issue in these terms: "The light, it is written, is 'to burn continually.' '. . from evening to morning before the Lord; it shall be a statute for ever throughout their generations on the behalf of the children of Israel' (Exod. 27:20). The rabbis interpreted the light as a symbol of Israel whose mission is to become a 'light of the nations' (Isa. 42:6). It is also written that Aaron and his sons were to set it in order each day. Can we fulfill this obligation by paying the bill from the electricity company each year? Shall this light be subject to strikes or to failure in the power line? No! This light is to be tended by the congregation as an act of remembrance. It must be a light that requires maintaining at short intervals, that flickers and threatens to go out so we may lovingly bring back the flame, being reminded of the ephemeral quality of our lives and the eternal need for vigilance in the fulfillment of duty. If this is so then let us tell the sculptor—and let him be the best artist we can find—make us a light fixture using oil or wax as fuel, designed so that it may be lowered for a weekly service of rekindling. On Sunday morning, the Confirmation class will go to the prayer hall and with a suitable statement (why not the very one from Exodus?) lower, clean, and rekindle this sacred light." *The American Synagogue; A Progress Report*, p. 132.

Artwork in the Prayer Hall

Part II

22. When this writer visited the synagogue he found a class of children with their teacher studying the biblical story in front of the doors of the ark.

23. The relation of Halakhah and Agadah is one of the most fascinating features in Judaism. One is represented as "angry faced, the other as smiling. One pedantic, severe, and hard as iron eliciting a full measure of justice; the other is described as permissive, easy going, soft as oil, and merciful . . . They really are but the two faces of one thing. Their relationship to each other is like the relationship between the word to thought and feeling, between action and concrete form and the word . . . Halakhah is the crystallization, the remaining necessary essence of Agadah. Their relationship is like the relationship of the flower to the fruit . . . Judaism which is only Agadah is like the iron one puts into the fire but does not let cool off. The wish of the heart, good will, an awakening of the spirit, inner love—all these things are beautiful and useful if at the end of them there are deeds, actions hard as iron and cruel responsibility." Chaim Nachman Bialik, *Halakhah and Agadah*. Kol Kitvey Bialik (Tel-Aviv 1939).

24. Agadah glorifies Bezalel, telling the following: "Moses had great difficulty with the construction of the candlestick, for although God had given him instructions about it, he completely forgot these when he descended from heaven. He thereupon betook himself to God once more to be shown, but in vain, for hardly had he reached earth, when he again forgot. When he betook himself to God the third time, God took a candlestick of fire and plainly showed every single detail of it, that he might now be able to reconstruct the candlestick for the Tabernacle. When he found it still hard to form a clear conception of the nature of the candlestick, God quieted him with these words: 'Go to Bezalel, he will do it alright.' And indeed Bezalel had no difficulty in doing so, and instantly executed Moses' commission. Moses cried in amazement: 'God showed me repeatedly how to make the candlestick; yet I could not properly seize the idea; but thou without having had it shown thee by God, couldst fashion it out of thine own fund of knowledge. Truly dost thou deserve thy name Bezalel, in the shadow of God, for thou dost act as if thou hast been in the shadow of God, while He was showing me the candlestick.' " Louis Ginzberg, *Legends of the Jews* (Philadelphia, 1956), p. 411.

Stained-Glass Windows

1. Viollet-le-Duc, *Vitrail*, translated from the French by F. P. Smith, p. 8. This book is still the most lucid summation of the art of stained glass.

2. The reader will find a good account of new developments in stained glass in Robert Sowers' *The Lost Art* (New York, Wittenborn, 1954).

3. Viollet-le-Duc clarifies the relation of painting to stained glass as follows:

"The representation in translucent glass of a painting in which the effects of linear and aerial perspective have been rendered in all their gradations of light and shadow, is as rash an enterprise as that of trying to reproduce the effect of the human voice on stringed instruments. We are dealing with a different process, other conditions and a separate branch of art. There is almost as much difference between the opaque painting which seeks to produce an illusion and the work of the stained glass artist, as there is between a painting and a bas relief. The bas relief even if it be painted cannot give the effect of an opaque painting as it still remains only an assemblage of figures on one plane. In the painting the intensity of the colors is under the control of the artist, who with half tones and shadows can regulate the values according to the different planes, diminishing and strengthening them at will. On the other hand, the radiation of translucent color in glass cannot be modified by the artist; all of the talent must be devoted to obtaining harmony on a single plane, as in a tapestry without any effect of aerial perspective. However it may be made, a window cannot represent more than a single plane surface, its true qualities impose this condition and any attempt to present to the eye several planes, destroys the harmony of color without creating any illusion for the spectator. An opaque painting rightfully should define various planes, and even if it consists of a single figure against a flat background, the artist attempts to indicate three dimensions in his figures. If the early painters did not attain this result, it was nevertheless their goal. To transpose this quality of the opaque painting to a translucent medium is wrong. The true ideal of translucent painting is that the design should express as energetically as possible a beautiful harmony of colors which when realized is all that can be desired. When we attempt to introduce characteristics that are proper to opaque work, we lose the most precious qualities of translucent painting, without any possible compensation. This is not a question of tradition or blind partiality for an art, in order to maintain its archaism, as some contended; it is one of those absolute questions determined by physical laws which may not be changed." Viollet-le-Duc, *op. cit.*, pp. 12-13.

4. Mendelsohn seemed to have very definite views about stained glass. Thus Rabbi Armand Cohen of the Park Synagogue in Cleveland has related the following:

"Everyone wanted stained-glass windows, the proponents pointing to the long tradition—stained glass as a feature of ecclesiastical buildings. Mr. Mendelsohn was adamant in his answer: 'When you will show me a stained glass that has upon it a design as beautiful as God's design of the surrounding trees, the flowing river and the sky above, then I will give you stained glass. But don't waste your time gentlemen, you won't find it! Besides, didn't the Lord say, "Let there be light." Why do you want to shut it out?' " Arnold Whittick, *Erich Mendelsohn* (New York, 1956), p. 183.

5. Dorothy Seckler, "Gottlieb Makes a Façade," *Art News* (March, 1954).

INDEX

Kelly and Gruzen, 208
Kepes, Gyorgy, 66-9, 181-2
Kneses Tifereth Israel Synagogue, *Port Chester, N.Y.*, 34, 37, 193-7
Kramer, Helen, 224

Lassaw, Ibram, 61, 88-90, 167, 171, 193-8, 200-1
Leaf, Reuben, 70
Lehman, Anne, 160
Levy, Abraham, 250
Lipchitz, Jacques, 120, 138-9
Lipton, Seymour, 111-2, 170-1, 189-90, 192
Loebl, Schlossman and Bennett, 96, 107, 163, 257
Loop Synagogue, *Chicago, Ill.*, 256-9
Löw, Leopold, 4, 8
Lydda, synagogue of, 21

Ma'ase Nissim, 48
Maimonides, 17, 87, 154
Ma'on Nirim, synagogue of, *Israel*, 16
Mendelsohn, Erich, 24, 31-2, 41, 174-80
Menorah, 14, 32, 41, 55, 57, 67-9, 78, 86, 106, 112, 114-5, 120, 122, 137-8, 144-6, 168, 170-2, 178, 184, 186, 194-7, 200, 210, 222, 224
Meyer, Howard K., 182
Michaels, Leonard, 104
Mihaly, Eugene, 155-6
Mikveh Israel Synagogue, *Philadelphia, Pa.*, 37, 40
Miller, Edgar, 163
Miller, L. Gordon, 64, 164
Mishkan Israel Temple, *Hamden, Conn.*, 160
Mohilev, synagogue of, 47-8, 50
Moller, Hans, 189
Moses and Hancock, 211
Motherwell, Robert, 79-81, 165
Mt. Kisco Jewish Center, 165
Mt. Sinai Temple, *El Paso, Texas*, 42
Mt. Zion Temple, *St. Paul, Minn.*, 31-2, 174, 178-80
Mumford, Lewis, 28

Na'aran, synagogue of, 143
Nathan, Fritz, 37-8, 53, 160
Nirim, synagogue of, 12
Noah's Ark synagogue stone, Jordan, 12

Oheb Shalom Temple, *Baltimore, Md.*, 36-7, 65-9
Oheb Shalom Temple, *Nashville, Tenn.*, 67, 102-3, 134-9, 151, 153

Park Avenue Synagogue, *New York City*, 208, 210, 242, 247
Park Synagogue, *Cleveland, Ohio*, 24, 28-9, 32, 153, 174-5
Pinart, Robert, 160, 185, 187
Polish synagogues, 12, 18, 37, 47, 67, 143
Prayer hall artwork, 140-237
Preusser, Robert, 67-9
Prowler, Stanley, 253

Quitman, Belle, 152

Rattner, Abraham, 58, 256-9
Rawinsky, Hans, 168
Refregier, Anton, 108-10, 129
Reyim Temple, *Newton, Mass.*, 114-5
Ries, Victor, 70-1, 104-5, 152-3, 156
Rodeph Shalom Congregation, *Philadelphia, Pa.*, 172
Rosenthal, Bernard, 116-7
Roth, Henry, 106

Saltzman, William, 239-41
Sanfeld, Max M., 182
Satterlee, Nicolas, 217
Schapiro, Meyer, 65
Schor, Ilya, 72, 151, 204
Second Commandment, interpretation of, 7-22
Segal, Chayim ben Isaac, 47-8
Setti, Napoleon, 248-9
Shaarey Zedek Congregation, *Southfield, Mich.*, 44
Shalom Temple, *Greenwich, Conn.*, 64
Shalom Temple, *Newton, Mass.*, 173, 248-9
Shammes, Juspa, 48
Simon, Max, 128
Simon, Sidney, 55, 122-4, 162
Sinai Temple, *Washington, D.C.*, 67, 215-23
Siporin, Mitchell, 224
Sons of Israel Congregation, *Lakewood, N.J.*, 39, 71
Sowers, Robert, 64, 253-5
Spotz, Charles, 251-2
Stained glass, 17, 53, 57, 64, 70, 72, 159-60, 182, 238-60
Steinberg, Milton, Memorial House, 72, 208, 210, 242-7
Sullivan-Wright style in architecture, 32

Tapestry, 17, 21, 58-9, 164-5
Temple of Solomon, 8
Tent of Testimony, 7